Art, Affluence, and Alienation

Art, Affluence, and Alienation

THE FINE ARTS TODAY

Roy McMullen

FREDERICK A. PRAEGER, *Publishers*
New York · Washington · London

FREDERICK A. PRAEGER, *Publishers*
111 Fourth Avenue, New York, N.Y. 10003, U.S.A.
5, Cromwell Place, London S.W.7, England

Published in the United States of America in 1968
by Frederick A. Praeger, Inc., Publishers

Library of Congress Catalog Card Number: 68-19508

ART, AFFLUENCE, AND ALIENATION: THE FINE ARTS TODAY
is a *Britannica Perspective* prepared to commemorate
the 200th anniversary of *Encyclopædia Britannica*.

Printed in the United States of America

Acknowledgments

The author gratefully acknowledges permission to reprint from:

"La casada infiel," Federico Garcia Lorca, *Obras Completas.* © Aguilar. S.A. de Ediciones. All Rights Reserved. Reprinted by permission of New Directions Publishing Corporation, Agents for the Estate of F. G. Lorca.

"La capra," Umberto Saba. By permission of Arnoldo Mondadori Editore, Milan.

"Von armen B. B.," Bertolt Brecht. By permission of Suhrkamp Verlag, Frankfurt am Main.

"Roses Only," Marianne Moore. Reprinted with permission of The Macmillan Company from *Selected Poems* by Marianne Moore. Copyright 1935 by Marianne Moore, renewed 1963 by Marianne Moore and T. S. Eliot.

"Prophétie," Jules Supervielle. From *Gravitations.* By permission of Editions Gallimard, Paris.

"Song of the Tart," Kaneko Mitsuharu. From *The Penguin Book of Japanese Verse,* Geoffrey Bownas and Anthony Thwaite, eds., Penguin Books Ltd., Harmondsworth, 1964. By permission of Penguin Books, Ltd.

"La Chanson du mal-aimé," Guillaume Apollinaire. From *Alcools.* By permission of Editions Gallimard, Paris.

"Burnt Norton" and "East Coker" in "Four Quartets," "The Waste Land," and "The Love Song of J. Alfred Prufrock," T. S. Eliot. From *Collected Poems 1909-1962,* Harcourt, Brace & World, 1964. By permission of Harcourt, Brace & World, Inc., New York; Faber & Faber, Ltd., London.

"Memorabilia," E. E. Cummings. From *Poems 1923-1954,* Harcourt, Brace & World, 1954. By permission of Harcourt, Brace & World, Inc., New York; Faber & Faber Ltd., London.

"The Locust Tree in Flower," William Carlos Williams. From *Collected Earlier Poems.* Copyright 1938 by William Carlos Williams. Reprinted by permission of New Directions Publishing Corporation, New York; MacGibbon & Kee, Ltd., London.

"A Poem Beginning with a Line by Pindar," Robert Duncan. From *The Opening of the Field,* Grove Press, 1960. By permission of Robert Duncan.

"Mattina," Giuseppe Ungaretti. By permission of Arnoldo Mondadori Editore, Milan.

"No Hay Olvido," Pablo Neruda. By permission of Pablo Neruda.

"Eloges. 2 (Pour féter une enfance)," Saint-John Perse. By permission of Saint-John Perse.

"Man and Wife," Robert Lowell. Reprinted with permission of Farrar, Straus & Giroux, Inc. From *Life Studies* by Robert Lowell. Copyright © 1958 by Robert Lowell.

"Metaphors," Sylvia Plath. By permission of the Estate of Sylvia Plath, Olwyn Hughes, Agent.

"Museum Piece," Richard Wilbur. From *Ceremony and Other Poems,* Harcourt, Brace & World, 1950. By permission of Harcourt, Brace & World, Inc., New York; Faber & Faber, Ltd., London.

"The Pasture," Robert Frost. From *Complete Poems of Robert Frost.* Copyright 1939, © 1967 by Holt, Rinehart and Winston, Inc. Reprinted by permission of Holt, Rinehart and Winston, Inc., New York; Lawrence Pollinger, Ltd., London.

"Babiy Yar," Yevgeny Alexandrovich Yevtushenko. From *Selected Poems,* Robin Milner-Gulland and Peter Levi, eds., Penguin Books Ltd., Harmondsworth, 1962. By permission of Penguin Books, Ltd.

"Die gestundete Zeit," Ingeborg Bachmann. By permission of R. Piper & Co. Verlag.

"Roman Wall Blues," W. H. Auden. From *Selected Poetry of W. H. Auden,* Curtis Brown Ltd., New York, London, 1959.

"L'anguilla," Eugenio Montale. By permission of Arnoldo Mondadori Editore, Milan.

Rainer Maria Rilke, *Sämtliche Werke,* Vol. II. © Insel-Verlag Wiesbaden 1957. By permission of Insel-Verlag.

Fernando Pessoa. By permission of F. Caetano Dias.

"Miniver Cheevy," Edwin Arlington Robinson. From *The Town Down the River,* New York, Charles Scribner's Sons, 1910.

"Toto Merumeni," Guido Gozzano. By permission of Renato Gozzano.

"Hugh Selwyn Mauberley," Ezra Pound. From *Personae.* Copyright 1926, 1954 by Ezra Pound. Reprinted by permission of New Directions Publishing Corporation, New York; Faber & Faber, Ltd., London.

"It's No Use Raising a Shout," W. H. Auden. Copyright 1934 and renewed 1961 by W. H. Auden. Reprinted from *Poems,* by W. H. Auden, by permission of Random House, Inc., New York; Faber & Faber, Ltd., London.

"ins lesebuch für die oberstufe," Hans Magnus Enzensberger. By permission of Suhrkamp Verlag, Frankfurt am Main.

"Poetry of Departures," Philip Larkin. From *The New Poetry,* Penguin Books, Ltd., Harmondsworth.

"The Second Coming," William Butler Yeats. Reprinted with permission of The Macmillan Company from *Selected Poetry* by William Butler Yeats. Copyright 1924 by The Macmillan Company, renewed 1952 by Bertha Georgie Yeats.

"Fragmente," Gottfried Benn. By permission of Limes Verlag, Wiesbaden.

"The Pylons," Stephen Spender. Copyright 1934 and renewed 1961 by Stephen Spender. Reprinted from *Selected Poems,* by Stephen Spender, by permission of Random House, Inc., New York; Faber & Faber, Ltd., London.

Contents

Art, Affluence, and Alienation

Some things I have said of which I am not altogether
confident. But . . . we shall be better and braver
and less helpless if we think that we ought to inquire,
than we should have been if we indulged
in the idle fancy that there was no knowing and
no use in seeking to know. . . .

PLATO

Chapter 1 Introduction

THIS BOOK EXAMINES the present state of the fine arts in the world at large and some of the issues arising from that state. An effort of such a scope, in a field where opinions are strong, evidently calls for a focusing of intentions and a few signs of humility.

I

Let us start with the focusing. A premise in the following pages is that recent styles and subject matters in art are linked to an economic, social, intellectual, and spiritual upheaval in which science and technology are important factors. This is not meant to suggest that modern artists should be looked at as if they were merely the seismographs of history. They too are active agents in the great change, and each has a unique outlook, without which he would be of little consequence.

Another assumption is that a little knowledge is not at all a dangerous thing. It is better than no knowledge, and need not be superficial. Moreover, at the moment the number of new and frequently parallel developments in art and science is so large that sampling over a wide range has become particularly advisable, not for the sake of becoming a jack-of-all-cultures, but because the alternative is to risk not seeing the full significance of what one does know. All this, of course, is not to deny the modern need for professionals committed to cultivation of narrow fields.

A third assumption, which may be more arguable than the other two, is that the modern movement in art is now, some two-thirds of a century after the first

3

experiments, a going concern with admirable works to its credit. But this is not to say that only the wilder bells ring in the new.

The result, as the reader should soon notice, of these and other propositions and counter-propositions is a relatively restricted undertaking. It is primarily neither chronological history nor evaluative criticism, although it makes frequent use of both. It can be most accurately described as simply a study in contemporary aesthetic situations, with the understanding that some situations are also predicaments.

Such a study involves the critic, or situator, in a number of risks and approximations. He has to be just toward many distinct—often fiercely distinct—positions without blurring what seem to him to be the right, or real, ones. He has to remember constantly that all works of art, including the masterpieces, shift unpredictably, like electrons hit by light, under the impact of successive appreciations. And all the while his preoccupation must be to answer a large and rather woolly, but fascinating and thoroughly legitimate, question: "Where are we now?" He thus differs from the usual art historian in about the way a navigator, aboard a fast ship on a windy night, differs from a mapmaker.

II

Where are we now in the fine arts? The question makes sense only when qualified. Who are "we"? "Where" in relation to what? When is "now"? What is "art"? Which are the "fine" ones? Although exact qualifications will emerge only as the inquiry advances, their nature can be indicated here.

Artists and audiences will often be assumed to be united, since a creator's style and an appreciator's taste are often, although not invariably, simply the active and the passive aspects of a single attitude. For the same reason, works and people can occasionally be treated as a cultural unit: a remark about "Guernica," for example, can also say something about Pablo Picasso and about at least some viewers of the painting. On the other hand, a puzzled or hostile public—one of the regular features of this century—may have a position worth examining. In sum, at one level whoever or whatever is being situated will be quite evident, although it may change frequently.

At another level, however, a "we" may appear without explanation, or be implied by a point of view. It can be taken to refer, very approximately, to educated adults living in the urban centres of the technologically more progressive countries. In other words, the hero, or villain, or victim, in this book—what is ultimately being situated—is 20th-century man. I think that this mythical, statistical personage, conditioned by free education, atomic weapons, automated prosperity, lunar probes, parking nightmares, and dozens of other benefits and calamities, is rapidly becoming real enough to allow most readers to effect an identification.

III

The table of contents outlines the discussion. After a panorama and a presentation of general themes, questions more or less peculiar to particular arts will be treated. The "more or less" is needed, for many of these questions have common elements which reveal the emergence of a multi-art period style.

Within each section of the large plan, "where" may have several frames of reference. For instance, many arts lend themselves to placing on a spectrum going from the representational to the symbolic or abstract. With others an evolutionary scale, which need not suggest progress (nor decadence) may be interesting; a music listener, for example, can usefully locate himself in the long and surprisingly orderly evolution of Western harmony. Another sort of situating can be done within the pattern of such eternally recurring tendencies as the archaic, the classical, the mannerist, the baroque, and the romantic. (Capitals will be used to set off the historical sense of such terms: thus "Romantic" will refer to the specific, largely 19th-century, movement in Western art, whereas "romantic" elements may be discerned in anything—in Hellenistic sculpture, in Gothic churches, in Surrealist poetry.) Again, a geographical spectrum may be used; the Westernizing of the East should not make us overlook the fact that European and American artists are more Oriental than they were a hundred years ago.

These contexts, of which the above list is only a sampling, overlap considerably; and nearly all, along with the relevant complexes of arts, artists, distributors, and audiences, can be said to occupy new positions in our total culture. Thus a reader of novels today may find himself in a legal situation, in regard to obscenity, which was unthinkable a generation ago. A viewer of paintings is in a religious situation which has changed markedly since the 19th century, and drastically since the 17th—during the life spans, end to end, of four believers. One cannot say "where," in several senses, music is today without considering the vacuum tube and its descendants. Poetry has not only a new aesthetic situation but also a new sociological one and even a new biological one, since it has largely ceased to be the aid to wooing it once was. Architecture has a new relationship with politics and economics. Our general artistic sensibilities are beginning to shift, under the pressure, among other things, of a kind of thinking brilliantly exhibited in the achievements of theoretical physics. And often we can simply forget that this all-purpose term "situation" is being used metaphorically, for modern methods of reproduction and distribution have altered quite literally the situations of many works of art—the "Mona Lisa" and Beethoven's Fifth, for instance, are now practically everywhere. Again I am merely sampling the coming discussion, but the reader should be able to see already why he will be asked to maintain a steady awareness of the inquiries being made in other fields.

He will also be asked to remember that every critical method has its perils. This book, like more orthodox histories of art, will be mostly a success story, but since its concern will be with today, with unsolved problems and with live issues, it may have a tendency to present a given situation as a "crisis." The remedy, of course, is to recall that some kind of art has always been in a crisis, when looked at from a contemporary angle. The rise of Renaissance architecture was a disaster from the point of view of Gothic masons. When the sonata form appeared in 18th-century Western music, the fugue was in trouble. As the manner of Shelley waxed, the manner of Pope and Dryden waned. The success story of the Lascaux cave paintings was probably considered the end of all art, "as we have known it," down in Altamira.

<div align="center">IV</div>

The "now" in these pages will seldom be narrower than the third quarter of this century, but it may often be much broader, since the present draws most of its emotional, and therefore artistic, substance from the persistence of the past and anticipations of the future. A large number of works produced in the years around World War I are still contemporary; they cannot, that is, be assigned to any other stylistic era than now. And since the attitudes and conditions from which the modern movement in art arose seem stable enough to last a good while, if we do not drift into a nuclear conflict, they warrant our making a few informed guesses about the future. Such guesses, even if they prove wrong, can help to bring out what is significant in our present situation. One can argue, to be sure, that nothing can be formulated until it is finished, and that therefore an account of an artistic style or movement must always be either an epitaph or a prophecy. But both horns of this dilemma exaggerate the pretensions of sensible critics.

In so large an enterprise, in which much of the material is merely illustrative, an apology for omitted details seems unnecessary. An explanation, however, may be wanted for the inclusion of certain artists and works, since the choice cannot be as obvious as it often is when one writes about the art of the past. The principle of selection will be threefold. First, although it would be futile to pretend that everything cited will prove timeless (and anyway the timely has its own value), no work will be discussed at length without the agreement of several experienced critics that it is worth serious attention. Second, within this area of choice, which will include many works whose power to survive has been at least briefly demonstrated, a preference will be shown for good points from which to take a bearing. Hence music in the manner of Anton Webern will get more attention than its quantity might appear to warrant. And third, a similar preference will be shown for works which throw light on, or simply raise, peculiarly 20th-century issues (it will be noticed that the three explana-

tions overlap). Hence T. S. Eliot's poetry will get more attention than his criticism. Again, the reader should remember that every approach has its perils.

V

It would be reasonable to beg off defining art in this introduction, on the ground that the entire book is an indirect definition, probably the only sort possible. An attempt at the impossible may, however, bring out some of my prejudices which the reader ought to weigh. So let me at any rate try the logical first steps of putting the phenomenon in a class and distinguishing it from another member of that class.

This approach leads to the perhaps unexpected. Art has a kinship with sexual behaviour, primitive magic, and much else; but surely what it most resembles is science. Both activities are divorced, in their creation and appreciation, from utility; and the fact that science can both heal and kill, or that architecture can be functional, or that music can foster chauvinism and get more milk out of cows, does not affect this observation. Both activities are directed, more than is commonly supposed by people not engaged in them, toward the establishment of order—an order which our minds, or our emotions, can accept as a revelation of necessity. (Given the respective circumstances, the sun must rise, Hamlet must die, and the Parthenon columns must be as tall as they are: anything else would be unscientific or unaesthetic.) Both are best when the order is most economical and the necessity apparently absolute; and both are strangely, in view of their nonutilitarian character, irritating when they leave loose strings. The achievements of both tend to become grandly banal with the passage of time.

But the differences are evident. Although modern scientists, on the practical and philosophical boundaries of their activity, are sometimes forced to see themselves as finally the prisoners of measuring devices and human reason, they are constantly aiming at objectivity. Aided by the discoveries of their predecessors, they move toward an all-inclusive order on terms set eventually by the entire universe. Artists, on the other hand, are notoriously dreamers and as-if thinkers. They move into arbitrarily limited orders on subjective, strictly human terms, usually their own; and they thus enjoy an advantage which partly compensates them for their lack of scientific authority. For while a necessity proclaimed by a scientist can be challenged by information from any quarter of the real universe, one presented by an artist can be upset only by something inside its own imaginary world. Because Ptolemy's system, venerable and ingenious as it was, did not absorb all the known facts, Copernicus could prove that it was inadequate. But no one will ever make a fool of Jane Austen on such a basis. She picked her own data, and exhausted them in her own freely created order and necessity.

The point here is familiar, but worth emphasizing because it will come up frequently in the following discussion. It must do so because one of the most important, and for the layman most unsettling, things about our total modern culture is the fact that both scientists and artists have reached, as a result of their own explorations, a stage of acute consciousness of the exact natures of their disciplines. They are now committed to the excitement and perhaps wistfulness attached to a complete loss of ignorance. What were possible exploits in other eras have come to be felt as obligations. Thus, for example, modern biologists try to fit the known facts about life into the order disclosed by the facts of non-life; not to try would be to concede that science is not quite universal, and so not quite science. In this book modern artists will be found facing the opposite sort of problem. Painters, to cite the most visible examples, are struggling with the consequences of having demonstrated that a picture is a nonuniversal order, a world in itself with its own law of gravity and all the rest. Not to struggle, it is felt, would be to concede that art is not quite art. Modern novelists, at the other end of one of our spectra, are in their version of the same situation.

I am getting beyond the business of an introduction, but at least one of the objections the reader has in mind ought to be answered. Doesn't all this come dangerously close to the aestheticism of the European 1890s? It does, since that doctrine, like all heresies, was a half-truth. The failure of the aesthetes was more ethical than aesthetical; they made overmuch of being right about the autonomous nature of art, and neglected what can happen when a work is experienced in the full complexity of living (that some scientists make a parallel error does not prove them wrong about the essence—the nonutilitarian core—of scientific work). For it is obvious that one of these small aesthetic "worlds" may have, in addition to its contemplative value as pure order and necessity, a seriousness that turns on a relationship with everyday reality. Even in the musical, abstract, and architectural arts such a relationship may exist in secret ways, usually untranslatable into prose. It is often felt in literature as an oblique comment on the meaning of life and death. If the effect on conduct is usually negligible, that on the moral imagination may be powerful indeed. There is no other plausible explanation for the sentiment of being riper and better adjusted which seeing, hearing, or reading a major work can produce. And of course one can argue that the axiom of Lucretius applies to artistic creation as well as to the other kind: from nothing, nothing.

Hence much that passes for art criticism, including much in these pages, is impure; it is mixed with other notions, ultimately ethical, and rightly so. The remark of Clemenceau about war and generals can be adjusted so as to sting everywhere; art is too serious a matter to be left to artists. The autonomous orders and necessities, however capable of standing alone, are also symbols and

metaphors, if we give our words a wide enough meaning. There are very few poems, for instance, even among the most gemlike, whose worth can be assessed without some resort to moralizing; and the same thing can be said about such abstractions as the proportions of Greek temples and the forms of symphonies.

The difficulty, of course, is that the moralizing does not tell us why the poem is effective, nor why it should be a poem at all and not simply a moral tract; and this sort of difficulty becomes more and more troublesome as we try to make our definition of art embrace more and more items, from scratched mammoth tusks on up, or down, to modern creations. Gradually we find ourselves being forced back toward the premises of the aesthetes, but with a growing suspicion that there is a source of satisfaction which is more widespread, probably more basic, than anything we have talked about so far.

Another look, then, at our theory seems called for. In the enormous variety of objects, performances, and records which we spot instantly as being "art," there is a striking common denominator: the arbitrariness already mentioned. In plainer language, a work of art functions as such only because we are quite certain that it is not really a slice of reality and that its pure order and necessity are as willed as the mud pies of children. Even a masterpiece is always felt as an extraordinarily intense kind of game; if a reader actually believes Jane Austen, *Emma* stops being art. And, after some forty thousand years, there is no use arguing that all this is not very serious: obviously some profound need is being filled. Hence the search for a definition of art, on any philosophical level, always turns at last into a question—which may as well be brought up to date. Why should people in the 20th century, with their superstitions dying, or at least becoming unconscious, and their minds open to the objective order revealed by science, continue to indulge so solemnly, and often so expensively, in such games?

Of the many answers available, several of which will be used in the course of this book, the most appealing is the most simple: art reassures us about our common humanity. Confronted by the Lascaux paintings, we experience a *fraternal* satisfaction which makes most of the standard theorizing, however ingenious and persuasive, seem irrelevant. Much the same thing may happen with Beethoven's Ninth, or with the fine curve of a Persian bowl, or with a play by Samuel Beckett. Man is a graffiti-making animal, in many media. A work of art, precisely because it does announce itself as an "unreal," arbitrary pattern, discloses his comforting presence and makes a sense not found in the real universe of science. A great work does many other things, and it is from these that aesthetic and ethical criteria are derived. But the comfort looks fundamental, in everything from prehistoric scratches to the latest avant-garde experiment.

These thoughts are not so remote from the present undertaking as they may seem. They are not a plea for art that says nothing, and do not excuse a critic from his duty to do all he can to get at the intended meaning of a work. But they do have implications for an appreciation of many modern achievements, and also for an approach to several artistic activities long regarded as minor in the Occident—Oriental pot-making, for instance, and calligraphy.

Moreover, they suggest that "communicate," taken too literally, can be a misleading, even an obscurant, term in criticism. It won't be entirely abandoned here, but will be used prudently—loosely, that is. For there is no getting around the fact that a first-rate work of the imagination may be a very inefficient device for transmitting specific messages from the artist to his viewer, listener, or reader. It may be simply a terrain of fraternal encounter.

VI

There should now be no need to explain the decision to treat as "fine" in the following pages several arts not in the various traditional lists, most of which stem from the curriculums of the older European academies. The adjective was kept merely to avoid the noun's possible reference to branches of learning and to certain skilled, but nonaesthetic, occupations.

The list could have been much longer. Cooking, for example, was excluded on the usual grounds that taste and smell are aesthetically inferior to sight and sound; but the case is arguable in some countries. Costume design, traveling, and even conversation might have been added. In fact, any creative, "useless" activity which is aimed primarily at giving us a vision of our own humanity can be called a fine art.

. . . in 1900, the continuity snapped.
HENRY ADAMS

On or about December 1910 human character changed.
VIRGINIA WOOLF

Chapter 2 The Feel of a New Era

SINCE CULTURAL HISTORY is a matter of wheels within wheels, art critics are constantly tempted to say something about everything. In these pages the temptation is strong, for there have been few periods of artistic activity when out-of-date frames of reference were as prevalent as they are now, and as certain to be fatal to an appreciation of contemporary work. People who would never think of judging a Renaissance painting, for example, in Gothic terms may be quite ready to judge a modern one in Renaissance terms.

Excellent frames of reference can be found, however, in surveys covering other fields. This chapter will therefore be a collection of reminders plus an attempt to isolate some common, and largely emotional, reactions to the course of modern events.

I

The reminders can begin with the fact that our era can be recognized as early as 1900. In that year the physicist Max Planck published his quantum theory, Sigmund Freud *The Interpretation of Dreams,* and Thomas Mann the novel *Buddenbrooks.* During these same twelve months the philosopher Edmund Husserl, whose phenomenological doctrine and method lie behind several lines of contemporary thought, brought out his *Logical Investigations;* the inventor R. A. Fessenden succeeded in transmitting speech by wireless over a distance of a mile; and gramophone firms in Europe and America moved toward at least low fidelity by recording their master disks in wax.

Three years later Wilbur and Orville Wright made their first powered flight;

11

and Maksim Gorki's play *The Lower Depths* (this chronology is extremely inexhaustive), which with a little forcing can be made to look like a cousin, if not quite an ancestor, of our kitchen-sink dramatic realism and the Theatre of the Absurd, began a two-year run in Berlin. One can detect already the new century's characteristic optimism and equally characteristic heartsickness.

The year 1905 brought more of the same. Albert Einstein announced the special theory of relativity and, like Lord Byron a century and whole world earlier, shortly awoke to find himself a culture hero. The Fauve painters, led by Henri Matisse, proclaimed their contempt for realistic colour. *The Great Train Robbery,* in which Edwin S. Porter developed the basic principle of film editing, opened near Pittsburgh in what has been called the first motion-picture theatre. James Joyce completed *Dubliners.* Henry Adams, convinced that a cultural and perhaps a cosmological clock had at last run down, wrote *The Education of Henry Adams.* Russia had a bourgeois rehearsal for its coming proletarian drama. V. I. Ulyanov, under the pseudonym N. Lenin, published *Two Tactics for Social-Democracy in a Democratic Revolution.* In St. Petersburg, slated to become Leningrad, Michel Fokine created *The Dying Swan,* which Anna Pavlova was to use to bring classical ballet to the world's theatrical sticks.

In 1908 Henry Ford brought out his Model T and sealed the fate of an urban aesthetic thousands of years old. Picasso and Georges Braque invented Cubism and sealed—for a while, anyway—the fate of a tradition which had begun with Giotto. Arnold Schoenberg upset—in this instance the fate-sealing is turning into a very complex operation—an even older Western tradition by ceasing to write tonal music. In Chicago, Frank Lloyd Wright was completing the Robie house, the most famous of his revolutionary "prairie" homes. Rainer Maria Rilke published the second part of his *New Poems,* and Ezra Pound, a poetical refugee from what he called "the most Godforsakenest area of the Middle West," arrived in Italy. Modern logic and mathematics moved ahead with Ernst Zermelo's first formulation of axioms for set theory; and the Original Dixieland "Jass" Band was formed.

Drastic innovation was becoming the rule. In 1910 Wassily Kandinsky painted the first purely abstract work, Adolf Loos built the strictly rational Steiner house in Vienna, and Sid Graumann staged the first dance marathon (if one rules out late-medieval performances). In 1913 Niels Bohr brought out his theory of atomic structure, Igor Stravinsky and Vaslav Nijinsky created a Paris scandal with the ballet *The Rite of Spring,* Marcel Proust published the first section of *Remembrance of Things Past,* and Moses Koenigsberg, editor of the *Chicago American,* began the syndication of comic strips.

This chronological counterpoint can be kept going with the aid of the *Encyclopædia Britannica* index, and the more obscure items checked in the same

way. The alleged firsts, of course, can all be challenged, and some quickly dismissed: the white O.D.J.B., although it started a craze, was obviously not the *original* Dixieland jazz band. One must grant that none of these events was spectacular, decisive, or symbolic enough to make its date a traditional end or beginning—our equivalent of the Roman 476 or the Renaissance 1453. Still, even this early, random fragment of the modern cultural configuration justifies some reflections that are relevant to today's issues in the fine arts.

First, since the new pattern emerged in the relatively peaceful and stable pre-1914 world, there is no support here for the common, if seldom explicit, assumption that contemporary thought, feeling, and art are products of the 20th century's wars, revolutions, economic crises, and international breakdowns in political morality. That these catastrophes have had many cultural effects cannot, naturally, be denied. They have destroyed an appreciable part of our civilization's material past, cut short millions of careers, and left psychological scars, notably a pervasive fear of what may happen the next time. They have provided the average modern sensibility with more tragedy than it can absorb without guilty feelings of boredom. They have also, witless as the methods were, cleared away a good deal of cultural rubbish, hastened technological progress, and brought about or at least confirmed some desirable shifts in social and political power. Yet, in perspective and particularly in the realm of art, they look mostly like interruptions in what has counted.

Second, despite this evidence of a normal historical growth, the break with the past was very sharp. It had the character of a fuseless explosion, one provoked simply by bringing together the critical amounts of slowly accumulated ingredients. Although the events on our list can be studied as developments, they can scarcely be called culminations: they conspicuously lack that quality of being a final synthesis which can be felt, for instance, in a Brahms symphony or a Renoir painting. Most of them have far more to do with the third quarter of the 20th century than with the last decade of the 19th.

Third, while one has to be extremely cautious in talking about cultural coincidences, convergences, and synchronizations—and remember that the descriptive terms employed may prejudice the case—the plain fact is that a lot of things happened at the same time. Radically new departures occurred almost simultaneously in art, science, technology, philosophy, mathematics, political theory, entertainment, folkways, and home life.

All this is not to say that the years just before World War I constitute an absolute watershed in the history of world, or even Western, culture. Aesthetic change, to limit ourselves to what concerns us here, is usually of the seeping kind. Curiously remote sources can be found for every individual style, and in several arts—poetry is one example—modernism begins well back in the 19th century. Also, these remarks have so far dealt with only a section of the general

situation, and within that mostly with a Western minority outlook. I shall presently have occasion, for example, to say that the styles and works of the past are still very much with us. Nevertheless, 1900 is a convenient, round date, useful for dramatizing the important fact that we are now living in a new cultural period, one that is as distinct and all-embracing as the Gothic and Renaissance periods that preceded it in the West—although much more complex and geographically extensive.

II

We can now return cautiously to what, in the absence of a less slanted term, can be called coincidences. One turned up while I was putting together the chronology that starts this chapter: I noticed that Einstein and Paul Klee were exact contemporaries, both having been born in 1879. Now in itself this fact is of course just mildly interesting, for readers who like dates; it certainly does not prove and should not suggest any reciprocal influence. Perhaps it should have been recorded as simply more evidence that a new kind of art and a new kind of science appeared together in Western Europe. But it refused to be left in so inert a state; instead it has become, at least in one imagination, a probably permanent reminder that two otherwise quite different modern intellects were curiously united by an interest in what Klee called "taking a line for a walk." Are such intimations of modern cultural unity worth serious consideration?

One can grant that they are, since they occur constantly to everyone. In fact, it is not uncommon for people to feel obscurely that the various strands in the 20th-century cultural pattern, the various arts included, go better with each other than each does with its own previous history. A modern building may have a stronger relationship with some automobiles down the street than with 19th-century architecture next door. A modern novel may seem closer to contemporary poetry and to the psychology of Freud than to the works of Tolstoi and Balzac. Whatever an analysis may show, many listeners are apt to feel that atonal music is closer to abstract painting and quantum mechanics than to Felix Mendelssohn's compositions. Probably I am not alone in thinking that some of Klee's pictures go better with Einstein's vision than with, say, Jan van Eyck's, even though painters and scientists may be upset by such dilettantism.

The felt coherence does not, of course, include every modern activity, and it seldom becomes a detail-for-detail relationship. Often it is no more than a glint of family resemblance among strongly individual creative minds. Again, in a miscellany of modern works, it may be like the taste of saffron that pulls a bouillabaisse together, without for a moment obscuring the diversity that is the principal characteristic of the dish. In short, it is no bar to noticing the multiplicity and complexity of our era, nor even to sharing the reaction of Henry

Adams, who meditated on the new century for several hundred pages and then suddenly felt himself sinking in a "multiverse." Nevertheless, the apparently irrational sense of unity does exist, and so a cultural critic is obliged to run the risk of saying something about its possible sources.

Ordinary, subjective association is usually at work; there can be little doubt that many modern things—buildings and automobiles, for instance—seem to go well together partly because they happened to enter our awareness together. A more objective kind of association can also be cited; sometimes modern artists, thinkers, inventors, and organizers have been consciously influenced by each other's ideas and works, or have arrived independently at subtly similar conceptions and styles—at structural, procedural, and metaphorical parallels —because they were seeking solutions to similar technical problems, or responding to similar intellectual challenges, or trying to extricate themselves from shared emotional difficulties. Speculation about these inevitably controversial matters must be kept for the chapters devoted to specific arts.

There is one source of felt coherence, however, which merits attention here (at the price of repetition later on) because of its importance in the general situation of the fine arts. It mixes ordinary association with dozens of intellectual challenges and emotional difficulties, and operates, often below the level of intentional activity, in the minds of both modern creators and modern observers. It is the manifold fact, now inescapable in the more advanced Western nations and increasingly so elsewhere, that in nearly every branch of human enterprise what was long accepted as "reality"—an antecedent certitude—has been destroyed or discounted.

The process, it will be objected, has been under way since the dawn of history. The sort of reality Samuel Johnson found in a stone he could kick has always been subject to criticism or abandonment by more subtle minds, and every new cultural period has discarded some of the supposed certainties of the preceding one.

All this is true enough. But what makes the modern period unprecedented is the fact that this time, in nearly every category, the old reality has not been replaced by something equally substantial, accessible, and satisfying. It has been replaced by a question in many instances, and by a negation in others: a doctor's thesis is waiting to be written on our use of the prefixes *a-* and *anti-*, as in *agnostic, amoral, apolitical, atonal, antihero, antinovel, antimatter*. Also, there is nothing in cultural history comparable to the scale and speed of the 20th-century withdrawal from familiar certainties.

Philosophers have joined, when they have not led, the general retreat. Their principal effort has been, not to repair established systems or build new ones, but to criticize; and the modern flavour is instantly perceptible in such typical assertions as that metaphysics is a foggy illusion, truth merely what works, val-

ue judgments often just bad syntax, freedom merely a synonym for anguishing uncertainty, and the condition of man absurd.

Modern religious thinkers have of course been more conservative but show little disposition to use the old arguments based on alleged historical realities. Fundamentalism has lost both intellectual and social status. Anthropomorphism has become equally unfashionable, and its decline has taken much of the reality out of praying. Hell has become mental instead of physical, and heaven is seldom mentioned. In recent years even the guardians and promulgators of dogma have manifested a tolerance which would have implied lack of conviction in an earlier era.

Modern scientists, besides contributing in obvious ways to the weakening of all orthodox fabrics, have had their own spell of doubt, and have emerged into a non-Euclidean space which does not, and never will, correspond to the data our nervous systems collect. The old, robust sort of positivism and determinism has few adherents. Today ultimate reality for a theoretical physicist is no longer made even of waves and particles, or "wavicles," but rather of bundles of abstract events, possibly discontinuous and finally unknowable.

One cannot, with much confidence, assume that the universe is at bottom mathematical, for since 1900 mathematicians have also been going through a reality crisis. Beset by apparent paradoxes, they have retreated from belief in self-evident foundations for their discipline to talk of "intuitions" and of merely formal, internally consistent "games," only to be shaken by the discovery that the supposed internal consistency cannot be proved mathematically.

As for the fine arts, the reader is probably already thinking of the many departures from conventional reality in contemporary Western painting, sculpture, and literature. Equally evident is the questioning of the nature of art itself. Much of today's music and architecture, for instance, would not have been accepted as such in 19th-century Europe and America. In fact, here we have an issue of such central importance that to discuss it now would be to anticipate much of this book.

These examples in the elite core of modern culture may seem remote from ordinary life. Actually they are not, but if they seem so, there are others at hand. Twentieth-century transportation and communication have so thoroughly demolished the ancient reality of distance that to say that Moscow is thousands of miles from Washington is to commit a flagrant anachronism; time, the most elastic and dreamlike of psychic substances, is now normally used to measure space. Ethical relativism has eroded the old absolute codes and made it hard to measure the reality of sin and crime, and hence also of virtuous actions. We have become too subtle to believe in villains and heroes. In the same spirit, we smile when referring to social strata, partly because education and dress have ceased to "place" people, and partly because only the elder-

ly and the snobbish appear confident of the reality of any classes except the governing and the governed. Indeed, the average modern person is regularly afflicted with doubts about even his personal authenticity, his own lack of phoniness—doubts of a sort rarely visible in the faces in daguerreotypes. And even if he is not the Hamlet type, he is apt to talk a language of disillusionment which would have greatly puzzled his ancestors. The tendency to explain the allegedly superior in terms of the inferior, which made its first important appearance in cultural history with the vogue of evolutionary theory, and its second with the vogue of Freudian psychology, has become a modern habit.

The speed with which the long familiar has been dislocated is discussed in studies of other fields, and the reader can find in surveys on technology and nature exciting, and sometimes depressing, evidence that the rate of change is accelerating. The tempo is not the same, of course, in all activities, nor in all the aspects of each activity; for instance, the modifications in automobiles themselves during the last fifty years have been negligible in comparison with the increase in production, sales, and traffic. In the arts a similar distinction must be made between the rate of basic stylistic change and the rate at which the new styles are spreading. Moreover, the relative stability of many social, political, legal, and religious patterns in thoroughly modern surroundings should not be overlooked, even if the stability (in politics and religion, for instance) often turns out after analysis to be more ritualistic than real. But these qualifications need not affect the general conclusion that 20th-century man is confronted not only by a widespread but also by an extraordinarily swift destruction of formerly accepted certitudes. His impression that the whole business somehow goes together is not surprising.

III

He is apt to have two other impressions, or intimations, or sentiments—a more precise term might be inaccurate. These are at bottom just different ways of perceiving and feeling the fundamental fact that our cultural continuity has snapped. They are worth noting, however, in this preliminary chapter, for they have a good deal to do with the present general situation of the fine arts and also, in all probability, with the future general situation. In many aesthetic sectors they are having a feedback effect comparable to what keeps automated processes going.

The first of these sentiments is that we have entered not only a new cultural period but also a new *series* of periods. In other words, cultural history now seems to be divided into two blocks: the modern and the nonmodern. Such a feeling has undoubtedly existed before in relatively restricted areas. Presumably some of the early settlers in America had it; and we know that during the French Revolution the present was new and vivid enough to fuse, in the collec-

tive imagination, the variety of the past into a single *ancien régime*. One can guess that something similar occurred in many Japanese sensibilities after the fall of the shogunate, and in many Near Eastern ones after the victories of Alexander the Great. But on these and the other occasions which could be mentioned there was nothing comparable to space travel, electronic computers, atomic bombs, and the hundreds of other results of the modern technological revolution. Nor, to switch from the awesome to an artistic example, was there anything quite like the recent virtual disappearance, for the first time in more than twenty-five centuries, of Greco-Roman motifs from new Western buildings. Seen from now, even the Middle Ages finds its place in the old Occidental continuity that snapped around 1900; Chartres and *The Divine Comedy* are closer to a Roman basilica and the *Aeneid* than to Wright's Guggenheim Museum and Eliot's *Waste Land*. And of course the same sort of perspective is even more noticeable in the Orient, where the past has always been something of a single cultural block.

The second sentiment, which flows from the first, is that history, in the sense both of recorded great events and of surviving cultural achievements, has lost a lot of the usefulness for the active, creative present—which must be distinguished from the passive, appreciative present—it once had. One may, to be sure, wonder if it was ever as useful as it used to be, but that is another matter. A belief in precedents and ancient models, and sometimes in the possibility that a whole society would return to an earlier cultural era, was common before 1900. It accounts for much of the dignity and the initiatory quality to be found in Eastern works of art. It inspired eager minds all over Renaissance Europe, and was long, as can be seen in hundreds of Greek and Roman place names in the United States, an active element in the frontier spirit. But today it is exceptional everywhere. Statesmen no longer refer to the lessons of the Peloponnesian War. Almost overnight, as cultural historians measure time, calling an American town the Athens of the West has become a joke. So has going to a picture gallery to copy old masters, or modeling one's prose style on Cicero, or erecting an opera house in the style of a Venetian palace. Hans Enzensberger, when he was one of post-Nazi Germany's angry young poets, summarized a view of tradition which has been that of many modern artists:

> die minderzahl hat die mehrheit,
> die toten sind überstimmt.

> the minority has the majority,
> the dead are outvoted.[1]

[1] Patrick Bridgwater, ed., *Twentieth-Century German Verse*, Penguin Books Ltd., Harmondsworth.

The practical import of these lines is not far from that of Henry Ford's "history is bunk," which caused an intellectual shudder in the 1920s—partly, one suspects, among people who resented a philistine's saying what they themselves thought.

Exceptions to these remarks will have to be considered. But here it may be enough to insist again on the difference between a passive, *appreciative* return to the past, which is certainly one of the most significant elements in the modern cultural pattern, and an active, *creative* return, which certainly is not. Even among today's ardent traditionalists there is a sense of having been cut off from usable precedents and models; and there is nothing comparable to European 19th-century—let alone European 16th-century, and Ming dynasty—stylistic revivalism. And among the modernists who have sought inspiration, or pedigrees, in the past, the most typical have turned from their own orthodox tradition toward the primitive or the exotic. The strategy suggests an attempt not so much to use history as to escape from it.

An imaginary museum has been opened. . . .
ANDRÉ MALRAUX

We are overwhelmed by the rank fecundity of the machine
LEWIS MUMFORD

Chapter 3 The Aesthetics of Abundance

NEVER BEFORE HAVE so many people been so occupied with so much art. This fact alone, even if none of the changes referred to in the previous chapter had occurred, would be enough to make the 20th century the beginning of a new era in cultural history.

The rejoicing has not been unanimous. If challenged, the critic who is also a democrat feels obliged to say that both the new abundance and its wide distribution are desirable. But critical theory has always taken scarcity for granted. The beautiful has been assumed to be rare by definition, the true artist an exceptional person, the great work unique, its availability restricted and its appreciation limited to the happy few. Thus one may wonder if what seems desirable from an egalitarian angle is altogether desirable from an artistic one—or even, strictly speaking, possible. Doesn't quantity automatically destroy quality?

It is a little early for a definite answer. But an outline of the situation may suggest where the answer will eventually lie.

I

The root reason for what has happened is ancient and axiomatic. Although the value of specific works may be violently questioned, no one doubts the value in general of creating, appreciating, commissioning, distributing, and collecting aesthetic things (including, of course, the nonphysical sort). Like love, games, pure science, and disinterested learning, artistic activity is recognized as a good in itself. Thus it can be—and has long been—used as a kind of cultural

20

gold currency, acceptable everywhere and forever as a measure of general worth. The final judgment on a state, society, or era, which is called "the verdict of history," is usually, and probably unfairly, aesthetic: Carthage is scorned primarily because it neglected sculpture and architecture, while Athens, in certain ways a less successful state, is admired primarily because it did not. Louis XIV's reign was a political and economic catastrophe for France, but nobody minds, for it was an aesthetic triumph.

The habit of judging people, one's self included, in the same fashion is equally strong, and almost as ancient. The Chinese scholar-official who was required to be a poet had a counterpart in the European aristocrat who felt that, however glorious he might be in ancestry and war, he was not quite legitimate without a demonstrated capacity for some branch of artistic activity, if only collecting. The Italian Renaissance pushed this idea to the point of considering a personality or a career as itself a work of art, and also gave a tremendous impetus to another development which has affected our modern abundance and distribution: the secularization and intellectualization of art. As soon as people began to think of a religious painting, for example, as simply a painting, it was caught up in a process which tended to detach it, both physically and in the imagination, from the church and make it available for private collectors and finally for museums, the imaginary kind included.

The middle-class families which acquired power in the West during the Industrial Revolution tended to stress work and religion, at least for a generation or two; but the Renaissance aesthetic and secular attitude (which became art for art's sake in its extreme form) was emphasized more and more by the new class of intellectuals and bohemians who appeared with the shift in the system of patronage, and who were to be the chief begetters of the modern movement. Books, museums, public concerts, and new travel facilities strengthened the attitude. Thus by the end of the 19th century a large and influential section of Western society took it for granted not only that an interest in artistic activity was beyond any need for defense but also that it might be the best indication of social status and even of the ultimate worth of an individual life. Bernard Berenson was talking about the "life-confirming" and "life-enhancing" value of art, and Oscar Wilde was predicting that "the future belongs to the Dandies." Emulating the old aristocracy, the newly affluent were legitimating their ownership of railroads and factories by sending their children on the Grand Tour and by buying paintings and season tickets to the opera. The ideological basis for what has happened since was established. All that was needed was a little more industrialization of artistic activity, and a little more democracy.

Both requirements have been met. Today, in every category of Western society, there are millions of people whose fundamental (often unconscious) assumptions would have been thought upper-class or bohemian a century ago.

Millions get pleasure, a sense of status, and a conviction of living the good life from museums, small private collections, concerts, plays, architectural tourism, novels, reproductions, and classical records. An indication of what has happened can be seen in the fact that printed criticism of current artistic activity, which hardly existed before the 19th century, is now a regular feature of mass-circulation newspapers. The housewife at the literary club, the Romanesque-architecture buff, the Sunday painter, and the balletomane without a black tie have become familiar modern types. And they are merely our highbrows and middlebrows. One must add the millions who find their life-enhancement in the cinema, television shows, popular song hits, and popular fiction.

A look at the contributing causes (to be seen particularly in the fields of education, technology, religion, economics, and politics) suggests strongly that we shall have more and more of this aestheticizing of outlooks. Allowance must be made for an emphasis on industrial rather than artistic production in the emergent and underdeveloped nations of Africa, Asia, and South America. Communist governments will perhaps continue to control creative activity, even though the effectiveness of that control is becoming more and more questionable. But there is little reason to predict the application of serious brakes. Thus the modern technological revolution, as it spreads and accelerates, can be expected to produce elsewhere the effects it is already producing in the more advanced Western countries. More economic security, more education, and more leisure will mean more people with the formerly aristocratic-bohemian attitude toward life. Automation will mean not only less work but a different kind of leisure. The quantity of time off will change the quality; the rest periods, having become much longer than the work periods, will lose their old negative character and become a time for positive activity. All but the few with authentic vocations will find (millions have done so already) what used to be called "outside" interests becoming their principal, inner ones. One can also suppose that modern technology will continue to reduce the area of political and economic choice in which the average, nonprofessional citizen and employee can feel competent and effective; the majority of the new "aristocrats" will be as far from the levers of real power as European nobles were when the middle-class lawyers, traders, and industrialists took over. The reality of religion having diminished, one can assume that the developing value vacuum will lead to a further expansion of interest in art.

Not, of course, in art alone. The importance of sports in this prospect, and in the present in the technologically older countries, should not be overlooked. Sports, besides being entertaining, offer obvious outlets for the suppressed political impulses and power drives of the new technological "aristocracy." Many games also resemble aesthetic activity. They do not, however, confer status,

and lend comfort and sense to existence, in quite the way even minor aesthetic activity can; and the most publicized of modern sports are far from attracting the audiences the arts have. The reader should bear in mind that here we are talking about all kinds of art, popular as well as elite, and ancient as well as modern.

The growing appetite for pure information—historical, archaeological, sociological, technical, and scientific—should also be remembered, along with the extraordinary interest in what might be called home technology (it goes considerably beyond old-fashioned tinkering). Here, as in the interest in sports, a parallel with the behaviour of leisure classes in the past is apparent: the modern armchair archaeologist, amateur scientist, and do-it-yourself addict would have felt at home in many an 18th-century seigneur's *cabinet de curiosités*.

II

The above paragraphs have presented the new situation of aesthetic abundance mostly (the various factors cannot really be isolated) in terms of demand, a demand generated by the opportunities art has in modern society to show its ancient ability to substitute for other value systems. Even without more automation, this demand will be increased by population growth and by the mere fact that people are living longer. It would not mean much, however, without a supply; and here again the situation in the more advanced nations is without precedent.

All of the major arts[1] have survived into our time, and several minor ones which seemed dead or dying in the 19th century have been revived: stained-glass windows, mosaics, tapestries, and many formerly neglected types of pottery are being made again in traditional ways. Certain orthodox disciplines have developed new modes which are almost separate arts: examples are electronic and concrete music, moving sculpture, and various sorts of modern novels and "antinovels." Several new minor arts—industrial design, musical comedy, and the comic strip come to mind—have appeared, along with one major innovation: the cinema. The output of all these activities, old and new, has been increased by an army of artists brought into being by such developments as the spread of literacy, the erosion of class lines, the sudden release of African and Asian peoples into the light of the 20th century, and the political coalescence of previously dispersed or disorganized peoples, the Jews and Arabs in particular. Multiplicity has been multiplied by industrial organization in many arts and, less strikingly but still significantly, by a new emphasis in academic institutions on creative work (poetry has become practically a university monopoly in the United States and Great Britain). Restorations of ancient

[1] This and the following paragraph are largely a paraphrase of extensive notes prepared by Clifton Fadiman, to whom I am greatly indebted throughout this book—and particularly in this chapter.

work often amount to reconstitutions—not only in architecture: modern scholarship has restored to playable condition enough old Occidental and Oriental music to have a perceptible effect on contemporary taste.

During the 20th century, and especially since World War II, all governments have been decidedly more Athenian than Carthaginian in outlook. Official support for artistic activity is regarded as being in the public interest at home and in the national interest abroad. In each of the major powers there is a ministry of cultural affairs or its equivalent. Cultural exchange among nations is flourishing, both on a bilateral basis and in such agencies as the United Nations Educational, Scientific and Cultural Organization. The motives are of course seldom pure. Art, since it brings tourists, is an important item in the balance of payments for many countries. It is used, notoriously by totalitarian regimes but to some extent everywhere, as an instrument of indoctrination, and of imperialism whenever the chance occurs; and the artists involved are apt to lose their theoretically absolute freedom (they can, to be sure, lose it in other ways). Significantly, the more influential officials concerned are attached to foreign ministries and not to education departments. But there is a great deal of disinterested enthusiasm which it would be unfair not to recognize; and, whatever the motives are, the result is always another increase in the quantity of art available to the world public.

In one way or another, nearly everything is multiplied and diffused by modern technology. The printing press, colour-reproduction processes, radio and television, motion pictures, recorded sound, and the rapid transportation of objects and performers are constantly replenishing the ocean of art that sustains and reassures 20th-century man, much as medieval man was sustained and reassured by an ocean of religion. When the work in question happens to be a building or something else which cannot easily be reproduced and distributed, tourist facilities diffuse the firsthand experiencing of it.

III

Here I wish to refer again to the perils in a book on modern aesthetic situations and predicaments. One of the dangers in the present context is that of indulging in the peculiarly modern sort of self-pity which technological progress sometimes arouses; and the corrective is hard to apply, since there is not much a critic can say about the benefits of artistic plenty without repeating the obvious. In the following remarks a good many things will be assumed to be common knowledge.

One of the slightly paradoxical sub-situations in the new abundance is that art has become less public. Diffusion by modern technology is certainly not the sole explanation for this change, which has been on its way for centuries, but has much to do with it.

A work of art, one might say, merits the adjective "public" if it is actually performed, as plays are, before an audience, or if it is meant to be appreciated, as frescoes and certain statues are, in public surroundings, or if it is concerned with public values—patriotic and religious, for example. This definition could stand some polishing, but even in a rough state may serve as a reminder of how far the "privatization" of art has proceeded.

The drama and ballet are flourishing in their public forms, but both are now frequently viewed by a television audience of millions, in domestic privacy. The cinema, although it may be called theatrical, provokes nothing comparable to the public-meeting excitement of a good play; each member of the audience is alone with the lighted screen (which, perhaps more than the absence of live actors, explains why it seldom occurs to him to applaud). Many people now prefer, even if they are reluctant to say so, the radio and records to public concerts and live opera. Symphonies are listened to as if they were privately performed string quartets. The microphone has transformed the old music-hall song into an intimate ballad, for you alone. The oration, although vestiges of its ancient form survive in literary criticism and the United States Senate, is practically obsolete, and has been replaced by the talk—again under electronic influence.

Murals and monumental sculpture are often enjoyed today in reproductions which give them the charm of miniatures or pieces of jade. And the modern viewer who eventually sees the originals in their public size and state may find them strangely pompous, for private art has come to be thought of as the only natural and sincere kind.

There are some signs of an opposite trend. There has been, for example, a good deal of enthusiasm for Baroque architecture and sculpture. But it has occurred among a small class of sophisticates whose delight in the old public vitality and the theatrical gesture is marked by modern irony. There has also been a revival of poetry recitation. But the 19th-century elocutionist has almost disappeared in the more advanced Western countries, the modern ideal being a microphone voice which suggests that one is simply overhearing private thoughts. In fact, jazz is about the only example of an art which has shown a disposition to dominate, stylistically speaking, technology by using it to reproduce a public feeling.

The facts should not be overstated. The new abundance has certainly not killed public art. There are plenty of statistics to prove that attendance has increased at concerts, theatres, museums, and monuments. It has not increased, however, as much as has private appreciation—not only at home but also in public surroundings—and there can be little doubt about the existence of a new kind of attentiveness, a new set of criteria, new "techno-styles," and even a new sensibility. Thanks to technology, all aesthetic experience has been tinged by

that sense of being alone with the artist's vision which previously only written literature could give.

The gains are evident. Private art can do without some of the exposition and most of the broadness of effect which public art requires, and can concentrate on immediacy and subtlety. It can produce a suspension of disbelief beyond the capacity of public art in most of its manifestations. But it pays for these gains in many ways. It must do without the energy and emotional warmth which a large participating audience generates. It has trouble handling general truths and big subjects. Most of the effects of scale are denied it. At its worst it becomes an art of evasion—a private dreamland.

IV

Privatization is a minor matter, however, when compared with the other effects of aesthetic abundance on quality. These raise questions which will crop up throughout this book and which often call for a more specific context than this chapter provides (often for a broader one also). But some preliminary notes may help to clear the air.

Obviously, as William Hazlitt put the matter in a more scarcity-minded era, "the diffusion of taste is not the same thing as the improvement of taste." But equally obviously, the diffusion of taste is not the same thing as the debasing of taste. We must beware of complaining that the masses have taken to munching *our* caviar. The fact that millions have in recent decades heard recordings of Antonio Vivaldi's *Four Seasons* is in itself a cause for neither cheers nor lamentation; such statistics mean something only when they can be safely interpreted as evidence of the quality of each separate experience of each listener.

Let us start, then, with this question: What have been, and are likely to be, the effects on individual modern sensibilities of technology's power to reproduce works of art and to induce, often to force, repetitions of the same aesthetic experiences? Reproduction and repetition—nearly everyone agrees that these are the potential criminals in our techno-aesthetic utopia.

The question implies comparisons between our era and earlier ones, but finding satisfactory bases for such comparisons is difficult. For one thing, more reproduction and repetition went on in the past than we usually suppose; the modern museum visitor tends to forget that nearly every ancient Chinese painting or Greek statue he sees is a copy and that the Rubens he admires was spread all over Europe by means of engravings. Contrasts between the alleged vulgarity of modern man and the alleged elegance or noble simplicity of pre-1800 Western and Oriental man can be dramatic but are apt to contain enough variables to be meaningless. Contrasts between 19th-century man and modern man may make the latter look better than he should, since the immediate effect of the Industrial Revolution was a good deal of "aesthetic" trash.

That last fact can be, and often is, used in an indictment of technology. Yet the very rapidity of the effect, particularly in the decorative arts, suggests that the Industrial Revolution revealed as much of an inability to discriminate as it caused. In the social strata between the fine yeoman and the refined lord there apparently had long existed a public which was simply waiting for a chance to indulge in some cozy horrors.

In printed literature, which is the oldest example we have of multiplicity and diffusion through technology, there is of course ammunition for any argument one wants to advance. The comic book can be answered with the paperback classic. Printing has diffused every kind of taste, and perhaps it has made the average person's taste more catholic, although we should not forget how widely medieval readers ranged. But its aesthetic effects have been almost entirely indirect, and have little to do with our present problem of technological reproduction and forced repetition. A literary work is not "reproduced" by printing, and the post-Gutenberg reader is as free as Chaucer was to avoid joyless repetition (more free, if one wishes to make a debating point, since he has a wider choice). In sum, in this instance technology cannot be said to have measurably either improved or debased the taste and appreciation of the individual consumer; and it has probably added to his enjoyment.

The 20th-century situation in music is quite different. Records, tapes, radio, and television, to which should be added the transport that has made modern concert schedules possible, do provide reproductions of performances and do force people to hear the same works over and over. Also, these inventions have encouraged a flood of popular and diluted-classical music which cannot be avoided in the way one can avoid the literary equivalent. It would be easy, then, to conclude that in this instance diffusion by modern technology must result in a debasing of taste, a distortion of appreciation, and a dulling of enjoyment; and it is no use arguing that nothing of the sort has occurred. Music for everything except to listen by has been ground out, and there was a time a few years ago when not hearing Vivaldi's *Seasons* was quite an experience.

There is plenty of evidence, however, for the other side of the argument. Gresham's Law does not seem to operate in the arts. Figures on concert attendance and classical-record sales are often presented with too much interpretation from interested sources, but they do prove that the realm of serious music has not been swamped by popular tunes and mood material. And, for all the complaints from the sensitive about being "overwhelmed by the rank fecundity of the machine," reproduction and repetition within the realm of serious music have apparently not done much damage to the taste, appreciation, and enjoyment of the few. The evidence is in record catalogs, among other places. Since disks devoted to the great classics have continued to dominate Western non-popular listings, one must assume that the elite listener has been neither cor-

rupted nor surfeited. There is also what might be called laboratory evidence. For a good many years a large number of modern people have been forced, often under economic pressure, to submit to the repeated hearing of reproduced music. Their taste, it seems, has not been debased, their appreciation not distorted, and their enjoyment only slightly dulled here and there. Their published reactions—the reference is of course to professional critics—are proof.

There are several explanations for these encouraging findings. The actual amount of repetition has probably been exaggerated by pessimists; the fact is that record catalogs have become more and more varied, and so have live programs in the larger cities and on the radio. The bad effect of the repetition which does exist has certainly been overestimated; the fact is that increasing familiarity adds to, rather than subtracts from, the enjoyment and understanding of good music, at least for a long time. And finally, modern reproduced music is not necessarily an inferior copy of a live original; in many instances it is superior in both sound and execution—although not in the atmosphere which only a public performance can provide. Today a taste formed largely from records may be more attentive to quality than one formed in concert halls.

The situation in painting, which is the other art most affected by modern technology's duplication power, raises stronger doubts. Here cheap reproductions abound, and even the good, expensive ones are always and inevitably inferior to the original works.

There is, to be sure, a peculiarly modern appeal—one might say another new art—in the sort of imaginary museum which presents juxtaposed photographs of a Botticelli nymph and a Gothic miniature Madonna and implies somehow that the originals are of the same size and material. This kind of privatization may initiate in the viewer's mind a dialogue unknown in other eras. Also, as Malraux has pointed out, it is from such reproductions, and not from our faint memories of real paintings, that the modern sense of styles and of their history has emerged. Yet at the same time the exact intentions of the artists, the full significance of their works, and perhaps an important public nuance may be utterly obscured by the lack of the proper colour, substance, bulk, and scale.

Moreover, since a painting is a unique physical object, even an isolated reproduction of all the elements in an original—a possibility, for example, when the work in question is a water-colour—will be a mere copy, in a sense in which a recording of a musical performance is not. It will always lack, to return to our attempt to define art, some of the original's power to reassure us about our common humanity. The presence of the creator will have partly evaporated, and in this zone of subtlety what we know may outweigh what we see. There can be no successful duplication of an autograph—which is what, among other things, a painting is.

Yet, perhaps for these very reasons, there is no conclusive evidence that technological reproduction and repetition in the visual arts have damaged taste, appreciation, and enjoyment to a significant extent; and there is considerable evidence (mostly, one should add, of the statistical kind which is open to attack) of desirable effects. Precisely because reproductions of physical objects can never be anything but copies, art albums arouse a wish to see the unique originals: the imaginary museum is today the chief source of visitors for real museums and galleries. Granted, such visitors may approach the originals from a privatized point of view, but here we should remember what was alluded to a few paragraphs ago: the fact that technology is not the sole cause of private art. Oriental works have always had a personal, lyrical quality; and Western painting as a whole has been moving away from public effects and public values ever since roughly the 14th century, when the easel picture first became important. Indeed, one might argue, taking a very long view, that the invention of the colour print was in part a response to a change in sensibility, besides being the cause of a further change. With that, having fogged the issue slightly, the defense can rest.

These observations may be overly optimistic. They are perhaps influenced by the fact that I happen never to have met anyone whose insensitivity to the finest art could be attributed to colour prints and phonograph records, and do happen to have met many persons, including hundreds of students, who have acquired knowledge and taste from such material.

Still, an anti-Luddite conclusion is hard to resist. The bad effects in the new abundance seem to have been overestimated, and in any event are not inherent in the new technological ways of achieving aesthetic experience. One can even go a little further, and maintain that the results obtained so far in the more advanced Western nations should not discourage the old belief that machines make possible a better and more democratic culture.

V

These results do suggest, of course, that there was something substantial in the old theory that the best art was for the happy few—although the few were selected on an unfair basis. Sooner or later, a conscientious commentator on the 20th century's techno-aesthetic plenty is obliged to sound non-egalitarian, and point out that what was said a few pages back about the deplorable in Victorian taste is a general truth: many of the evils attributed to technology are simply revelations of a previously existing lack of aptitude. Before our era millions of people never had the chance to prove that they could not enjoy Beethoven's quartets and that they had something like an innate preference for mood molasses. The Mumford quotation at the head of this chapter can be countered with one from José Ortega y Gasset: "Behind all contemporary life

lurks the provoking and profound injustice of the assumption that men are actually equal."

Should technology be condemned for its revelations of inequality? Should an attempt be made to turn off the molasses tap, at the cost of also turning off the Beethoven tap? Such questions are not entirely frivolous and academic, for some control over aesthetic commerce is exercised by all of today's governments. Also, there is more abundance on the way in the more advanced nations, and there are still millions of people in various parts of the world living in alleged Edens of artistic scarcity. But surely the answer to both questions ought to be a cautious no.

The problem here, it should be noted, is simply the counterpart in the aesthetic field of much more grave problems faced by modern politicians, educators, scientists, and technicians. Should physicists pursue inquiries which they know may lead to more and more fearful weapons? Should automation be continued in the midst of evidence that it is a cause of unemployment? Should doctors save and prolong lives in areas where overpopulation is already a cause of starvation? The situation in art is merely a mild example of the general ambiguity in 20th-century progress. In the long run the only sensible, humane, and democratic remedy is, not to reject our gains, but to accept a greater, and more and more complex, moral responsibility for their evil consequences.

The difficulty, of course, is that we cannot know who has an innate aptitude for enjoying good art and who has not. We have to assume that everybody has, however unjust the assumption may be for connoisseurs. Thus the new abundance has given educators a new responsibility, the full extent and nature of which do not seem to be generally realized, in spite of the number of appreciation courses in Occidental schools. Serious art curriculums are still overwhelmingly literary. It is thought normal that a person should spend years in school learning to appreciate poetry and novels, and a large part of the rest of his life actually appreciating the cinema, architecture, painting, and music. Literature, of course, is central in every nation's culture, and there is no intention here to belittle its absolute importance. But there is no use pretending that a change in its relative importance is not under way. And educators who turn out the equivalents of illiterates in the visual and aural arts have little moral right to deplore the fecundity of the machine.

It is true, as Robert M. Hutchins points out in his book *The Learning Society,* that an educational system cannot do everything, and that many social institutions are at work undoing after hours what the school does during the day. It is especially true that modern advertising tends to turn appreciators into mere consumers, with prefabricated tastes. All this, however, is scarcely an excuse for the anachronistic literary emphasis in most of today's classrooms.

VI

Here this discussion can be temporarily halted, for it is beginning to develop impingements in all directions. I am aware of having limited the subject in a perhaps unjustifiable way by talking almost entirely about technology and its effects on appreciation. There are effects also on artistic creation, and there are many situations of abundance in which machines are less important than industrial organization and marketing methods. Complex relationships and chain reactions will have to be alluded to in later chapters, along with some mysteriously stable elements. Something will have to be said about such matters as standardization, transformation, and the tendency of multiplicity and diffusion to turn the nonconforming artist into a member of the Establishment. What will be said may sound considerably less cheerful than what has just been said about the specific problem of reproduction and repetition. There should be no occasion, however, to abandon the main point the present chapter has tried to make, which is that the tools we use do not really know more than we do.

The Tao is something blurred and indistinct.
How indistinct! How blurred!
Yet within it are images.
How blurred! How indistinct!
Yet within it are things.
How dim! How confused!
Yet within it is mental power.

LAO-TZU

Chapter 4 The Main Currents

A SNAPPED CONTINUITY, a sense of lost certitudes, a feeling of starting a new historical series, a conviction that the past has become less usable, a both exhilarating and troubling awareness of aesthetic abundance—to mention such things is to give a not very firm answer to the question about where we are now in the fine arts. The reader may have begun to suspect that nobody knows where we are and that that is the essence of the 20th-century situation.

He may be right. But before deciding we ought to take a synoptic look at another characteristic of our era: its unprecedented number, not only of styles, but also of different *kinds* of art. If such a look does not tell us exactly where we are, it may provide an inkling of where we are going.

I

In a primitive society there are no highbrows, no lowbrows, no museums, no art markets, no avant-gardes, and no classifying critics. Such disciplines as poetry, music, the dance, painting, and sculpture tend to merge in a sort of continuing grand opera dedicated to magic, religion, ancestors, survival, and social cohesion. There is only one kind of art and one kind of audience. The situation can be called, with only a slight exaggeration, mono-aesthetic.

The pattern changes as soon as workers, peasants, priests, aristocrats, and court coteries emerge and become class-conscious. Still, seen from today, all ancient Western cultures strike us as having been surprisingly close to mono-aesthetic. There were certainly some crude craftsmen in Attica, and the fact that most of their work has perished should not be forgotten, but one does not

32

normally make a categorical distinction between ancient Greek folk art and the elite Acropolis kind. The differences between Roman plebeian and patrician art can be felt, but they are largely differences in quality, and do not call for separate sets of criteria.

Much the same thing could have been said about Oriental cultures until quite recently—until, that is, Western influence produced an aesthetic scission. Even today a visitor to Japan, the most modernized of Asian nations, is apt to feel that a waitress arranges flowers on a table according to the same principles which guide a director making a film or an emperor composing a *haiku*.

In medieval Europe the line between aristocratic and common was clear in certain arts: one cannot imagine Piers Plowman taking a passionate interest in the refinements of courtly love. Most of the vigorous specimens of folk and popular taste—ballads, mysteries, and moralities—are rather late in the period, however; and one can fairly say (as fairly as one can make any such generalization about the propensities of an era) that in the high Middle Ages a single aesthetic and a single public existed for architecture, sculpture, and painting. Music had more degrees of complexity, but the same modes, rhythms, and even melodies were to be heard in fields, streets, palaces, and churches.

With the Renaissance, however, differences began to deepen and to multiply. The revival of Greek and Roman styles separated the folk and elite categories much more sharply than they had ever been during the Gothic period. Popular art (I shall try in a moment to distinguish it from the folk kind) acquired a new momentum with the invention of printing, the rise of the middle classes, and the spread of literacy. Primitive art was discovered and reevaluated by Europeans and Americans. Another category was added when elite art split into the traditional and modern sorts. Thus by the middle of the 20th century the average appreciator in one of the technologically older nations was farther from the mono-aestheticism of tribal man than anyone had ever been in history. Five *kinds* of art were reaching his sensibility, in a multitude of personal and group styles. A sixth kind was constituted by the growing quantity of museum art—in the broad sense in which all works of the past, executed in styles no longer active, are pieces of museum art. The situation was thoroughly pan-aesthetic.

II

A cultural pattern which offers so many basic choices might be assumed to be unstable and transitional; and in fact it is already showing signs of sorting itself out into something less complicated, less creatively pan-aesthetic; that is, some of the world's five active kinds of art—primitive, folk, popular, traditional elite, and modern elite—already are faltering, becoming minor, being absorbed by others, or simply dying into the different life of museum art. One

cannot discuss such a fluid situation without risking some forecasts. A proper forecaster, however, ought to have an apparatus of general laws and weighed facts, and we may as well admit at the start that in the present instance no such apparatus exists. The laws are too numerous to be very coherent, the facts are hard to weigh, and every statement calls for an immediate qualification.

A relatively mono-aesthetic society is usually a static one in terms of technology. We cannot say, however, that such a society is by definition poor and backward, and that the richer nations of today will continue to have many different kinds of art. For the actual level of technological achievement seems to be less important than the rate of change. When change speeds up, the aesthetic responses become uneven in the society in question, or in the world as a whole if we are thinking of that context, and also, mysteriously, in individual sensibilities. When change slows down, a unified response has a chance to develop. And yet we cannot use this law for predictions, since we cannot say that an accelerating rate of technological change is the *sole* cause of our pan-aesthetic (Henry Adams might have written "multiversal") situation. For one thing, the decisions affecting technology are usually taken outside the realm of technology, by men motivated by political, or economic, or vaguely ideological, and sometimes even aesthetic considerations. For another thing, modern technology acts in contradictory ways: it may produce uneven aesthetic responses and complex cultural lags, but it also standardizes and unifies; it undermines the vitality of old styles, and then gives them a new life by diffusing them more widely than they ever were in the past; it alienates and integrates, debunks and rebunks.

In all this equivocal activity it has long worked with, or through, dozens of other influences on artistic creation and appreciation. The secularization of values has destroyed the unity which existed when kings and peasants shared the same religion. Mass education, besides providing a market for popular art, has created a knowledgeable audience for all kinds of art, has sharpened some divisions by giving uneven responses more of a chance to express themselves, and has tempted totalitarian regimes into the anachronisms and emptiness of imposed mono-aestheticism. Democracy and economic opportunity have helped to create an audience which is on the whole more open-minded and—in spite of advertising—less inclined to uniformity than publics were in the days when every man knew his station. Nationalism, Romanticism, and various revolutionary political doctrines, along with tourism, have helped to preserve an interest in non-elite art, the folk kind in particular. And of course 20th-century painters and sculptors are responsible for much of our interest in primitive work.

This last fact is a reminder of another point. Art, as this book begins by saying, is not necessarily a secondary activity, a mere effect of something else, for

all its links with other things. An authentic artist selects his influences and is himself an influence. All of the five kinds of active art we have mentioned, and even the museum kind, have their own histories, their own rates of change, and their own tendencies to provoke uneven responses. They may flourish or fade for reasons which have nothing to do with religion, politicians, and machines.

By these wavering lights we can try to see into the future, with the hope of thus seeing the present a bit more clearly.

III

"Primitive" will be used here for the kind of art still being produced by tribal man, notably in black Africa but also in isolated parts of other continents and on some Pacific islands. "Folk" will refer to the kind of art still being produced by unsophisticated and untutored working men, peasants, and artisans in relatively advanced, non-tribal societies. The most familiar examples of primitive art are carvings and dances, whose content is usually magical or religious. Creative folk activity may also be in the service of religious values, but is more often concerned with broadly human sentiments, or simply with decoration and recreation. These definitions are of course strictly of the working sort.

In this instance a forecast is easy. As the technological and other modern revolutions accelerate and spread, and destroy ancient beliefs and customs, the primitive and folk arts will either be absorbed by the popular and elite (both modern and traditional) kinds, or become merely performing, noncreative arts in a popular or elite frame of reference, or become completely inactive, museum styles. This future is already the present in much of Europe and in the United States, where people take it for granted that the cowboy singer in the pastel shirt may be from Brooklyn, that the primitive rain dance may be the work of a choreographer from Monte Carlo, that the stone idol may have been carved in Chelsea, and that the naïve painter may have a contract with a downtown gallery. The process of absorption has actually been under way for a long time; one has only to think of the folk tales and folk forms in English poetry, of the peasant pots used in the Japanese tea ceremony, of the number of jigs in Bach suites. What is new is the drying up of the sources for such borrowings.

In the emergent nations the inevitable outcome is still distant, and the period of transition promises to be hard on everyone concerned. In many parts of black Africa, where the problems are apt to be more acute than in Asia, there are still tribal audiences for primitive work. Most of the new governments are naturally inclined to encourage native art, for reasons which include a dash of Rousseauism (the majority of the new administrators have European educations), a reluctance to imitate the styles of the old colonial powers, an understandable national pride, and of course a genuine admiration for the achievements of the past. The typical native artist—a sculptor, for example—is likely

to be sharply aware, however, that he is no longer producing for a local tribe whose beliefs and customs can be assumed, but rather for a new national audience which has developed unevenly, and often for tourists or a foreign art market. In these circumstances he is in danger of falling into a peculiar and damaging sort of aesthetic impersonation—the contemporary African equivalent of the American Negro entertainer who impersonated a white minstrel impersonating a Negro folk singer.

The best policy for these nations, in terms both of artistic quality and racial dignity, would seem to be to forget sentiment and to hasten the inevitable. Whatever public funds are available for art might profitably be spent on the construction of more museums for a tribal heritage which is rapidly deteriorating or being dispersed abroad, and also on training a generation of artists for a future which is certain to be non-tribal and non-folk.

IV

Since "elite" has perhaps been provoking a smile (another lost certitude), and since the meaning that was wanted has probably been established, I shall try to do without the word from now on. That leaves us with the task of defining "traditional." It should be noted that we are discussing an active kind of art—a kind that is still being turned out in sufficient quantities to have an impact on sensibilities in Chicago, Marseilles, and Tokyo. In this context Western "traditional" is practically synonymous with 19th-century European. Oriental "traditional" cannot be narrowed down in so satisfying a fashion; it must refer, for example, to Islamic and several Indian styles as well as to the better-known Chinese and Japanese ones. All of these styles reached nearly complete definition between the 13th and 15th centuries; and many were declining, in terms of quality if not of quantity, when they encountered the challenge of Western culture. They are still classifiable as active, however, and some have recently been stimulated into new life by nationalism, Communism, and the discovery of parallels between the Occidental modern and the ancient Oriental outlooks.

The last remark may appear to undercut any forecast. Nevertheless, we can reasonably suppose that in the long run the traditional arts of both East and West will share the fate of the primitive and folk categories. They will, that is, either be absorbed by popular and modern art, or become merely performed arts, or fade into an inactive, museum status. The signs are not hard to read. It is true, for example, that in the West a lot of strictly traditional, deliberately academic painting is still being done. But nearly all of it goes unnoticed even by conservative critics, and very little of it is purchased by serious collectors. It is becoming an art of illustration, of anecdote, of familiar sentiments—an art of appeasement of popular taste. When traditional pictorial elements do find their way into an important New York or Paris gallery, they usually do so in paint-

ings that no 19th-century master would have signed; they are absorbed by a modern style. Similar tendencies can be seen in poetry and fiction, although there they are less obvious and harder to interpret. Traditional architecture, so far as large buildings are concerned, has become an inactive art; no one today is likely to think of putting up even a village post office in a 19th-century style, except as a joke or a stage set for tourists. Traditional opera as a performed, and not a created, art has become so normal that such great houses as La Scala and the Metropolitan are the equivalent of museums.

The obvious reasons for the trend are an exhaustion of the possibilities in the old styles and a lack of felt consonance between these styles and the rest of today's culture. These reasons do not, to be sure, have the same force everywhere, since a large part of the earth's population is still living in a cultural yesterday. Nor do they have the same force in all the arts: if they are strong enough to be almost uncontested in nondomestic architecture, they are weak enough in the novel to be the subject of a serious and continuing debate.

Traditional styles, then, are not going to sag into the popular or disintegrate into the modern overnight. But the tendency is there. It becomes apparent as soon as one tries to compile a list of the major (the reader can define this adjective as he wishes) poets, painters, composers, architects, sculptors, novelists, playwrights, and critics of the last fifty years. How many can be called traditional in their outlooks? On the other hand, an examination of the popular art of the same period will reveal dozens of devices which were used by major 19th-century artists.

V

It will have been noticed that the discussion has drifted around again to the snapped continuity, the sense of lost certitudes, the feeling of starting a new series, and the notion that the past has become less usable. We are also back with the question of our new aesthetic abundance, and with the problem of the difference between an active, creative return to the past and a passive, appreciative return. Thinking about all these factors in combination provides an occasion for mentioning again, with a fresh emphasis, the extraordinary importance of museum art.

One might suppose that the books, prints, records, concerts, theatres, galleries, and tourist trips devoted to the traditional masterpieces of the past would form a large carry-over audience for new work in traditional styles; but there is little evidence that they are doing so. Since they are obviously not forming an audience for modern styles, a peculiar situation can be discerned. The Verdi fan who dislikes Alban Berg's music cannot be relied on to like a new traditional opera, for he is apt to be sensitive and sensible enough to grant the incongruity of the old forms in a new context. An admirer of Victorian novels may de-

test the latest French experiments, but he is apt to admit that a neo-Victorian approach will not do either—will in fact produce quite ordinary popular fiction. The man who warms at the sight of the traditional architecture of the past, and who finds most modern buildings bland and bare, is not therefore apt to suggest that his town's new bank should be a neo-Greek temple. For the first time in history there is a sizable audience of cultivated people who, perhaps without being fully aware of their position, reject all kinds, the conservative included, of contemporary art. Indeed, they are perilously close to rejecting the whole idea of art as a creative activity that is still going on. It is for them something that happened in the past, and is today merely a matter of connoisseurship—often merely of antiquarianism. While 20th-century artists, critics, and one section of the public have been waging battles over modern, traditional, popular, folk, and primitive *active* styles, this new audience has been withdrawing into contemplation of inactive ones: *necro-styles*.

The advantages of such a withdrawal are great, for of course the bulk of our artistic masterpieces are in necro-styles, and the masterpieces are still very much alive; Amiens Cathedral has handsomely survived the death of Gothic, and *Lycidas* the death of Baroque. The appreciator need not feel insecure with his standards, since time has already made most of the aesthetic judgments. The facts are all in, and have only to be studied. The styles themselves have acquired a sort of aesthetic perfection, since their orders and necessities cannot be altered by a living artist with his own arbitrariness. The status value is solid; a man sitting in a Louis XVI apartment and listening to Mozart announces who he is in a fashion quite beyond a man sitting in a plastic chair and listening to Aaron Copland. Most of the issues discussed so far in this book can be avoided, for there is no question either of mending a continuity or of beginning a new one.

It is difficult to estimate the effect of necro-styles on the future of world art, but they should be kept in mind during our forecasting. The audience for them in the United States and Western Europe has grown rapidly since about 1950, if one accepts as evidence the statistics on such things as paperback classics, phonograph records, and architectural tourism. On the other hand, the public appetite for novelty also has grown, and we have already had occasion to stress the fact that the number of artists has increased. Also, there is no way to tell how exclusive the commitment to necro-styles is becoming. The whole situation is a reflection of the fact that in our physically, socially, and intellectually mobile modern society an audience is not so much a group of people as a state of mind. The same man may be simultaneously a member of several audiences. As good a prophecy as any, then, can be made by the reader of these speculations, if he is given to introspection and feels that he is a good representative of our statistical 20th-century man. Let him, taking into account the varying in-

tensity of his interest and the hours he devotes to the different arts, examine his sensibility and decide how much of an audience he is for live styles and how much for dead ones—for museum art, that is, in the large sense. Let him estimate his own rate of change and imagine the type of audience he might be a hundred years from now, in a world in which such marvels as home television tours of the Louvre and Angkor Wat will certainly be commonplace. And let him imagine a contemporary artist trying to cope with this new audience and this ghostly competition from old masters. We are speaking, of course, of elite (the word cannot be avoided altogether) art and not of the popular kind, in which creativity may be in trouble for quite other reasons.

Perhaps the implications are too pessimistic. After all, the millions who are taking advantage of our new aesthetic abundance do not spend all their time contemplating the perfection, the closed cycles, the preselected virtues of Sumerian styles, Gothic styles, Sung styles, Byzantine styles, Sassanid styles, Chou styles, or prehistoric styles (the deader the better is the rule in some quarters). There is a real audience for active kinds of art. Moreover, there is something instinctive in man's urge to create and not merely enjoy: the artists can be counted on to stick it out to the end. Cultural critics probably worry too much about where and how people find their good. What is so terrible about getting acquainted with the glorious masterpieces of the past?

Yet is is difficult not to worry at least a little. Already there is a marked tendency for artists—they have become numerous enough to do so—to set up as their own publics. Figures are lacking, but one can guess that contemporary poets now form the largest and most faithful part of the audience for contemporary poetry. Contemporary architecture gets most of its serious appreciation from architects and other people in the business: the average nonprofessional is more of a connoisseur of arches and buttresses than of cantilevers and concrete. Contemporary sculptors are well known chiefly among contemporary sculptors. Again, one should not exaggerate. Yet it is hard not to feel that the separation of a large number of amateur appreciators from a large number of professional creators will eventually result in a loss of vitality on both sides of the line. There is a point beyond which it is not good for artists to take in each other's washing, and a point at which connoisseurs ought to face the uncertainties of the present and stop betting on sure things.

VI

We can now summarize the general forecast. If we judge by what is already happening in the United States, Western Europe, and the technologically advanced Oriental nations, the primitive, folk, and traditional kinds of art are destined to survive only in museum forms, in performances (where music and the theatrical disciplines are involved), and as absorbed elements—mere in-

gredients. A situation is shaping up in which popular and modern will be the only active kinds of art, the only alternatives to museum styles. It would be foolish to lay out a time schedule for the change, but it is already possible to say that things are happening much too fast for a good many people. The common reaction of such people is a mixture of professed disbelief and contradictory regret. And indeed there is, even for an ardent modernist, a strangeness and a sense of historical tragedy in the thought that Titian's kind of painting, Beethoven's kind of music, Palladio's kind of architecture, and many other wonderful kinds of Occidental and Oriental art are on the wrong side of our snapped continuity, and will eventually be as finished, so far as new work is concerned, as the illumination of manuscripts and the building of buggies. Here we have an "issue," in the large and rather vague sense in which the word is being used in this essay; and being aware of this issue does not automatically make a critic a cultural dinosaur.

It is, however, an issue about which little can be said except that there it is and that one cannot unring bells. The rest of this inquiry will therefore be concerned mostly with the two most vigorous kinds of art, modern and popular— with the emphasis heavily on the former, as befits its greater value and seriousness. This emphasis will not be exclusive, of course, for there is no point in pretending that there are not some arts—the novel appears to be one—in which traditional forms are still vigorous and the future of modernism is unclear. But even in these arts one can argue that what calls for explanation and what raises the modern issues is modernism. An era has to be characterized in terms of how it differs from other eras, rather than in terms of what it shares with them.

A preliminary and brief statement of what will be meant by "modern" and "popular" may help to get the discussion on the rails. "Modern" will of course refer to the kind of art which became recognizable as a general phenomenon just before World War I in Europe and the United States, with the American contribution being particularly important in poetry and architecture. It is in part an expression of sharpened historical awareness (to be modern is to insist on showing that one knows one is living in the present), and in part an acceleration of such 19th-century trends as Realism, Impressionism, Expressionism, and Symbolism. Although far from a monopoly anywhere, modern art has become supranational, largely because of the cultural imperialism—not always intentional—inherent in the technological advance Europe and America has had on the rest of the world. There is evidence that by the third quarter of the 20th century modern art was stylistically adult—that is, it had invented a fairly complete new language of forms, much as the Renaissance had by the beginning of the 17th century, and Athens had by the end of the 5th century B.C. Such historical analogies cannot, naturally, be pressed very far, because of the present rate of technological change, and also because our civilization, unlike those

of Greece and Renaissance Europe, is not just one closed system among others which can influence or even replace it, but is rather an evolving world system, in spite of political differences.

Popular art is almost impossible to define, but I think that in each specific case the reader will recognize what is meant. Notice that what is usually present in it is an *intention* to appeal to a large audience, and that the actual appeal may have nothing to do with the case. A novel may fail commercially and still be clearly of the popular kind, and a piano concerto does not become "popular" music when a million disks are sold. Popular art often resembles the folk kind in being destined for an unsophisticated audience, but differs in not being the creation of members of the audience—at least not normally. It is created (in many instances "calculated" would be a more accurate term) by artists who differ from the serious, or elite, artists in their tendency to express not their own views of life, but rather the views they think the customer has. Consequently popular art is often scarcely art at all; it is often literally meretricious. It makes use of artistic means for non-artistic ends. But not always. Sometimes it is merely a simpler, less serious kind of traditional or modern elite art.

All art constantly aspires towards the condition of music.
WALTER PATER

Music . . . is continually in danger of falling apart.
AARON COPLAND

Chapter 5 The Sound of History

NO SINGLE ART has become dominant in our era. We have no equivalent for the way sensibilities were conditioned, for instance, by poetry in imperial China and by architecture in Gothic France. The lack undoubtedly contributes to the feeling of fragmentation which often counters the sense of unity noted in Chapter 2.

Occidental music, however, is a strong candidate for leadership. Since it has few classics earlier than the 18th century, it combines the appeal of one of man's oldest expressive disciplines with the relevance of one of the most recent. It renews its effects in performance more often and perhaps more vividly than any other art does. It loses little in reproduction, and is suited to diffusion in a world civilization. And finally, it is the most artistic of the arts: the least limited, that is, by ethical, representational, and utilitarian considerations. To call it, as some theorists have, a language without concepts is to go a bit far, but composers do have the advantage of using a *nondiscursive* language, one which need not—cannot—be translated and which nevertheless can generate a powerful human significance. This abstract language has had an attraction for all sorts of modern creative minds. Painters, sculptors, architects, poets, and even novelists have turned toward the effects of melody, harmony, and rhythm, in disagreement with the many 19th-century artists who aspired in exactly the opposite direction—toward the effects of descriptive, narrative, and moralizing prose, toward *discursive* language.

A look, then, at the situation in music today should disclose issues that go beyond the strictly musical.

42

I

A sampling of facts can launch our inquiry. During 1967 the monthly *Schwann Record Catalog,* listing all the long-playing disks available in the United States, needed more than a hundred pages an issue for the older classical music, and less than ten for the recorded works of composers born since 1900 (this proportion did not, of course, reflect sales, in which the moderns fared much worse). During the 1963–64 concert season in Paris four symphony orchestras, playing every Sunday, performed one contemporary piece. During the 1962–63 operatic season in German-speaking countries, according to the International Music Council, there were 7,159 performances of Mozart, Verdi, Wagner, Puccini, and Richard Strauss; and 917 of works by the ten most often staged modern composers. Similar data could be cited from any advanced nation. One can safely say that 90 percent of the serious music—of what is sometimes called "art" music—being heard in the second half of the 20th century was composed in some other era.

In sum, here is a striking example of one of the currents listed in the last chapter. In the majority of Western cultivated minds music has almost ceased to be regarded as a creative activity still going on. It has become largely a performed and interpretative art, comparable to acting. One does not need statistics for this conclusion, since a glance at a newspaper file will do. The average music critic, unlike his colleagues in literature, painting, drama, and the cinema, seldom has occasion to write about a new work (these remarks are an account, not a reproach). In fact, he hardly ever evaluates an old work except in passing, for he is primarily an expert on performances. His chief duty is to make fine comparisons among interpretations of a few hundred standard compositions, most of which he assumes his readers already know in some detail.

Things were different in the European 18th century. The hundreds of cantatas by Bach and his contemporaries are evidence of how often even the church audiences of the period heard new compositions. Public and private patrons in the days of Haydn and Mozart usually insisted on contemporary works, much as theatre and film patrons now do; and even the special programs of nonmodern music were relatively up-to-date (in 1776 the organizers of the London Concerts of Ancient Music announced that "ancient" referred to pieces more than twenty years old). Composers, then as now, were interested in the work of their predecessors. But a sizable public for noncontemporary music appeared only when the Romantic stylistic revivals got under way, and it did not keep new works from getting hearings at ordinary concerts throughout the 19th century.

The situation today has provoked a flood of comments, including some which discount its seriousness. After all, the antialarmists can point out, innovating composers have always had to go through acceptance phases; and an in-

terested public, which is by no means made up entirely of snobs, does exist for modern music. It has grown since World War II in both size and enthusiasm. Anyway, how many of Haydn's contemporaries heard his symphonies when he was a liveried servant? Part of the 20th-century change has been simply the addition of a public which in the past never had much access, except on Sunday, to art music, and which has naturally shown an initial preference for the established classics. Moreover, critics tend to talk as if modern music, or modern art in general, were the only modern development without a majority blessing. The reality is that millions of educated Westerners are still happy with Newton's universe, and that Keynes would do no better in a popularity contest with Adam Smith than Schoenberg has been doing with Mozart.

One can add, less cheerfully, that the acceptance phases of composers have been prolonged by the fact that performance, both live and recorded, has become a big business. It is true that a few modernists have benefited greatly from our techno-aesthetic abundance and that avant-garde works do somehow get diffused. But the counter-truth is that the need for a large market, if costs are to be absorbed, has made today's typical concert, opera, or disk impresario extremely conservative. He feels obliged to play economically safe and repeat what has already pleased; and he thus keeps his customers from acquiring the listening experience which must precede a taste. He winds up, as businessmen do in many sectors of today's culture, in a cycle of catering to desires his catering creates. And the only way out of such a cycle is to spend, not to make, money on art, which is something that apparently only governments can now do on a scale large enough to counter the effects of commerce. There is thus a point at which the tendency for music to become a museum activity turns into a political problem, of the sort that democracies are peculiarly unfitted to solve. You have to be a brave official to spend the majority's tax money on a minority's aesthetic. Are authoritarian regimes better fitted for the task? The history of patronage might lead us to think so, but only if we ignore the section dealing with the present century. In Communist and other countries with cultural policemen the desire for a large political and doctrinal market has long had musical effects indistinguishable from those produced by commercial exploitation. Provincial stylistic lags have been encouraged because of their alleged wholesomeness. It is only recently, and most noticeably in the smaller nations of Eastern Europe, that modern composers have been freed from fear and given some chance to be heard.

To continue, however, our inquiry along these lines would be to distort the real situation and underestimate its gravity. For after due weight has been given to all the technological, economic, social, and political aspects, the fact remains that the principal obstacle faced by modern composers is aesthetic. People prefer the old music largely because they find the new—all of it at first and

much of it permanently—hard to follow and to understand. This difficulty is what provides the businessmen and the politicians with their opportunities and does so with a good deal of solid justification; and it constitutes an important difference between the present acceptance phases and most of those in the Western past. Berlioz's audiences may at first have disliked his orchestral effects and literary pretensions, but they knew pretty well what he was doing.

Music that is not held together by understanding rapidly decays into irritating sounds, and finally, if we are told that we ought to understand it, into insulting noises. Hence, what might have been a good argument between traditionalists and modernists has turned into a quarrel; and there are reasons for temper all around. Many of today's audiences are aggressively lacking in curiosity, and many avant-garde composers are complacently obscure and clan-minded. But there has been a lot of historical unluckiness in the situation. Just when education, democracy, the phonograph, the radio, status-seeking, big business, big culture, and much else combined to encourage millions of listeners to return appreciatively to the past, several phenomena convinced serious composers that a creative return had become impossible, that an entire musical era was finished. At precisely the historical moment when continuity was massively reinforced on the performing side of music, it snapped on the writing side.

It would seem that why it snapped should be looked into before we continue the argument, or the quarrel, about the audible results.

II

During roughly a thousand years, from Carolingian times to the early decades of the 20th century, Western music underwent a steady and intelligible development. To ask why it did so is to be reminded that it was not alone. Occidental polyphony evolved along with medieval architecture and scholasticism, on the shared assumption that the spiritual could be made rational. The gradual discovery of new orders and necessities in tonal reference points coincided with the discovery of the laws of perspective in painting. The composers who rationalized the snags out of the key system were contemporaries of advancing mathematicians. Those who invented the sonata form were representative of an age when economics, politics, and science were also being given classical structures. The clarinet, the piano, the valve trumpet, the perfected flute, and dozens of improvements in other instruments appeared at the same time as the machines that helped to start the Industrial Revolution.

We emerge with a truism. Western music evolved because Western culture in general has long been informed by the conviction that man must keep moving out of the past and "make" history. This conviction, which goes with a sentiment that history is a fairly straight succession of points in time, can be contrasted with the Oriental and ancient idea that history is simply to be endured

and is perhaps more spatial than temporal—a panoramic map instead of a line moving into the future. There is very little *felt* history, from the Western point of view, in the traditional East; and so the traditional Eastern musical styles have evolved very little. They have remained for centuries in a permanent past, or an eternal present.

The Occidental onward-and-upward idea did not function all by itself. European political disunity, for instance, promoted change by producing a large number of competitive fine-art centres in a small area; one cannot imagine Western music without feudalism, Italian cities, and especially the hundreds of little German courts which continued to accelerate the newness rate after it had slowed in such centralized nations as Britain and France. The evolutionary feeling, however, was not a vague something which a cultural historian has to distill and label. Our 20th-century awareness of modernism and of artistic movements is already clear in the terms *Ars antiqua* and *Ars nova* (the Old Art and the New Art), which came into use at the beginning of the 14th century to mark a change in music.

There are some evident reasons why Western composers, rather more than other artists, were sensitive to history and tended to be evolutionists and rationalists—acceptors of challenges and solvers of problems. Music, because of its mathematical, logical, and (in performance) practical aspects, can be felt as a realm of potentialities which are more definite than those in literature and painting, and more numerous than the definite ones in architecture. Composing therefore invited not only creative activity, but also exploration. The rules of classical harmony, for instance, were partly discovered as well as invented; their mathematical and verifiable content had given them a prior existence in reason and nature, like that of the modern scientist's atom. An early violin sonata, to take a more obvious example, was not just a work of the free imagination, as a poem can almost be. It was also, as were many later ones, a response to the challenge of the expressive potentialities in the instrument.

Each discovery disclosed unsuspected potentialities, and each response brought new challenges, or became one itself. By accepting the idea of rational change composers put themselves in a typically Western situation of dynamic instability. Sometimes the uneven development of elements produced a leap-frog advance: notation, for example, made polyphony possible, and polyphony soon made a more detailed notation necessary. Ears accustomed to history "digested" each novelty, and the resulting demands drove the entire system toward self-realization. Admittedly, none of this occurred in quite the tidy fashion these remarks may suggest. There was a lot of backing and filling, and one should not be so unromantic as to argue that everything would have happened as it did without the intervention of individual genius. General cultural attitudes do not create specific works of art. In retrospect, however, this millen-

nium of Western musical history before 1900 has a remarkable inevitability about it—something close to the necessity and order we recognize in a single musical composition which keeps coming up with what we were somehow expecting. And, granting the ultimate mystery of individual styles, one can say that part of the genius in the greatest of Western composers has been a dazzling lucidity about historical junctures. What Bach did with the fugue, Haydn with the string quartet, Mozart with the concerto, Beethoven with the symphony, Wagner with opera—many other examples could be given—was partly to make explicit what was implicit in the evolutionary musical situation. This fact helps to explain the fairly rapid public acceptance of their innovations.

III

Evolution, exploration, development, potentialities, realization, challenges, problems, junctures—the terms used so far in this discussion show how insistently Occidental music raises the most important and protean issue 20th-century man faces: the reality of progress. Perhaps something can be said about it without provoking the usual ironical smiles and Romantic heckling.

Certainly Handel's *Messiah* is not an improved version of a work by a 9th-century composer, and Monteverdi was not an early attempt to be Verdi. A work of art is like an individual human being—always unique in some way, and therefore finally and quite literally incomparable. Yet, well into the 19th century, the majority of sensible and informed people assumed that art had progressed since its allegedly rude beginnings. Were they vain about themselves and their periods? Often they were; many European critics seem to have been believers in Sartre's definition of progress as "that long road which led to Me." But to emphasize this fault might convict us of it, and in any event there are more stimulating ways of looking at the matter.

One such way is to suspend consideration of the incomparable and to limit contexts. This may appear illegitimate, but we get by with it habitually. Although no one would argue that the theory of relativity is better than the discovery of the circulation of the blood, we do say, without much fear of being misunderstood, that science has made progress in specific contexts. In a similar spirit, we can say that Gothic architects made progress in the economical use of the pointed arch, and that Renaissance painters made progress in perspective. And music, for reasons already mentioned, lends itself very well to this sort of limited comment. It is indeed grotesque to argue that *Rigoletto* is better than *Orfeo* because it is later. But to say that between the 9th century and the close of the 19th the nondiscursive language of music was enlarged and disciplined is merely to state an important fact in Western—and world—cultural history.

Ancient music and the surviving traditional Oriental kind can be called "prehistoric," since the word normally refers to what happened before the in-

vention of writing. Performers in dynastic Egypt used hand signals for essential tones, and the Greeks had a nomenclature; but notation is almost entirely a Western European development. Medieval Occidental composers were the first, strictly speaking, anywhere: the first, that is, to have a control over their productions which was exact, extensive, and lasting enough to warrant our referring to them as authors. And notation has progressed so much since then that we are justified in calling its invention, as was that of writing five thousand years ago, a decisive event in the long process of extricating the individual human personality from the tribal one. Thanks to it, Debussy has as much identity as Proust.

Similar observations can be made throughout the field. Europeans began, for instance, their musical history with roughly a common East-West stock of instruments; but there has been nothing in the traditional Orient like the gradual emergence of the magnificent, articulated sonority of Occidental orchestras. The traditional music of the East has been, as was that of the ancient world, primarily melodic; logical harmony and the use of dissonant and consonant chords to create elaborate, coherent structures of psychological tension and relaxation are Western achievements. The Greeks and ancient Chinese seem to have thought of a tuning system which conveniently "tempered" each semitone, in violation of acoustical laws, into an equal interval; but there are no parallels for the use made by Western composers, especially after Bach's *Well-Tempered Clavier,* of such a rationalization of nature.

Since Asian readers may find the attitude back of these remarks unduly confident, I feel obliged to insist here both on my admiration for Eastern music and on my awareness of contexts in which talk of progress is absurd. Within the comparatively static Oriental tradition there are fascinating worlds of subtle rhythms, expressive modes, instrumental colours, and melodic ornaments which the Occidental evolution, at least until this century, has largely ignored or misunderstood; and there are Oriental virtuosos and ensembles whose exquisite, half-improvised works are to many a notated symphony what an Oriental vase or screen may be to an overblown 19th-century palace. But these splendid counterfacts do not alter the significance of the Western achievement. There are no ancient or Oriental musical "palaces," either good or bad. In progress-minded Europe what we can call, to appease the Romantic hecklers, the science of music advanced to a point where the art of music, for the first time anywhere, became capable of producing masterpieces as complex and permanent as those of architecture, literature, painting, and sculpture.

IV

Yet, around 1900, a number of European composers were profoundly dissatisfied with the way the system was working. What had gone wrong? Al-

established classics maintained their power, new works in traditional forms and language tended to seem hackneyed. Architects, sculptors, painters and to some extent dramatists were in the same sort of predicament. Physicists also had the end-of-the-line feeling; the 19th-century vocabulary, drawn from atomistic materialism and classical mechanics, did not permit the full expression of the emergent ideas of a new universe. And back of this exhaustion of old "languages" there lay a spiritual crisis—although it was not always avowed. Classical sonata form reflected a kind of confidence in a world order and in man's status which was out-of-date.

These notions, however, leave an inner area of mystery, which must be approached with analogies. A political historian might say that traditional Western music was like the Roman Empire, which also lost its vitality when it reached the limits of its expansion—which turned out to be, not a state, but a dynamic historical process. A scientist might recall the second law of thermodynamics and point out that Western music, being a closed system, finally unwound itself to a point where not much could happen without the application of external energy. An expert in information theory might remind us that such an idea may be more than an extended new metaphor, since the equations for heat phenomena do resemble those for coded message systems, and music is a kind of code. An expert in psycho-acoustics might chime in with the fact that a repeated sound may eventually fail to penetrate our awareness (many music critics would probably confess that there are familiar harmonic progressions which they hear the way they do the air conditioning: only when something goes wrong).

Oversimplifications? Such analogies are better thought of as promising attempts to find a passkey. But as of now they have the defect, common to all "scientific" art criticism, of seeming to rule out value judgments; and so perhaps the best analogy for the history of traditional Occidental music and its denouement is the one used a few paragraphs ago—the one with a single musical composition. If we grant that this centuries-long "composition" was nearly finished by 1900, we can understand, and hear, why attempts to add to it were marked by a loss in power. One of the symptoms, as every artist knows, of the end of a specific creative job is a tendency toward diminishing returns. A painter, for example, always reaches a point where one effect begins to cancel another; to persist amounts to starting a new picture.

We are dealing with something highly subjective, for which no proof can be offered. But enough composers were troubled enough for us to say that the symptom in question actually existed. Dissonance, for example, was an expressive element in itself, much as an emotional break in a speaking voice can be; and it was also part, in a particular work, of an expressive pattern of disturbed feelings followed by satisfactions in consonance. But since it is relative, and as

though there is not enough space here for a full answer, the central troubles have since become plain enough to be described in a few images and examples.

A medieval philosopher might have predicted the denouement, since any kind of progress implies its own end—you cannot advance in boundlessness. Music as it was conceived in the Occident was at one time an immense continent of potentialities; but an army, officered by geniuses in each generation, moved across it, and by the close of the 19th century just about everything had been explored that seemed to be worth exploring. There they were—twelve semitones within the octave span, twelve seven-toned scales in the major mode and twelve in the minor, and a small number of basic types of chords, rhythms, and forms. Evidence that the exploration was nearly complete can be seen in the fact that most of the traditional instruments had stopped evolving by around 1850. Their makers were no longer being challenged by the discoveries of composers.

Probably the reader is already objecting that these statements are absurd. Music, for all its scientific aspects, is not really a discipline like chemistry, which ended one segment of its progress when the first ninety-two elements had been discovered. Nineteenth-century music was primarily expression, and only incidentally investigation. To say that the elements had been worked over is simply to notice that a vocabulary was available. What composers "said" in this traditional language, by utilizing the myriad of combinational possibilities, was what mattered. True, but here again there was disquieting evidence that the end of the line was near. Composers around 1900 were finding it increasingly difficult to produce expressive works within the system.

One possible, if rather mechanical, explanation for what had happened is that in general a nondiscursive language—a system of symbols and abstractions—lacks the thousands of precise meanings to be found in the words of a discursive language, and therefore in practice offers fewer effective combinational possibilities than one might suppose (abstract painters, for instance, have discovered that they are constantly menaced by monotony, and hence by a loss of expressive power) And from Bach to Brahms an immense number of combinations had been brilliantly used. Geniuses had both advanced and exhausted the system. Also, we can now see that an art which had practically reached the end of its progress as investigation was bound to be in trouble about expressiveness at the beginning of the 20th century. For the new combinational nuances which could be got out of the completed traditional system had to compete for attention in a nonmusical world in which investigation was continuing at an accelerated rate.

Another explanation can be found in the general cultural pattern of the period—in the coincidences and convergences we have already commented on. By 1900 many sensitive poets and even novelists were finding that, while the

assimilable as a drug, more and more had to be used. By the end of the 19th century the amount which a composer's ear told him was needed in terms of power was apt to be enough to wreck the traditional pattern of disturbance and repose, and convince his conservative listeners that what they were hearing was cacophony.

The same conclusion can be reached through a consideration of tonality, that elusive property in a composition which creates a sense of gravitation toward a key centre and allows us to say that all the harmony is related to a single tone. In the middle of the 18th century a composer could produce a neat little sensation of contrast and repetition, and hence of form, by moving—modulating—from his main key to another and then back to home base. But sophisticated ears soon found such a simple pattern dull. By Wagner's day (his Prelude to *Tristan und Isolde* is a standard example) rapid and far-ranging modulation and the accompanying chromaticism—the expressive use of many sharps and flats to produce tones foreign to the prevailing seven-note scale—were already making it hard for a listener to sense the key of a piece. By 1900 it appeared that the evolution could not go much further without fatally weakening the principle of tonality itself, and along with it the forms it reinforced and clarified.

The problem was particularly acute in terms of dissonance and tonality because, as we have noted, logical harmony was basic in the Occidental system. But essentially the same difficulty had arisen in rhythm, melody, timbre (tone colour), texture, structure, and the complex multi-art patterns of opera. In each instance what seemed to be a necessary evolution of a part seemed destructive of the whole. And the problem was by no means purely theoretical. Attempts to evade it can be heard as a prudent femininity, an evident desire merely to please, in many late-19th-century compositions. It looms, in a differently dangerous way, in the music of Richard Strauss, one of the last traditionalists to achieve something comparable to the power of the great Romantics. Admirable as a work like *Elektra* is, one feels that with just a little more straining for expressive meaning the musical structure would crack, the eloquence become bombast, the tragedy a melodrama.

V

Since 1900 (it is perhaps time to point out again that this date is merely a dramatization of a change that occurred unevenly in the careers of many artists) this situation, or predicament, has been the justification for many individual and group styles. Each has its shade of difference. They can be conveniently classified, however, under the headings of four principal responses to the historical challenge: the conservative, the revivalist, the exotic, and the avantgarde. Such vague labels and the fact that all four responses may be found in

the career of one composer, often in a single work, need not prevent our knowing fairly well what we are talking about.

The value of any composition must of course be tested by ear; and I hope to avoid being trapped by this discussion into hinting that certain styles can under no circumstances yield fine things. Any style, with the proper afflatus, may catch fire. But even a contemporary historian can point out that some, on the record, are not very apt to; and a critic can always argue that the flame might have been brighter. Some general judgments, therefore, based on personal listening and allowing for exceptions, will be risked in the rest of this chapter. They may at least have the merit of provoking dissenting readers into fresh reflection on issues which are likely to be around for a long while.

The conservative response to the crisis of 1900 is essentially Romantic. It amounts to an attempt to halt the history of Western music at about the year 1880, and thus implies a recognition of the fact that by then the old system was practically complete. (Here, all of today's musical parties, the reactionary as well as the revolutionary, are in tacit agreement.) It has had an educative importance which its denigrators usually ignore. Music schools have found no substitute, in their new materials and methods, for a thorough and old-fashioned grounding in the rules and masterpieces of the 19th century; and composers and listeners, including the avant-garde, who lack this grounding invariably betray the fact. Thanks mostly to Romantic conservatives, Occidental music in its rich maturity has become one of our humanities, a corpus as indispensable to a cultivated sensibility as the Latin classics once were.

New work, however, in a 19th-century style is another matter. It may have the appeal of craftsmanship, and occasionally something more; symphonies and concertos which use the formulas of the great Romantics can be expected to catch fire momentarily from their models. But the bulk of such compositions have about as much vitality as Renaissance Latin verses (which is some, of course); and since World War II even this much has become rare. Moreover, the illusion that an elite public which rejected modern music would accept Romantic pastiches has collapsed, with the ironical result that the conservative craftsman is having to count more and more on untutored audiences. He is also having to depend more and more on nonmusical help—from the cinema, for example, or from the purveyors of candlelit-mood disks—to achieve an imitation of the expressiveness denied him by his failure to evolve. And each year his formulas sound a bit more like the exclusive property of the popular-music industry, in which, although large sums are devoted to fostering a contrary impression, authentic innovation is usually the last thing that is wanted.

The revivalist response is more interesting, in both its strategy and its music. It amounts to an attempt to back out of the impasse of 1900 and return stylistically to a time—usually the 18th century, but often earlier—when modulation

and chromaticism had not yet begun to raise problems. The maneuver is executed knowingly, and so the anachronisms usually have the witty flavour of a time voyage. Vocal music is unpretentious; and chamber groups, in which each musician is treated almost as a soloist, are favoured over the large orchestras and the thick textures of the Romantic conservatives. Wind instruments may replace the more emotional strings. The listener may be asked to shift his interest from chords to counterpoint, from the solemn thrill of hearing a vertical arrangement of notes to the drier pleasure of following the combinations of superimposed horizontal lines. In sum, pure sound and intellectual clarity are relied on to compensate for a loss in contemporary expressive meaning. And all this has to be said in the present tense, for it still looks attractive to the many antiacademic composers who shrink, often after personal experiments, from the perils of avant-gardism and who are sincerely eager (this is true of many Communist musicians) to write works which a large public can enjoy.

But revivalism, unfortunately for the recent convert, has of course already had a chance to show its value and its defects, and can be judged in perspective. In the 1920s, in the form of neoclassicism, it seemed to be the main musical movement of our era. With Stravinsky as their leader and Paris as their international capital, a generation of composers fled backwards from the alleged fog, morbidity, and religiosity of the central German tradition in its late phases. The outcome was excellent low-temperature music, frequently brilliant and always rational. Many neoclassical compositions appear certain to endure, partly as post-World War I period pieces and partly for their intrinsic qualities. The movement itself, however, has been losing speed steadily in the second half of the century. For one thing, it has helped to accelerate the current rediscovery of its models. Why should we listen to new work "in the manner of" pre-Romantic masters when musicologists, concert managers, and record companies are inundating us with the real stuff, often performed on ancient or reconstituted instruments? For another thing, what sounded clever in the 1920s sounds less so in the atomic age. At the risk of stuffiness, one must say that most of our revivalists are not serious enough. They withdraw not only from the foggy impasse of 1900 but also from the responsibility—the high cultural ambition—which a 19th-century composer took for granted. Significantly, their most satisfactory works are ballets, songs, and light operas, and their least satisfactory are in the abstract forms (string quartets and piano sonatas, for instance) in which music must say something on its own. Entertaining as their output is, it does little to weaken the argument that in the West musical power is still a function of evolution.

Exotic-minded composers accept this argument, in a mild and modified form. They grant, that is, the eventual futility of the conservative attempt to stand still and the revivalist attempt to back up in the traditional Occidental

system, and are willing to risk leaving it occasionally. They choose to do so, however, not by doors which open on an unknown future, but by side exits: those which open on existing primitive, Oriental, folk, jazz, and popular music. Hence "exotic" is merely a handy compromise label; this particular response to the 1900 challenge can also be called "lateral," or "eclectic." It is not, to be sure, entirely new (for that matter, neither are the conservative and revivalist responses); but there is a perceptible difference between the old practice of using folk thematic or rhythmic material in traditional art music, and the 20th-century attempt to break out of the system, to broaden it both geographically and socially—in short, to universalize the history Occidentals hear in music. The difference can be felt by listening first to a Romantic pseudo-Chinese or pseudo-Hungarian piece, and then to what Béla Bartók does with authentic Magyar peasant scales and dances, Aaron Copland with cowboy and Mexican tunes, Darius Milhaud (less convincingly) with jazz, or Olivier Messiaen with Balinese timbres and Hindu rhythms. In the earlier instances the foreign material is absorbed; in the later ones traditional European music is more or less transformed.

Is this sort of lateral evolution a valid response to the post-Wagnerian crisis? Listening to specific works, one can feel that it is. The music has a sharp flavour and an expressiveness rarely found in conservative and revivalist work. In the perspective of a few decades, however, an ominous lack of continuity appears. For example, classical composers who have tried jazz usually have gone on to something else after one or two experiments. It is true that they have often had only a superficial knowledge of the real thing, and that jazz calls for virtuoso performers rarely found among conservatory-trained orchestra men; but one also has an impression of expressive effects quickly exhausted. The only consistently successful exotic composers have been those using folk or Oriental material; and even these have had no disciples of their own stature—no one, that is, whose *primary* response might be called exotic (the East-West convergence in avant-garde music is a slightly different matter). One can argue that a Bartók or a Messiaen cannot be expected to come along very often and that a great artist is unique. But Haydn was unique, and he had followers who found that they could express their personal visions by developing his forms and procedures. While waiting for another idiosyncratic genius to prove us wrong, we can conclude that exoticism offers too little in the way of an evolutionary system. It can easily turn into a mystical, antihistorical reaction to our tough historical situation, since it relies on the essentially timeless arts of the folk and the Orient. Already, to experienced ears, much of Bartók and Messiaen sounds as if it had been written in no stylistic period—in a musical eternity. Since the music is marvelous, one may feel that none of this matters. But folk and traditional Oriental arts are not only timeless; they are also losing their vitality and

subsiding toward an inactive, museum status. One can wonder how, in a world civilization whose rate of change is accelerating, new music which relies on such static cultural elements can avoid sounding eventually like a mere variation on Romantic conservatism or neoclassical revivalism.

These remarks may seem to be hastening toward a rigged conclusion. Having disposed more or less cavalierly of three categories of 20th-century music, are we now about to bestow exclusively on the avant-garde the prize for being truly modern? We are not. The categories are not the music itself; they are simply ways of considering it, ways which can help us to gain insights both into particular works and into trends. The same piece by Stravinsky, for example, can be listened to as if it were in turn conservative, revivalist, exotic, and avant-garde work, and each time there is a strong possibility of our hearing something we might otherwise have missed. "Modern" should be applied, as it usually is, to a large and varied tract. Also, the avant-garde is not always modern, strictly speaking, since a style of the unborn future may be as anachronistic as one of the dead past. There have been recent concert seasons when it seemed, amid the spectral souvenirs and the poltergeist anticipations, that our real problem was a lack of enough full-bodied compositions for right now.

None the less, it does appear, after more than half a century of experiments with standing still, backing up, and moving sideways, that Occidental music is condemned to evolve. The alternative is to accept a lower level of expressive meaning than was reached in the past: to allow a major and peculiarly Western art to decline from affirming and provoking to the agreeable but minor job of embellishing and appeasing. A creative musician can be modern—expressive in the context of today—with or without the three responses discussed so far, and to pretend otherwise would be to deny the evidence of our ears. But he cannot be modern without the avant-garde response, without taking a step forward in history. This is the conclusion of a growing number of prominent composers since World War II, and there are no signs of the trend's being reversed again as it was by the revivalists in the 1920s. The fact is worth pondering, for it suggests the need for a new public attitude toward the issues raised by modern music. They are disconcerting for admirers of the old masters, and some appear to upset the premises of all artistic activity. But there they are. That noise, although ignored on a large scale, is not going away.

VI

I have just defined, in passing and in a vaguely philosophical-metaphorical fashion, the avant-garde (the term is here hopefully meant to be descriptive and neutral) response to the crisis of 1900 as "taking a step forward in history." Since this is what Western composers have been doing for more than a thousand years, avant-gardists can maintain that they are the only genuine

traditionalists—which they are, if tradition is regarded, as probably it should be, as a process of change. But of course the catch is that going forward from the point reached in 19th-century European music has meant leaving what is usually, and will continue to be in this essay, referred to as "the" traditional system. Beethoven moved ahead from Haydn on the same continent; Schoenberg, when in 1908 he pushed ahead with Wagnerian chromaticism and thus automatically abandoned tonality, stepped off the edge. Other 20th-century composers, in other ways, have done likewise. One result is that many listeners have felt at sea ever since; another is that modern music—music in which the avant-garde response is apparent—can be described in terms of what it has left behind.

The most important thing it has left behind is the old system's generous prompting of the listener's memory. Modern music might almost be called amnesic in principle (naturally, there are degrees of adherence to this principle, but artistic styles are best understood in their extreme cases). It is characterized by *an avoidance of obvious repetition*—a shunning of traditional development, variation, and recapitulation. It is seemingly discontinuous not only within a historical perspective but also within each composition; immediately recognizable allusions to the past of a moment ago are as rare as allusions to the masterpieces of a hundred years ago. In other words, the onward tendency which has long marked Occidental music as a whole is constantly present in miniature; the psychological rule that musical power is a function of evolution is applied to details. A thoroughly modern piece tries to be a model of dynamic history—to be unfamiliar at each instant. I apologize for hammering, but feel that the emphasis is necessary. Much of the difficulty in today's music is the result of listening for what is not, and was never meant to be, there.

Webern's *Five Pieces for Orchestra,* opus 10, provide an early and, as such things go, even popular illustration of the principle of apparent discontinuity. They are scored for flute, piccolo, oboe, E♭ clarinet, clarinet, bass clarinet, horn, trumpet, trombone, percussion, mandolin, guitar, celesta, harmonium, harp, violin, viola, cello, and bass; but each musician is treated as a soloist (in this particular avoidance of obvious repetition, this refusal to double instruments, the revivalist and avant-garde responses frequently coincide). The compositions are atonal; no tone, that is, is repeated often and emphatically enough to give a listener a feeling of gravitation toward a key centre. There are no conventional themes: no subjects which, like those in the first movement of a traditional symphony, are stated, contrasted with other material, and repeated. Indeed, any repetition of something long enough to be recognized as a theme is ruled out by the fact that the average length of the pieces is about seventy seconds, many of which are devoted to silence—to absolute nonrepetition. Also, each phrase and often each note is itself a minuscule history of change. The

fourth piece, for instance, begins with a tinkle from the mandolin, in the middle of which the harp offers a liquid plunk. Then the viola sounds and is succoured by the clarinet, while the trumpet starts an arabesque and leaves it to be completed by the trombone. The snare drum adds three taps; the harp functions again; the clarinet, celesta, and mandolin join in; the violin essays another tiny arabesque. Then, abruptly, a silence opens toward the future; there is no hint of an old-fashioned orchestral amen. The entire composition occupies only seven measures; but there are a dozen changes in timbre, eight crescendos and nine diminuendos, four changes in tempo, three directions in Italian and four in German for expressive execution, and more than the usual number of signs for accentuation and ornamentation. Nothing is ever what it just was. Hearing this music is like watching a time-lapse film in which flowers bud, bloom, and fade exquisitely in a matter of moments.

Apparently discontinuous melody is of course implied by the above description, but it is perhaps more clearly—and cruelly, for singers—evident in Schoenberg's vocal music. In such modern classics as *Pierrot Lunaire* and the opera *Moses and Aaron* the melodic line differs radically from the traditional one; instead of rising and falling in short, connected steps, it leaps and dives with no apparent concern for where it has just been. It has a marked tendency to avoid, for as long as possible, repeating its own notes and those in the supporting harmony. The jagged, tormented, and sometimes comic effect is reinforced by rapid changes in intensity and by a vocal variety which includes whispering, howling, half-singing and half-speaking, and something best described as hysterical bel canto.

In many respects Webern and Schoenberg were such daring pioneers that, since this inquiry is not a history of modern music, we can almost dispense with examples from the second half of the century. In their handling of rhythm, however, these innovators were relatively conservative. It is largely since 1950 that modernists, building on the ideas of such exotic-minded composers as Messiaen and the early, Russian, Stravinsky of the *Rite of Spring,* have established in this department as well as the others the principle of avoiding obvious repetition. But it is now thoroughly established. It would be difficult, for example, to get farther away from Bach's sturdy, relentless beat, and closer to a rhythm which is new every instant, than Pierre Boulez does in *Le Marteau sans Maître.* The successive time signatures for the last twenty-five measures of this work are $\frac{3}{8}$, $\frac{5}{4}$, $\frac{5}{8}$, $\frac{5}{4}$, $\frac{4}{4}$, $\frac{5}{8}$, $\frac{7}{8}$, $\frac{2|3}{2}$, $\frac{6}{8}$, $\frac{9}{8}$, $\frac{4}{4}$, $\frac{3}{8}$, $\frac{5}{8}$, $\frac{5}{8}$, $\frac{3}{4}$, $\frac{4}{8}$, $\frac{6}{8}$, $\frac{2|3}{4}$, $\frac{4}{4}$, $\frac{5}{8}$, $\frac{6}{8}$, $\frac{7}{8}$, and $\frac{1}{2}$. There are, that is, only two occasions when the same time is kept for two measures in a row. A listener with kinesthetic imagination is kept lurching along as if he were a dancer obliged to switch at every step from a waltz to a jig to a march to a minuet.

Admittedly, this example is a little far out, and may be thought representa-

tive only of a certain kind of ultraism. But a very similar tendency can be heard in the work of such typically post-1950 modernists as the German Karlheinz Stockhausen, the Italian Luigi Nono, the American Gunther Schuller, the Belgian Henri Pousseur, the Polish Tadeusz Baird, the Greek Yanis Xenakis, the Japanese Toshiro Mayuzumi, the English Richard Rodney Bennett, the Spanish Cristóbal Halffter. Such apparently irrational rhythms can be called normal in music which is atonal and athematic, which fragments the old building blocks of melody and logical harmony, and which seems to be composed of nothing larger than notes.

VII

In such a context, dissonance rapidly ceases to worry even the most conservative ear. The important—one might almost say the sole—issue here is coherence. Music has been in particularly dire danger of falling apart ever since Schoenberg decided ("noticed" might be more accurate) that the tonal system was obsolete. Many modern composers have of course chosen to ignore the possibility, and have gone on writing symphonies and concertos as if nothing had happened. But the results are seldom satisfactory: either the traditional form takes the force out of the modernism, or the modernism takes the substance out of the traditional form and leaves it a mere, and distracting, shape. Atonal sonata form makes about as much sense as a rhymeless sonnet.

The threat of disintegration can be, and frequently has been, evaded by composing ballet, vocal, and program pieces in which the modern musical atoms adhere to forms borrowed from other arts. Such compositions can have a power (*Pierrot Lunaire* and Berg's *Wozzeck* are proof) denied to their revivalist equivalents. They do not, however, by themselves constitute an adequate reply to the crisis of 1900. To settle for them alone would be to make the 20th century's music what the 19th's would have been without the abstract Germans—with only the theatrical and literary Italian and French composers.

Webern's miniaturism is not exactly an evasion, but it too is open to objections. For one thing, we can scarcely hope for many instances of his uncanny ability to maneuver, with the help of magical silences, a small form into implying a large one. For another, this sort of musical litotes might begin to sound like mere wispiness if it were to become common; in the long run, understatement depends for its elegant effects on the existence somewhere of full statement. In fact, no one can listen to Webern's early, short pieces very often without asking himself the question a modern composer faces every creative morning: How can a sizable work of art which must unroll in time be made to cohere if obvious repetition is avoided?

The most widely used answer to this question is a series. In a so-called classical state (no longer very common, but useful as illustration), as conceived by

Schoenberg during several years of meditation and experiment prior to 1923, a series is an arrangement, valid everywhere in a single composition, of the twelve semitones which were practically all that was left of the traditional system after expressive dissonance and chromaticism had wrecked tonality. It is not a melody, for it is played backwards, forwards, upside down, backwards upside down, and in vertical blocks. It is simply a pattern of intervals between tones, a pattern which undergoes perpetual variation without losing its internal relationships; and since the entire pattern is used in each variation, none of the twelve tones can sound more important than the others and imply that it is a key centre. In other words, the composer has a micro-structure which germinates an entire work and which automatically produces a modern—that is, an atonal and athematic—result. A series, at least in theory, provides the repetition needed to save a time art from anarchy, and at the same time an avant-garde guaranty that all obvious (the reader can now see why I have insisted on this adjective) repetition will be avoided. It is both continuous and discontinuous, both a permanence and a flux. No critic should discuss the device without first acknowledging the passionate brilliance, and the courage to face up to ambiguity, of the mind that invented it.

This, however, is theory. How does it work out in practice? Creatively, very well. The serialism of Luigi Dallapiccola is of course not quite like that in Schoenberg's *Variations for Orchestra* or Webern's *Concerto*. That of Boulez is not like that of Stockhausen. Many composers have used rows of less than twelve tones, and have not resorted to all the "classical" variations. Others, notably Stravinsky in his last works, have blended the new technique with old ones into a very personal approach. A few, notably Hans Werner Henze, have learned things from Schoenberg's discipline and then have moved back into more conservative territory. Around 1950 a number of serialists, obeying with zeal the Occidental impulse to realize all potentialities, began to employ rows not only of tones but also of timbres, instrumental attacks, time values, and intensities. The results discouraged even the most mathematical-minded and encouraged a trend toward lyricism. But in general serialism has proved to be a stimulating and practical method of composition, and this is by no means a minor point in its favour. One of the appalling aspects, from a craftsman's angle, of the collapse of the traditional system was that it left no good way of getting a purchase on musical materials and organizing them. A pre-serial atonal composer was a man with strong words and no grammar. A serialist has everything under the control of an order whose intricate and never-failing rightness must please anyone who enjoys being rational—and which has therefore given rise to a vast literature of musical analysis.

From an average appreciator's point of view, the prospect is less pleasing. Often, when a concert-goer drops his super-rational program notes and settles

back to listen, a disturbing thing happens. The series, if firmly in mind, may be heard distinctly in its initial presentation, and then it may be heard for a while, amid all the permutations, as a sort of unifying musical climate governed by the recurring intervals; the distance covered by a melodic leap may be heard as the same as that covered by a recent dive. But gradually an ancient fact reasserts itself with tedious insistence: a musical palindrome is unrecognizable. The recurrences fade and leave the listener to grapple as best he can with a composition which is joltingly novel each instant. Of course, being up-to-date, he had not expected an obvious form in the traditional sense—a macrostructure. He had, however, counted on a slightly less nonobvious microstructure, on a gadget with a little more aural reality.

This sort of disappointment does not always occur. There are serial compositions in which the subtle gadget is both there and not there, in which it is just strong enough to suggest that, after all, things are not actually falling apart, and just weak enough to allow for a feeling of constant change. But even the adepts in the discipline are likely to grant that, if the heard music is somehow structured, the unheard is infinitely more so. And on the whole, at least for our allegedly average listener, the Schoenbergian reconciliation of repetition and nonrepetition must be called unstable: its calculated ambiguity usually dissolves into a marvelously rational reality on paper and an irrational reality (which may also be marvelous, in a different fashion) for the ear. Serialism is more revolutionary than many serialists, reassured by their scores, seem to think.

But before we draw any more conclusions it may be helpful to try some longer perspectives and look at some nonserial matters.

VIII

The first of these perspectives, which has to do with notation, must be tried questioningly and with common sense, but is none the less interesting. We have seen that notation has given composers almost the full, lasting authority and identity of men of letters (not quite, and the need for executants suggests analogies with architects and film directors). What about the effect of this invention on the art itself? We can guess that much of the double difficulty which listeners find in modern music—the impression that it is at once fiendishly rational and fiendishly irrational—is due on the one hand to a slow historical process which was under way long before Schoenberg's time, and on the other hand to a vigorous reaction to that process. In psychological and metaphysical terms, notation appears to have contributed to the emergence of a music which oscillates, and sometimes hovers, between mental abstraction and pure sensuousness, between an ideal "essence" and an actual, "existential" kind of reality.

Certainly the reality of music is still assumed by most people to be existen-

tial; just as a horse race has to be raced for us to speak of horse races, so, we feel, a composition—a sequence of sounds in time—has to be heard. In music, we would argue, existence has a logical precedence over essence; the notated phrases and expressive nuances cannot be called real without a performance, and the form or structure *must* be perceptible to the unaided ear. Such a conception of the art has the apparent solidity of common sense. But in fact, has it not been undergoing an erosion for centuries? We have only to recall that whereas the typical figures in prenotation, or "prehistoric," music—in the ancient, Oriental, and folk worlds—have often been blind, Beethoven was deaf. Evidently notation makes it possible for music to be a purely imaginative experience as well as, and even instead of, an aural one. Ghostly symbols can replace the sweating, expressive performer; a preexisting essence the existential reality.

The possibility might be dismissed as mere philosophy, if heard and unheard music were always exact replicas of each other. But they are not; and the willfulness or inexperience of performers is not the only reason. Since a written score, which can be likened to an elaborate road map, freezes the aural journey through time and allows a nearly simultaneous awareness of "now" and "a little while ago," it makes feasible a complexity well beyond the grasp of a listening memory; and Western composers have never neglected the opportunities thus provided. There are, to cite only a few examples, medieval and Renaissance polyphonic webs which no listener can unravel without visual help, Bach passages which appear to have been worked out on a computer, and refined to-and-fro allusions in Beethoven's quartets which nobody actually hears (unless he has memorized the work, and thus has an equivalent of the score to go by)— they are simply the evidence on paper of what went on in the silence of their creator's mind. Some of these abstractions undoubtedly have a reality overlooked in our era of "spectator" art and sport, since they were often intended for the appreciation, not of a public audience, but of private performers. They are not numerous enough to alter our opinion that, on the whole, pre-1900 music relies on obvious, audible repetition. But they do show that some of the difficulty our ears have with notated serial structures has long been on the way.

The history of poetry offers a parallel. Blind poets, of whom Homer is the great example, were once as common as blind musicians; and all of our older poetry is full of obvious repetition designed partly to provide a structure for the "blind" listening memory. But writing and especially printing (there have been other factors, of course) have made possible and prevalent a kind of verse which, while still patterned in sound, could not be imagined within an oral tradition. Today we assume that any serious poem must be appreciated with the aid of a printed text, however pleasant hearing it recited may be. Is some-

thing like this ahead for music? Certainly not in any immediate future, but the long-term tendency is worth some attention, particularly from educators. Today nearly all of the fermenting and exchanging of ideas about new music is a paper operation; and no conscientious critic would think of pronouncing a considered judgment on a new work without studying the score. Already, confronted by any serial composition, a nonreader of notes is almost as handicapped as a nonreader of words would be if confronted by Eliot's *Four Quartets*. And is this added literacy requirement quite so outrageous, in the light of cultural history, as some conservatives seem to think?

Twentieth-century creative reactions, however, to this long-term "paper" tendency should also be remarked. If they cannot exactly be called reactions toward simplicity, they are at least toward an existential sort of musical reality. They begin most clearly with Debussy, who was revolutionary because, as Copland once observed, he was the first European composer in a long while to judge harmony by ear instead of by the rules. The reactions continue with all the pioneers of modern music. I have described, perhaps rather insistently, the collapse of the traditional system as a historical consequence of chromaticism, which indeed it was: one can actually hear those sharps and flats, those historical termites, eating away the tonal foundations. But (now that I want to make another point) it should also be said that one can hear, in the tinkles and toots of Webern and in the vehement argumentativeness of such other and such different innovators as Berg, Bartók, Stravinsky, and notably Edgard Varèse, a reaffirmation of music's right to be sheer, fresh, constantly surprising sound—sound free of those overtones of predestination which written works may produce. Schoenberg can also be cited in this connection, since his decision to continue, by inventing serialism, the Occidental trend toward "paper" music was in part a reaction to his own earlier—sometimes rather chaotic—reaction toward expressive sound.

In the second half of the 20th century these reactions and re-reactions have swung so far in each direction that referring to such oppositions as the irrational-rational, sensuous-abstract, existence-essence, and heard-unheard seems inadequate. Something at once more primordial and more sophisticated appears to be involved, as it often is in art. Borrowing a primitive pattern from the anthropologist Claude Lévi-Strauss, we might say that Western music is showing signs of being polarized into the natural and the cultural, the nonelaborated and the elaborated—the "raw" and the "cooked." Or, less fashionably, we might borrow from old China and say that our principal modern nondiscursive language is showing signs of breaking up into a mandarin dialect and a vernacular.

We can risk such metaphors usefully, however, only if we add that the modern sensibility is very much a looking-glass world. For instance, the totally seri-

al music which appeared around 1950 can be called thoroughly cooked mandarin, or at least cut-and-dried. The random, or aleatory, music with which a number of modern composers, following the leads of John Cage and Stockhausen, have been experimenting can be called anticultural, if not exactly natural. But total serialism has been largely abandoned because of its tendency to sound like a non-elaborated, flavourless chaos. And random music achieves its best, most exciting effects—of live musicians, unhampered by scores, following their impulses expressively and dangerously—with methods which are a long way from those of an 18th-century soloist improvising a cadenza. Aleatory composers realize that the usual instrumentalist cannot be trusted to create an impression of constant renewal; he is distressingly apt to remember things, even old-fashioned things, and he is almost certain to slip into obvious repetition of phrases. His randomness must be controlled in the score; the raw flavour can be obtained only by careful cooking. The result can be called vernacular music in a sense, since what is heard is not entirely written: the performer does usually have a choice of nuances, or of time values, or of sequences of permutations. But it is a very modern sort of vernacular, a vernacular for people who are already fluent in mandarin.

"Concrete" music provides another example. This genre, after some interesting experiments in the 1950s, now seems likely to survive mostly as a widening of the horizons of other music, but it certainly reveals the modern tendency toward the natural. What could be less cultural, more *raw* than a work composed, not of tones or even of sounds, but of noises? Yet the noises—the crash, say, of a falling bottle, or the creak of a door, or the buzz of an insect—are captured with microphones, transformed with re-recording equipment until they are unrecognizable, and finally organized on tape. And what is more cultural, more *cooked* than a composition put together directly on magnetic tape? Here, one might say, is the end toward which notation has been moving for a thousand years: a work whose written score is audible, and whose essence must therefore always be identical with the existential reality.

Computer music is equally ambiguous in terms of our culinary analogy. The machines, cunningly programmed, are exploring previously inaccessible aspects of musical materials, styles, and appreciation; and they are being used by composers to extend and speed up structuring processes. The aestheticians, mathematicians, psychologists, and artists involved are operating on the assumption, abundantly supported by Western history, that there can be an intimate relationship between musical research and musical creation. With a few romantically sciency exceptions, they regard the computer simply as a tool, not as a superman. Many were working, although infinitely more laboriously, on their stochastic (probabilistic) compositions and on their higher randomness long before they turned to IBM for help. Should the results be called cooked

and cultural, or raw and natural? Elaborately cooked and cultural, one might say, thinking of all those equations. Then, listening to the great, toppling slabs of sound and to the strange, aleatory scurryings that are often produced, one might also say that here is the rawest, most anticultural music man has yet concocted.

And, while we are being slightly futuristic, we can add electronic music (music, that is, which is not only taped, as the concrete genre is, but is based on electronic sound sources) to the pattern. During much of the 20th century the avant-garde response to the crisis of 1900 has been inhibited by the failure of musical instruments to evolve, and this general situation can be expected to persist for a long while—as long as traditional masterpieces continue to dominate the market. But vast possibilities have been opened up by the sound-wave generators and mixing equipment which have been perfected since World War II. Every kind of pitch, colour, intensity, attack, fade-out, and rhythmic pattern can be synthesized; sounds which have never existed can be created. Since there are no performers, the composer's control is absolute. Here indeed is a cultural phenomenon, and an excellent example of how the Industrial Revolution in its new phase can change the quality of living. Yet the average, curious, cultivated listener can surely be pardoned if, encountering for the first time the works of such electronic pioneer-masters as Varèse, Stockhausen, Milton Babbit, and Luciano Berio, he concludes that music is going back to, and even back of, its primitive condition. Is this what the Carolingians had in mind when, with notation, they set historical sail? Or is this really the song the sirens sang?

IX

I observed a while ago that "serialism is more revolutionary than many serialists, reassured by their scores, seem to think." The best conclusion for this chapter might be simply to say that everything is more revolutionary than many people seem to think, and that everything is getting more and more revolutionary than more and more people seem to think. But perhaps something more constructive can be managed.

In résumé, what has happened and is happening looks like this: Driven by the demand for expressiveness in an evolving, history-minded civilization, modern composers have abandoned the "completed" traditional Western musical system and with it any obvious repetition as a structural principle. Driven by conflicting demands for coherence, for a lifelike lack of predestination, for mathematical order, for aural reality, for a realization of all potentialities (the technological included), for human significance, for clarity, for mystery—in short, for both a "cultural" and a "natural" effect—modern composers have re-

sorted to methods of composition involving micro-structures and permutations. The most typical of these methods remains serialism, although since the early 1960s it, or at least its classical variety, has been losing ground noticeably (not, however, to conservatism). At any rate, the central difficulty we have noticed in serialism has become typical of nearly all modern music, whatever the compositional method may be. In nearly all of it, that is, the differences between the notated and the audible are striking for a layman; and the paradoxical, through-the-looking-glass relationships which can be established between the "raw" and the "cooked" accentuate these differences. Plainly, when Schoenberg gave up obvious repetition he loosened the principal cement which for centuries had been holding together the Occident's two kinds of music: the written "essential" and the heard "existential." And he, unlike some of his successors, appears to have been thoroughly aware of the revolutionary situation, for he symbolized it in his *Moses and Aaron.* Moses has been up on the mountain top, has brought back the ineffable, and cannot sing it to the people; Aaron sings eloquently, but not, of course, of the ineffable. (In the third act of the libretto Moses is finally victorious, but Schoenberg never succeeded in writing the *music* for that act.)

What can laymen—our statistical 20th-century man—do? Evidently they can do what the great majority are doing: simply refuse to live musically in the modern age. But it seems to me (I feel I can now say something for the defense without being accused of partiality) that a better course is to grant that modern music is historically not at all a gratuitous thing, that it deserves to be judged, as does any period style, at its best level, and that it would repay some study, some thinking about its cultural context, and more listening.

"Study" is not a seductive word in art appreciation, and it goes against the current tendency (another analogy with the old aristocratic outlook) to fear pedantry more than ignorance. But in this instance it is the right word. On the whole, modern music is the most intellectual and the most glitteringly unsentimental ever composed; it is the exact opposite to mood pieces, and cannot be taken passively. Neither, it will be said, can a serious 19th-century pièce. But the shapes and structures in a Brahms symphony are reasonably evident, and partly familiar to a listener acquainted with Haydn, Mozart, and Beethoven; they resonate in the traditional system. In a modern work a listener must attempt to narrow the gap between the notated and the heard, and must prepare himself as a resonator; otherwise the difficult will also be thin.

Such preparation will inevitably lead to thoughts, not entirely solemn, about the cultural context. Composers are not the only people in our era who have gone through the looking-glass from the apparently rational to the apparently irrational; and the gap between notated and heard is as characteristic of today

as polyphony was of the age of scholasticism and Gothic vaults. Here we are back with the lost realities discussed in Chapter 2, at merely a slightly different angle. The Moses of Schoenberg's opera is not only the modern composer but also the modern religious thinker, the modern politician, the modern economist, the modern artist, the modern scientist, and of course the modern Everyman. In just about everything the disappearance of traditional, obvious macrostructures has let concepts and percepts drift apart. Nor is this the only parallel. Physicists, generally supposed to be the most advanced and typical of 20th-century thinkers, have in quantum theory an equivalent—at least an emotional equivalent, which is all we are talking about—for serialism's equivocal attempt to reconcile continuity and discontinuity; they have in Heisenberg's indeterminacy principle their own little aleatory night music; they rely, as do certain computer composers, on probabilities to control randomness. These analogies can be pushed too far; in fact, as has been suggested, they have been pushed too far by some composers, whose music is almost as fictional as modern physics. But the point is still valid; a modern sensibility can feel at home in modern music. There is a grain of truth in the avant-garde contention that the real difficulty in this music is that its contemporary meaning is rather too plain for the taste of a public addicted to musical reverie.

How should one listen? The answer has been implied: with unswerving attention. If that requirement is met, many of the problems raised in this chapter may fade. The listener will then become aware of an unusually vivid sound, a sound which is specifically musical, which has almost none of the literary and pictorial overtones common in the art music of the past. The timbres are apt to be remarkably distinct, and to blink on and off in the sort of constantly evolving pattern which Schoenberg called *Klangfarbenmelodie,* "tone-colour-melody." Intensities, instrumental attacks, rhythms, and all the other elements in the musical fabric will be bathed in the same strange clarity, as if they were being heard with the help of mescaline. And the "form"? It is apt to be what might be called an anti-form, a form whose chief function is to keep on dissolving and renewing itself. It will, if the piece is good, and typically modern, create a strong impression of a multidirectional space-time process, open toward the future on all sides and at each moment, the last moment included. The meaning? In addition to having the general cultural significance already mentioned, the work may, of course, be about something specific, indicated in the title. But it is very apt to be mostly about music and about being alive in the immediate present, two subjects which are arguably as important as, say, the affection of Robert Schumann for Clara.

A conclusion for these conclusions might be that modern music, in spite of or even because of the problems I have been discussing, is quite capable of con-

forming to my introductory definition of art—of being a terrain of fraternal encounter where we can glimpse, and be reassured about, our common, modern humanity. But one can doubt, in view of the difficulty of the terrain, that a very large public will get together on it in the near future.

. . . and all the people in the joint (I mean the place)
would rave, and you could see a gladness
in their faces.

<div align="right">LOUIS ARMSTRONG</div>

Chapter 6 Other Music

CULTURAL HISTORY OFFERS more than one example (Western European drama, the novel, and the Japanese print are three) of vigorous, complex, serious art emerging unexpectedly from dormant or humble sources while critics were talking about dying forms. Could something of the sort be happening now in music? One can only guess, and one guesses in such affairs partly by taste and temperament. But the question may help us to see where we are now in Oriental, popular, folk-popular, and semipopular music.

<div align="center">I</div>

The traditional musics of the non-Western world are still being performed and created. Indian connoisseurs can still enjoy their *tala-raga* rhythmic-melodic system; the Chinese, more rarely, their opera; the Japanese their *koto* variations, Nō plays, and court dances; the Indonesians their gamelan orchestra; the Arabs their embellished melodies and elaborate metrical phrases. In each of the emergent Asian and Middle Eastern nations there are active partisans of native art.

Such facts look fragile and inert, however, in the perspectives of the second half of the 20th century. Along with much else from the Occident, Occidental music is clearly destined for dominance in a world civilization. The trend is evident even if one grants the limited appeal of modern music and of the peculiar supranationalism it shares with all modern art; for everybody everywhere is being swept, materially and emotionally, from prehistory into history. Western-style conservatories, symphony orchestras, chamber groups, and singing socie-

<div align="center">68</div>

ties have become common throughout the Orient. The traditional, pre-1900 Western system has been accepted by both composers and audiences because of its logical harmony, its repertory of masterpieces on paper, and the expressive power of its instruments. Interest in these aspects has been reinforced by the prestige of Western science, technology, political thought, social organization and—vaguely—progress; an up-to-date Oriental listens to Mozart and Beethoven for the same reason that he wears Western clothes. Especially since World War II, radio networks have speeded up the serious proselyting; and the Beethoven-less part of the Oriental public has been absorbing, if only subliminally, the basic elements of the traditional Western system in popular music, diffused by disk and cinema empires whose headquarters are in Europe and the United States.

In these circumstances, simply preserving Oriental music as a performed, "museum" art, in the way medieval music is being preserved in the West, may be impossible. It will, in any event, be a delicate operation, with a built-in tendency toward self-defeat. For the best and most typical examples of Eastern music exist, as was observed a while back, in an eternal present; and part of their magic evaporates when they are appreciated as samples of period styles. The best Eastern musicians are performers and composers who create as they play and who rely on a rapport with a knowledgeable audience. They, their aural traditions, and their empathic public must somehow be kept going. Notation, if carried beyond the sketching of formulas, is apt to freeze the system into a datable past. Even recordings, which are obviously the least dangerous way to preserve this music, risk turning it into dry specimens.

Can such an art make a contribution toward an evolving world music? Not an important one, a historian writing fifty years ago would have replied, for the characteristic virtues of Oriental music sound like flaws in the structures of traditional Occidental compositions. But these "flaws"—the subtle timbres, the illogical harmony, the absence of obvious syntax, the improvisations—are apt to become virtues again in the ears of a post-1950 modern listener, and avant-garde composers in both the East and the West have demonstrated their awareness of this possibility. Oriental music, it seems, does have a chance to leave the museum and become an ingredient in an active, expressive, modern discipline. This chance, however, can scarcely be called an Asian development, and it will probably continue to exist only within an Occidental frame of reference, accessible in the immediate future to a regrettably small international public.

II

In previous chapters it has been suggested, without being explicit, that popular music may be a simpler kind of elite and may contain folk elements. The two tinges are usually mixed, but can guide a brief inquiry into the potentiali-

ties, or the lack of them, in a realm hard to organize for criticism. What is said here will concern only Western popular music, but will probably be true everywhere eventually.

What first strikes even a friendly meditator is the gap, in terms of both style and quality, which has opened between the best light music and the best art music. The late 19th century and the early 20th were rich in operettas, ballads, and popular descriptive orchestral pieces which were comparable in everything but complexity and purpose to serious opera, lieder, and symphonic poems; in fact, it was normal for them to be written by classical composers. New intermediate work of this sort, which often initiated young tastes into the zone of masterpieces, has become rare. The Sunday concert of the municipal band, where it still exists, is mostly matter for nostalgia; and the kind of potpourri which has replaced it on the radio and in stereophonic spectaculars is best left to sound engineers for analysis.

Musical comedy, which has achieved what might be called elite popularity, does indeed show many signs of becoming a serious, dynamic form of art; in its librettos, its staging, and above all its dancing it already has lessons for opera producers. Compare, however, the derivative, merely agreeable, merely competent score of a recent New York success with the melodic verve, rhythmic sense, and pungent orchestration of one of Sullivan's or Offenbach's hits. The musical falling off cannot be doubted. And the same conclusion is apt to emerge from a consideration of the best elite-derived pop ballads. Here too there are signs of evolution; in Europe and the United States there are now many popular troubadours who set and sing their own verses or those of other poets and who are afraid neither of ideas nor of authentic emotions. But their admirers are obliged to concede that musical ideas as fresh as the literary ones are very scarce and that the purely musical emotions are seldom up to the level almost any Neapolitan or German tunesmith could reach a hundred years ago.

In other words, a composer of elite-derived popular music must face the fact that for him as well as for classical creators the old Occidental system has reached the end of its evolution and has run low on expressive power. He may not mind much, since his aim may be simply to turn out pleasant, appeasing stuff. And if he does mind? Clearly, he cannot make the avant-garde response to his little version of the 1900 crisis (although an aleatory pop ballad might be interesting). He can, however, try the exotic one, which of course is precisely what a great many popular composers have been doing—and which brings our inquiry around to the folk-tinged potentialities.

Again some achievements of the 19th century and early 20th should be noticed. While enthusiasts were continuing the rediscovery (under way since the mid-1700s) of old folk music, there was an extraordinary flowering of new—however old the roots—folk or folk-popular genres: the cowboy ballad,

the Negro spiritual, the blues, and jazz in the United States; the flamenco in Spain; the fado in Portugal; the calypso in the Caribbean; the rumba, samba, and related dances in Latin America; the pub and music-hall number in England; working-class, street, and café songs in France, Germany, and Italy; balalaika-type music in Russia; dulcimer-type in Hungary and Bohemia; and accordion-type practically everywhere. All of these genres have been exploited commercially, and their vitality can probably explain away most of the objections the reader has been making to the generalizations risked a couple of paragraphs ago. It would be difficult to name a good popular song, dance, or musical comedy of the last forty years, even in the category of the mainly elite-derived, which does not owe much of its indefinable appeal to a folk tinge.

With one important exception, however, this vitality has not been enough to start an evolution toward a new kind of art music. These folk-popular songs do not seem to be about to develop into elaborated arias; the dance forms are not recapitulating the history of the classical suite. And in most cases the absorption predicted in Chapter 4 is far along: the folk element is disappearing into the popular.

The exception, of course, is jazz.

III

Jazz (the blues included) is perhaps the most surprising artistic phenomenon of our era. It became recognizable a little later than most of the other folk-popular music I have mentioned, but in a sordid urban setting fairly typical of many created by the 19th-century migration to the towns. Along with several other genres on my list, it is partly a product of class and racial injustice. It is, again quite typically, European music with an expressive non-European accent. Yet, unlike its flamenco, fado, calypso, and other cultural kin, it has exhibited—during the lifetimes of some of its pioneers—a lively ability to meet the historical requirements for the development of high art from "low" sources. It has managed to borrow from and contribute to Tin Pan Alley enough elements to create an enduring confusion in the minds of academic musicologists; but it has never really been absorbed by the popular-music industry. Even more remarkably, it has radiated from its original milieu and acquired geographical, social, and racial universality without losing its identifying early characteristics or fading into the merely exotic (granted, the finest performers and, at least until recently, all the creators have been American Negroes—the point here is that excellent jazz, and practically no flamenco or fado, is produced by white Americans, by Frenchmen, by Russians, by Japanese). In fact, jazz in its unalloyed state is already partly in the abstract category of absolute art. It has lost that exclusive attachment to balladry and dancing which is one of the traits of folk music. It is not popular in any of the usual senses. Its public, to

judge by record sales, is actually smaller than that for traditional Western art music; its successes are by no means ephemeral; its creators are no more commercial than other artists are; and it is showing a marked tendency to evolve rapidly at the cost of leaving part of its old audience bewildered and irritated.

This evolution is what raises questions. Is it a necessary response to aesthetic requirements, or simply change for the sake of change? If it continues, won't jazz eventually cease to be jazz? What then? A glance at some of the stylistic trends since World War II—since roughly the brief but revolutionary career of saxophonist Charlie Parker—can provide material for several conflicting answers.

Orthodox jazz, the sort of jazz most people would call central (in the way Haydn's music is central in the traditional system), and which is linked to the genius of Louis Armstrong, can serve as a point of reference. It has an emphatic, rock-steady underlying rhythm, usually four beats to a bar, upon which are imposed subtle shifts in accent and a fluctuating tempo. For melody it uses a probably African-influenced scale with the third and seventh flatted into "blue" notes. For harmony it uses the common European major scale. The few stringed instruments are treated percussively; the brass and woodwind are played with vibrant expressiveness in styles approximating those of folk vocal music. Improvisation, although not always present, is common enough to be called a characteristic; in any event the performers are creatively more important than the composers. The form is apt to be that of a folk or pop song, with variations. The mood is uninhibited.

Almost none of this description can be applied without qualification to post-World War II modern jazz—the jazz of such brilliant innovators as drummers Max Roach, Philly Joe Jones, and Elvin Jones; saxophonists Parker, John Coltrane, Sonny Rollins, and Ornette Coleman; trumpeters Dizzy Gillespie and Miles Davis; pianists John Lewis, Bill Evans, and Thelonious Monk; trombonist J. J. Johnson; vibraharpist Milt Jackson; arrangers and composers Lewis, Monk, George Russell, and Gil Evans; and bassist Paul Chambers (this sampling is unfair to dozens of musicians, but may suggest what is being talked about). Some of the innovations are not entirely recent, but important innovations seldom are—the spirit and scope are what to look for.

The old, emphatic, driving rhythm is often present today only by implication; and the implication may be hard to get among the fragmented beats, suddenly solid blocks of sound, and floating islands of insecurity. The melody may be either a bland statement in an unusual timbre, or a slow, fascinating hint, or an antimelody—a burst of staccato phrases and wild runs in which it is difficult to make out the basis for the variations or even catch separate notes. The harmony, which was once so simple that a pianist could get his sidemen going by vamping three or four chords, has been enriched and transformed by Debussy-

isms, dissonance, polytonality, and sometimes atonality. Organs, violins, flutes, flugelhorns, and other untraditional instruments are being used more extensively than ever before. Saxophonists, who in the early days were associated with the more bourgeois kinds of jazz, dominate most of the modern ensembles. They favour a big, bleak, honking, rasping, bagpipe tone which is remote from the sentimental human wail of a generation ago. While gifted soloists have been indulging in extremely aleatoric improvisation, arrangers and composers have been moving toward a "paper" jazz much more complex than anything Duke Ellington ever attempted. Rondos, fugues, Oriental modes, self-engendering avant-garde forms, and even a bit of serialism may be heard, mixed perhaps with memories of the blues and allusions to pop themes. The chamber group has pretty much replaced the band. The mood tends to be rather solemnly intellectual.

It is important to notice that this musical evolution has coincided with an equally rapid and violent evolution in the attitudes of American Negroes toward racial injustice. The typical jazz musician of the older generation was what Southern racists referred to as a "good" Negro who did not change with success. He was resigned, or at least seemed to be, to playing the role of the childlike primitive, the mere entertainer, even the clown. His music, particularly his blues, might be infinitely sad, but it was sad on a personal level and did not imply any revolutionary protest. The modern jazz musician is profoundly different. He is apt to be a middle-class Negro brimming with an explosive compound of intelligence, education, and wounded pride. Angrily aware of what life is like in the crowded, poverty-stricken Negro ghettos of New York, Chicago, Los Angeles, and other large cities, he is inclined to dismiss any interest in the older, more folkish kinds of jazz as submissive and reactionary "Uncle-Tomism" (the revival of New Orleans styles, which has coincided with the growth of modernism, has been almost entirely the work of white amateurs, assisted by a few authentic Negro pioneers). He knows, however, that many critics in the United States and Europe regard jazz as the most important original American contribution to world music, and from this knowledge he has derived a double, and perhaps ultimately contradictory, determination: to push jazz further and further toward the status of art music, and at the same time to extract recognition for it as a fundamentally Negro achievement. Hence some of the most startling innovations since the 1940s have been inspired, according to the testimony of the virtuosos involved, primarily by a wish to do something that "they"—white musicians—could not do. But "they" do learn to do it, more or less, and so the Negro inventor feels compelled to reassert his patent rights by inventing again and again.

This aspect should not, of course, be isolated and overemphasized. One has only to glance at a list of modern-jazz tendencies—or better, listen to a few

disks—to perceive that the flow of ideas has not been in a single direction, and that much more than a racial protest is involved. Jazz, after borrowing during its early decades from American and European hymns, polkas, marches and popular ballads, is now being influenced by modern art music. Many of the new players, both Negro and white, have classical musical training, and they have been encouraged in their experiments by the emergence since the late 1930s of a relatively small but sophisticated new public, by the spread since 1945 of the avant-garde response to the crisis of 1900 in art music, and by the appearance in 1948 of the long-playing record, which ended—in theory if not entirely in habit—the formal restriction imposed by the three-minute 78-r.p.m. disk.

In sum, it would be unfair to say that the recent evolution is merely change for the sake of change. One can understand and sympathize with the racial, social, and artistic aspirations which lie back of it; and one can often enjoy the result as an exciting second sort of modern music—without asking it to rival the heavyweight classics in range and seriousness, and without being condescending. But so far at least there is not much reason to accept the claim, frequently advanced by its partisans, that modern jazz is, or is about to become, the primary art music of our era. Moreover, there are some disturbing signs for the future. Concerts and records, which have become stylistically more important than cabarets, dance halls, and jam sessions, convert discoveries into clichés. There is evidence—this time in an avant-garde context—of a resurgence of the yearning for long-haired musical respectability which led to the "symphonic" pretentiousness of the 1920s. And finally, of course, there is still the question of how long the trend toward obscure harmony, eccentric rhythms, odd timbres, and free improvisation by star soloists (many of whom regularly run on beyond their supply of ideas and the average listener's attention span) can continue without forcing a choice between formlessness and absorption by modern art music.

That dilemma, to be sure, is still fairly distant; and in the meantime creative Negro musicians, their racial self-consciousness somewhat reduced by progress toward integration and social justice in the United States, may reconsider their attitude toward their folk heritage. If they do, they may agree that some of the recent stylistic evolution has not been aesthetically inevitable. In fact, much of it has occurred in an abnormal, hothouse atmosphere. One cannot argue convincingly, as one can in the case of late 19th-century classical music, that the jazz of the late 1930s was running out of steam. Although it was abandoned by most of the best young Negro performers, much of it remains—in the ears of qualified listeners all over the world—thoroughly contemporary. Returning to it for inspiration and for new lines of development need not be considered a surrender to revivalism.

IV

On the principle that every kind of art, the popular included, deserves to be judged at its best, nothing has been said here about the kitsch which is manufactured—the process is really an industrial one—as background music for airplanes, elevators, bars, film spectaculars, television shows, and much else. Never before has so much bad music been produced deliberately. But for that very reason the issues it raises lie beyond the scope of this book. They are the concern of economists, educators, sociologists, and political scientists.

The age demanded an image
Of its accelerated grimace.
EZRA POUND

We speak of . . . the immediate self, the
very plasma of the self. D. H. LAWRENCE

Chapter 7 The Poetic Confrontation

TO MOVE FROM MODERN MUSIC into modern poetry is to enter one of the frontier regions between non-discursive and discursive expression—between the realm of symbolizing and the realm of describing, reasoning, or narrating. It is also to encounter many warnings against generalizing excessively. Poets are apt to be unique, even private, voices. Each literary language is in itself a poetic style, a distinct mode of apprehending and organizing. Each nation has its own patterns of thought, feeling, and sound. Modern verse has a remarkably complex history, one that teems with doctrines and groups whose labels were meant to be exclusive. The critic-historian begins confidently with Symbolism and Naturalism, and soon finds himself involved with Expressionism, Imagism, Futurism, Ultraism, Dada, Trans-sense, Vorticism, Surrealism, Functionalism, Social Realism, the New Apocalypse, the Movement, New Romantics, Beats, Angries, Renascents, Projectivists, Lettrists, Concretists, Zeroists, and their rivals and splinters. Chronologies are local; in France, for instance, the poetic 20th century begins in the 19th with Nerval, Baudelaire, Rimbaud, Mallarmé, Laforgue, and their disciples. Although French influence has had an internationalizing effect, there are independent precursors to be considered: for example, Hopkins in England, Whitman in the United States, Leopardi in Italy, Hölderlin in Germany. Such diverse writers as Góngora, Donne, Villon, St. Francis, Li Po, and the Japanese *haiku* masters have been revalued into ancestors. In some respects the modern movement is another wave of Romanticism, in others a revival of Mannerism, of Oriental classicism, or of popular

76

balladry. In all countries traditional verse has continued to appear, and from time to time has seemed about to start a counterrevolution.

But that is probably enough hedging. Since most people, including most literary critics, find it natural to refer to *the* modern movement in poetry, we can assume that there are attitudes and procedures which, although not present in every work, recur often enough to form a recognizable period style. This chapter will be an attempt to describe a few of these attitudes and procedures, and to isolate some of the issues they raise.

I

The standard modern indictment of 19th-century European poets (the precursors and pioneers of modernism are of course exonerated) goes like this:

They were manipulators of escapist rhetoric. Challenged by social, religious, philosophical, stylistic, and other problems that meant the end of an era, they turned toward the never-never lands of childhood, gentility, academicism, insipid mythology, and sentimentalized history. What passed for a poetic diagnosis of the human condition was often no more than metrical eloquence, intrinsically prosaic, about commonplaces. Even the more vigorous minds were infected enough to imply in their diction that the writing of verse had little to do with actuality. The vernacular was normally reserved for humorous or bucolic effects, since elevated poetic ideas, along with elevated religious, political, legal, and architectural ideas, were felt to call for a slightly archaic or pseudo-archaic dress. And so the ideas themselves tended to be pompously lacking in contemporary relevance, for in art, language, and much else the "how" cannot finally be divorced from the "what."

The considerable amount of injustice in all this need not detain us. Tennyson, Hugo, and the other great 19th-century poets can put up their own defense in the mind of a fair reader. What matters for the present discussion is that there is enough substance in the indictment partly to explain and largely to justify the reaction that has occurred. Go through any historical anthology of verse, and when you reach the modern section you will be struck by a gust of the contemporary atmosphere and by a tone of suddenly meaning business. Not that modern poetry is by definition entirely solemn. There are gay, tender lyrics about love and about the odd corners of 20th-century existence; and there is a lot of excellent light verse. These things cannot be dismissed by anyone who enjoys literature. But in the middle of the cultural configuration there is a struggle to confront poetically the reality of now—or the realities, if there is an objection to the implication of modern oneness.

It may be argued that such a struggle is not new enough to make modern poetry essentially different from that of many other eras. "Back to reality!" in one sense or another has been the slogan of nearly every artistic revolution and

counterrevolution in history. But in other eras people knew, or thought they knew, what reality was. In the 20th century an artist has to reckon with that destruction or discounting of antecedent certitudes which has been repeatedly referred to in this book. In fact, to assert that a modern poet is trying to confront reality is simply to resort to a convenient and rather old-fashioned manner of speaking. He is apt to be engaged in an anguished search for reality, or in an attempt to restore a reality damaged by seekers in other modern fields. He may be repelled by what he finds, or by his failure to find anything at all. If modern verse can be called, in regard to its central intentions, a poetry of confrontation, it is often, in regard to results, a poetry of alienation.

One more preliminary remark may help to put the discussion in the right perspective. In some modern arts a historian feels unsure about ultimate, collective value. Here there is no such worry; in country after country the modern movement in poetry has been a brilliant renaissance. There will always be disagreement, of course, about the merits of particular writers and works; but the 20th century (with the French 19th included) has already established itself as one of the great poetic ages. The issues are of the kind that only a vigorous art can raise.

II

The effort to confront, find, or restore reality is apparent in two attitudes and two corresponding procedures—in sum, two strategies. One strategy is antipoetical, the other antiprose. Both may be evident in a single work, for to be antipoetical is not to be antipoetic, nor pro-prose, and there is no literary law against simultaneous assault and infiltration. Both strategies, of course, have historical precedents. Many of the early Romantics were antipoetical, and Wordsworth, in his famous *Lyrical Ballads* preface (inspired and later attacked by Coleridge) went so far as to declare: "There neither is, nor can be, any *essential* difference between the language of prose and metrical composition." On the other hand, there have always been writers ready to try to say something that could not be said without breaking the rules for prose sense. Modernism in poetry is very much a matter of degree and of a new frame of reference—which is not to say that the modernism does not exist.

The antipoetical strategy can be illustrated by opening almost at random any collection of modern verse in any language (Oriental ones included, since Eastern poets, besides borrowing from the West, have their own indictment of escapism). Here, for example, is Federico García Lorca, starting off his best-known poem as if it were an overheard barroom conversation:

> Y que yo me la llevé al río
> creyendo que era mozuela . . .
> *La casada infiel*

And so I took her down to the river
thinking she was a virgin . . .[1]
The Unfaithful Wife

Umberto Saba approaches the ancient theme of the universality of suffering with a lack of flourish which an earlier Italian poetic generation would have found scandalous:

Ho parlato a una capra.
Era sola sul prato, era legata . . .
La capra

I talked to a goat.
She was alone in the field, she was tied up . . .
The Goat

Here is Bertolt Brecht, detecting the brotherhood of man in a fashion that would have surprised Goethe:

Ich sage: es sind ganz besonders riechende Tiere
Und ich sage: es macht nichts, ich bin es auch . . .
Vom armen B. B.

I say: they are peculiarly smelly animals
And I say: no matter, I am one too . . .
Poor Old B. B

Marianne Moore apostrophizes the rose, the most poetical of flowers, in a way Longfellow would have thought suitable only for philosophy:

You do not seem to realize that beauty is a liability rather
than an asset—that in view of the fact that spirit creates
form we are justified in supposing
that you must have brains . . .
Roses Only

Traditional French rhetoric yields to sensuous precision and understatement when Jules Supervielle foresees a world catastrophe which will leave only

De feu l'Océan Atlantique
Un petit goût salé dans l'air . . .
Prophétie

Of the late Atlantic Ocean
A slight taste of salt in the air . . .
Prophecy

1 An apology should be made here for these nonpoetic translations and for the desultory internationalism of the illustrative material. The alternative to both defects was to risk implying that the modern movement is merely British and American.

When Kaneko Mitsuharu takes a straight look at one of Japan's post-Hiroshima prostitutes, centuries of Oriental poeticalness are rejected:

> She yawns, fit
> To swallow a man whole.
> Never in Japan a crater
> As gaping as this yawn.
>
> Wordy, tedious debates,
> War guilt, liberalism,
> All these flung into the abyss
> Of that tart's yawn
> Make only a ripple.
>
> *Song of the Tart*

Such quotations could be continued, and there is a temptation to do so, merely for the pleasure of cutting the ground out from under people who say they do not read such things because they cannot understand them. Obviously, at least one of the principal characteristics of modern poetry is a relative simplicity. At certain moments in certain countries or with certain poets this characteristic may be dominant. Not much has been made of it in criticism, partly because it may be ruled out by narrow preconceptions of "poetry" and of "modern," partly because it may occur in combination with the antiprose strategy—with, that is, several sorts of difficulty—and also, of course, because there is not much an exegete, a deputy reader, *can* make of simplicity. But there it is. The antipoetical strategy may take the form of a deflation of the old fancifulness, a rejection of "noble" subject matter, or a puncturing of bardic pretensions. It is most apparent, however, as the above examples suggest, in the level of linguistic usage; a line count by an electronic computer might reveal that modern poetry is the most plain-spoken in history. Several modernists have made hostility to archaic, elevated diction—to the English thee-and-thou school or its equivalent in other languages—almost their entire program, convinced that the feel of being alive and seriously adult in a new era could be conveyed only in the words and locutions used in everyday talk. The more dogmatic have insisted that 20th-century reality can be confronted only at the levels of slang and argot.

Such programs exact a price. Antipoetical verse forgoes the advantage of having the reader in a lofty, ceremonious state of mind, ready to believe in artistic conventions. It forgoes, for example, the operatic splendour which Racine could give to Phèdre's confession of incestuous love:

> Ce n'est plus une ardeur dans mes veines cachée:
> C'est Vénus toute entière à sa proie attachée.

It is no longer a passion hidden in my veins:
It's the full length of Venus attached to her prey.
Phèdre (Act I, scene 3.)

It also gives up—for the sake of being tough and bold—the cultural patina a "poetical" surface may provide. No modernist can evoke the European classical past in the way it is evoked in Arnold's *Thyrsis:*

O easy access to the hearer's grace
When Dorian shepherds sang to Proserpine!
For she herself had trod Sicilian fields,
She knew the Dorian water's gush divine,
She knew each lily white which Enna yields,
Each rose with blushing face;
She loved the Dorian pipe, the Dorian strain . . .

There are other problems. A vernacular or colloquial style, in countries where the only widely read language is a literary one, can make for a strictly local audience. It demands not only an unusually alert ear but also an unusually strong sense of basic human values, for it tends to date rapidly. If it moves toward the prose poem, as it has with certain writers throughout the modern era, it may slip out of the category of poetry altogether. It is in constant danger of affectation, of turning into an escapist strategy for the sophisticated reader who wants merely to play with reality—who is looking for the modern equivalent of the old pastoral convention. And once such a style has been used by an influential talent, it begins to recapitulate the previous evolutions of poetic languages toward the literary and even the "poetical" level: by World War II scores of minor English, American, and Commonwealth poets had converted the vernacular turns of Eliot and Pound into clichés.

These perils should not be exaggerated. The attempt to call a spade a spade has brought important gains in poetic concision, power, and wit. It has freed poetry from the suspicion of being merely a sort of adolescent reverie, and has made more than one anthology of verse a useful introduction to modern living —a manual for confrontation which can help people, if they ever get around to reading it, to cope with the factitiousness of our era.

III

The antiprose strategy is by its nature less easy to talk about; and perhaps I ought to begin by adjusting a focus. While it is *not* true that all, or even most, modern verse is harder to understand than the traditional sort (18th- and 19th-century in the West), some modern poems and passages are very hard indeed, and hard in a way that is more strikingly modern than the above-mentioned simplicity. And, to complicate things, there is the already cited fact

that the antipoetical and antiprose strategies may be used simultaneously. A relatively colloquial diction does not rule out a collapsed syntax; a conventional sentence structure does not guarantee precision in the links between ideas and between images; and spade-calling does not rule out obscure symbolism.

"Antiprose" sounds a bit negative, but some such overtone is needed, for the strategy in question is not poetic in a merely positive way. It is designed to impede, to render ambiguous, and in some instances to prevent completely the emergence of the usual kind of prose meaning. In short, it is one more sign of a crisis in modern consciousness. At the core of the crisis, to say again what must be said frequently in these pages, there is a conviction that reality has become separated by a great gap—which an artist can feel as tragic, comic, ironic, depressing, or challenging—from the reassuring systems of information, formulation, logic, and reproduction that Western man took for granted until fairly recently. Prose is such a system, one of the oldest and one of the most taken for granted (especially during the 18th and 19th centuries); and modern poets evidently distrust it. They are not alone. Many thinkers today tend automatically to have more confidence in non-prose disciplines than in the others; theoretical physics gets more intellectual respect than sociology, for example, does. But, whereas such thinkers are inclined to distrust prose because it is not precise enough, modern poets find it altogether too precise. In their view it lends a false clarity and order to reality—or, which comes to the same thing, to the impact of reality on a modern sensibility. Their remedy is to push discursive language toward non-discursive. It is in this sense, and not because of any increase in the variety of rhythmic and sound patterns, that modern poetry can be said, in Pater's phrase, to be aspiring toward the condition of music.

·Is there a relationship, other than a contradictory one, between the antipoetical strategy and the antiprose one? The best answer is perhaps to point out that this pair of trends has its counterparts in recent cultural history and in the private imaginative and emotional experience which is constantly repeating cultural history. Allowing for uneven development in various activities and in different countries, we can liken the antipoetical strategy to such trends toward objectivity as visual fidelity in painting (which reached a peak in Impressionism), positivism in philosophy and science, and naturalism in the novel and the drama. Each of these trends has been called "modern," although all were prominent in the 19th century (particularly in France) and can be traced back at least to the Age of Enlightenment. Much more characteristically modern, however, is the way each trend, pushed far enough, flips inside out, so to speak; almost without transition the historian finds himself moving from visual fidelity to abstract compositions, from positivism to a universe of relativity and equations, from naturalism to the psychological novel and a drama of metaphors. The "objective" technique may be retained; there is, for example, a lot of natu-

ralism in ultra-modern novels and in the Theatre of the Absurd. But other techniques—which parallel the antiprose devices of verse—are employed, on the assumption that being unblinking and calling a spade a spade, while excellent up to a point, may not get beyond the shape and surface of reality.

IV

Verse is always in conflict with prose. In the European past, however, truces have been arranged, and during classical periods the arbitrary patterns of poetry have been made to coincide with, and even reinforce, prose meanings. Consider, as a rather extreme example, the familiar lines from Pope's *Rape of the Lock:*

> The hungry Judges soon the sentence sign,
> And wretches hang that Jury-men may dine ...

The couplet binds the idea into a neat, functional package, understandable at a glance or at one hearing, and as easily recalled as a proverb. What is strong in the verse structure of sounds and silences parallels exactly what is strong in the structure of prose sense. The relatively long pauses at the end of each line match the semantic pauses marked by the comma and the semicolon. The shorter verse pauses—the caesuras, or rhythmic breaks—within the lines match the phraseological divisions. The rhyme stresses and links two important words, both verbs. Alliteration adds strength to the semantically strong "hungry-hang" and "soon-sentence-sign" connections. The metre coincides with normal syllabic accents and with the intonation required by the prose meaning. In sum, the whole thing is close to being a kind of super-prose. It is a crisp example of the rule that a man with a proper respect for his neighbours will write, not merely so that he *can* be understood, but so that he cannot possibly be misunderstood.

Admittedly, this kind of verse-prose parallelism is not to be found in all non-modern Occidental poetry. It becomes less evident whenever the romantic and baroque impulses recur, in an individual poet or in a society. Donne, for instance, has been an influence in the 20th century partly because of his readiness to wrench accents:

> And all my treasure, which should purchase thee,
> Sighs, teares, and oathes, and letters I have spent.
> Yet no more can be due to mee,
> Then at the bargaine made was ment,
> If then thy gift of love were partiall,
> That some to mee, some should to others fall,
> Deare, I shall never have Thee All.
> *Lovers infinitenesse*

Moreover, the 18th century in Europe was in many of the arts unusually rational and prosaic; poetry, although not verse, strikes us as having come close

to dying out altogether in France, Italy, and some smaller literary regions. A hundred years after *The Rape of the Lock* things had changed enough in England to allow Coleridge to make his famous, subversive, and proto-modern observation that "poetry gives most pleasure when only generally and not perfectly understood." Nevertheless, on the principle that easy cases make good law, Pope's couplet can serve as a point of departure for some remarks about the antiprose strategy in modern poetry. Metre, rhyme, assonance, alliteration, and rhythmic breaks often look quite traditional in this verse, but they are seldom used to lock prose meaning into a classical couplet or an equivalent parallelism, and they are not infrequently made to strain against, or even dislocate, the structure of prose emphases. Racine would certainly not have approved of Guillaume Apollinaire's readiness, in the passage below, to rhyme the semantically feeble *-ait à* with the strong *jeta,* to chop a phrase in two, and to allow, by eliminating punctuation, the detached structure of verse silences to dominate completely the structure of prose silences:

> Un soir de demi-brume à Londres
> Un voyou qui ressemblait à
> Mon amour vint à ma rencontre
> Et le regard qu'il me jeta
> Me fit baisser les yeux de honte
> > *La Chanson du mal-aimé*

> One evening of half fog in London
> A rascal who looked like
> My love came to meet me
> And the look he threw
> Made me lower my eyes in shame
> > *The Song of the Ill-Beloved*

Pope might have accepted the first two of the following lines by Eliot, but would have scorned the rest as Gothic mystification:

> Time and the bell have buried the day,
> The black cloud carries the sun away.
> Will the sunflower turn to us, will the clematis
> Stray down, bend to us; tendril and spray
> Clutch and cling?
> > Chill
> Fingers of yew be curled
> Down on us? After the kingfisher's wing
> Has answered light to light, and is silent, the light is still
> At the still point of the turning world.
> > *Burnt Norton,* in *Four Quartets*

Notice how the clematis-like pattern of sounds and silences ("bell-buried-black," "day-away-stray-spray," "cloud-clematis-clutch-cling," "chill-still," "cling-wing," and "curled-world" are merely the more evident elements) grows through and around the pattern of prose meaning, sometimes reinforcing it in surprising ways, and sometimes fragmenting it into ambiguity. The unusual device of rhyming the first and last words isolates the "Stray-spray" line in a puzzlingly emphatic fashion, and makes "spray" sound like a verb even after we have assured ourselves that it is indeed a noun. The word "Chill," since it occupies an entire line, is apt to be read slowly, with a heavy pause afterward, and it is therefore strongly attracted toward the verbs "Clutch" and "cling" before it turns into the adjective for "Fingers." The "still" at the end of the next to the last line is rendered permanently ambiguous by the stress and pause of the verse structure. Does it mean "silent," or "motionless," or "continuing to exist"? This kind of close reading may seem fussy, but it can elucidate what, in the actual and more rapid experiencing of a poem, produces a modern—and, in these works of Apollinaire and Eliot, a gravely beautiful—effect.

We are dealing with a propensity and not with something that is always and everywhere evident. The obscurity may be very slight, and may be reduced by the eye's ability to ignore the displaced verse grid and select certain elements in the prose grid. Often, however, even the eye may wonder, and what it suspects the ear will usually confirm. When Pope's couplet is recited, with careful attention to the verse structure, the prose meaning becomes even more thumpingly clear than it is on the page. When the lines from *La Chanson du mal-aimé* and *Burnt Norton* are treated in the same way, the antiprose intention emerges. We get what Paul Valéry (he was referring to his own poetry) called "a prolonged hesitation between sound and sense"—in short, a serious kind of double-talk.

V

This modern use of verse techniques to shift and confuse instead of heighten prose emphases is worth attention because it is more widespread than its practitioners usually admit, and also because its deliberately ambiguous character is not always recognized—readers are naturally inclined to assume that writers are trying to make ordinary sense. But there are, of course, other elements in the antiprose strategy.

There are such tactics as the mixing of voices, the suppression of word relations, the breaking of continuity in ideas, the use of unacknowledged quotations, the introduction of unfamiliar biographical or coterie data, the elimination of alleged redundancy, and the employment of metaphors without saying what they stand for. These and similar practices can be considered under the general heading of a weakening of reference.

The resulting difficulties may be only momentary. Anyone who has seen the

tourist crowds in Venice and heard the cries of the gondoliers can separate the voices and straighten out the continuity in this E. E. Cummings vignette:

> i do signore
> affirm that all gondola signore
> day below me gondola signore gondola
> and above me pass loudly and gondola
> rapidly denizens of Omaha Altoona or what
> not enthusiastic cohorts from Duluth God only
> gondola knows Cincingondolanati i gondola don't
> *Memorabilia*

But the job becomes harder (if the reader does not simply abandon the poem and think only of its title) when words are transformed into the discontinuous dabs of an Impressionist painter, as they are sometimes in the work of William Carlos Williams:

> Among
> of
> green
>
> stiff
> old
> bright
>
> broken
> branch
> come
>
> white
> sweet
> May
>
> again
> *The Locust Tree in Flower*

And even the most resolutely modern of intellectuals may falter on first looking into something like the following, which is an extract from Robert Duncan's eloquent and many-leveled *A Poem Beginning with a Line by Pindar* (the passage is from the third section):

> In the story the ants help. The old man at Pisa
> mixd in whose mind
> (to draw the sorts) are all seeds
> *as a lone ant from a broken ant-hill*
> had part restored by an insect, was
> upheld by a lizard

(to draw the sorts)
the wind is part of the process
 defines a nation of the wind—
 father of many notions,

 Who?
 let the light into the dark? began
 the many movements of the passion?

The fact that the poet has just been commenting on the story of Psyche's tasks, which included the sorting of seeds, can take care of the entering transition; and the last three lines can be read as an allusion, with many overtones, to Psyche's insistence on seeing Cupid. But the whole central part floats off on its own and apparently disintegrates in the manner of the kind of modern music which seems to be made of isolated notes. The ancient prose rule against assuming your reader will guess your intentions—and accept them in lieu of deeds— is violated. Strictly speaking, there is no continuity in the lines themselves. It has to be discovered in Ezra Pound's *Cantos;* and since there are no footnotes there is no hope for a reader who cannot spot the italicized (by Duncan) quotations from Pound's work, or who cannot at least put himself on their trail by recalling that Pound was imprisoned at Pisa at the end of World War II.

Such complicated instances of weakened reference may finally be less difficult, however, for certain readers, than a spectacular economy of means—a truly ruthless elimination of alleged redundancy. Here, for example, in its entirety, is what has been called the most hermetic of Giuseppe Ungaretti's poems:

 M'illumino
 d'immenso
 Mattina

 I fill with light
 of immensity
 Morning

There is nothing to look up; imagination must supply the referent, or the referents. And this is often the situation in modern work in which metaphors or symbols are left, so to speak, unanchored—as they are pretty much in this fragment of one of Pablo Neruda's "sonatas":

 Si me preguntáis en dónde he estado
 debo decir "Sucede".
 Debo de hablar del suelo que obscurecen las piedras,
 del río que durando se destruye;
 no sé sino las cosas que los pájaros pierden,
 el mar dejado atrás, o mi hermana llorando.
 No Hay Olvido

> If you ask me where I have been
> I must say "It happens."
> I must speak of the soil which the stones obscure,
> of the river that enduring destroys itself;
> I know only the things that the birds lose,
> the sea left behind, or my sister weeping.
>
> *There Is No Forgetting*

It is possible to discover, with patience and some luck, that the "lone ant" in Duncan's quotations is Pound and that the "broken ant-hill" is war-shattered Europe. Neruda, however, insists on our knowing only the second term—the image half—of a comparison. Instead of saying, as a traditional simile-maker would have, that something is *like* "the river that enduring destroys itself," or, as a traditional metaphor-maker would have, that this something *is* the river, he omits the something and simply speaks of the river. And at the end of his poem he repeats, with additional unanchored images, his refusal to say exactly what he is talking about:

> no mordamos las cáscaras que el silencio acumula,
> porque no sé que contestar:
> hay tantos muertos,
> y tantos malecones que el sol rojo partía,
> y tantas cabezas que golpean los buques,
> y tantas manos que han encerrado besos,
> y tantas cosas que quiero olvidar.

> let us not bite through the rind that silence accumulates,
> because I do not know what to answer:
> there are so many dead,
> there are so many dikes that the red sun split,
> and so many heads that beat against the boats,
> and so many hands that have enclosed kisses,
> and so many things I want to forget.

We are deep in a kind of poetry which, to paraphrase one of Eliot's (and also Coleridge's) critical formulations, appears to be trying to communicate without ever being understood.

VI

It is time for another warning against generalizing excessively. In the Orient, notably in such great poetic nations as China and Japan, traditional verse has long been strongly antiprose—particularly in its tendency toward a severe economy of means and its use of juxtaposed images without explanation or referents. In such countries modernism tends to be mostly a matter of antipoetical plain

Now twelve years later, you turn your back.
Sleepless, you hold
your pillow to your hollows like a child;
your old-fashioned tirade—
loving, rapid, merciless—
breaks like the Atlantic Ocean on my head.
 Man and Wife

VII

Such correctives do not abolish, however, nor render less central in the modern cultural situation, the issues raised by the antiprose strategy. For if, as Max Black points out in his book *The Labyrinth of Language*, language is not a mere medium of exchange, but is rather the very stuff of which ideas and much else are made, then it is not a small matter that some of the most lucid and sensitive of contemporary minds, avowedly intent on confronting reality, have resorted to such tactics as ambiguous emphasis, broken continuity, and generally weakened reference.

A strong theoretical case against these tactics can be constructed, and might go like this: Literature is, after all, fundamentally different from the other arts. It is not something that creates its own language, as music, painting, sculpture, and architecture do to a certain extent. Instead it makes use of a language which is used for other purposes. This language is discursive—logical, explanatory, descriptive, with precise controls over meaning and with basic rules and structures. It is no use pretending that this vast, centuries-old, extremely conservative system of signs (if it were not conservative, communication would be impossible), built into our nervous systems from childhood, can be changed arbitrarily in the space of a few years by a group of avant-garde poets, in the way a group of other artists may change the nondiscursive "languages" of music or painting or architecture. To say that poetry can really reach the condition of music is to fall for a mere figure of speech. Also, a poem, unlike a picture or a vase, cannot just "be," as some of the early modernists argued it could. The poet must communicate, quite literally.

Practical objections can be added to the theoretical. For instance, there are many reasons for the death or obsolescence of certain poetic forms: the epic was killed long ago by the values of sedentary civilization, and the genuine folk ballad by progress in education. Films, novels, and the already noted (in Chapter 5) long-term effects of writing and printing have to be remembered. But undoubtedly one of the reasons for the 20th-century fading of such forms as satire, song, narrative, and the long poem in general is the fact that the antiprose strategy is not suitable for them. You cannot be effective in satire with weakened reference, and it is hard to sing "hey nonny nonny" with ambiguous emphasis,

speaking, of new subjects, and of the abandonment of ancient forms; and many excellent poets (including Mao Tse-tung) have found the old styles adequate to their needs. In the West it would be easy to name several great modern poets whose antiprose tactics do not correspond to those we have been considering. The verse of Aleksandr Blok, for example, is informed by his highly individual belief in what he called "the Spirit of Music." The metaphors of William Butler Yeats are often less unanchored than they seem, for he had his own occult universe of referents. The rhetoric of Saint-John Perse often heightens extravagantly instead of weakening a prose grid of sounds and silences:

> Et les servantes de ma mère, grandes filles luisantes
> ... Et nos paupières fabuleuses ... O
> clartés! ô faveurs!
>
> *Eloges. 2. (Pour féter une enfance)*[2]

> And the servants of my mother, tall shining girls
> ... And our fabulous eyelids ... O
> brightness! o favours!
>
> *Praises 2. (To celebrate a childhood)*

The effect is usually rhapsodical rather than hermetical, although some readers, wondering about the exact meaning of such a phrase as "fabulous eyelids," may sometimes feel that there was a point to one of Perse's jokes about his poetry: "a long, single sentence without break and forever unintelligible."

Since World War II, and especially in England, there has appeared a body of soberly modern verse distinguishable from the traditional sort only in its themes and its avoidance of old-fashioned poetical diction. This evidence of a retreat from obscurity (and also, perhaps, from ambitiousness) should be kept in mind as a corrective to some of the remarks in the present discussion. Also, the importance of starkly everyday linguistic usage should be remembered. Robert Lowell, one of the most vigorous of post-World War II American poets, is obscure only in his references to his private life, but he is unmistakably modern:

> ... Oh my *Petite,*
> clearest of all God's creatures, still all air and nerve:
> You were in your twenties, and I,
> once hand on glass
> and heart in mouth,
> outdrank the Rahvs in the heat
> of Greenwich Village, fainting at your feet—
> too boiled and shy
> and poker-faced to make a pass,
> while the shrill verve
> of your invective scorched the traditional South.

[2] The ellipses after "luisantes" and "fabuleuses" are the poet's and do not indicate omissions.

or tell a story without continuity. Devices designed to achieve concentration may eventually become intolerable in a long work (in Pound's *Cantos,* one of the few long modern poems, they do). Even in a short piece they are apt to tax the reader's patience severely, and so they encourage poets to offer in compensation something more serious than a song or a tale. The strategy tends to dictate its use. It may also cancel out all or part of the effect of antipoetical plain speaking, since a single obscurity can make an entire poem unclear, or at least distract a reader from the clarity of the remainder. Even in such a fine, tough, and tender piece of reality-confronting as Lowell's *Man and Wife,* the unexplained reference to "the Rahvs" is arguably a blemish. The reader who happens to be unacquainted with the American critic Philip Rahv (if indeed the reference is to him and his family) will be halted. There may be an impulse to think there is more in the mysterious allusion than apparently there is; and the unifying mood of the poem may be broken by vexation over what seems to be a lapse into coterie mentality.

I have already implied, while talking about the relative simplicity of some modern work, that I doubt that the smallness of the audience for contemporary poetry can be attributed to resistance to obscurity. For one thing, the best-known and presumably most widely read modernists are by no means all in the easy category; the list would include such antiprose strategists (to name only a few in the earlier generations) as Mallarmé, Valéry, Rilke, Eliot, Pound, Ungaretti, and Eugenio Montale. Equally impressive are the lively reputations made in England, the United States, and France since World War II by the difficult Dylan Thomas and René Char. For another thing, the public for verse of all periods is small; the situation is not like that in music, where an audience exists for noncontemporary work. The main troubles seem to be that verse is too meditative an art for an age of hurry, and that it cannot compete for publicity with other arts in which there is money to be made. Nonetheless, partisans of poetry as a whole can argue with force that the obscurity of a good deal of modern verse has helped their already powerful enemies. Although it may not be the real deterrent for a reader, it provides a respectable excuse; and even among friendly critics it has had an effect. As recently as the middle of the 19th century in Europe and America, poetry was still almost the cultural institution it had been for hundreds of years—a disorganized institution perhaps, but anyway a fairly important one. Poets could still, without smiling, refer to themselves as the seers and legislators of mankind, and their funerals were frequently splendid. If today the institution has declined into what is often referred to as a self-regarding enterprise, and if poets are apt to be thought of as merely eccentric private inquirers, must not the antiprosers accept at least a small share of the blame?

In any event, they must accept the blame for a lot of unpoetic footnotes and

critical analyses. It is true that they themselves—Duncan and Lowell are examples—do not always provide the footnotes. But it is hard to see why they do not: if a reference to Pound or the Rahvs is important enough to be in the poem, the average reader ought to be given a fighting chance to get it. If he is not given such a chance, he can be pardoned for wondering how important, in the poet's own estimate, the reference was. This is not to maintain that artists should supply interpretations of their works for slow imaginations. A footnote mentioning Pound's *Cantos* would not exactly predigest Duncan's poem.

VIII

Are there good answers to these theoretical and practical arguments against obscurity? We can assume that there must be, for we can scarcely accuse the major poets in a dozen countries during more than a century (remembering the French pioneers) of being consistently wrong—not without raising countercharges. There is always a point, in time and in the accumulation of widely accepted works, when an artistic trend begins to refuse to be dismissed and begins to judge its judges; and that point would seem to have been passed long ago by the hermetic trend in modern verse.

The antiprose strategy can be said to have at least three uses, from the point of view of the common reader. One is to augment the specificity of verse—to take advantage of the division of labour in the arts. Another is to open and extend significance. And another is to intensify imaginative experience. When the various antiprose devices function properly the result is poetry which is doing its own job instead of something that prose might do better, and which at the same time reproduces the multiple import, the peculiar density, and the sharp immediacy of lived reality. In lived reality we do not normally encounter the equivalent of a neat, transparent prose grid of emphases and referents. Things, at the outset anyway of an experience, are opaque. They are nondiscursive; they tend just to be. A rose is a rose. If it can be thought of as a metaphor, it is quite "unanchored"; and it is coloured, perfumed, and clean-contoured in the mind partly for that very reason—because it has no reference which might divert attention from its roseness. It is rich in possible meanings. If we insist too soon and too much on hooking it to something else or on making it merely the second term in a simile, we dim the vividness and limit the significance. Since poetic obscurity counters these dangers, it can be called, to borrow Berenson's praise of painting, "life-enhancing."

The dangers exist for words as well as for images. A word in its free dictionary state is a sonorous object in itself, and also a small orchestra of denotations and connotations. But in a prose sentence it loses part of its flavour and usually all of its meanings except one or two. Obscurity—in particular the breaking of continuity and the subversive employment of the verse structure of sounds and

silences—isolates words and lets them be vivid and emit overtones for at least a moment before the decay into function begins. A small achievement, perhaps, but effective poetry is made of effective details.

These defensive remarks can be applied also to the incorporation of quotations. Here I may as well cite the *locus classicus,* the last lines of Eliot's *Waste Land:*

> London Bridge is falling down falling down falling down
> *Poi s'ascose nel foco che gli affina*
> *Quando fiam uti chelidon*—O swallow swallow
> *Le Prince d'Aquitaine à la tour abolie*
> These fragments I have shored against my ruins
> Why then Ile fit you. Hieronymo's mad againe.
> Datta. Dayadhvam. Damyata.
> Shantih shantih shantih

The mosaic turns out, with the help of Eliot's notes, to be made of bits from an English nursery rhyme, Dante, the anonymous *Pervigilium Veneris,* Swinburne, Nerval, Kyd, and the Upanishads. It is undoubtedly too much of a good thing, and represents an extreme in cosmopolitanism and technique from which poets have since retreated. It may have been wanted by Eliot as evidence of disdain for 20th-century mass culture and as an automatic selector of an elite audience. Nevertheless, the rewards for a patient and industrious reader can be extraordinary. Taking the trouble to find the quotations in their original contexts will build up a reverberating pattern of meanings derived from several civilizations, and this pattern will amplify, in a way no prose statement could, the poet's feeling that the modern world is a spiritual waste land. Notice also that, although all of the quotations are from past, and some from remote, periods, we are dealing with live stuff. The modern use of old monuments as quarries can produce striking effects in verse, owing to the nature of literary substance. A quotation from Dante or Nerval is not a copy, as a comparable pictorial or architectural allusion would have to be; it is an actual fragment of the original, a breathing chunk of the past. The poet is in the position of a painter who happens to have around the studio some Giottos and Corots which he is free to cut up for collage purposes. His reluctance to diminish the effect of living presences by adding prosaic identification tags may be irritating, but it is understandable —at least in the text of the poem itself.

These "practical" observations can lead to some rebuttal of the theoretical arguments against poetic obscurity. Art, as was pointed out in the first chapter of this inquiry, is not always and primarily a "message"; if it were, we could substitute a piece of explanatory prose for a poem. Great art is never exhaustively, unambiguously understood, any more than life is. Like life, it is experienced. And while it must be granted that poetry does use our common language, and

does have certain obligations to communicate because of that use, no experienced reader would agree with Wordsworth's assertion that there is no essential difference between the language of prose and that of verse. Consider the following, by Sylvia Plath:

> I'm a riddle in nine syllables,
> An elephant, a ponderous house,
> A melon strolling on two tendrils,
> O red fruit, ivory, fine timbers!
> This loaf's big with its yeasty rising.
> Money's new-minted in this fat purse.
> I'm a means, a stage, a cow in calf.
> I've eaten a bag of green apples,
> Boarded the train there's no getting off.
>
> *Metaphors*

Here there is none of the poetical diction to which Wordsworth was hostile, but surely the result (even when the reader gets half a clue by noticing that the lines are of nine syllables) is profoundly different from the communicating effect of prose. Poetry does have, in addition to our common system of signs, a language of its own—one which resembles in some ways the "languages" of the nonliterary arts and which, like them, has had to change in order to say new things in a new era.

Finally, there is something that can be said for obscurity per se, even if it is not quite what can be said for clarity per se. A puzzle forces its solver to repeat to some extent its invention. In the words of Mallarmé, a difficult poem can afford an active reader's mind "the delicious joy of believing that it is creating."

IX

That modern verse, in its intentions at least, is a confrontation of reality can be seen in much besides the antipoetical and antiprose strategies. It is evident, for instance, in the sheer difficulty of creation. Few modern poets have been prolific, many (beginning with Rimbaud) have become silent after a struggle, and nearly all have shown signs of the discouragement Eliot felt toward the close of his verse career:

> So here I am, in the middle way, having had twenty years—
> Twenty years largely wasted, the years of *l'entre deux guerres*—
> Trying to learn to use words, and every attempt
> Is a wholly new start, and a different kind of failure.
>
> *East Coker*, in *Four Quartets*

A desire to face reality is implied also in the irreverent attitude toward the fine arts which appeared in poetry around World War I and became particularly

noticeable after World War II. Here it is in the wit of Richard Wilbur:

> Edgar Degas purchased once
> A fine El Greco, which he kept
> Against the wall beside his bed
> To hang his pants on while he slept.
>
> *Museum Piece*

The desire is undoubtedly at work in the use, frequent since the example was set by Baudelaire, of urban instead of rural poetic decors; a cityscape is for many sensibilities the most modern and the most real of modern realities.

More subtly, a wish to confront—or at least a wish to seem to be confronting —is implied by the presence in many poems of a character or several characters whose function is to react to a given situation or to stand for a reaction. In other words, a lot of modern poetry is essentially dramatic, even when it seems to be something else; and the principal characters in these little closet dramas can be thought of as confronters. They may or may not be the poets themselves. Lowell is evidently the husband in *Man and Wife,* Brecht is "poor old B.B.," and Eliot is the "I" in *East Coker.* On the other hand, the gypsy lover in *La casada infiel* is not Lorca, the post-Hiroshima prostitute cannot be identified with Kaneko Mitsuharu, and the *mal-aimé* both is and is not Apollinaire. But unless the reader happens to be working on a biography, or to be afflicted with an unreasonable yearning for "sincerity" in art, the distinctions make surprisingly little difference. For when modern poets are present in their poems they are seldom there merely as authors. They tend rather to be present as dramatis personae. It is as such that they prefer to do their confronting of reality, and the fact is worth some attention.

This tendency, of course, is neither new nor exclusively Occidental. Poetry turns easily into drama. The philosophical drunkard in the verses of Li Po is not quite Li Po the T'ang poet; he is Li Po confronting reality as a persona. Omar Khayyam the hedonist is a persona. So is Petrarch the lover, and each of his Renaissance followers. Donne may be dramatic even in his poetic dealing with God. Still, a casual reader can go through a large amount of traditional verse without being much *aware* of theatrical—or cinematic—effects. Stories seem to be merely narrated; persons and situations are described. It is Milton the author who speaks to us of his blindness; he does not invent a small play with himself or an aspect of himself in the role of a confronter. Pope tells us plainly what he thinks about manners and morals, but does not seem to be thinking, or soliloquizing, right now right there in front of our minds. Goldsmith strolls through *The Deserted Village* merely as a man of letters:

> How often have I loitered o'er thy green,
> Where humble happiness endeared each scene!

With the early Romantics we can feel a change. Coleridge's ancient mariner is a persona; Byron's work is tinged by the role he invented for himself in public life; and a stock character, the Poet, speaks and meditates in many 19th-century lyrics.

The change is more apparent in Browning, and striking in the work of the modernist precursors and pioneers. In *El desdichado* (*The Unfortunate One*)— one of the first, most obscure, and most fascinating of modern poems—Nerval is vividly on stage and in the process of picking the right personae with which to face up to the terrible reality of his loveless life and his insanity:

> Je suis le Ténébreux,—le Veuf,—l'Inconsolé,
> Le Prince d'Aquitaine à la Tour abolie:
> .
> Suis-je Amour ou Phébus? . . . Lusignan ou Biron?

> I am the Dark,—the Widowed,—the Unconsoled,
> The Prince of Aquitania of the ruined Tower:
> .
> Am I Eros or Phoebus? . . . Lusignan or Biron?

In *Spleen* Baudelaire is "the king of a rainy country, rich but impotent, young and yet very old." Whitman, in *Song of Myself,* dramatizes both himself and his talent:

> Speech is the twin of my vision, it is unequal to measure itself,
> It provokes me forever, it says sarcastically,
> *Walt you contain enough, why don't you let it out then?*

Hopkins, it might be argued, is among the least theatrical, the most genuinely personal, of poets. But it can also be said that he creates this impression because he is one of the most successfully theatrical. He does not suggest that we are reading about emotion recollected in Wordsworthian tranquility, but seems to be confronting reality now:

> No worst, there is none. Pitched past pitch of grief,
> More pangs will, schooled at forepangs, wilder wring.
> Comforter, where, where is your comforting?
> Mary, mother of us, where is your relief?

He too is a character in a play—a persona and not just an author maintaining a certain aesthetic distance from his work.

Again, I am talking about a difference of degree and of frame of reference. There are many recognizably modern poems in which description, analysis, and narration are more important than dramatization. But even in these there are

apt to be characters—authors in roles—who can be classed with the dramatic confronters. The variety of personae is therefore immense. It includes, for example, the not always convincing farmer used by Robert Frost as a confronter of our industrial society:

> I'm going out to fetch the little calf
> That's standing by the mother. It's so young
> It totters when she licks it with her tongue.
> I shan't be gone long.—You come too.
> *The Pasture*

It includes the Jewish personae with whom Yevgeny Alexandrovich Yevtushenko, shifting abruptly into, out of, and again into a completely dramatic technique, confronts the reality of anti-Semitism:

> I have no strength, go spinning from a boot,
> shriek useless prayers that they don't listen to;
> with a cackle of "Thrash the kikes and save Russia!"
> the corn-chandler is beating up my mother.
> I seem to myself like Anna Frank
> to be transparent as an April twig
> and am in love, I have no need for words,
> I need for us to look at one another.
> How little we have to see or to smell
> separated from foliage and the sky,
> how much, how much in the dark room
> gently embracing each other.
> They're coming. Don't be afraid.
> The booming and banging of the spring.
> It's coming this way. Come to me.
> Quickly, give me your lips.
> They're battering in the door. . .
> *Babiy Yar*

There are the strange personae, in a mental landscape of unanchored metaphors, with whom Ingeborg Bachmann confronts the hallucinatory reality—if it can be called a reality—of time in human affairs:

> Drüben versinkt dir die Geliebte im Sand,
> er steigt um ihr wehendes Haar,
> er fällt ihr ins Wort,
> er befiehlt ihr zu schweigen,
> er findet sie sterblich
> und willig dem Abschied
> nach jeder Umarmung.

Sieh dich nicht um.
Schnür deinen Schuh.
Jag die Hunde zurück.
Wirf die Fische ins Meer.
Licht der Lupinen!

Es kommen härtere Tage.
 Die gestundete Zeit

Over there your beloved sinks in the sand,
it rises round her flowing hair,
it cuts her short in a word,
it orders her to be silent,
it finds her mortal
and ready for death's departure
after each embrace.

Do not look around.
Buckle your shoe.
Drive back the hounds.
Throw the fish into the sea.
Light of lupins!

Harder days are coming.
 Borrowed Time

There is the combination of ancient Roman soldier and 20th-century blues singer through whom W. H. Auden considers the panorama of Western European history:

Over the heather the wet wind blows,
I've lice in my tunic and a cold in my nose.
 Roman Wall Blues

There is the stubborn, valorous, splendid eel through which Montale confronts a hostile universe:

L'anguilla, la sirena
dei mari freddi che lascia il Baltico
per giungere ai nostri mari,
ai nostri estuari, ai fiumi
che risale in profondo, sotto la piena avversa,
di ramo in ramo e poi
di capello in capello, assottigliati,
sempre piú addentro, sempre piú nel cuore
del macigno, filtrando
tra gorielli di melma finché un giorno

> Entre o sono e o sonho
> Entre mim e o que em mim
> É o quem eu me suponho,
> Corre um rio sem fim.

> Between sleep and dream
> Between me and what is in me
> The who I assume to be,
> Flows a river without end.

And, very noticeably throughout the modern movement, there is the Little Man persona, the antihero, the opposite of the art-cult high priest and of Montale's yea-saying eel. The Little Man can be recognized in an early form in the Harlequins and Pierrots who were favoured by late 19th-century writers (and who continued to interest painters and composers during the first decades of the 20th century). He already has his symptomatic self-consciousness in Laforgue's *Locutions:*

> Je ne suis qu'un viveur lunaire
> Qui fait des ronds dans les bassins ...

> I am only a lunar playboy.
> Who makes circles in ponds ...

In Eliot's *The Love Song of J. Alfred Prufrock* he suffers from his awareness of being the particular persona he is:

> No! I am not Prince Hamlet, nor was meant to be;
> Am an attendant lord, one that will do
> To swell a progress, start a scene or two ...

He is—or is an ingredient in—Edwin Arlington Robinson's Miniver Cheevy, who "coughed, and called it fate, / And kept on drinking"; and he is a sort of a burlesque Leopardi, saved by his lack of heroism, in Guido Gozzano's *Totò Merùmeni:*

> La Vita si ritolse tutte le sue promesse.
> Egli sognò per anni l'Amore che non venne.
> sognò pel suo martirio attrici e principesse,
> ed oggi ha per amante la cuoca diciottenne.

> Life took back all her promises.
> He dreamed for years of Love that did not come,
> dreamed for his torment of actresses and princesses,
> and today has for his love the cook, eighteen.

He helps Pound with some confronting in *Hugh Selwyn Mauberley:*

una luce scoccata dai castagni
ne accende il guizzo in pozze d'acquamorta,
nei fossi che declinano
dai balzi dell'Appennino alla Romagna;
l'anguilla, torcia, frusta,
freccia d'Amore in terra . . .

<div align="center">

L'anguilla

</div>

The eel, the siren
of cold seas that leaves the Baltic
to come to our seas,
to our estuaries, to rivers
which it ascends, deep down, against the flood,
from branch to branch and then
from tendril to tendril, narrowed,
ever more inland, ever more into the heart
of rock, filtering
through pockets of slime until one day
a light glancing from chestnut trees
catches its streak in the stagnant pools,
in ditches that run down
from the steeps of the Apennines to the Romagna;
the eel, torch, lash,
arrow of Love on earth . . .

<div align="center">

The Eel

</div>

There is Rilke, confronting reality as a high priest of an art cult, in verses which suggest that closet drama is about to reverse history and become religious ritual again:

O sage, Dichter, was du tust?—Ich rühme.
Aber das Tödliche und Ungetüme,
wie hältst du's aus, wie nimmst du's hin?—Ich rühme.
Aber das Namenlose, Anonyme,
wie rufst du's, Dichter, dennoch an?—Ich rühme.

O say, poet, what do you do?—I praise.
But the deadly and monstrous,
how do you endure, how do you accept them?—I praise.
But the nameless, anonymous,
how can you, poet, call upon them?—I praise.

There are the four poetic personalities, each with a name and a distinct style, of the extraordinary Fernando Pessoa; and within each there are at least two personae:

For three years, out of key with his time,
He strove to resuscitate the dead art
Of poetry; to maintain "the sublime"
In the old sense. Wrong from the start—

In Auden's *It's No Use Raising a Shout* he accepts, antipoetically, his defeat by life:

It's no use raising a shout.
No, Honey, you can cut that right out.
I don't want any more hugs;
Make me some fresh tea, fetch me some rugs.
Here am I, here are you:
But what does it mean? What are we going to do?

In Enzensberger's *ins lesebuch für die oberstufe* ("in a schoolbook for the upper grades"), he has some advice for those who will grow up to be Little Men confronting the realities of tomorrow:

. . . lerne unerkannt gehn, lern mehr als ich:
das viertel wechseln, den pass, das gesicht.
versteh dich auf den kleinen verrat,
die tägliche schmutzige rettung . . .

. . . learn to go unrecognized, learn more than I did:
to change your district, passport, face.
be knowledgeable in the small betrayal,
the dirty daily escape . . .

He has daydreams of revolt, checked by his genteel sense of reality, in Britain's post-1950 "welfare-state" verse, of which Philip Larkin's *Poetry of Departures* is a good sample:

I detest my room,
Its specially-chosen junk,
The good books, the good bed,
And my life, in perfect order:
So to hear it said

He walked out on the whole crowd
Leaves me flushed and stirred,
Like *Then she undid her dress*
Or *Take that you bastard;*
Surely I can, if he did?
And that helps me stay
Sober and industrious.
But I'd go today,

> Yes, swagger the nut-strewn roads,
> Crouch in the fo'c'sle
> Stubby with goodness, if
> It weren't so artificial . . .

The Little Man may not be as exciting as the Prince of Aquitania, but he is arguably the most significant persona modern poetry has created.

X

We have been considering three trends in contemporary verse—the anti-poetical, the antiprose, and, loosely, the dramatic—which are mostly matters of method and of the implications in method. As a preliminary to a concluding look at the whole situation, something ought to be said about a striking feature of content: namely, the pessimism of many modern poets about their era. Eliot's wasteland theme recurs again and again. Pound's outburst after World War I, which goes far beyond a condemnation of militarism, is also typical:

> There died a myriad,
> And of the best, among them,
> For an old bitch gone in the teeth,
> For a botched civilization . . .
> *Hugh Selwyn Mauberley*

So is the sombre prophecy of Yeats:

> Turning and turning in the widening gyre
> The falcon cannot hear the falconer;
> Things fall apart; the centre cannot hold;
> Mere anarchy is loosed upon the world,
> The blood-dimmed tide is loosed, and everywhere
> The ceremony of innocence is drowned;
> The best lack all conviction, while the worst
> Are full of passionate intensity.
>
> Surely some revelation is at hand;
> Surely the Second Coming is at hand.
> *The Second Coming*

And Rafael Alberti's symbolic account of the triumph of disorder over harmony in the 20th century:

> Y en las muertas pizarras,
> el ángel de los números,
> sin vida, amortajado
> sobre el 1 y el 2,
> sobre el 3, sobre el 4 . . .
> *El ángel de los números*

> And upon the dead blackboard,
> the angel of numbers,
> lifeless, shrouded
> above the 1 and the 2,
> above the 3, above the 4 . . .
> *The Angel of Numbers*

Or Gottfried Benn's capsuled cultural history:

> Fragmente,
> Seelenauswürfe,
> Blutgerinnsel des zwanzigsten Jahrhunderts—
>
> Narben—gestörter Kreislauf der Schöpfungsfrühe,
> die historischen Religionen von fünf Jahrhunderten zertrümmert,
> die Wissenschaft: Risse im Parthenon,
> Planck rann mit seiner Quantentheorie
> zu Kepler und Kierkegaard neu getrübt zusammen—
> .
> Ausdruckskrisen und Anfälle von Erotik:
> das ist der Mensch von heute,
> !as Innere ein Vakuum,
> die Kontinuität der Persönlichkeit
> wird gewahrt von den Anzügen,
> die bei gutem Stoff zehn Jahre halten.
> *Fragmente*

> Fragments,
> souls' discharges,
> coagulations of the twentieth century—
> scars—circulatory disorders of the dawn of creation,
> the historical religions of five centuries demolished,
> science: cracks in the Parthenon,
> Planck with his quantum theory
> converged on Kepler and Kierkegaard obscured anew—
> .
> Crises of expression and attacks of eroticism;
> that is the man of today,
> inside a vacuum,
> the continuity of the personality
> is preserved by his suits,
> which last ten years if the material is good.
> *Fragments*

To these passages might be added several already cited in this chapter; those by Neruda and Kaneko Mitsuharu, for instance, and all those in which the Little Man persona appears.

There are, to be sure, some cheerful, or at least not gloomy, modern poets. There are those, like Rilke, who delight in being receptive to everything; and there are a few whose imaginations are stimulated by technological progress. Stephen Spender is one of them:

> Now over these small hills they have built the concrete
> That trails black wire:
> Pylons, those pillars
> Bare like nude, giant girls that have no secret.
> .
> This dwarfs our emerald country by its trek
> So tall with prophecy:
> Dreaming of cities
> Where often clouds shall lean their swan-white neck.
>
> *The Pylons*

And of course modern poets have many other things to write about besides the state of civilization in general. But insofar as they do write about it, their majority tendency is to be violently disapproving.

Why? A possible answer is to point to two world wars and the threat of new atomic horrors, to political bullies and ideological spies, to the steady encroachment of the mass mind on the individual one, to the loss of nature as a resonator for human emotions, and to the decay of rural values and ancient rituals. A contemporary poet with a strong sense of period can scarcely be expected to smile steadily at the way things are going.

Another possible answer is that verse—unlike the visual arts, music, and the theatrical disciplines—cannot utilize, cannot metamorphose or digest into its own substance, the more hopeful aspects of the technological, scientific, secular, egalitarian civilization. These hopeful aspects appear to be deficient in that accumulation of human connotations and in that organic relationship with nature and the cultural past which the poetic imagination requires, or which at least it has always required up to now. Our unhopeful aspects, on the other hand, do have the connotations and the relationship, partly because they are often just new versions of old woes, and partly because they are the negatives, so to speak, of lost positives—charged with the emotion of what is gone. Looked at in this context, the Romantic escapism of the 19th century becomes more pardonable. Perhaps it was simply the first symptom of a real case of poetic indigestion, a case which is bound to become more and more severe as our technological revolution accelerates and spreads.

A third possible answer—less charitable—is that many modern poets are more sentimental in their desolation than their tough-minded air of confronting reality indicates. Perhaps they enjoy selecting for confrontation precisely those aspects of 20th-century civilization which can be condemned, omitting from consideration, for example, the material benefits, the intellectual excitement,

and the profoundly ethical significance of modern science. Science may indeed be unpoetic, but no one so far has used it enough in modern verse to test the assumption fairly.

A fourth possible answer is that poetry has become an art addressed by private persons to other private persons (hence the embarrassment it often produces when recited by elocutionists) and that in many of today's social, cultural, and political contexts a private person is a reactionary almost by definition. He is naturally inclined to be out of step, to sentimentalize the past, to rail at the times, and to be unimpressed by collective advances.

These speculations raise the question of the relationship between political thinking and avant-garde poetry; and the principal answer to that is that there seems to be none. Some modern poets have been Liberal or Leftist (Lorca and Brecht are examples), while others have been deeply, even absurdly, reactionary or Rightist (Eliot and Pound); and the politically conservative have been among the most revolutionary in verse techniques. The Marxist nations have produced no modern-art movements of their own, and the new nations in Asia and Africa show no signs of doing so. This is not to argue, of course, that the political opinions of poets are unimportant, or that verse forms are unrelated to modern culture in general—to the culture of the technologically advanced countries.

XI

We can now turn to some larger issues, the most important of which has to do with the nature of "reality." In the course of this chapter the term has been used inconsistently, as it normally is in conversation and criticism, to refer to all sorts of *data,* to whatever is *given* for confrontation in a poem—married love, European history, universal suffering, roses, prostitutes, locust trees, God, time, war, the modern individual, welfare-state escapism, and anything else that is in focus enough to be named. Even the loss of old realities can be thought of as a reality to be faced. Modern poets, using the antipoetical and antiprose strategies and a kind of closet drama, or at least narration and meditation with similarly dramatic rather than expository effects, have done a good job of confrontation at these everyday, nonphilosophical levels—on the whole a better job than 19th-century traditionalists did. But finally an artist, however concerned he may be with immediate, given realities, cannot avoid operating simultaneously at a level of philosophical speculation. Even if he says nothing explicit about the ultimate nature of being and hence about the ultimate bases of ethics and the meaning of human life, his artistic methods will imply certain vaguely metaphysical premises. And, if he is serious, he must grant such premises are a proper subject for cultural—if not purely aesthetic—criticism.

What are the metaphysical implications in the modern poetic methods we have been discussing? Nothing, of course, can be proved in this zone of half

lights and the unsaid, but then not much is ever proved about literary phenomena.

A case can be made for an implication in this verse that ultimately in any human predicament there is always something factual "out there" and that the task of the poet is to come to grips with this external reality. The closet dramas and their confronting personae can be said to imply a conflict between the imagination and a cold, "real" outer world. The antiprose devices are simply tools, in this hypothesis, for probing the external existence of fragmented entities which cannot be investigated with prosaic logic; and the antipoetical diction assumes that there are brutally evident things which ought not to be dodged with fancy words. Probably a large number of modern poets would agree with this interpretation of their procedural evidence.

Nevertheless, a good case can be made for an exactly opposite interpretation. In the widespread use of personae there is a suggestion that the world is best understood as a kind of theatre in the mind. The little plays which many modern poems tend to be are indeed *closet* drama, or closet cinema, or perhaps closet opera (*The Waste Land* can certainly be read as such). They are designed, that is, for production on a strictly imaginary stage, and the obscurity in many of them makes even recitation incomprehensible unless the audience happens to have read the text—the libretto. Note also that the displaced emphases, the broken continuities, the weak references, and the ambiguities of the antiprose strategy suggest an inner world of the imagination as much as they do a presumably fragmented and illogical outer reality. It can even be argued that the antipoetical strategy, when it becomes as insistent as it is in many modern poems, has implications quite different from those it may seem to have at first. A writer who seriously posits the existence of an outer world—a scientist, for example—will tend to use a high, cool, distancing terminology and to avoid those lower, warmer, familiar levels of linguistic usage in which words are personally affecting, in which things are brought home to us, in which reality is interiorized. Obscenity, to cite the lowest level of antipoetical usage, is notoriously a language of fantasy. Classical poetic diction (which ought to be distinguished from the "poetical" anachronisms of the 19th century) is on the whole a language of philosophical externality. These remarks are not meant to take back the praise bestowed earlier in this chapter on simple language in modern verse, nor to amend the earlier defense of the antiprose strategy. We are now speaking, not of given "realities," but of metaphysical premises. On this plane it is quite easy to conclude that many modern poets, whatever their vividness and honesty and whatever they may think they think, actually assume that the universe is ultimately subjective. At any rate they seem to think it ought to be. In this respect the contemporary movement in verse is a continuation of the Romantic movement. The notion, already ancient, that reality is ultimately subjective colours a great deal of 19th-century European action, thought, and

art, in spite of the simultaneous spread of positivism and naturalism. It can be seen in the demand for more expressiveness in music, a demand which, as we have already noted, accelerated the erosion of the tonal system, particularly in the highly subjective operas of Wagner. It is related to the individualism of the period, to the appearance of alienated bohemian artists, to the growth of psychology and the rediscovery of myth, and of course to the "escapist" tendencies in poetry.

Finally, it is possible to discern, dimly but fairly constantly, a third implication in contemporary verse. This one amounts to a reversal of emphases in the familiar idea that form ought to be shaped by content, and gives the precedence to form. To try to get behind certain obscure modern poems into a presumably more fundamental reality is as futile as trying to get behind an equation in pure mathematics. Even in relatively simple contemporary verse there is apt to be a final weakness of reference about which nothing can be done. The reader is left to assume that ultimate reality is neither a theatrical dream nor an objective fact, neither in our minds nor out there. It is in the method of representation. It *is* the method. This assumption—like many, seldom stated—can be seen in the magical view of poetic language held by the early French modernists: mystically by Nerval, blasphemously by Rimbaud, icily by Mallarmé. In the 1960s avant-gardists were more modest. Many were experimenting with computer verse, with phrases in chance combinations, and with materials on the psychological frontiers of words, noises, symbols, signs, and pictures. But the "procedural" premise was still evident.

In sum, there is enough subject.vism and enough proceduralism in modern verse to suggest that what set out to be confrontation of reality has turned out to be, in ultimate terms, self-confrontation. The poet simply faces himself, or his method faces itself. But of course people are not ultimate all the time, and anyway self-confrontation is not necessarily bad.

When the vines of my village are nipped with the frost,
my parish priest presently concludes, that the
indignation of God is gone out against all
the human race MICHEL DE MONTAIGNE

Nihilism has appeared among us because we are all
nihilists. FEODOR DOSTOEVSKI

Chapter 8 The Stage and All the World

WHEREAS 20TH-CENTURY COMPOSERS and poets have had the advantages and embarrassment of coming just after great periods, modern dramatists have had to start almost from scratch. European and American theatres in the middle of the 19th century were run by entertainers and pastiche-mongers. Few first-rate writers were involved, and those who were did not produce work comparable to what was being done in several other arts.

In a long perspective, the situation was not unusual. An honest critic, simply applying standards of the kind used in music, poetry, painting, and architecture, can easily make the twenty-five centuries of Western drama dwindle to the careers of less than a score of great playwrights: a few Greeks, a few Elizabethans and Jacobeans, a couple of Spaniards, and three Frenchmen. Even an indulgent specialist must grant that there have been spells during which everything was ephemeral. And he can note that this is the only major Western art which has had to be invented twice.

Reasons for the chronic trouble are not hard to find. The drama has often been plagued by a lack of enlightened financial support. It is an unstable compound of language on the one hand and painted and mimed representation on the other, in constant danger of dissolving into literature or mere spectacle. It is in some respects the most realistic of the arts and in others the most dependent on conventions, and hence prone to decay into meaningless pseudo-facts or into lifeless symbols and puppetry. As a public affair it derives some of its quality from the interest of audiences in values which are both important and playable—and which are not always on hand. Playwrights must work with a

108

contemporary public in mind, and so they have a tendency to think in terms of a hit rather than in terms of truly creative expression.

In sum, the creation of a fine play is demonstrably so difficult in itself, and so much a matter of luck with external circumstances, that nobody would ever make the attempt if the rewards were not exceptionally great. But of course they are, and not just in terms of money. The stage at its best has a fascination, a power, and a peculiarly human splendour which can make the other fine arts seem cool and remote. Nothing else has quite the same ability to erase the distinction between art and life. We have no old saws to the effect that all the world's a symphony, a poem, or even a novel.

These considerations ought to make for a thoughtful and charitable attitude toward the modern theatre. Here is an aesthetic activity which raises issues simply by trying to exist.

I

Something of the range and nature of these issues can be evoked by joining the labeling game which has been fashionable in recent years. Is there a single, sufficiently inclusive and illuminating phrase to be found for all the new themes, methods, and aesthetic premises—or new combinations of old themes, methods, and premises—which constitute the modern theatre? We can begin the game by eliminating "the Naturalistic Theatre," "the Symbolist Theatre," "the Theatre of the Absurd," "the Theatre of Derision," "the Theatre of Metaphor," "the Epic Theatre," "the Theatre of Mirrors," "the Theatre within the Theatre," and "the Anti-Theatre," among others. Each of these tags has had a certain vogue among critics, and is a help in seeing how things are going, or have gone fairly recently. Each, however, excludes too much that common sense would accept as modern.

More territory can be covered by "the Theatre of Diagnosis." Has there ever been a theatrical era as persistently and intensely diagnostic as the one which, to be arbitrary about a date, began with Henrik Ibsen's *Ghosts* in 1881 and is still going on? Has there ever been so much seeming agreement among playwrights that we are psychologically, socially, politically, philosophically, and culturally sick? Diagnosis, however, implies eventual treatment; and modern dramatists, especially since World War II, do not offer much. They tend simply to pose discouraging rhetorical questions. Like Alison, the young wife in John Osborne's *Look Back in Anger,* they divide 20th-century mankind into those who are "hurt because everything is changed" and those who are "hurt because everything is the same"; and they wind up with a French, American, German, Italian, Spanish, or some other national equivalent of her laconically British "Something's gone wrong somewhere, hasn't it?"

Often the discouraging rhetorical question is more manifested than actually

posed. The plays themselves, that is, in both content and form, can be taken as evidence that something's gone wrong somewhere. With this thought we arrive at another possible label, "the Theatre of Symptoms." It is unfair to many artists, unless we assume that there can be symptoms of good as well as bad health. Also, who, or what, is showing the symptoms? Modern man? Modern society? Man in general? The modern theatre? Or just a small group of eccentric playwrights and producers? The reader who is vexed by so much vagueness is at liberty to drop the labeling game at this point. Other readers may find that thinking about "the Theatre of Symptoms" and perhaps objecting to it can at least serve to get a situating discussion started.

In the following pages the discussion, while limited to modern work, will be organized roughly around the eternal reasons for the drama's troubles. It will focus first on audiences, enterprises, and money, then on what seems to be the present relationship between text and production, and then on such hard-to-define matters as naturalism and anti-naturalism. During the last sections it will also examine a few values and attitudes which appear to be affecting contemporary theatrical achievements.

II

Who goes to the theatre in our age of cinema, television, sports, and long out-of-town weekends? Certainly a smaller, and perhaps a better educated, part of the total population than went in the old days. It is still divided, however, into two sections in all of the advanced non-Communist nations of the West, and to some extent in the Communist and Oriental worlds. The larger public is mostly a continuation of the 19th-century middle-class one, which tended to regard a play as after-dinner entertainment. The smaller, more earnest public, presumably less in need of digestives, detached itself from the European bourgeoisie shortly before 1900 and now coincides approximately with the minority interested in modern music, painting, and literature.

Two principal sorts of commercial dramatic enterprise, often referred to as the majority and minority theatres, have also existed in Europe and America since the end of the 19th century. The majority theatre, which is dominated by such centres as Broadway in New York, the West End in London, and the Boulevards in Paris, is flanked by a subsidized category which includes the community repertory house—traditional in Central and Eastern Europe and now spreading in the United States—and the repository of national classics and acting styles, of which the Comédie Française is a splendid example. The minority theatre is represented by off-Broadway and various "little" companies and playhouses, and shades into a large number of amateur, notably university, operations.

Oversimplifying with a political analogy, one can say that the minority pro-

fessional theatre has been the dramatic Left of the 20th century, the party of movement, and that the majority theatre has been the Right, the party of wealth and the established order. The animators of the "little" companies have not had a monopoly on sincerity and bright ideas; in fact, at their most typical, they have been involved in plays which were poor to start with or were botched during production. But they have been willing to take fruitful risks, largely because they have had little to lose. On the other hand, the businessmen of the majority theatre have not, on the record, always been against originality; they have merely been against it when its drawing power was untested. They have been disposed to look about for a sure thing, and the only sure thing in taste is past taste. Hence one of the cultural curiosities of Europe and America is still the number of commercial plays which each season are aimed squarely at the fashionable market of about 1910. Why these frothy anachronisms succeed as well as they do is hard to understand. Perhaps some of today's audiences enjoy pretending to be the old audiences and reacting when given their cues. The theatre theatricalizes everybody to some extent, spectators included.

The following, by the lively and internationally experienced British critic Kenneth Tynan, can help to check any wild optimism:

> I am writing in the spring of 1963, and as I look at the list of productions available in the West End, my heart sinks a little. Old hat retains its ancient preponderance over new wave. In 1950, two out of three London theatres were occupied by detective stories, melodramas, quarter-witted farces, debutante comedies, overweight musicals, and unreviewable revues: much the same is true today. The theatre advertisements are packed with such titles as *Boeing-Boeing, Miss Pell is Missing, One for the Pot,* and *Goodnight, Mrs. Puffin....*[1]

Old hat was doing just about as well elsewhere. Notice, however, the implication that serious drama was being performed in a third of the theatres; that proportion certainly represents an improvement over the situation a century earlier. And since World War II the change has been accelerating slightly. A more sophisticated public, instructed by a powerful and impatient corps of newspaper critics, has been making life increasingly hard for the fabricators of traditional digestives. Symptomatically modern plays originating—or whose prototypes originated—in the minority theatre have been having runs on Broadway, on the Paris Boulevards, in the West End, and in their counterparts in other large cities. The dramatic Right, like the political Right in many countries, has been learning to perpetuate itself by adopting some of the ideas of the Left.

The development, to borrow an E. M. Forster joke suitable for many contemporary occasions, is worth two cheers, but not three. A critic can rejoice over the (slowly) growing commercial success of modern drama and over the new prosperity of its authors. But a system in which a great deal of the money, the production experience, and the acting talent tends to accumulate in the ma-

1 *Curtains,* Atheneum, New York; Curtis Brown Ltd., London; Longmans, Green & Co., Ltd., London, 1964.

jority theatre, and in which a great deal of the writing talent and the production audacity tends to come from the minority theatre, can scarcely be called efficient. It often means that the best ideas and the best ways of realizing them get together tardily and by chance, instead of developing in the kind of communal, integrated activity which has characterized the most satisfying periods of theatrical history. Promising experiments are seldom continued long enough to yield solid results, for the usual minority-theatre company does not last more than a few years. It lacks the funds needed to survive a few failures, and its good people are hired away by the parasitic Right after a few successes. Typical is the way in which many good modern directors have begun as the founders of small troupes and have wound up as wandering geniuses doing a play here and there, with no chance to work out their mature conceptions with their own companies and playhouses.

The system may also be partly responsible for an apparent lack of universality in the modern theatre, which I hope I can mention without being dismissed as a wholesome philistine. Certainly there are good reasons, rooted in the stresses of 20th-century living, for the symptoms of maladjustment, breakdown, and philosophical despair to be found in many recent plays. But cannot we add, as another and less respectable reason, the fact that modern playwrights are so often and so obviously minority artists, formed in a milieu where alienation has long been rife? Even if we cannot, or should not, it is to be feared that the average spectator comforts himself excessively by regarding the average modern playwright as an outsider whose truths are not home truths.

Lower production costs might encourage original experimentation within the majority theatre. The modern drama which emerged might be more broadly appealing and less eccentric—a more genuinely public art—than what our era has seen so far. The trend in costs, however, is up and up. Soon the right to flop and get up and try again, basic in any movement toward the future, may be only a memory in such centres as Broadway. Hence, if we continue to think in commercial terms, the chances are that the alleged outsiders of the minority theatre will continue to be the principal creators of modernism. They will be the only people able to afford the necessary risk.

Of course we need not continue to think in commercial terms. There is statistical evidence that the commercial theatre is dying, and already there are professionals who see the future in terms of the subsidized community and state repertory companies and houses. If they are right, the future may be magnificent, but perhaps restricted in scope. It is impossible to imagine subsidized substitutes for Broadway, the West End, the Boulevards, and the other commercial centres; and it is difficult to imagine, in countries without prevailing ideologies, a subsidized substitute for the rapport between theatrical creators and audiences which commercial trial and error can establish.

III

Ibsen's *Ghosts* has been suggested as a marker for the beginning of modern drama. Many readers may find, however, that as they think through theatrical history everything seems different after such events as the founding of the Moscow Art Theatre by Konstantin Stanislavski in 1898, or the plays directed by Harley Granville-Barker in London in 1904, or the opening of Max Reinhardt's Kleines Theatre in Berlin in 1906, or the founding of the Théâtre du Vieux Colombier by Jacques Copeau in Paris in 1913, or the establishment of the Theatre Guild in New York in 1918. In other words, a sufficiently bold historian might define theatrical modernism as simply a pronounced shift of the centre of aesthetic gravity from the written text toward the production as a whole. A small sign of the shift has been the growing tendency in everyday English to drop the term "drama," with its overtones of a literary art, and to refer to the entire activity as "the theatre," or "the stage." A much more significant sign has been the increasing importance of the director, who scarcely existed as an identifiable type of artist before the last quarter of the 19th century. He has not achieved quite the position of the motion-picture director, who today is often credited with being the author of nearly everything in a film, but he has a role which implies strongly that a dramatic text is merely a recipe on paper, or perhaps just one of the ingredients, for the creation of an integrated work of staged art.

What such an integrated work might be like has been well described by Lee Strasberg, an active participant in the modern movement in the United States as both a director and a teacher:

> The theater generation after the first World War felt itself to be part of a new dream which it hoped would lead to a new theater. It was not to be words, scenery, and acting as separate elements uniting into a somewhat mechanical entity. It was to be the word transfigured from its purely logical and literary meaning on a page by the living presence of the actor whose creation of the moment, the event, the situation, brought out or added dramatic meaning to the word The actor's presence and behavior was to be changed and affected by the scenery, which was no longer a static background, or an interior decorator's design, or a picturesque tableau, but was the world upon which and within which the actor lived, and which helped or hindered the development of the dramatic logic. The lighting on the stage was to be a living, moving "actor" which contributed not simply the time of day but the atmosphere and inner pulsation of the scene[2]

All this, Strasberg goes on to say, has been spoiled in the American theatre by the lack of "a coherent unified company of actors with artistic leadership to express its vision of the dramatist's intention"; but perhaps this conclusion can be discounted as that of a disappointed idealist. The dream has obviously been part of the 20th-century theatrical movement everywhere in the Occident.

2 Reprinted from Introduction by Lee Strasberg to *Famous American Plays of the 1950s.* Dell Publishing Co., Inc., New York, 1962, pp. 15–16.

The idea, however, that the aim of such a concert of theatrical talents could be simply "to express its vision of the dramatist's intention" calls for some comment. Early in the modern movement the leading minds perceived that there were implications in their dream not only for actors, scenery designers, lighting experts, and directors but also for playwrights. Existing dramatic texts, including many Western classics, were found to contain a good deal of what Strasberg calls "purely logical and literary meaning"; and this meaning did not always lend itself to transfiguration by nonliterary methods in an integrated production. Indeed, there were passages which were so nearly perfect already as imaginative creations in language that attempts to add or bring out meaning with stage effects diminished their impact. Evidently the new theatre, in order to become fully what its pioneers envisaged, had to have new texts, written by playwrights capable of forgetting that they were men of letters and ready to join in the outlook of the new powers in the world of drama—the directors.

It cannot be said that the requirement has been met completely and cheerfully. Literature will creep in, and many playwrights throughout the 20th century have continued to insist on priority for "the book" in the integrated work of theatrical art. Many have undoubtedly continued to share, at least in secret, the attitude of Luigi Pirandello, who arranged in his *Tonight We Improvise* to have an arrogant modern director driven off the stage after announcing that directors were more important than playwrights. But the title of that piece is itself an indication of the broad change in emphasis we are discussing. The change has recently reached an extreme form in avant-garde "happenings," most of which are about as remote from literature as the theatre can probably get. In a less striking form, it can be seen in the fact that the playwrights who seem typically modern tend to write production scripts instead of literary drama. Their texts do not become a kind of actuality in the imagination of a reader, as a novel, or *Macbeth,* may; instead they become simply performed plays. Director Peter Brook, commenting on the work of Jean Anouilh, has defined the trend—and incidentally revealed the antiliterary outlook of a representative modern director:

> [Anouilh] conceives his plays as ballets, as patterns of movement, as pretexts for actors' performances. Unlike so many present-day playwrights who are descendants of a literary school, and whose plays are animated novels, Anouilh is in the tradition of the *commedia dell'arte*. His plays are recorded improvisations. Like Chopin, he preconceives the accidental and calls it an impromptu. He is a poet, but not a poet of words: he is a poet of words-acted, of scenes-set, of players-performing....[3]

This lack of emphasis on words, this willingness to regard dramatic compositions as "pretexts for actors' performances," would be hard to imagine in Sophocles, in Racine, or even in Shakespeare, actor though he was. And it would

[3] Quoted by J. L. Styan in *The Elements of Drama,* Cambridge University Press, 1963, p. 4.

be easy to show that Anouilh is not as exceptional among present-day playwrights as Brook seems to feel he is.

Perhaps the power of the modern director will eventually be checked by writers capable of anticipating every last detail of a production, much as some modern composers anticipate on paper all the expressive nuances of a performance. Such an outcome for the trend is already more than half visible in the text of Samuel Beckett's *Waiting for Godot,* now generally recognized as one of the classics of the modern theatre. Here is a typical passage, just after the start of the second act:

> [*Vladimir*] *remains a moment silent and motionless, then begins to move feverishly about the stage. He halts before the tree, comes and goes, before the boots, comes and goes, halts extreme right, gazes into distance, extreme left, gazes into distance. Enter Estragon right, barefoot, head bowed. He slowly crosses the stage. Vladimir turns and sees him.*

VLADIMIR: You again! (*Estragon halts, but does not raise his head. Vladimir goes towards him.*) Come here till I embrace you.

ESTRAGON: Don't touch me!
> *Vladimir holds back, pained.*

VLADIMIR: Do you want me to go away? (*Pause.*) Gogo! (*Pause. Vladimir observes him attentively.*) Did they beat you? (*Pause.*) Gogo! (*Estragon remains silent, head bowed.*) Where did you spend the night?

ESTRAGON: Don't touch me! Don't question me! Don't speak to me! Stay with me!

VLADIMIR: Did I ever leave you?

ESTRAGON: You let me go.

VLADIMIR: Look at me. (*Estragon does not raise his head. Violently.*) Will you look at me!
> *Estragon raises his head. They look long at each other, recoiling, advancing, their heads on one side, as before a work of art, trembling towards each other more and more, then suddenly embrace, clapping each other on the back. End of the embrace. Estragon, no longer supported, almost falls.*

ESTRAGON: What a day![4]

Here there is certainly a lean, Irish, catching poetry of words; but the emphasis is on a poetry of words-acted, of scenes-set, of players-performing. The passage reads more like balletic notation than like literature, and this effect is not a result merely of the unusual quantity of instructions for the actors. It is rather a matter of the imaginative priorities which are established at the start and maintained throughout. The dialogue, that is, derives most of its literary elo-

4 Translated from the original French text by the author. Grove Press, Inc., New York, 1954; Faber & Faber, Ltd., London, 1959.

quence from the rhythm of the stage business; the emotions are expressed in movements and gestures before they are put into words. This is the method, not of a man of letters, but of an actor expressing the vision of a director.

IV

It would be difficult, and ungrateful, to find a lot of fault with this modern emphasis on theatre as theatre. Merely to start naming at random some 20th-century director-producers—Stanislavski, Reinhardt, Copeau, Brook, Vsevolod Meyerhold, Granville-Barker, Erwin Piscator, Orson Welles, Edward Gordon Craig, Sir Tyrone Guthrie, Elia Kazan, Jean Louis Barrault, Franco Zeffirelli, Jean Vilar, Brecht, Günther Rennert—is to realize how much they have enriched the drama. They have indeed "transfigured" the purely logical and literary meanings of modern texts by their coaching of actors and their concern for significant shapes, patterns, colours, lights, and tempos. They have given new theatrical life and often a vividly contemporary import to classics which were in danger of sinking into the category of closet drama. And not the least of their achievements has been the rescue of the commercial stage from the tyranny of the 19th-century type of star performer, who usually regarded a play as simply an occasion for unrestrained virtuosity. The modern effort toward organic unity in productions has eliminated a good deal of traditional, tiresome, and unartistic vanity.

There are, however, three ways in which this generally praiseworthy movement may, and occasionally does, get out of hand.

First, it may encourage a new kind of theatrical vanity which is almost as tiresome and unartistic as the traditional strut-and-rant kind; that is, it allows an ambitious director to spoil an excellent play by burdening it and distorting it with production tricks designed to call the audience's attention to his own cleverness. He can be tempted to forget his duty to interpret the playwright's intentions, in much the way that imaginative orchestra conductors (whose rise to power also began in the late 19th century) can be tempted to ignore the wishes of composers; and the temptation may be insidiously hard to resist. Only a fine line separates the creative director from the ham director.

Second, even when the playwright's intentions are not deliberately ignored by the director, they may be lost on an audience that is distracted by the sheer lavishness, novelty, or ingenuity of the production. Then the whole point of the modern reform movement disappears, for the new dream was not of a 20th-century equivalent for the Baroque and Romantic stage and its operatic effects. The new light was not to be necessarily prettier; it was to contribute, in Strasberg's words, "the atmosphere and inner pulsation of the scene." The scenery was not to be necessarily more striking; it was to become the dynamic "world upon which and within which the actor lived, and which helped or

hindered the development of the dramatic logic."[5] In short, spectacle was not to overwhelm significance.

Third, the insistence of the modern director on texts that are primarily playable, that are mostly the raw material for a stage performance, can easily become too strong. The enthusiasm of sensitive theatrical minds for what Brook calls the poetry of words-acted, scenes-set and players-performing is understandable, but his contempt for "descendants of a literary school" is troubling. For the awkward truth is that "the tradition of the *commedia dell'arte*" (and of Anouilh) is marginal in the Occident, despite its charm and interest. The great, central tradition in Western drama is literary. In fact, one could argue, texts in hand, that the finest moments in Racine, Shakespeare, and the Greek dramatists are precisely those in which the problems of staging and acting are dismissed and a poetry of words alone takes control of the audience's imagination. Such an argument could not be pushed very far, of course, without getting into the absurdity of denying the very premises of theatrical art. Even so, meditating on its possibility ought to check any excessive modern scorn for the dramatic literati.

V

The 20th-century dream of an integrated, *signifying* type of production using all of the stage's resources—what some of its promoters call "total theatre"—is by no means entirely new. It has had, however, as one of its consequences a new concentration of attention on the means by which playwrights, actors, designers, lighting experts, and directors can achieve the double objective of their art: truth (or reality) and a persuaded audience. And this concern over means has generated a long, ill-tempered, and confused quarrel between the partisans of naturalism and the partisans of something else (here the labeling game can be resumed).

This typically modern quarrel has existed, to be sure, in other arts, but it has been particularly intense in the theatre, for the evident reason that a theatrical creator can be more naturalistic than any other sort of artist. Unlike a painter, a sculptor, a poet, or a novelist, he can match substance with substance in his medium. He can create people with people, conversation with spoken language, gestures with gestures, tears with tears. His time may be actual clock time, his tables and chairs tables and chairs. In his house of illusions he can practise not only representation, but also presentation.

An additional reason for the intensity of the quarrel is the difficulty of knowing, in the absence of a context, what is being talked about. Theatrical naturalism is often described by its advocates as uncompromising realism, and by its enemies as middle-class illusionism. It can be a bit of both. It may bite

5 Strasberg, op.cit., pp. 15–16.

deep into the action and psychology of a play, or it may be just a matter of surfaces—of everyday language, understated acting, and carefully copied clothes and settings. Although it is sometimes an aspect of very contemporary and even avant-garde pieces, two of the principal influences on it have been academic figurative painting and the 19th-century French novel. At one end of its spectrum it is sordid and brutal; at the other end it merges with Romantic melodrama and commercial comedy. Perhaps it would have caused less controversy if from the start it had been called something that implied less of an exclusive claim to honesty and less of a naïve confusion between theatrical truth and the means by which that truth can be revealed.

Clear thinking about the issue has not been helped by the fact that both naturalistic and non- or anti-naturalistic performances normally take place on the same kind of traditional proscenium stage. The exact effect of the picture-frame and peep-show arrangement on a play's truth and persuasiveness is arguable, but certainly important.

Efforts toward drastic changes in theatrical architecture have not made much of an impact, partly because very few new professional houses have been built in large Occidental cities since the 1930s, and also because conditions in the old houses are still apt to govern the imaginations of even avant-garde playwrights and directors. The extra levels, open aprons, and other novelties of some of the new minority-theatre stages (many of them erected for university performances) may eventually bring about a revolution, but none is now in sight. In the majority of modern playhouses the audience still sits out front and looks and listens across a barrier which is the aesthetic and psychological equivalent of the old footlights and proscenium.

VI

Most of the pioneers of the minority theatre in Europe around 1900, convinced that 19th-century playwrights, performers, and decorators had lost touch with real people and contemporary predicaments, were fervently naturalistic in outlook and method. Their ideas have since been diluted and commercially processed in the majority theatre, and used to justify realistic veneer for romantic evasions and sentimental comedies. They have been violently challenged by avant-gardists and rear-gardists. But that naturalism is still a force cannot be doubted. One has only to think of details in the work of such prominent post-World War II playwrights as Arthur Miller, Edward Albee, Jean Paul Sartre, and John Osborne, or to examine, dramatic element by element, the net results of the antinaturalist reaction.

Why, then, does "the Naturalistic Theatre" seem an inadequate label for modern drama, particularly in the second half of the 20th century? The answer is the old one about winning battles and losing a war. Or perhaps, since art has

too many military metaphors already, we ought to say that the naturalists have been winning the weather and losing the climate.

The clearest naturalistic victory has been won in the field of acting. The old-fashioned performer whose own flamboyant personality was always twice as evident as the one he portrayed, who invariably tore a passion to tatters, and whose trade-marked tricks were recognizable from the highest balcony, began to disappear during the first revolutionary phase of modern directing (and with him went some of the fun in theatre-attending). Since his departure there have been interesting experiments in other kinds of artificiality. Hieratic and ballet-type acting, for instance, has been tried, sometimes under the influence of the Orient or of what is known about ancient Greek and Roman methods. Supposedly traditional styles for the performance of English and French classics have been partly preserved, and under their influence a few directors have developed new types of formalism. Italian pantomime has stimulated many imaginations. The mere "demonstration" of roles, rather in the spirit of knowing children who are playacting without emotional commitment, has been advocated, notably by Brecht, and I shall refer to it again in a moment. The overwhelmingly dominant style for contemporary drama, however, has been one in which the actor loses himself completely in his impersonation and behaves, most of the time anyway, utterly "naturally"—as if, that is, the audience were not present. This privatization of acting has become so familiar we are apt to forget how close to being historically unique it is.

In the realm of language naturalism has also been mostly victorious, and here the odds against it have been much greater. In theory, the ordinary conversational prose of 20th-century man is unfit for high art; it is stuffed with dead metaphors, and punched into inanity by journalists, politicians, television announcers, advertising men, and the regiments of experts who keep modern society functioning. Also in theory, verse ought to be the remedy for the drabness and the narrow vision which many people find in modern drama; after all, every one of the tragic masterpieces of the past is in verse. But the fact is that contemporary playwrights have managed to be effective in prose, and eloquent once in a while (admittedly, often with the help of an exotic or folk idiom not strictly naturalistic), whereas 20th-century verse drama has been a disappointment. It has been tried by a long list of able men—among them, William Butler Yeats, Hugo von Hofmannsthal, Jean Cocteau, T. S. Eliot, Maxwell Anderson, Archibald MacLeish, and Christopher Fry—and there have been seasons when an important movement appeared to be under way, especially in English. Aside from the fine fragments, however, the only really memorable result is Eliot's *Murder in the Cathedral,* which is significantly closer to medieval church ritual than to contemporary theatre. And the reasons for the general failure are evident. If the playwright resorts to the tough, plain-speaking, "anti-

poetical" kind of modern verse, he is likely to miss the higher, wider vision for the sake of which he turned to verse in the first place, and he may become merely another kind of drab naturalist. If he resorts to the obscure, "anti-prose" strategy in modern verse, he will lose his audience in five minutes. Hence he may be tempted into antiquarianism and merely decorative metaphors. If he avoids these faults, he is still up against the fact that the modern emphasis on integrated productions and a "natural" acting style does not favour the kind of delivery poetic lines require. When the integration works, the poetry tends to become unnoticeable; when the poetry works, it tends to become an opaque, detached element. These problems of incongruity are perhaps not insoluble, and there are currents in the theatre—in modern art as a whole—which seem to lead logically to verse drama. The playwright who succeeds, however, in this noble genre will have to think not just of adding verse, but of transforming the existing dramatic system. Here history will be against him; since the 17th century in Europe, all of the important transformations of dramatic systems have been accomplished in prose.

Antinaturalists have had more success with scenery, in which they have been helped by the expressionistic, symbolic, and abstract creations of modern painters and by the range of fantastic stage effects which became available to directors when electric light replaced gas. New, swift machinery has made possible changes in place and time which are too numerous to be called realistic. But some of all this is not particularly, nor very meaningfully, contemporary, and the rest can scarcely be said to weaken the effect of the combination of everyday 20th-century prose with unhistrionic acting. There is a naturalistic tone—a realistic aesthetic surface—in most modern plays which is noticeable enough to set our theatrical era off from preceding ones.

When, however, we go beyond this tone or surface, we encounter some characteristically modern structures of themes, action, presentation, and mood for which "naturalistic" will not do. An adequate inquiry into such structures is impossible in the present space, but glancing at a number of successful mid-20th-century plays can raise points which the reader can elaborate on—or challenge—with more evidence.

Arthur Miller's *Death of a Salesman,* for instance, is in many respects a virtuoso's exercise in factualism. The language and the personalities of the failed salesman Willy Loman and his failed sons, Biff and Happy, are painfully familiar to anyone who knows the American lower middle class. Willy's decision to kill himself, ostensibly for the insurance money his wife will get, has the drab reality of a newspaper item. Yet the play as a whole drifts through the imagination of a spectator as if it were a lyric, in the elegiacal mood. Musical motives are used in a half-Wagnerian way. There are other kinds of symbolism: Willy can no longer keep his car on the road; things will no longer grow in the back

yard of his little home, now shaded by towering apartment houses. This back yard—an apron curving beyond the forestage into the orchestra—also serves as the locale for past events in Willy's mind: the actors enter it by stepping through the "fourth wall" of stage realism. "An air of the dream," according to the author's instructions, should cling to the house—"a dream rising out of reality." Willy himself is a dream figure, dreamed by himself out of the reality of American small business. "He had the wrong dreams," says Biff. "All, all, wrong. . . . He never knew who he was."[6]

Edward Albee's *Who's Afraid of Virginia Woolf?* is also strongly naturalistic at several levels. This account of a night-long drunken quarrel between a middle-aging professor and his loud wife, with another faculty couple as audience, never euphemizes:

GEORGE: You're a spoiled, self-indulgent, willful, dirty-minded, liquor-ridden. . . .

MARTHA: SNAP! It went snap. Look, I'm not going to try to get through to you any
 more. . . . I'm not going to try. There was a second back there, maybe,
 there was a second, just a second, when I could have gotten through to you,
 when maybe we could have cut through all this crap. But that's past, and
 now I'm not going to try.[7]

(Act II)

But in the end, when George "kills" his imaginary son, we realize that this study in domestic billingsgate is actually an expulsion ritual. The first act is subtitled "Fun and Games," the second "Walpurgisnacht," and the third "The Exorcism."

In Jean Paul Sartre's *Huis-clos* (variously translated in English-language performances as "Vicious Circle," "In Camera," and "No Exit") the setting is a French living room with ugly Second Empire furniture, the dialogue is in an only slightly literary version of the style of conversation in such places, and the characters are a valet, a journalist, and two young women, one of them very homosexual and the other very heterosexual. But beneath the naturalistic surface the living room turns out to be a chamber in hell in which the journalist and the women are condemned to spend eternity together, and the conversation turns out to be an Existentialist sermon on human self-realization and liberty—which winds up with the famous line "Hell is other people."

In Ugo Betti's *La regina e gli insorti* ("The Queen and the Rebels") the scene represents a large hall in the main public building of a hillside village. A revolution is under way, and a bus has been halted for an examination of the travelers' identity papers: the rebels are looking for a mysterious woman

6 Penguin Books Ltd., Harmondsworth, 1961, pp. 7, 110–111.
7 Atheneum, New York, 1963.

known as "the Queen," whose dignity and courage have fascinated the common people. Among the travelers is Argia, an amateur prostitute who says frankly that she has "come a long, long way just to go to bed with a man." But when the rebels persist in their suspicion that she is really the Queen she suddenly accepts the opportunity to rise above her "squalid and humiliating" life; and her lines as she walks out the door to be shot are a denial of the earlier naturalism in the play: "How lovely and serene it is over the mountains. . . . Unquestionably, this is a seat for kings, and in it we must try to live regally."

To such examples one can add others in which the naturalistic tone or surface is much less evident, although still discernible. In Harold Pinter's unpretentious but symptomatic *The Lover,* a sophisticated middle-class couple try to keep passion aflame by simulating an illicit affair between themselves at home, complete with costume changes and five-o'clock assignations. In Jean Genêt's *Le Balcon* ("The Balcony") the clients of Madame Irma's brothel get their satisfactions by playing, with the help of her prostitutes, the roles of bishops, judges, or generals; and the sexual-social charades turn serious during a revolution which transforms Irma into a queen. In Tennessee Williams' *Camino Real* an ex-boxer with a bad heart wanders into a tropical port whose inhabitants include Lord Byron, Jacques Casanova, and Marguerite Gautier, and then wanders out into "Terra Incognita" in the company of Don Quixote. In Eugène Ionesco's *Les Chaises* ("The Chairs") a potty old couple near the end of their meaningless lives fill the stage with chairs for an imaginary crowd of distinguished guests, gathered to hear the husband's message for the world. In Brecht's *Der gute Mensch von Sezuan* ("The Good Woman of Setzuan") the good woman in question, a prostitute who becomes a shopkeeper, discovers that she cannot be effectively good without the help of an imaginary "bad" cousin, whom she impersonates.

This listing had better be halted here, before it implies an obligation to be complete. It ought to be rounded off, however, with a reminder of how fond modern playwrights in general are of playhouse irony—tricks which can be called, according to one's point of departure in the argument, either extremely naturalistic or extremely antinaturalistic. One such trick is to activate the audience by bringing it into the play or the play into it. At one point Willy Loman addresses the house as if it were the crowd watching Biff play football: "There's all kinds of important people in the stands. . . ." Don Quixote staggers down the central aisle of the theatre on to the stage of *Camino Real,* jostles the elbow of a spectator, and mumbles an apology. At the end of *Le Balcon* Madame Irma, turning out the lights in her brothel, addresses the audience: "You must now go home, where everything—you can be quite sure—will be even falser than here. . . . You'll leave by the right, through the alley. . . ." At the end of Ionesco's *Amédée ou comment s'en débarrasser* ("Amédée or How to

Get Rid of It") a woman at a window on the stage says, "Let's close the shut-
ter, Eugène, the show's over!" These last two examples can also illustrate an-
other approach, in which playhouse irony is used to achieve aesthetic distance—
to break, temporarily or even permanently, the spectator's belief in the reality of
the personages and action on the stage (note that a certain amount of natural-
istic illusionism is needed, however, to give point to the irony). In the middle
of a long more or less nonsensical passage in *Waiting for Godot* Vladimir sud-
denly observes: "Charming evening we're having." "Unforgettable," says Es-
tragon. In Brecht's work this trick becomes systematic: songs, narration, un-
realistic settings, prologues, epilogues, asides, and the "demonstration" style of
acting are used to persuade the audience that what it is seeing is merely a show,
with no more claim to being real than a sporting event has. The actor who
plays Wang the Water Seller opens *Der gute Mensch von Sezuan* by introduc-
ing himself to the house: "I sell water here in the city of Setzuan. It's a difficult
business."

Audiences have always known, of course, that plays are merely plays.
Theatre-within-the-theatre and Thespian irony are probably as old as the drama
itself; there are traces in Shakespeare of illusion-breaking jokes addressed to
the house ("I did enact Julius Caesar," says Polonius, and he—the actor play-
ing him, that is—actually did). But the 20th-century tendency to insist that
make-believe reveal itself as such, which developed in the work of Pirandello
and of such pioneering directors as Piscator and Meyerhold and has become
particularly apparent since World War II, fits into its modern context too well to
be dismissed as an old pleasantry.

VII

We can now risk some generalizations, without pretending that they exhaust
the evidence.

First, naturalistic settings, acting styles, and language are often employed by
modern dramatists as merely the external aspects of methods which are closer to
symbolism than to realism. The apparent exceptions to this remark—authors
like Miller, Albee, Betti, Pinter, Osborne, and the British angry or kitchen-sink
realists—can be shown, by an analysis of the inner structures of their work, to
be less exceptional than they seem. On the whole, political or social actuality
has little appeal for contemporary playwrights. In fact, an important number of
the most successful and perhaps the best mid-century plays are not even osten-
sibly about real people in real situations.

Second, as a corollary to the above, we can say that there has been a general
raising of dramatic sights from the particular to the universal sort of problem.
The mid-century theatre has moved from the psychological plane, where natu-
ralism is at home, to a dubious plane which can be called philosophical—

although, as always in art, the term ought not to imply any very systematic body of thought. The shift is evident in the work of Sartre, Beckett, Ionesco, Genêt, and Brecht; and it can be detected in the work of many other playwrights. Ultimately, *Who's Afraid of Virginia Woolf?* is not a play about a marriage on the rocks; *La regina e gli insorti* is not about a woman trapped in a cruel revolution; *Camino Real* is not about an ex-boxer adrift; *Death of a Salesman* is not about Willy Loman. Not ultimately, though to argue in this fashion is not to deny the interest and pity which vividly drawn characters can inspire.

Third, while a modern play on this philosophical rather than psychological plane may be about any one of dozens of things, it is extremely apt to be also and ultimately about authenticity. Authenticity, in one form or another, is the problem of Willy, George, Martha, Argia, Vladimir, Estragon, Pinter's lovers, Madame Irma's clients, Williams' ex-boxer, Ionesco's potty old couple, the good woman of Setzuan, the angry young men of Britain, and many other personages. A morbid concern with it is partly what makes other people hell for Garcin, the journalist in *Huis-clos*. Prostitution, inauthenticity incarnate, is the most frequently represented profession in contemporary drama.

Fourth, there are many implications in both the content and the form of modern plays that the only possible reply (it cannot be called a solution) to the problem of authenticity in the middle of the 20th century is to attempt to live without illusions. Willy, George, Martha, Argia, Madame Irma, and the others and the predicaments they are in are not used by their creators to suggest a positive system of real values to which we the audience can cling. We are simply told to stop fooling ourselves about ourselves, about society, about the meaning of life and the universe—and about the theatre, which after all is merely make-believe. This message emerges very clearly in the work of Brecht, Ionesco, and Beckett, who are usually considered the most modern of modern playwrights and whose ideas and methods have been filtering around the theatrical world in the second half of the 20th century, affecting authors and directors who would never think of joining the minority theatre's avant-garde.

Brecht, in such plays as *Galileo, Mutter Courage und ihre Kinder* ("Mother Courage and Her Children"), *Der kaukasische Kreidekreis* ("The Caucasian Chalk Circle"), and the already mentioned *Der gute Mensch von Sezuan,* is the master of throwing cold water on our ardour to believe in political and moral realities. His bleak wit, elaborate playhouse irony, and frequently inconsistent characterizations are particularly destructive of the bourgeois-liberal idea of the individual. To be fair, I suppose one ought to add that as a Marxist he was aiming at the construction of a new system of values and a new, more just society; but the fact is that his drama appears to destroy the basis for "Soviet man" as thoroughly as it does other kinds of idealism. As several critics have

pointed out, the only reality he seems to believe in theatrically is that of the apolitical, amoral human animal—Mother Courage, for example.

Ionesco, notably in *Le Rhinocéros, Les Chaises, Amédée ou comment s'en débarrasser, La Leçon* ("The Lesson"), and *Victimes du devoir* ("Victims of Duty"), derides conventional ambitions and personal, family, and social relationships; his usual method is to combine a fantastic farce with a Dada-Surreal babbling of the commonplaces of modern conversation. Beckett, notably in *Waiting for Godot, Endgame,* and *Happy Days,* uses symbolic Nowhere settings, vaguely cosmological time, naturalistic dialogue, static characterizations, vaudeville reminiscences, and dramatic action which is nearly zero to assert that life is a meaningless treadmill.

Occasionally a modern playwright draws the drastic conclusion to such iconoclasm; Willy Loman drives his car off the road for good, and the old couple in *Les Chaises* jump out the window. More often than not, however, we are let off with a warning to go and fool ourselves no more. Upon what basis are we to live after we have lost our old certitudes and have found no new ones? Since scientific facts are irrelevant in a value realm of discourse, and are seldom mentioned anyway by dramatists, we are left with the implied conclusion—explicit in several of the plays mentioned in this chapter—that we must learn to live stoically (and perhaps die heroically, as Argia does in the Betti piece) on a strictly as-if basis. Examined closely, this basis turns out to be a substitution of aesthetic "belief" for religious faith, moral conviction, and philosophical reason.

Not that purely aesthetic values are recommended; Brecht, Beckett, Ionesco, Albee, Miller, and their fellows are not 1890 dandies preaching an ersatz cult. But their strictly negative critique of inauthenticity does come down to a suggestion, conscious or unconscious, that to live successfully in the 20th century we must both believe and not believe, which is of course precisely what we do in experiencing a work of art.

VIII

The Alison of *Look Back in Anger* seems to have a point. Something's gone wrong somewhere, hasn't it? But where? Is destructive pessimism of the sort I have been outlining, which, when not suicidal, leads to an ambiguous doctrine of wide-awake make-believe, a symptom of something that has gone wrong merely in the modern theatre? Merely among the exiles (the word can be applied literally to Beckett, Brecht, and Ionesco) and alienated eccentrics of the minority playhouses? Or among modern people in general? Is the symptom old hat or new wave? Has the world suddenly become really absurd? Has it been privatized to the point of turning into a farcical dream? This jumble of questions, which probably corresponds to the reactions of many contemporary

playgoers, is best answered in a slightly jumbled way which does not suggest clarity where there is none.

Symptoms which are very similar to today's can be found in Western drama a long way back. In an admirable book[8], to which I am indebted, the American critic Lionel Abel isolates and describes a uniquely Western dramatic form which he calls "metatheatre" and which is already discernible—in fact, full fledged—in the work of Calderón and Shakespeare. In a metaplay, of which *The Tempest* is a familiar example, the implications are that all the world's a stage and life is a dream. Are not these implications almost exactly the same as those we have been pursuing, via a different argument, in this chapter? Does not even such an apparently separate phenomenon as the shift in emphasis from the text to the production, where illusion can proclaim itself as illusion, fit neatly into the large pattern? Abel classifies the plays of Brecht, Beckett, and other modernists as simply more metatheatre, and disagrees with critics—in particular with Martin Esslin, the most eloquent exponent of the "Theatre of the Absurd" idea—who find in mid-20th-century drama a great deal of evidence of a spiritual and cultural crisis.

The world, in Abel's view, has *not* suddenly become absurd. He conducts his analyses with skill. It is difficult, however, to avoid the feeling that when he turns to the post-World War II theatre he lets himself succumb, because of the very soundness of his historical case, to the temptations to underestimate the novelty of what he finds. There is an extremism in this theatre which may admittedly be a matter of degree, in comparison with Calderón and Shakespeare, but which is noticeable enough to warrant our speaking of something new— something that might be called, to preserve the historical perspective, "ultra-metatheatrical." Abel muses pleasantly over the fact that he should be the first to think of designating a dramatic form which has been in existence for several hundred years. May not part of the explanation be that he belongs to a generation of Western critics whose sensibility has been alerted by modern plays and modern thought to the possibility of such a form? This is not to dismiss his historical evidence. But there are suggestive analogies in the many ways in which the ultraism of other modern arts—both painting and poetry come to mind— has led us to discover hitherto unsuspected tendencies in the work of the old masters.

As for the absurdity or non-absurdity of the world, it will always lie partly in the eye of the beholder; and there is always the possibility that what is absurd will turn out to be the beholder. There are indeed strains in today's playhouse pessimism (a word, by the way, of fairly modern coinage) which can set the teeth of a reasonably tough mind on edge. There is a lot of self-pity, a lot of pointless hide-and-seek with appearance and reality, a lot of neo-Romantic dis-

8 *Metatheatre*, Hill & Wang, Inc., New York, 1963.

appointment at the alleged death of God sometime in the 1880s, a lot of illogical despair over the loss of value systems which were in fact never capable of surviving serious examination. But after the discounting is finished, a recognizable 20th-century malaise remains—one which has appeared in other arts, notably poetry and the novel. Critics and cultural historians cannot dispose of it by announcing firmly their conviction that the world has really not suddenly become absurd. They are professionally obliged to reckon with the evidence that a great many sensitive, unabsurd people think that somehow it has, or that at least something's gone wrong somewhere. The reasons for their thinking so—the accelerating rate of change and the loss of formerly accepted certitudes—have been discussed in the second chapter of this undertaking. Further meditation on the subject may be inspired by noticing how through the centuries we have been losing the comforting power to keep our beliefs in compartments. As recently as a hundred years ago even educated people could entertain scientific skepticism in one chamber of the mind, and in another chamber preserve the myths and the unexamined codes which gave meaning to their universe and their lives. The partitions have been coming down. And if all this sounds a little too lofty to explain why a man should write a play about two hobo-clowns fooling around while they wait for a Godot who never comes, we have only to reflect on the actual significance of what millions of modern people are doing every day, and on what they are waiting for. Or watch television, preferably with no TV dinner to interrupt the flow of inauthenticity.

In fact, an objection to many modern plays might be that they tell us too many truths which are becoming banal under the conditions of modern life. But it was perhaps inevitable that the theatre, which underlines everything and which is itself an experiment in illusion and reality, should have become overly fascinated with the modern problem of authenticity.

IX

Looked at formalistically, the modern theatre becomes simply more evidence of the period style we have seen emerging in 20th-century music and poetry. In the shift of the centre of aesthetic gravity from the text toward the production, plus its many consequences, we can see again the modern distrust of discursive language, of mere literature, even though the shift has been accompanied by a persistence of naturalistic dialogue. As in some kinds of modern music, the stress is on the existential aspect of the art rather than on its preexisting "essence": the actual performance counts for more than the blueprint. As in some kinds of modern poetry, naturalism goes so far and then flips inside out and becomes antinaturalism. As in nearly all modern art, there is a manifest desire for specificity: the theatre strives to shed all impurity and become purely theatrical, while music is becoming purely musical and poetry is becom-

ing purely poetic. Like all modern art, the theatre is freshly conscious of itself as art—as make-believe which announces itself as such. This last characteristic fits the principal, ultimate subject matter—the problem of authenticity in modern life. Form and content cannot even be separated for purposes of discussion.

What about the future? Let us begin our projection with two assumptions. First, we shall continue to enjoy, for a long while anyway, plays which are only moderately modern and moderately important; the era of the digestive and of commercial naturalism is not over. Second, tragedy of the classical, more or less Aristotelian, sort will continue to be as dead as it has been since Racine. It calls for a public acceptance of the reality of myth and for an ideal world superstructure which modern science and philosophy have apparently destroyed forever. We may, of course, have some other kind of "tragedy," but to say that is simply to restart the labeling game under trying conditions. "Tragedy" ceases to be a useful term in criticism when it ceases to mean, approximately at least, the Aristotelian kind.

What about the future of modern ultra-metatheatre? Of the sort of drama represented in an advanced way by the work of Brecht, Ionesco, and Beckett? We may of course continue for some time to have more of the same. If we do not, what are the prospects for new developments along the lines already laid down? It must be said that such prospects scarcely exist. This kind of theatre does not appear to be an evolutionary art. Pushed only a little further, Brecht's demonstration-style acting, playhouse irony, and loose, "epic" form must result in the break-up of drama into mere narration and mere spectacle—at best a puppet show. Ionesco's attack on conventional language cannot be carried much further without destroying the literary ingredient in drama altogether. Beckett's anti-heroic tendencies and his insistence on depicting the end of a story—the end of man's history—can be "developed" only into a rejection of all dramatic action.

These remarks are not meant to be gloomy, but rather to suggest that the time is ripe for some innovations in dramatic form.

*A gesture can say anything—but you must have
something to say.* MAURICE BÉJART

*The naughty nineties and the traditional draught
of champagne in the dancer's slipper
are difficult memories to live down*
 ARNOLD HASKELL

Chapter 9 The Stage and the Dance

THE RESTRICTED CONTEXT indicated by the above title is open to at least two objections. First, in many parts of the world—Africa and India are examples—some of the most typical dancing is only incidentally, if at all, a theatrical activity; it is tribal or religious ritual. Second, ballroom or nightclub dancing, especially in the Occident, often has as much cultural significance as performances for audiences have. Twentieth-century man has foxtrotted, Charlestoned, jitterbugged, twisted, and so forth not only for the recreational and social reasons his grandparents had but also to exhibit his awareness of change and his conviction of being emancipated, blasé, integrated, alienated, and modern—or perhaps anti-modern. The eroticism and the primitive sources of some of the fads have implied a wish to discard today's bourgeois civilization altogether.

These objections should be kept in mind, for the following discussion will indeed be short and narrow. But to try to say something about the ritualistic and participant aspects of the dance would make the subject unmanageable in the available space; and one can maintain that the art reveals most clearly its contemporary possibilities and problems when it is secularized, theatricalized and presented in unified works with music, drama, decor, and costumes—when it becomes ballet or something analogous.

I

Here the terms "traditional" and "modern" do not have as much significance as they have in talk about several other arts.

There are, of course, two principal Occidental dance disciplines on the stage

129

today; and they are usually referred to as the classical, or traditional, and the "free," or modern. The classical one—ballet in the strict sense—arose from a combination of social dancing, acrobatics, and court spectacle during the Italian Renaissance, defined and refined itself in France during the 17th and 18th centuries, produced a series of masterpieces early in the Romantic era, declined in Western Europe to the level of amusement for rakes or demonstrations for pedants, and regained its dignity and vitality at St. Petersburg during the last years of the 19th century. It has since flourished notably in the Soviet Union, France, Great Britain, Denmark, and the United States—largely under the influence of Russians and their disciples, although each nation is now developing its own school. The "free" discipline, which rejects the codified classical steps and attitudes and relies on personal inspiration and more natural movements, was created in the 20th century in Central Europe and the United States by such gifted artists as Mary Wigman, Isadora Duncan, Ruth St. Denis, Ted Shawn, and Martha Graham.

Increasingly, however, since World War II, the more classical choreographers have shown a willingness to borrow ideas from the "free" sector. At the same time many modernists, instructed by experience in the double fact that not every dancer is a natural genius and that a personal system does not usually outlast its inventor's career, have begun to appreciate the value of classical dancing, if only as muscular education and a basic vocabulary for innovations. The amount of convergence should not be overestimated. Pure traditionalism is strong in the Soviet Union, sometimes to the point of turning marvelously endowed and trained people into academic acrobats; the extremely free discipline has in the United States adherents who are hard to distinguish from barefoot improvisers; and there is certainly a difference between the neoclassicism of George Balanchine and the aleatory avant-gardism of Merce Cunningham. But on the whole there is little evidence of the cultural break apparent in several other arts. An important number of excellent and representative choreographers —Jerome Robbins, Agnes de Mille, Antony Tudor, Roland Petit, Maurice Béjart, and even the relatively "free" Paul Taylor come to mind—have created in mixed styles that are best described, not as modern or traditional, but simply as contemporary. And it should be noted that Cunningham has worked with both Balanchine and Martha Graham.

There is no need to conclude that modernism has somehow been a failure in its attempts to convert Terpsichore. A better conclusion is that she has not required much converting; she is, so to speak, almost naturally modern. Even the purely classical ballet can be abstract, symbolic, existential, nondiscursive, and obscure enough to suit the kind of sensibility which has welcomed 20th-century painting, sculpture, music, and poetry. There is chronological evidence, for what it is worth, for this conclusion; the present widespread fasci-

nation with ballet began—I am thinking of the first Western invasion of Sergei Diaghilev and his company—at the same time as Cubism, atonal music, and several other aesthetic revolutions. There is also a lot of combinational evidence; a classical *pas de deux,* for instance, does not seem at all incongruous against a backdrop designed by Picasso, and the abstract traditionalism of Balanchine has a thoroughly modern feel when used to interpret the serial music of Stravinsky's *Agon.* Furthermore, the popularity of this formerly esoteric art—increased appreciably by its incorporation into American musical comedy—fits in very well with other tastes which have grown as our interest in printed culture has declined (relatively). It fits in with the success of whatever is dynamic and whatever moves: with the vogue for kinetic art, for athletics, even for bullfighting.

Balletic modernism—the free-style as well as the mixed kind based on the classical vocabulary of movements and positions—has certainly made important contributions. It has cleansed the dance of the pantomimic impurities encouraged by Romanticism and has helped to bring out the art's specific potentialities. It has added warmth and expressiveness to exhibitions of virtuosity. Above all, it has fostered the use of serious, often psychological, subject matter in place of the old fairy tales, exoticism, and supernatural sentimentality.

It has not, however, made the Occidental dancer's heritage unusable.

II

If the above is roughly correct, it follows that problems of style in the dance should not be pondered at the level of generality this inquiry is trying to reach. Every case ought to be judged on its merits, with the intentions of the choreographer and the talent of the interpreters taken into consideration.

There are, however, three nonstylistic questions which ought to be looked into here, for if present trends continue all three will be of critical importance within another generation or so. They are the notation question, the integration question, and the authorship question (which can also be thought of as the Diaghilev question). They are best examined in an Occidental frame of reference, but Asian and African parallels might also be found, for similar problems arise whenever and wherever the dance becomes, broadly speaking, balletic.

III

The ancient Egyptians and Romans had crude methods of symbolizing in writing the movements of the human body. Between the late 15th and the early 20th centuries a number of systems of dance notation were invented in Europe, and some of them were fairly widely used. In addition, there were of course pictures and prose descriptions, and musical scores which indicated rhythm, tempo, and emotional character. The details of performances, however, were

so generally omitted that one can say that the art, until very recently, has been mostly unrecorded. We know how Racine wrote and how Lully composed, but we do not really know how Louis XIV danced. Was the style of the ethereal Marie Taglioni classical or romantic? An elementary question of that sort, about one of the greatest of ballerinas, can be answered by a historian with little more than speculation. How did Nijinsky dance? Soon, when the last of the pre-1914 ballet fans dies, no one will really know.

More serious than this sort of ignorance, which after all exists in all the performing arts to a degree, is our ignorance of balletic works. In fact, a critic used to dealing with painting, music, and literature might argue that there has been no such thing—again until recently—as a balletic "work." What remains of *La Sylphide,* the most revolutionary ballet in history, is a legend. Since no notational system was used to record the original choreography of *Giselle,* what remains of this masterpiece is merely the story line, the music, and a tradition handed down—and certainly altered—by a succession of ballerinas. And works in even this special sense of the word do not go back very far: the oldest surviving ballet is usually said to be Vincenzo Galeotti's *The Whims of Cupid and the Ballet Master,* first produced in 1786.

In sum, the dance has had, in comparison with other arts and for good or ill, little authentic, detailed, and *available* stylistic history. It has had instead a kind of collective living memory, which has functioned as well as it has partly because the positions and movements of classical ballet have been clearly defined and partly because the dance world has long been a small, conservative realm in which ideas could be passed on personally from teacher to pupil—dancers in France, Denmark, and Russia can sometimes trace their stylistic ancestry back to the end of the 18th century.

Things may be vastly different a few dancing generations from now. Scientific systems of dance notation now exist (that of Rudolf von Laban, perfected in 1928, is one of the best known), and recording centres have been established. The preservation of important works on film, with the complicated sequences analyzed in slow motion, is of course possible; and there would seem to be a balletic future for devices like video tape. The consequences of these various recording methods have been slow to appear, since many companies have been reluctant to invest the necessary time and money. But that consequences are on the way cannot be doubted.

Will they be good or bad? The answer at the moment must be a matter of the answerer's general outlook, and of guessing on the basis of analogies with other arts. The dance seems destined to lose, gradually but surely, its present semi-Oriental "prehistoric" status, and to acquire an available stylistic history of the dynamic Occidental kind. A century from now a troupe will be able to perform a Balanchine ballet as accurately as an orchestra can now perform a Bach con-

certo; and probably the ballet will date in the way the concerto now does—both delightfully and sadly. It will have an authenticity *Giselle* cannot have, and will have paid for it by losing some of the freshness the constantly recreated *Giselle* has. One can foresee dance libraries and museums, dance critics who read ballets as easily as music critics now read symphonies, and choreographers who create on paper much as composers do. The art will presumably become less "existential"; it will be more under the control of preexisting patterns. On the other hand, the closed, personal master-disciple circuits will be broken, for a dancer will be as free to choose influences as painters and writers now are. Authentic period and individual styles will make possible a number of phenomena which are, strictly speaking, impossible today—revivalism, pastiches, allusions, and "quotations." For the same reasons, a new attitude toward innovation may develop. In the dance world of the future the difference between traditional and modern will have a substance it lacks today.

IV

The integration question does not involve us in the above sort of prophecy, for it has long existed and has provoked answers which can be studied as facts, or at least as the aesthetic equivalents of facts. It can be phrased this way: Granted that the dance achieves its highest significance when it is integrated with other arts and becomes a sort of a cousin of opera, how is this integration best managed?

The question is most interesting, and difficult, when music is the other art to be considered; and to meditate on this aspect of it in the light of the situation in Europe and America in the late 20th century is not to be exactly reassured. Of the some three hundred ballets which can be said to constitute the contemporary international repertory (many of which are of course seldom performed), only about half contain music intended for the dance, and a number of these use scores not intended for those particular ballets. The remaining hundred and fifty or so borrow symphonic, chamber, solo-instrumental, and sometimes transcribed vocal music. Choreographers tend to prefer the works of Chopin, Bizet, Beethoven, Berlioz, Brahms, Wagner, and other 19th-century geniuses, but considerable use has been made of familiar later compositions.

There can be little objection to this borrowing so long as the nonballetic music is left in its original state and the dancers are limited to interpreting its emotional atmosphere, its abstract structures, or—when program music is used for a dramatic ballet—its story line. In fact, such interpretations may add to or clarify the original significance of the music, much as a melody may deepen and emphasize the intended meaning of a poem. It is certain, for instance, that Leonide Massine's choreography in *La Symphonie Fantastique,* which follows the story line indicated by Berlioz, has helped people to understand the sym-

phony. Balanchine has devised eloquent visual projections of many musical abstractions, even including the micro-structures and silences of Webern (in *Episodes,* for which Martha Graham did part of the choreography).

A case can also be made for a kind of negative projection or anti-interpretation, a choreographic heightening by contrast, which leaves the borrowed music intact. This is seldom attempted, but a good example is Roland Petit's *Le Jeune Homme et la Mort,* in which a violently sordid drama of death and physical passion is danced ironically to the transcendent strains of Bach's Passacaglia and Fugue in C Minor. (Petit tried to make sure of the "anti-interpretation" by rehearsing his dancers to a jazz score and not letting them know until the opening night that the Bach was to be used.) The technique resembles the employment, in *The Waste Land* and many other modern poems, of quotations from the noble past as bitter commentary on ignoble aspects of the present.

Unfortunately, however, interpretation and anti-interpretation are not all that happens. What is troubling for a music-lover, or for any respecter of the uniqueness and unity—the life, that is—of works of art, is the widespread dance-world habit of cutting, arranging, or otherwise tampering with independent musical masterpieces in such a way as to reduce them to mere accompaniments for the *entrechats* and *fouettés,* or mere mood fabricators for the story line, or mere background noise, heard but not listened to, for the spectacle, and what is surprising is the number of talented choreographers who have the habit, or who at least are occasionally willing to misinterpret or ignore the plain intentions of a composer. Where many are guilty, it is unfair to single out; but two examples can help to make the point. Both Peter van Dijk, in a ballet called *Poem,* and Antony Tudor, in *Pillar of Fire,* borrowed the music of Schoenberg's *Verklärte Nacht,* an early, Romantic, instrumental work of the still tonal composer, with a story line based on a poem which is a dialogue between a man and a woman walking through a moonlit forest. Van Dijk uses the music abstractly and atmospherically, and Tudor uses it with a story line completely unlike the original one. Yet Schoenberg was not at all approximate in his literary inspiration; the sections, structures, melodies, and timbres in his piece reflect very closely the movement and details of the poem. To ignore his story line is to miss half the meaning in the music; to substitute a different story line is to make hash of his intentions.

It will be said that the ballet's viewers can still listen to the untampered-with *Verklärte Nacht* on records or in a concert hall. But there is no certainty that they will; and in any event the possibility of a distortion's being eventually straightened out is scarcely justification for committing the distortion. It will also be said that *Poem* is a pleasant item and that *Pillar of Fire* is an exceptionally powerful psychological study—one of the reasons the dance is no longer

regarded as a frivolous art which attempts no criticism of life. That is granted, and other successful ballets which misuse borrowed music might be cited. But one must be a balletomane indeed to argue that the dismantling of a masterpiece from another art is not too high a price to pay for the construction of a good piece of choreography.

Moreover, there is plenty of evidence that there is no need to pay such a price. Leaving aside the 17th and 18th centuries, when much instrumental music used dance forms even when dancing was not the immediate idea, we can point out that the famous ballets of the Romantic era—*La Sylphide, Giselle, Coppélia*—all had music written particularly for them. When the art reached another peak at the end of the 19th century, it was with Tchaikovsky's *Swan Lake, The Nutcracker,* and *The Sleeping Beauty.* The next great period, that of Diaghilev, was characterized by the balletic works of Claude Debussy, Maurice Ravel, Igor Stravinsky, Richard Strauss, Erik Satie, Manuel de Falla, Sergei Prokofiev, Francis Poulenc, Darius Milhaud, and Henri Sauguet. More recently, many of the best ballets have had the specific music of such composers as Aaron Copland, Leonard Bernstein, Morton Gould, Benjamin Britten, Hans Werner Henze, Henri Dutilleux, and Jean Michel Damase. In fact, there are commonsense as well as historical reasons for fearing that the habit of borrowing nonballetic music is a sign of balletic decay, however successful the results may be now and then. Obviously, the great 19th-century symphonies and concertos were not meant to be danced to. Using them leads inevitably to a procrustean kind of integration: the choreographer is constantly obliged to choose between stretching and chopping, if he does not succumb to the temptation to modify the preexisting musical bed. Often neither expedient is possible, and so in many symphonic ballets there are distressing moments when the visible and the audible elements do not get together at all. The dancers might just as well be engaged in what Debussy, in a fit of composer's pique, once accused Nijinsky of doing: "Watching the music go by."

For the good, then, of the dance as well as for the protection of musical monuments from vandalism, the choreographer and the composer in creative partnership ought to be the answer to the balletic integration question. And of course the decor and costume designer ought also to be in the partnership at the start of the planning, and not called in later as a mere decorator. The finest of choreographers, precisely because his gift is for choreography, is apt to compose exclusively in terms of line and pattern, and to neglect possibilities in colour, texture, light, and shade which a painter would think of at once. But the painter cannot make his full contribution if the tableaux are organized mostly before he arrives.

Actually, hardly any professional in the realm of the dance would disagree, in theory, with these conclusions. They are, in theory, commonplaces. Why

then are they being frequently—in spite of some brilliant exceptions—and apparently increasingly neglected in the balletic practice of the late 20th century? One cause is undoubtedly the trend, often mentioned in these pages, toward a modern division of aesthetic labour, toward exploiting the specific potentiality of each art (there are counter-trends, but they are not relevant here). Composers of the post-World War II serial and post-serial schools are interested primarily in music as music; they are not as disposed toward ballet as their immediate, more supple, frequently neoclassical predecessors were. Their contemporaries in painting have a similar, if slightly less determined, attitude. So, on their side of their aesthetic border, have many contemporary choreographers; they are, to exaggerate a bit for the sake of the point, more interested in the dance as such than in ballet. Their most typical, often striking, productions are performed in rehearsal clothes on an unadorned stage with little or even no musical accompaniment, and depend for expressiveness on the natural eloquence of the human body in motion. The integration question is not so much answered as refused.

There is, however, another aspect of the problem to be considered, if the reader is still accepting the premise of this chapter that the dance is most satisfying when combined with other arts. We can approach this aspect by supposing that integration requires an integrator. With that supposition we arrive at our third question, the one concerning balletic authorship.

V

Who ought to be the author of a ballet? The following remarks are intended less as a reply than as a demonstration that the question is not as absurd as it may look.

One can, to be sure, take the position of an optimistic anarchist and argue that nobody and everybody ought to be the author—that the choreographer, the composer, the painter, and, if there is one, the story-line contributor or librettist should simply get together and let their ideas merge. But if such a procedure were ever actually carried out it would probably destroy that element of personality which most of us are still romantic enough to look for in works of art. And in fact such a procedure is never carried out; either the ideas of the various partners do not merge, or one of the partners assumes creative control and reduces the others to the status of assistant authors. Sometimes they become interpreters of his ideas, and sometimes little more than translators.

This "chief author" may be, and often was during the early period of court spectacles and opera-ballets, the designer of the decor and the costumes—the

elaborately fantastic outfits Louis XIV wore as a dancer were twice as significant as whatever he did with his feet. The chief author may also be, more rarely and in a more subtle way, the librettist; in some 19th-century ballets the scenario is important enough to make the other ingredients look or sound like projections of literature. The composer, of course, especially if he is a major figure, always has an excellent chance of obtaining creative control and reducing his balletic partners to interpreters. It is not uncommon for him to do so long after the first production of a ballet, and even after his death. *The Sleeping Beauty,* for example, which originally owed much of its unity and structure to the dancer's mind of choreographer Marius Petipa, has in subsequent versions owed more to Tchaikovsky.

In recent years, however, the tendency has been not to question the choreographer's right to take over as chief author. We may speak of Tchaikovsky's *Sleeping Beauty* and of Léo Delibes' *Coppélia,* but—unless the reference is to the music alone—*Rodeo* belongs to Agnes de Mille, not Copland, and *Fancy Free* to Jerome Robbins, not Bernstein. The designers of decor and costumes are seldom mentioned, and librettists scarcely at all. And all this reflects a power reality. Even when the dance is integrated with musical comedy, as it now often is, or with some other kind of "total theatre," the choreographer is apt to emerge in the new partnership, if not exactly as the chief author, at least as the chief integrator. In ordinary ballet he is apt to be an absolute monarch.

There is no need to deplore this development when the results are good, as they often are. Moreover, a strong case for it can be made in general terms. If the premise is that one member of the balletic partnership must be given power, the choreographer is a more logical candidate than the painter, the composer, or the librettist. His art is the one that gives the amalgam its distinctive quality.

We can, however, without indulging in deploring, wonder mildly about the above premise while thinking of some of the things mentioned in this chapter—the coming consequences of notation, the tendency to use borrowed instead of new, specific music, the fairly general lack of balletic emphasis on decor, costumes, and story lines, and the strong emphasis on the dance as an isolated discipline. Perhaps contemporary ballet would be richer and more unified if a qualified person outside the partnership, somebody not committed exclusively to any one of the constituent arts, were more often the chief "author"—it is to be understood that we have been using this word in a slightly metaphorical way, and that now we are doing so more than slightly. "Director" might not be quite the right title for such a person, since ideally he would be more intimately involved in the creative process than most directors of plays, or even of films, are. But it is an odd historical fact that ballet in the late 20th century should be so disinclined to make use of something like the director sys-

tem, which has been widely adopted in the drama and the cinema, and is being used with success in ballet's cousin art, opera. Diaghilev, after all, was in his way one of the pioneers of the system, and ballet was one of the first arts to benefit from it. Possibly the explanation is simply that Diaghilevs are rare.

*. . . from a confusion of shapes the spirit is quickened
to new inventions.* LEONARDO DA VINCI

There is less in this than meets the eye.
TALLULAH BANKHEAD

Chapter 10 Painting and Its "Post-history"

IN CHAPTER 5 MUSIC was referred to as possibly the dominant art of the 20th century, and the remark can stand—with a reminder that the reference was to music of all sorts and eras. Painting, however, must be called a strong contender for the honour, at least if we are thinking of recent creative work. For while it is true that the "condition," to use Pater's term again, toward which much of the art of our time aspires is very evident in music, it is also true that the origins and consequences of the modern movement are exceptionally clear in painting, and not only in the sense of being visible. Hence painting has often been the immediate inspiration for praise, denunciation, definitions, and cautionary accounts of contemporary art as a whole.

The following discussion was written in the hope of not falling into any one of these critical categories, and may therefore fall into all of them. In any event, it will not exclude the notion that what has happened in painting can happen, or is already happening, in other arts.

I

Some familiar information ought first to be cited. Modern painting is sometimes said to have begun in the 1870s, when Claude Monet, Alfred Sisley, Camille Pissarro, and their fellow Impressionists dropped literary subject matter for snapshots of contemporary scenes, replaced academic brushwork with flickering dabs of colour, and concentrated on light instead of contours. But Impressionism can also be regarded (without, of course, questioning the value of its masterpieces) as the end, not the beginning, of a period; it was the ultimate

139

variety of the optical naturalism in which painters had been absorbed since the early years of the Italian Renaissance. More significant in modern terms was the achievement of the principal Post-Impressionists. Paul Cézanne, partly through a reconsideration of classical French methods, succeeded in his stated aim of turning Impressionism into "something solid"; he used colour, that is, to express underlying structures and to model shapes, much as traditional painters had used tone values. Vincent van Gogh resorted to writhing forms, arbitrary colours, and rhythmic brushwork to depict a subjective reality which he found "more true than literal truth." Paul Gauguin, convinced that "art is an abstraction," turned toward tribal, medieval, and Oriental work, and used solid colours and vaguely hieratic shapes to create a nonnaturalistic, mythical kind of reality. Georges Seurat worked out in theory and practice the "scientific" use of picture space, formal composition, and colour contrast. Largely because of these masters, the idea that a painting is an autonomous entity, governed by laws unlike those found in ordinary visual experience, was being much discussed around 1900.

From that point, as we have already noted in Chapter 2, the evolution toward a sharp and general break in the European painting tradition was rapid. Matisse, André Derain, Maurice de Vlaminck, and the other Fauves in France distorted forms, flattened space, and employed strong colours without reference to the things represented. At about the same time (around 1905) Ernst Ludwig Kirchner, Karl Schmidt-Rottluff, Erich Heckel, and other German Expressionists were resorting to similar methods for more emotional reasons. Then came the heroic years, 1908 to 1912, of Cubism. Picasso and Braque, supported notably by Fernand Léger and Juan Gris, furthered the collapse of optical naturalism by freeing drawing of any obligation to obey Renaissance laws and by transforming it into a system of signs—a purely pictorial language. Points of view were multiplied and facets were flattened into the plane of the canvas in such a way as to represent the mental reality of a thing seen in a series of aspects during a succession of moments. "The senses deform," Braque said, "but the mind forms." Between 1909 and 1914 Umberto Boccioni, Giacomo Balla, Carlo Carrà, Gino Severini, and the other Italian Futurists used geometric forms related to those of Cubism in an attempt to capture on canvas the dynamism of the modern era and to demonstrate that "movement and light destroy the substance of objects." In 1910 Kandinsky pushed the organic, intuitive, Fauve-Expressionist tendency to a conclusion by painting his first lyrical nonrepresentational work. Then Mondrian reduced the linear, logical, Cubist tendency to the geometrical shapes and primary colours which have since become standard in a great deal of modern decoration, advertising, and industrial design.

Thus, by the outbreak of World War I the most important energy centre in

20th-century painting—the nucleus of the system—had been created. We can call this nucleus abstractionism, with an apology for an inadequate term which is now too well established to be discarded. A picture need not, of course, be completely abstract—just a formal arrangement of shapes, lines, and colours—in order to merit the label "modern." There are degrees in all styles, and there are always some works, not necessarily inferior, which lie out on the periphery of a given system, where the pull of the nucleus is scarcely perceptible. Nontheless, it would be difficult to name an indisputably modern pictorial masterpiece which does not imply a rejection of the Renaissance assumption that painting should mirror a possible visible reality; and there are few which do not reveal—in unrealistic colours or arbitrary spatial organization if not always in distorted forms—the powerful attraction of abstractionism.

There are, however, two only slightly less important forces which must be kept in mind, for their pulling power can usually be found coinciding with, reinforcing, or deflecting that of abstractionism. One can be loosely called primitivism, and the other, barbarously, quidditism.

The pull of primitivism is most evident in modern paintings which resemble archaic or tribal art; familiar examples are the Breton and Tahitian works of Gauguin, Cubist compositions which approach African and early Iberian sculpture, post-World War II abstractions which may recall the styles and subject matter of any number of exotic times and places, from preclassical Greece to pre-Columbian Mexico. But there are many other manifestations of essentially the same impulse to get away from the sophisticated, rational, tasteful, and well-made sort of painting which was dominant in the Occident between the 15th century and the 20th. Works of naïve amateurs of the type of the Douanier Rousseau and Grandma Moses are admired by modern painters and hung in modern museums. Many professional artists—Picasso and Jean Dubuffet are early and late examples—have imitated the draftsmanship of children, of the insane, and of the recorders of latrine reveries. Serious critics have been fascinated by the brushwork of apes. Random, irrational, deliberately careless methods of applying, or dripping, paint on canvas have been employed, notably by Jackson Pollock, Willem de Kooning, Franz Kline, and other Abstract Expressionists of the New York school. Since 1924, when Surrealism was officially founded, Max Ernst, Joan Miró, Yves Tanguy, Salvador Dali, and a large number of disciples have explored—by means of erotic symbols, chance associations, hallucinatory images, and sometimes automatic drawing—the primitive regions of the subconscious mind which have been revealed by psychoanalysis and the study of ancient myths. A different, but parallel, attempt to find the springs of human spontaneity is represented by the work of Paul Klee, who proclaimed his wish to paint as if Europe had never existed. What can be thought of as social primitivism is apparent in the tendency of many

modernists—Andy Warhol, Robert Rauschenberg, and other Pop or nearly-Pop artists are among the recent examples—to reject elite and intentionally aesthetic things and seek inspiration in the popular and the commercial, or in the kind of willful vulgarity variously known as corn, schmaltz, kitsch, and camp. And perhaps it is not illegitimate to find some primitivism, along with the obvious scientism, in the savagely simple retinal appeal of the Hard-Edge geometrical abstractions, Op eye-teasers, and kinetic tableaux of the 1960s. It would not be difficult, for instance, to cite precedents in tribal art for the patternmaking of Victor Vasarely.

"Quidditism"? Although the coinage is merely the least of several possible evils, it does label something that needs a label. In Webster's New International Dictionary (second edition) the word "quiddity" has two senses: "1. The essence . . . of a thing; that which answers the question, *Quid est?* or What is it? 2. A subtle . . . distinction; cavil; quibble." Both senses are pertinent; a large number of 20th-century pictures can be said to reduce, or at least to try to reduce, the art of painting to its essence, and a good many answer the ordinary viewer's *Quid est?* with a quibble—if they do not beat him to the punch with a "What is it?" or a "Who are you?" of their own. Here Marcel Duchamp, Francis Picabia, and the Dadaists of 1916–1922, with their wild disparagement of aestheticism (the modern kind included, be it noted) and their attempts to fog the frontier between objects and art objects, naturally come to mind first, partly because they have had many successors (about whom more later). Examples, however, are everywhere; most of the artists already mentioned might serve. Any semiabstract picture can be regarded as, among other things, an attempt to emphasize the formal aspects, and hence the nonliterary and nonrepresentational essence, of painting. Lyrical abstractionism of the Pollock and early Kandinsky sort is a reduction of the art to basic materials, gestures, and psychology; and geometrical abstractionism is a reduction to Euclidean, or perhaps Platonic, ideas. Both types can raise questions, disturbing for a partisan of modernism, about the difference between painting as an independent discipline and painting as a partly dependent one—as decoration. Questions and quibbles about the essential nature of a picture, and sometimes about the quiddity of art in general, are involved in the widespread modern use of the collage technique to create "paintings" by sticking paper, cloth, metal, or other material to the canvas or wood ground; and the quidditism becomes particularly strong when the material used is also the material of the thing depicted, or is the thing itself—when a picture of a wall, for example, is made of plaster, or a picture of a newspaper is made of a newspaper. More questions are raised when reproductions are utilized. Where does the quidditism halt in a Pop work which is a trompe-l'oeil painting of a collage assembled from magazine photographs?

I am already getting, almost involuntarily, out of the preliminary situating

of issues and into the issues as such. But before backing up a bit and proceeding in a more orderly and detailed fashion I ought to make explicit two things which are partly stated in the above paragraphs and which head up into more issues. First, the forces of abstractionism, primitivism, and quidditism constantly overlap, like everything else in the exceedingly variable realm of artistic styles and sensibilities, and often they are the aesthetic, psychological, and philosophical aspects of a single phenomenon. Second, the single phenomenon is usually extremism; modern painters have exhibited an unprecedented desire to rush to the end of every line of possible evolution. Although I shall return to this desire and its consequences, it ought to be kept in mind during talk of other matters, other questions.

II

The most durable and difficult of these questions, and the parent of most of the others, is of course this: What are the advantages, if any, in the break with Renaissance figuration and optical naturalism which has been brought about by the combined forces of abstractionism, primitivism, and quidditism? A complete answer is impossible, but a few opinions, inevitably personal, may serve to put the question into better focus than it usually is.

Again some capsuled knowledge ought to be recalled. The Renaissance change in painting was one of the most splendid events in the history of art. In the easel picture, itself a quite recent invention, the tempera process was replaced by the Flemish oil technique, which permitted retouching and more realistic effects of light and relief. Proportions and the rules for an effective *mise en scène* were codified. Medieval pictorial space, which had been a largely emotional construction with many vanishing points, several horizons, and practically no middle ground, gave way to an illusion of true perspective; and the illusion was heightened by an atmospheric envelope, built up from subtle variations of tone and colour, which replaced the old airless background. A picture thus became a kind of hollow theatrical area, or a mirror, or a magic window which could be opened in any wall. With these advances in technique, painting took on a new documentary value and began to afford a new and extraordinarily keen recognition pleasure. It could render, for the first time, the full beauty of nature; in fact, pictures taught people to see real landscapes. The naked human body acquired a nobility and an attractiveness it had not had in art since the great period of Greek sculpture. The still life, which had scarcely existed before the 16th century, became an established and poetic genre. The psychological portrait contributed to the definition of individual personality—to that awareness of the self we take for granted, forgetting that it had to be learned and refined during several centuries.

Now if this kind of painting were still flourishing as it did between roughly

1450 and 1900 there would be little point in defending modernism as anything more than a series of interesting experiments. But of course the flourishing is not going on, and even the most conservative critics do not argue that it is. Ingres, the last 19th-century master in the central Renaissance tradition, has had no successor of comparable stature in our era. Nor has Monet. Traditional figuration and optical naturalism have become the resources of minor painters for the most part, and show very clearly the tendency of traditional styles in the 20th century to sag toward the popular category. What may seem to be exceptions to this generalization usually turn out to be something else. Several well-known modern painters have made sincere attempts to return to traditionalism, and the results have not held up; the formerly admired neoclassicism of Derain, for example, is now generally recognized as a distressing failure of nerve. Picasso's fine things in more or less traditional manners date from before the decisive modernist revolution; his post-Cubist efforts along the same lines are either caricatures of traditionalism or exercises in style (by a virtuoso, admittedly). The "new realism" hailed by interested critics and dealers every few years either flickers out after a short season or reveals itself as another variety of modern Expressionism, in which the pulls of abstractionism and primitivism are apparent. The best Surrealists—artists like Ernst, Miró, Tanguy, and Matta—have been the most abstract, and the others have employed the devices of Renaissance illusionism in ways which show that they are no more interested in exploring the visible world than Kandinsky was. Almost the same thing can be said of Pop artists as a rule, and when it cannot be said, when the complex irony of quidditism fails to work, what emerges from the figuration is not Pop (which is of course aimed at an elite audience) but a drearily authentic variety of popular art—an art of catering rather than creating.

The point, then, to be noted in the breaking of the Renaissance tradition is that the alternative was, and still is according to the available evidence, to allow painting to sink to a lower level of quality and seriousness than that which it had occupied for several centuries. This is worth stressing, for conservative viewers commonly suspect modern painting of being a joke, or a fraud, or both, with the long-suffering bourgeoisie the designated victim. Sometimes the suspicion is justified, but on the whole modern artists have perhaps a deeper respect for their art than the average traditionalist has. At least they are not resigned to letting it lose its vitality.

Why has the Renaissance style (in the broad 1450—1900 sense) been so ineffective in the 20th century as an active, still being created, kind of art? Why, to put the same question in another way, have so many good painters of three generations now—too long a time for talk of a mere fad—found the pulls of abstractionism, primitivism, and quidditism so hard to resist? One explanation is that the old style's monopoly as a provider of documentary value and recog-

nition pleasure has been destroyed by photography. The cinema now takes care of painting's ancient literary function, and television takes care of the ancient journalistic and historical function. Having a realistic portrait done by a painter has become a kind of antiquarianism, like sending a valet with a message instead of telephoning. There is not much evidence, however, that the competition of the camera was the primary reason the Fauves, Cubists, and early abstractionists had for rejecting traditional illusionism; and so we must look further—into the nature of our era and into the nature of painting—for an explanation of the old style's sudden inability to seem quite serious.

Granted, it is hard to explain anything in art with such a vague concept as "the nature of our era." Since artists are usually among the leading creators and the most severe critics of an era, the argument is always to some extent circular and contradictory. Nevertheless, in the light of what has been said in previous chapters about the general cultural temper of the 20th century, one might suppose that Renaissance figuration would be in trouble. A painting style which is committed to the rendering of a literary, external, static (mathematical perspective assumes that the observer and the observed do not budge), and public type of reality is not very well adapted to a period which has become strongly aware, in practically every field, of a nonliterary, internal, dynamic, and private type of reality. Such a style is acceptable in the masterpieces of the past, as a museum art, because it can then be viewed imaginatively in its own historical context, with its claim to relevance limited. But when it is used for the production of contemporary work it is certain to seem out of cultural phase to experienced eyes, and therefore weak; it lacks the power an art gets from resonating with the other arts and sciences of its time.

There are reasons, however, for thinking that the old style would be almost as low on vitality, as uninspiring for first-rate talents, as it is today even if the new era had not dawned. Van Gogh, Cézanne, Gauguin, Matisse, and Picasso—and even Kandinsky and Mondrian in their early periods at least—were not particularly sophisticated men aware of and influenced by the tremendous changes in other arts and in religion, philosophy, science, and technology that were getting under way at the end of the 19th century and the beginning of the 20th. They and their fellow revolutionaries were primarily just sensitive and independent artists who found the results unsatisfactory when they painted in the manner that had been dominant in Europe for the preceding four hundred and fifty years. Although the fact that people in other arts and sciences were making similarly disconcerting discoveries at about the same time should not be forgotten, something had evidently happened in painting itself, quite apart from the history of culture in general. There was a local crisis. It can be described in the terms already used for the crisis in tonal music; generations of geniuses had worked over the possibilities opened up by Renaissance figuration

and optical naturalism; the old pictorial "language" was beginning to seem hackneyed; the closed energy system was running down; painters could not advance without leaving the tradition as a whole behind them; and so forth. But since the history of European painting is not so linear and "scientific" as that of music, a different way of talking about it seems desirable.

One way is to be elementary. A painting—or rather our complex visual, emotional, and intellectual experiencing of a painting—can be thought of, very crudely, as having two poles: a positive and a negative (this is an electrical metaphor, of course, and not a judgment of value). At the positive pole we are aware of a referent, of something represented visually, of the presence, say, of Frans Hals's jolly toper. At the negative pole we are aware of several things— canvas, flatness, colour, tone, lines, brushwork, pattern—which constitute the picture's form and announce the absence of the jolly toper. And obviously the vitality of a picture—its existence, even, as a work of art—depends somehow on there being a proper tension between the referent and the form, between the positive pole and the negative, between presence and absence. Trompe l'oeil fails completely, as Ruskin observed, if it actually does fool the eye; only at the moment of betraying itself as mere paint on canvas does it achieve its shock. On the other hand, if the negative pole of form has too heavy a charge, if the jolly toper or his equivalent is totally absent, the result is at best decoration and at worst mere paint on canvas. The toper has to be there and not be there.

The history of European painting (of Oriental also, although that is not our concern here) can be regarded as a struggle, over long and short periods and within the careers of individual artists, to maintain and renew when necessary this relationship between referent and form. Spectacular and relatively lasting shifts of emphasis from one pole to the other characterize the procession of such period styles as archaic Greek, classical Greek, Roman, Byzantine, Romanesque, Gothic, and Renaissance. Within the periods a less pronounced and more rapid alternation occurs; the High-Renaissance emphasis on referent, for instance, is followed by the Mannerist shift toward form. Such movements do not, of course, occur in social, economic, and intellectual vacuums; and our schema is not a "law" that will guarantee the accuracy of predictions. It does suggest, however, that the lack of vitality which became apparent in Renaissance figuration and optical naturalism toward the end of the 19th century was in part due to a lack of artistic ambiguity. The jolly toper was too much there. That emphasis on the referent—on documentary value and recognition pleasure—which had once been stimulating, and had finally provoked the invention of photography, had begun to be regarded by ambitious painters as a weakening of tension. The Impressionists, although they stuck to naturalism, started the reaction by using a technique which called attention to the painted canvas as such and which, at least for traditionalist critics, seemed to dissolve

the referent. The next generation reemphasized form, tightened the tension, and renewed drastically the ambiguity by turning toward abstractionism, primitivism, and quidditism. The jolly toper became very absent.

Thus modern painting can be defended, and attacked, as simply art freshly conscious of itself as art, as self-proclaimed make-believe; and in saying this we return again to the nature of our era. We return, for instance, to the tendency of 20th-century poets to weaken, or omit entirely, the referents of their metaphors, and to the liking of contemporary dramatists and directors for illusion-breaking playhouse irony—theatrical quidditism. Music, of course, weakened the referent long ago, but it has been doing what it can to continue the process.

III

The above remarks may seem a rather feeble compliment for modern painting. Is the best that can be said for it an assertion that it is not alone and a suggestion, which has perhaps never been sufficiently tested, that a general return to traditionalism would be worse?

One must be unusually conservative, and visually unresponsive, to think so, for the basic elements of painting have acquired a new vividness—as have musical sounds and poetic metaphors—as a result of being less dependent on the referent. It would be difficult, for instance, to find in traditional masterpieces exact equivalents for the effects of the pure colours of Matisse, Mondrian, Mark Rothko, Chagall, and dozens of other moderns; for the powerful blacks of Kline; for the abstract light of artists like Hans Hartung; for the signs, arabesques, and calligraphy of Klee, Picasso, and Mark Tobey; for the agitated brushwork and rich impasto of Pollock and De Kooning; for the varieties of pictorial space which have been created by Cubists, Surrealists, and abstractionists.

But this, it can be said, is mere hedonism, and if that is our doctrinal approach to painting, Renaissance figuration and optical naturalism still have something to offer, in spite of the competition of photography. There are still traditionalist painters who can turn out lovely landscapes in the manner of Claude Lorrain, reassuring still lifes in the manner of an old Dutch master, voluptuous nudes in the manner of Rubens or Fragonard. It would be awkward to have to argue that enjoying Rothko's abstract rosiness is somehow aesthetically and morally a jot above enjoying an illusion of a rosy bosom. Also, there is the pleasure in the virtuosity of the artist to be considered, a pleasure often negligible in modern painting.

And of course hedonism is not enough. Nor is that quality in art which I have been referring to variously as vitality, ambiguity, and tension—the quality which springs from our awareness of the referent and the form at the same time. Even if the superiority of modernism over today's surviving traditional-

ism is conceded from all these points of view, its superiority in terms of meaningfulness can be, and is by many viewers, profoundly doubted. Obviously, the pictorial masterpieces of 1450–1900 have not survived simply because of their documentary value and the recognition pleasure they provide. We feel that they contain messages about the human condition, even though those messages may be different for different observers and may be untranslatable into nonpainterly terms. Can the same be said, on the whole, of modern painting? The weakening of the referent—of illusionism and recognizability—may indeed make the form more thrilling. But may it not also destroy the subject of a picture, and make the form merely self-referring?

It may. But this concession to conservative criticism ought to be balanced by a few other remarks.

The most common error of antimodernists is to assume that the referent must be a reasonably accurate reproduction of something visible which we can recognize immediately and consciously. A little reflection will reveal that it need not be that at all. The ancient philosophical critics were, of course, right in thinking of art as an "imitation" of nature, since ultimately there is no other source for a referent. But Paul Klee was also right, or partly so anyway, in his frequently quoted assertion that "art does not reproduce the visible, it renders visible." One need not be a Freudian or a Jungian to admit that the nature which is imitated in a painting may be something hidden or half hidden in the individual or collective unconscious. It may be a nonlocalized mountain, plain, sea, or sky; or some aspect of the erotic symbolism which the human imagination finds everywhere. It can be an only vaguely familiar space, light, stuff, or texture. It may be simply a muscular movement, which we recognize in a kinesthetic way. Whatever it is may have been metamorphosed long ago and many times into mere signs or vestigial patterns.

Another common error is to assume that the referent is the subject of a painting—what the work is really about. This is comparable to assuming that Proust's great novel, for example, is really about a series of love affairs (instead of time, memory, snobbery, and much else), or that the subject of *Hamlet* is what happens in the line of adultery, murder, and revenge. The subject of a successful painting arises from the painting as a whole, referent and form together, and also from what the viewer knows and feels about many other things and relationships: about himself, the artist's intentions, the occasion for the work, the history of art, the history of the times. What is Picasso's "Guernica" really about? Originally it was about the bombing of a Spanish town in 1937, and the significance it had then has been increased by the bombing of hundreds of cities and the ultimate horror of Hiroshima. But originally it was also, to some extent, about private suffering and sexual anxiety; the evidence is in the fact that Picasso had used images and distortions of the "Guernica" type for

such personal subjects. Pointing to this evidence, the English critic John Berger concludes (the italics are his):

> *Guernica,* then, is a profoundly subjective work—and it is from this that its power derives. Picasso did not try to imagine the actual event. There is no town, no aeroplanes, no explosion, no reference to the time of day, the year, the century, or the part of Spain where it happened. There are no enemies to accuse. There is no heroism. And yet the work is a protest—and one would know this even if one knew nothing of its history. Where is the protest then?
>
> It is in what has happened to the bodies—to the hands, the soles of the feet, the horse's tongue, the mother's breasts, the eyes in the head. What has happened to them *in being painted* is the imaginative equivalent of what happened to them in sensation in the flesh. We are made to feel their pain with our eyes. And pain is the protest of the body.[1]

In other words, by weakening and even obscuring his referent and by emphasizing form, Picasso produced not only artistic tension but also, as thousands of viewers of this painting would testify, an immense significance. Perhaps this significance owes more than it should to publicity and historical chance, but the same thing could be said of many Renaissance masterpieces. Part of what is called meaning in art might be better described as availability for meaning.

This availability can also be described, within limits, as universality of meaning; it is involved when a work seems to be, in the words of the introduction to this book, simply a terrain of fraternal encounter, not a device for sending a message from the artist to his audience. We must say "within limits," for of course there is a point at which a possible multiplicity of meanings becomes no meaning. But inanity can also be reached by traditionalist methods, for there is a point beyond which any strengthening of the referent converts it into a historical or journalistic fact, and a fact as such, without interpretation (in this instance the interpretation provided by painting form), is meaningless.

Often, as in travel, the viewer brings home what he set out with. For instance, when Pollock first exhibited his dripped Abstract-Expressionist doodles, bewilderment was pretty general, since there seemed to be no referent at all. Then a few critics suggested that the referent was the act of painting itself, without preconceptions (there have been other suggestions, but that one will do for the point). With this referent and the unusually free form in mind, many people have found in Pollock's most violent work strong statements about problems with which they themselves are preoccupied: in particular, the problems of individuality, authenticity, and self-realization in modern society. Are such meanings actually there? The pull of quidditism is evident, but we can at least say that there is a lot of availability for such meanings. And there is nothing particularly odd, in a modern context, about using as a referent the process of making a work of art. It is done in a good deal of modern poetry (that of Mallarmé and Wallace Stevens, for example), in music of the aleatory

1 *Success and Failure of Picasso,* Penguin Books Ltd., Harmondsworth, 1965, p. 169.

or partly improvised kind, in Pirandello's and similar drama, and of course to some extent in all architecture which draws attention to its construction.

Picasso and Pollock, however, are relatively easy to defend. What about purely geometrical abstractions, Op dazzlers, Pop vulgarities, Surrealist jokes, Dadaism, neo-Dadaism, and other kinds of avant-gardism? Without putting too much strain on the word, can such things be said to "mean" something worth the attention of a busy adult? If they are perhaps trivial in isolation, do they nevertheless add up to a significant pattern?

To attempt to answer these questions is to talk, as promised some paragraphs back, about extremism.

IV

We can start by noting that it is sometimes helpful to consider apparently wild statements in criticism, for their supposed wildness can foster orderly discussion. So this can be offered as a provocation and for examination: *Painting has reached the end of its history.*

Traditionalists have frequently advanced the idea during the last half century, and have usually been dismissed, often rightly, as reactionaries. But it has also appeared, in one guise or another, among people whose modernism cannot be doubted. Duchamp's decision to deride, and finally to abandon, his art was one of the early manifestations. Mondrian, with a different point of view, was inclined to prophesy that what he called "pure plasticity in palpable reality" was about to replace easel pictures. More recently, thinking along the same lines, Miró has declared:

> The painter, as we know him today, is already a figure of history, destined to disappear. There will no longer be painters, but rather men who express themselves by three-dimensional means and who participate in other arts, such as architecture, which are more direct in their effects, more in contact with society.[2]

These opinions of artists are supported, with various nuances, by those of a large number of both moderate and avant-garde post-World War II critics—in spite of such facts as that there are today more than a thousand commercial galleries of painting in New York, London, and Paris, that the number of museums, books, and magazines devoted to painting continues to grow, and that according to a recent estimate, based on the catalogues of one-man and group shows, there are some forty thousand active painters in France alone. How much substance can we find in the gloom?

Roughly this much: If by "history" we mean an evolutionary sequence, a process of change and development, and if by "painting" we mean what most people have meant for thousands of years, then painting can indeed be said to have become "post-historical." It is a thoroughly mature art, one in which radi-

2 *Le Nouvel Observateur,* Paris, May 20, 1965.

cal innovations can no longer be reasonably expected. That, to be sure, is the sort of remark which has often been made in the past and which has always proved to be nonsense; but this time the danger is certainly not great—let the reader try to imagine, within the limits of what he would call painting, anything more illusionistic or more formalistic than what has been achieved already. To say, however, that the evolutionary history, the "invention," of painting is now complete is *not* to say that the art is doomed. Creation is not necessarily invention, although the two have often occurred together. Jan van Eyck can be considered inventive in the oil medium, Piero della Francesca in mathematical perspective and proportion, Leonardo in transitions from light to dark, Monet in brushwork and optical mixtures of colours. But Watteau, Tiepolo, Renoir, and dozens of other fine painters of the 1450–1900 period invented practically nothing; the history of Western painting would be essentially what it is, although infinitely poorer, if they had never lived. They were simply creative; they used familiar methods to achieve a personal vision. Modern painters, working within the limits of the modern period style, can do the same thing; in fact, and necessarily, that is precisely what many have been doing for some time now—since roughly World War II at least. The originality of Pollock, for example, was not like that of the Cubists during their inventive phase; it sprang from an exemplary temperament which employed, with a new freedom and in new combinations, devices long familiar in the work of Kandinsky, the German Expressionists, and the French Surrealists. And a moderate modernist can hope that a virtue will continue to be made of necessity, that painters will cultivate their visions rather than their gadgets, and that responsible critics will look for quality rather than novelty—will judge poetically, so to speak, instead of historically.

Still, the perils in this situation of stylistic maturity are evident. Talents strong enough, studious enough, and brave enough to accept the completed evolution and to fuse the already seen into new creations are proving to be rare, as could have been expected. It is easy to believe that in periods of upheaval the great artists are the great upheavers, but less easy to think that in periods of consolidation they ought to be the great consolidators. The line between academic eclecticism and legitimate consolidation is in any event hard to draw. The temptation to settle for the minor delights of traditional figuration and for the I-told-you-so applause of conservative critics is strong. So is the temptation to turn out, for the applause of avant-garde critics looking for new trends to grow famous with, a parody of the inventiveness of the modernist pioneers—an imitation of history which is evolutionary only in the jargon that accompanies it. Complicating everything is the distribution system. Here one must be careful to be fair, for modern painting owes a lot to the perceptive and generous dealers—people like Daniel-Henry Kahnweiler in the Cubist years and Peggy

Guggenheim during and just after World War II—who have encouraged unknown artists. Without them and their clients there might not be much contemporary art, for official patronage of the new is fairly recent. But in the present situation the system is anachronistic, for it is based on the assumption of periodic revolutions. It is geared to sell inventiveness rather than non-evolutionary creativeness, and so it too has a weakness for mere imitations of history. At its worst it confuses utterly the distinction between style and fashion, converts art collecting into mere status-seeking or financial speculation, and persuades painters to change their visions as often as dress designers change hemlines.

Finally, even a moderate and hopeful modernist must wonder about the ultimate feasibility of a non-evolutionary sort of creation. Granted, the painting sensibility system which became mature in the late 1920s (the devices of Surrealism were the last important "inventions") is marvelously complex and very resonant with the other arts and sciences of our era. Artists can use its existing resources for a long time without running out of fresh, personal combinations. An analogy—which may have been occurring to the reader—with the predicament of Western composers at the end of the 19th century would not be accurate; a better one would be with the musical situation at the start of the Romantic period, when the mature system was in place and not yet in crisis. Even so, the end of the line in terms of expressiveness and power must eventually (a guess, based on the past, could be "within two generations") follow the now fairly evident end of the line in terms of inventiveness. Shall we or our children then have to settle for a painting equivalent of the musical revivalism which prevailed in the 1920s? Perhaps we shall, although I have already given some reasons for believing that such a "solution" of the problem would be unsatisfactory. But perhaps also we won't have to wait for the normal end of the line. The whole idea of a non-evolutionary phase in anything has become foreign to the 20th-century temper. In the United States in particular, the post-World War II modern painting public, newly affluent and relatively new to art collecting, has been educated by journalists to feel that whatever has stopped being invented is best left for dead.

V

What happens when artists, disregarding the evidence that painting has reached the end of its "historical" tether, try to haul or push it onward into new revolutions? They break the tether, of course. The results are works that the ordinary viewer would not agree, without qualification, to call paintings, although they may exhibit some of the characteristics of the painting of the past. They can be described, with the usual understanding that there are degrees and that everything overlaps, as moving toward some other art, or toward science and technology. Such works have become abundant in the United States and

tion toward architecture is apparent in the wall-filling size of many paintings since World War II, and also in the practice, which became noticeable in international shows in the 1960s, of using canvases that turn corners on to adjacent walls, the ceiling, or the floor; the viewer experiences the painting partly as he would a room.

These "post-historical" painter-sculptors, painter-musicians, painter-dancers, and painter-architects (along with the painter-painters) are increasingly active, but they have some energetic rivals in the painters who have felt the attraction of technology and science. This is of course no newer than the crossing of artistic frontiers; Leonardo and dozens of his contemporaries were scientists as well as painters. Also, here our terms overlap even more than usual, for a painter-technologist is apt to be at the same time a painter-sculptor and, with the aid of electronics and tape, quite literally a painter-musician. Nevertheless, a distinct 20th-century trend can be made out. Among the recent manifestations have been the Op works of Vasarely and his school, and the related kinetic art—the "movement movement"—of a number of artists who are usually called sculptors but who think in more or less pictorial terms; here, at the risk of being out of date before being in print, one can cite the motorized projectors and reflectors of Nicolas Schöffer. The ideas in both Op and kinetic art can be traced back through the Bauhaus to pre-1914 experiments, and sometimes on back to such things as the early colour organs. Many of the shapes utilized reveal the same affinity with geometrical abstractionism which has long been evident in the real realm of technology and science.

VI

It is well to admit right away that we have no very reliable criteria for these mixtures of painting with other disciplines. Theories have not yet been fully formulated, time has not yet selected any masterpieces which might serve as ideal examples, and in some of the new genres the number of works is not yet large enough to permit useful grading and comparing. While we are waiting, however, a possible procedure is to isolate the disciplines in a given mixture, judge them separately by the usual standards, and then meditate a bit on the hybrid.

How effective, for instance, when considered approximately as painting, is a particular piece of painting-sculpture? How effective is it as sculpture? Can the mixture, or the juxtaposition in one work, of the two arts stand up to a pure picture or a piece of pure sculpture in which about the same quantity of talent and ambition is perceptible? Judged by the usual criteria for musical compositions, do the structures and permutations in a piece of avant-garde painting-music have enough clarity to be real, enough complexity to be interesting, and

Western Europe since the early 1960s, when a drop in the inflated market for Abstract-Expressionism provoked a feverish dealer-artist search for something new. Most of them, however, have modern counterparts dating back to the 1920s or further, and a few have ancient precedents; one of the ironies in the present situation, usually unnoticed in the midst of the enthusiasm and the indignation, is that anti-painting may be as much at the end of its tether as painting is. (And what can *it* evolve into, except painting?)

The reader will notice that here the trend toward specificity, toward a division of aesthetic labour, which has often been mentioned in this book as one of the chief characteristics of modern art in general, runs into a counter-trend toward a blurring of frontiers and toward the creation of works which, like opera, combine the effects of two or more arts. The idea, apparent in abstractionism, that painting should just be painting is no longer dominant. Note, however, that the counter-trend appears after, and to some extent as a consequence of, the pushing of the division-of-labour idea to extreme limits. Its products normally have an air of desperation, of historical urgency, which makes them something other than merely updated versions of the artistic hybrids common in other times and places—notably in Baroque Europe.

The other arts toward which the modern painter is attracted are often such near-at-hand ones as tapestry, ceramics, stained glass, photography, and bas-relief or incised sculpture; and an indefinable zone between painting and these foreign disciplines is apt to be preferred. Ridges of paint may be thickened until the material itself, as in sculpture, produces light and shade; such non-painting materials as metal, cloth, and glass may be used purely as colours and tone values; three-dimensional objects may be arranged on panels as if they were patches of flat paint; photographs, or reproductions of them in paint or dye, may be inserted in abstract works, or may, complete with the dots of a halftone photoengraving, constitute the entire work. Examples of these and similar processes, employed with a "post-historical" nuance, are common. Less common—in spite of the aspiration toward the "condition"—are examples of musically organized painting, but a few colourists and geometrical abstractionists have tried, sometimes with the help of light projectors, to use something like an octave, or a Schoenbergian series, of colours and shapes, and have been as ready as avant-garde composers to talk of structures and permutations. Literature, although officially proscribed by right-thinking modern painters, reappears in the allusive titles of abstract or Surrealist pictures, in the Pop use of rebus, comic strip, and cinematic techniques, and more subtly in works that make sense only when accompanied by prose explanations. An attraction toward such performing arts as the dance and pantomime can be found in the emphasis on gestures in lyrical abstractionism; and a few painters have gone on to execute—to perform—their pictures before theatrical audiences. An attrac-

enough emotional associations to be meaningful? Can the gestures of a performer-painter endure comparison with the dancing of a competent ballerina? Is the picture—the post-notation, you might say, of the performance—capable of standing on its own as painting after the show is over? Once again, such questions are in varying degrees unfair, since a hybrid creation calls for a hybrid criterion; an opera, for example, has to be judged as opera, and not as pure music or pure drama. But merely to ask them is to be reminded of the difficulties faced by the painter who decides that the way out of his "post-historical" predicament is to mix the arts. He may indeed come up with a work which has a referent, a form, and a subject. He is very apt, however, on the record of recent exhibitions, to produce something which is minor in terms of its constituent arts and finally minor as a whole, at least when compared with unmixed things.

Why this should happen as often as it does, and to artists of demonstrated talent, is not altogether clear; but there are precedents which ought to worry a thoughtful modernist. The number of first-rate prose poems, for instance, is small. Bas-reliefs have seldom generated the intensity of sculpture in the round; in fact, they have usually been classifiable as ornament rather than as independent works. Even in opera, the most successful of the Baroque hybrids, the total of manifestly great achievements is far below that produced in music and the drama in separation; and operatic subjects are notoriously short on seriousness. Possibly the explanation for all this, aside from the fact that artists with two gifts are rare, is that the double form in a hybrid work somehow divides, confuses, or otherwise weakens our awareness of the relation between form and referent. The latter is transformed, is rendered "absent," in more than one way and more than one material, and our attention fails to concentrate. The order imposed on reality is uneconomical; its necessity is not apparent enough. These theoretical suggestions may account for at least some of the peculiar artificiality and the general lack of aesthetic muscle to be felt in many, although certainly not all, modern examples of painting mixed with some other art. But again perhaps the trouble is simply that we have not acquired the knack of perceiving the allegedly double form as a single new one. We see and think "painting plus sculpture," for example, when we ought to be seeing and thinking something like "painture"; and this is not merely a matter of words, for in art, as in much else, a nomenclature implies standards.

The divide-and-judge procedure can also lead to a relatively low opinion of many avant-garde attempts to combine painting, or a painting hybrid, with science and technology. Often the shapes and colours in Op and kinetic works are too simple, or too plainly derivative, to survive being judged by the criteria normally used for painting alone. What there is of science is apt to be something elementary about the behaviour of light which would not have astonished

an 18th-century squire. Often the technology, in spite of a few up-to-date touches intended to confer status in the present phase of the industrial revolution, is less impressive than that exhibited in many old toys, clocks, automatons, and kaleidoscopes. Far too often the effect of the tableau-gadget is exhausted as soon as the viewer has got over being surprised by the movement or the visual trick. Even the best type of Op or kinetic work tends to function less as an aesthetic object appealing to the imagination than as an apparatus affecting the nervous system directly; and there is a disturbing analogy not only with the devices of hypnotists but also with the use of drugs instead of meditation to heighten awareness (pessimists can note that Vasarely's retinalism became fashionable at the same time as LSD mysticism). Here again, however, we must be ready to discard inappropriate standards, and we can be grateful that at least an attempt is being made to unite the "two cultures" of art and science. Moreover, it would be unjust not to mention, along with the weaknesses just listed, the craftsmanship, wit, elegance, and period optimism to be found in some Op and kinetic pieces. Perhaps there are no very strong reasons for thinking that a fulfillment of Mondrian's prophecy of "pure plasticity in palpable reality" is around the corner, but recent experiments may in time lead to a new sort of environmental art—to something that will not quite be painting and yet will be too intense and stimulating to be dismissed as decoration. Or they may lead, in the hands of an inspired artist-technologist, to works in which referents and forms are found for truly imaginative treatments of subjects drawn from modern scientific thought.

VII

Accompanying the extremism, the tether-breaking, and the frontier-jumping is a tendency for modern painters to become speculative critics of their discipline—either by indulging in symbolic acts or, more often, by turning out works which are only incidentally, if at all, art objects and are primarily art-criticism objects. This is quidditism, of course, and I have already given some examples under that heading. But a few more can show that the tendency is worth emphasis, and that it is remarkably persistent.

In 1913, for instance, Kazimir Malevich exhibited at Moscow a black square painted on a white background. In 1918 he produced a white square within a white one. That same year Aleksandr Rodchenko executed his "Black on Black," and shortly afterwards a panel covered evenly with a brilliant purple. In 1953 Rauschenberg exhibited large all-black and all-white works; in 1957 Yves Klein came out with all-blue ones; in 1963 Ad Reinhardt returned to all-black ones. Can such things be regarded as paintings? Perhaps they can, but surely they are just as easily regarded as demonstration-statements about painting, or as demonstration-questions about the proper relationship between

painting and reality—in short, as art criticism of the speculative kind. And the same remark can be applied to hundreds of pieces of modern ultraism. Is painting possible after abstractionism? Rauschenberg asked that one—possibly he meant to answer it—with a symbolic, and quite expensive, act: he obtained a drawing from De Kooning and erased it. Has abstractionism gone too far in its formalism, in its insistence on the "absence" of the referent? Is painting after all just a state of mind? Klein staged an "art show" in a Paris gallery and left the walls bare (he even sold some of the invisible works). What are the differences, if any, between popular and elite art, between advertising and art, between reproductions and paintings? Is an aesthetic outlook reactionary, phony, and undemocratic? Such questions were posed over and over again in the 1960s by Andy Warhol, James Rosenquist, Roy Lichtenstein, and other Pop artists. Is a carefully done, full-sized painting of an archery target a painting or an archery target? The fact that it is looked at instead of shot at can hardly be the basis for an answer. Does putting a picture frame around it make all the difference? Jasper Johns, although a gifted artist, has often been more interested in alluding visually to such problems than in producing conventional painting.

The amount of farce in all this makes evaluation difficult, so let us grant right away that many of the jokes are now middle-aged, and aimed at a bourgeoisie which exists mostly in retrospect—in short, imitation of history is abundant. Also, when essentially the same *Quid est?* is manufactured in quantity and sold at a high price for cocktail conversations, the disinterestedness of the inquiring authors can be doubted. And finally, many of the ostensibly speculative devices answer the questions they raise too quickly to have much point. I have noted the tendency of some Pop pictures to subside after a second look into merely expensive examples of popular art; and clearly there is no pressing need for artist-critics who announce that pinups are pinups and comic strips are comic strips (the contention, frequently advanced by their partisans, that such artists stimulate awareness poses the problem of who wants or has to be made more aware of pinups and comics). A similar instability can be discovered in some of the Dada and neo-Dada quibbles about art and non-art; a torn poster, for example, may turn out after a second glance to have been deliberately and aesthetically torn, to have had a form imposed on it, in which case it is an authentic, if not necessarily good, work of art, and the quibble collapses. Or the thing may turn out to be obviously just an accidentally torn poster, and again the game is over almost before it begins.

There does exist, however, a respectable body of modern painting about painting, or about art in general. It can be called meta-painting, in order to suggest how thoroughly in tune with the times it is. It often parallels what Lionel Abel calls "metatheatre," not only because meta-theatre is theatre about theatre but also because meta-painting tends to eliminate the distinction be-

tween art and life and to suggest that all the world's a painting. There are analogies too with the speculative constructions which have appeared in many other 20th-century activities: with the technical meta-language which linguists use to refer to language; with meta-mathematics, which is mathematics about mathematics; with the models used by biologists and other scientists to further their inquiries; with the theoretical "games" played by modern-minded businessmen, economists, statesmen, and generals.

How should meta-pictures (they are often, of course, "post-historical" hybrid paintings) be judged? The question plunges a critic into the deep inwards of what H. L. Mencken called the criticism of criticism of criticism, and finding one's way out is complicated by the fact that the subject of many of these works is how any kind of art should be judged. But usually it is possible to say that a particular painter in a given meta-picture is effective, or is not, in the way he raises a critical question: Johns, for example, in his target pictures, has a referent and a form which yield an ambiguous subject hard to evade; whereas some of the Pop comic-strip enlargers do not seriously trouble the viewer for more than a moment. Then, if a critical question is effectively raised, one can try to decide if it is a good question. And finally one can try to judge the artist's implied answer, if there is one.

For instance, in the 1960s Rauschenberg and several other painters, experimenting in the zone between art and life, suggested that a painting can be produced by chance (here they joined forces with the composers of aleatory music), that the alleged human impulse toward order is in fact an impulse toward disorder, and that anything can become a work of art if it is placed in a cultural context in which the perceiver expects to find a work of art. Are the critical questions back of these suggestions important? They undoubtedly are. Do the suggestions, examined subjectively in the light of our personal experience, and objectively in the presence of the art history accumulated in the world's great museums, stand up as sound critical theory? If they do, the definition of art sketched in the introduction to this book was obviously wrong, for it stressed the order-making impulse which leads artists to create recognizably human enclaves—terrains of fraternal encounter—in the non-human order, or chaos, of the universe.

But in practice, whatever his theory may be, can an artist avoid the implications of this definition? What Rauschenberg and his school seem to think is that the artist can function as a mere designator, as a magician who can point at something, and presto—it will become a work of art. Possibly he can—especially if there are avant-garde spectators around who will connive, as children do in their games. But aren't we dealing here with simply the first stage of essentially the same process of selection as that to be seen in the Sistine

Chapel? Aren't we dealing with one more example of the pull of primitivism in modern painting?

VIII

One more puzzle can bring to a halt a chapter which has perhaps been over-loaded with puzzles. Suppose we grant that photography, the nature of our cultural era, and a certain lack of artistic tension in the old style made a new sort of painting inevitable around the beginning of this century in Europe (the same factors have been at work in the Orient, although there the acceptance of the new has been facilitated by the fact that the old was already fairly "modern"). Suppose we grant also that abstractionism, primitivism, and quidditism are apt to be attractive to any young painter with an inquiring mind and an expanding sensibility. Suppose we note the accelerating effect, the demand for novelty, created by modern multiplicity and diffusion. We still have not quite accounted for the seemingly uncontrollable and, to many viewers, dismaying *speed* with which drastic changes in painting have occurred. What made this art rush, or skid, in less than a generation from Renaissance figuration and optical naturalism into all-out modernism and on to the end of—even beyond—its tether? The problem grows when we recall that abstractionism, primitivism, and quidditism have existed in other eras without causing a "post-historical" crisis.

A possible, although unfortunately negative, explanation is that the external brake failed. In other eras, places, and cultures—in the early European Middle Ages, for instance, or in Africa, or in the iconoclastic Jewish and Islamic civilizations—the tendency toward abstractionism and aesthetic primitivism was always under the control of a prevailing ideology, usually religious and frequently political at the same time. Any extremism which might theoretically have emerged from, for example, the Christian cross was braked by the fact that the form was not felt merely as an abstract shape in a sensibility system, but rather as a symbol in a system of nonaesthetic values. Of course ideological brakes of this kind (they control a lot of Oriental painting which looks abstract to Occidental eyes) began to be ineffective with the secularization of Renaissance Europe, but by that time literature and illusionism, codified in academies all over the Occident, were firmly in command—the restraint formerly supplied by religion had been replaced by that supplied by the visible world. It was only when, around 1900, the latter was rejected that the loss of the former became evident, at least to painters as painters. With no system of public values strong enough to check it, painting began a runaway evolution toward stylistic maturity, toward the end of its "history," toward neighbouring disciplines, toward science and technology, and toward criticism—toward having itself as its subject.

These grossly simplified observations can be applied, of course, to other modern arts. But they apply particularly to painting because this art has relatively few brakes of its own with which to slow an initiated process of change. It has nothing comparable, for instance, to the friction of linguistic conservatism which restrains literature, to the instruments and trained performers required by drastically new music, or to the need for capital, workmen, and practical justification which check architectural innovation. Painters can explore all their possibilities in a few years. In fact, they have.

Balanced forms and proportions are the great Yes:
through them we can get to know ourselves.

CONSTANTIN BRANCUSI

Our primitivism is the extreme climax of complexity

UMBERTO BOCCIONI

Chapter 11 Sculpture and Allied Arts

A BEGINNING OF MODERNISM in sculpture can be found in the rejection of academic illusionism by Auguste Rodin, Medardo Rosso, and a few other 19th-century masters. A clean break with the past occurred in the early 1900s, when Constantin Brancusi began his simplification of shapes. More important, however, than any purely sculptural development was the influence of painting's abstractionism, primitivism, and quidditism; and today the majority of sculptors are still working along lines which began with pictorial innovations—with Cubism, for example. Thus many of the issues raised by modern painting appear also in sculpture, and this chapter can be shortened accordingly. But we ought to make an important shift in emphasis and notice some matters for thought which, while fairly common in the modern cultural pattern, emerge with a peculiar force from a three-dimensional context.

I

The shift in emphasis concerns what I have referred to, with some reservations, as "post-historical" phenomena in painting. These can be discovered in sculpture. The allusion in the title of this chapter to "allied arts" was needed to cover the large number of modern sculptors who have created works which, although in three dimensions and of relatively hard materials, lie beyond the traditional frontiers of the discipline. On the other hand, an even larger number have in recent years stopped trying to invent strikingly new styles—to make history. They have settled for expressions of their personal visions in one of the established modern idioms, and have thus joined their frontier-jumping

colleagues in tacitly granting the difficulty in any serious attempt to push further the evolution of their art.

In terms of the solid evidence, then, the parallel with the situation in painting is close. Yet somehow it is not felt as being close, and in this matter of art and "progress" a feeling is what counts. Among sculptors and their public there is little of the talk of a historical crisis which can be heard in painting circles. The anguished milliner's mentality which has infected the painting business, and which causes certain New York, Paris, and London dealers to fear that even last season's pictures may be old hat, tends to disappear when sculpture is the merchandise. Sophisticated critics, who may be chronically upset by recent failures to innovate drastically in painting, remain calm when a young sculptor chooses to work in a manner obviously derived from Brancusi, Picasso, Naum Gabo, or Henry Moore. He is expected to have a 20th-century manner, of course, and his own flavour, but he is not condemned for creating without inventing a new mode.

We can only speculate about the reasons for this failure to get ruffled. Perhaps the principal reason, which may eventually cease to work, is merely that in this instance museums, reproductions, commercial galleries, and other facilities for multiplicity and diffusion are not effective enough to start an accelerating demand for newness. We can also note that Western man's sense of history has always been relatively unprogressive, rather placidly Oriental, where sculpture is concerned. Probably the artisanal aspects of the art, combined with its weightiness and bulkiness, favoured an acquiescence in stylistic stability, once the important modern innovations had been got through. Moreover, at least some of these innovations were bound to resist ordinary fashion changes, for they were a return to sculptural first principles—to a feeling for materials, masses, and volumes—after three centuries of, on the whole, academicism and trumpery (a look at a few of our older public monuments, or an attempt to list the great sculptors between Michelangelo and Rodin, will confirm this sweeping judgment).

However, we do not need to understand the causes to see that the atmosphere of stylistic confidence which now surrounds modern sculpture can prove important in the future. We can guess that if modern painting were ever to collapse into complete triviality under the pressure for novelty (it probably will not, but the possibility cannot be ruled out) its historically slower sister-art would be on hand to take over. In fact, the take-over may be under way. Sculpture, including its allied activities, has been gaining public favour rapidly since about 1960, when the painting market ran into trouble. In most of the big international art shows of recent years the new sculpture has been considerably more impressive than the new pictures. We have already remarked on its tendency to pull pictorial forms into its realm, and there are signs of a similar at-

traction for architectural forms. At its present success rate modern sculpture could well become, by the end of this century, as important as statuary was in the ancient world and still is in primitive societies.

Is the prospect altogether encouraging? Is there a special significance to be found in the growing appeal of this particular art for the sensibility of 20th-century man? The reader will of course want to answer such questions, which are to some extent personal, for himself. He may find it helpful, however, to be reminded of a few of the differences between modern sculpture and the traditional Occidental sort—the sort that goes back at least to Phidias and was still being produced in great quantity, if without much quality, when the time came to erect monuments to the dead of World War I (a comparison of these monuments with those erected after World War II would be revealing about many things besides sculpture).

II

Oddly, during their approximately 24 centuries of high productivity, traditional sculptors seem never to have thought of developing still life and landscape genres, as Occidental painters did during the Renaissance. Statues have, by traditional definition, mammalian referents. And if they have frequently been representations of lions, horses, or other members of the highest class of nonhuman vertebrates, they have quite overwhelmingly been images of man—including woman, of course. One can go a bit further and say that for most Europeans and Americans a statue, to qualify completely as such, must not only represent man, but do so in an idealized or heroic, and more or less anatomically accurate, fashion. Even a carved image of a humanized god must conform to this definition; if it does not, we tend to refer to it as an "idol."

On this basis, modernism in sculpture can be described negatively as the end of the long reign of the Occidental statue. Clearly, the word cannot be applied to contemporary abstract cages, spheres, and cubes, nor to the three-dimensional still lifes of Futurist, Cubist, Surrealist, and Pop artists, nor to the mobiles and machines of the kinetic school. Granted, many 20th-century sculptors have continued to turn out images of man. But "statue" has exactly the wrong connotations for Henry Moore's mutilated warriors and perforated nymphs, Alberto Giacometti's thin, solitary walkers, Germaine Richier's eroded, insect-like beings, or Marino Marini's unbalanced equestrian figures. And these creators from the older modernist generation are regarded as conservative by some of the younger sculptors, whose images of man are conditioned by a sharper awareness of such inventions as concentration camps, atomic weapons, and electronic brains.

One must be careful not to interpret the evidence crudely. Many of the apparently heroic statues erected by traditionalists are lifeless stereotypes, and

therefore meaningless. Many apparently antiheroic modern works change under sympathetic scrutiny; there is, for example, a deep current of humanism in the figures conceived by Moore and Giacometti. A lot of abstract sculpture is not to the point here, for it is largely the result of seeking solutions for aesthetic problems. Another category (about which more in a moment) is partly the result of an intention to entertain. Nevertheless, when all these nuances have been allowed, a comparison of modern with traditional sculpture does reveal that an art which was once almost entirely anthropocentric has become significantly less so and that images of man in the round have become less flattering. The implication that man's pride and confidence in himself have dwindled is arguable, but hard to resist.

III

Modernism has also brought a stronger feeling for the actual stuff of sculpture. Serious carvers and modelers have always emphasized, of course, the intrinsic qualities of materials, and some of today's feeling can be traced back to the Renaissance, when the ancient and medieval taste for coloured effigies began to weaken among connoisseurs. Traditional statuary, however, tended to draw attention to its images of heroic man rather than to its substance, and it was encouraged to do so by the prevailing human self-esteem. Narcissus was not interested in the intrinsic quality of the water.

Bronze, traditionally "noble," practically indestructible, and capable of taking a rich patina, has been the favourite material of modern sculptors. It has acquired a new shock value as a result of 20th-century interest in rough textures and abstract, distorted, archaic, zoomorphic, or strange plant-like forms. The traditional stone materials, in particular marble, have been rather out of fashion, but when used—by Isamu Noguchi, for example, or Étienne Hajdu—they also seem to have nontraditional sort of vitality. Wood, after centuries of neglect by sculptors in the elite category, has been rediscovered and exploited by artists with styles as varied as those of François Stahly, Barbara Hepworth, Étienne-Martin, and Louise Nevelson.

Many 20th-century sculptors, however, in spite of the freshened appeal of bronze, stone, and wood, have felt that a rejection of the traditional "statue" mentality could not be psychologically complete without a rejection of traditional materials. Steel has been used eloquently by such modern masters as David Smith, Theodore Roszak, Anthony Caro, and Norbert Kricke, and defended by Smith because of its suggestions of a new era: "The metal possesses little art history. What associations it possesses are those of this century: power, structure, movement, progress, suspension, destruction, brutality." Ibram Lassaw, to take an example from a quite different camp, has achieved some of the most subtle expressions of the modern sensibility by experimenting for years

with metal alloys, jewels, salts, and acids, and has brought colour back into sculpture, not through paint, but in the materials themselves. Among the sculptors who have attracted critical attention since 1950, Reinhoud is remarkable for his use of brass, and Alicia Penalba for her use of concrete (as well as bronze and stone). Other modernists have employed glass, aluminum, plastics, paper, string—even water and beams of light, which must certainly be called sculpturally post-historical. But of course iron has provided the biggest surprise.

Not since the days of the Hittites, for whom iron was rare enough to be used in royal gifts and tributes to the gods, has this everyday metal occupied so high a place in the fine arts. It is the substance in some of the most witty and profound pieces of modern sculpture. Here I think, with as usual no attempt to be exhaustive, of Eduardo Chillida's gloomy, snake-like symbols, Robert Müller's botanical forms, Jean Tinguely's futile junk machines, Lynn Chadwick's poised menaces, Rudolf Hoflehner's mythical and Freudian personages, Reg Butler's caged people, Robert Jacobsen's satirical dolls, and Bernhard Luginbühl's organization of space. One should also mention Julio González, the Catalan blacksmith who came up to Paris in 1900 (that date is hard to avoid), fought poverty and public neglect for forty years, and with some help from Picasso laid the foundations for the achievements in iron sculpture which came after World War II and are still appearing.

Iron—in particular secondhand iron—has been such a success it is reasonable to suppose that some factors besides a simple desire to break the monotony of bronze and marble have been at work. Easy historical explanations cannot be found; there would seem to be no connection, for instance, with traditional wrought-iron decoration, except sometimes in terms of technique. Steel, as David Smith pointed out, is the metal with the obvious associations for the 20th century. But perhaps iron resonates with the modern sensibility in secret ways. It is very much an underground substance, with none of the warmth of bronze and almost none of the brilliance of steel; it reflects only a chilly sort of twilight. One can think of it as something fiercely independent, since it does not invite the touch of a hand as bronze does. Proverbially it is tough, and capable of lasting forever. But in fact it looks naked without a coat of paint, and in fact it is far from invulnerable; eventually it rusts to death. In sum, iron goes reasonably well with what are alleged to be some of 20th-century man's traits: his sombre interest in his buried life, his preoccupation with authenticity, his tough bluffing and actual insecurity, and his rueful awareness of his own and possibly his industrial civilization's mortality. If all that is pushing the symbolism too far, we can at least say that this banal metal is thoroughly suitable for an art reluctant to nourish human pride and confidence. A heroic statue automatically becomes a parody, an anti-statue, when conceived in rusty iron.

IV

The end of statuary and the fresh emphasis on materials have been accompanied by a renascence and a revolution in technique. A century ago the average sculptor was something of a gentleman-artist, a creator of clay or plaster models who left to workmen the manual labour of actually carrying out a project—of cutting the marble or casting the bronze. Today, although casting is still usually done by specialists and large monuments may not be executed by the artist, the average sculptor is apt to be his own craftsman; and as such he can give his pieces a personality and a vitality rarely found in the work of 19th-century traditionalists.

He may attack his materials directly, without the aid of preliminary sketches and models. This way of working is open to objections, particularly from the traditionalist point of view, for it reduces severely the possibility of experimenting and of correcting mistakes during the course of creative activity; when the marble, for example, is cut away it cannot be put back as plaster can. But there are effects of spontaneity to be gained; and a work conceived boldly in the material in which it is executed may have an integrity denied to translations from the clay or plaster of a preliminary study. In any event, it is likely to appeal to that part of the modern sensibility which responds to aleatory music and Action painting, which prefers pragmatism and existentialism to philosophies of pre-existing essences, and which tends romantically to assume that impulses are somehow more respectable—more real and honest—than taking thought is.

The direct sculptural attack, however, cannot be used in its full purity when casting is part of the process, and anyway it is by no means exclusively modern; it was favoured by Michelangelo, for instance, is common among primitive and folk artists, and even has overtones of the 19th-century Gothic Revival. Much more revolutionary have been the antistatue impulses which have led "sculptors" to abandon, in various degrees, traditional carving and modeling in favour of constructing and assembling. These 20th-century techniques have been used to create striking works which suggest, according to the spectator's mood, some cheering or disconcerting conclusions as to where we are now, not only in art but in our modern culture as a whole.

The ancestry of today's sculptural constructivism is easy to trace. It goes back through the works and theories of such pioneers as Vladimir Tatlin and the brothers Naum Gabo and Antoine Pevsner straight to the collages, Cubism, and abstractionism of pre-1914 modern painting. Along the way there were marriages with Platonic ideas, architectural forms, and technology. The results, to be seen to advantage in the creations of such artists as Picasso, Gabo, Pevsner, Alexander Calder, Herbert Ferber, Richard Stankiewicz, Hans Uhlmann, David Smith, and Anthony Caro (many of whom cannot be called doctrinaire Constructivists), may be enjoyed and evaluated in several ways: as

three-dimensional Cubist or abstract (sometimes Abstract-Expressionist) drawings in the air; as ideal structures; as visible music; as 20th-century symbols of progress or decay; and—very often—as a kind of absolutely classical architecture, an architecture without emotional content and without utility. What they cannot be enjoyed and evaluated as is traditional sculpture, for they are relatively poor in terms of volume, mass, and tangibility. They tend more to articulate space than to occupy it. And of course there is not a potential Galatea in the entire collection.

The technique of the "assemblage" is less easy to isolate in words, for it is ambiguous almost by definition and is usually found in combination with one of the other principal techniques—carving, modeling, and constructing—or with the methods of painters. Basically it is the union of "real" elements in such a way as to create a poetic metaphor, a kind of sculptural pun, or a tableau in which the reality of art and the reality of reality are questioned. A well-known and very successful example is Picasso's metamorphosis of a bicycle's seat and handlebars into the head of a bull. More elaborate examples can be found in the Pop art of the 1960s, and here the real elements may be mixed with plaster or plastic casts of people and things, or with paintings and photographs. A detailed section of the artist's environment—a favourite bar, for instance— may be reproduced and assembled; or the technique may be limited to the insertion of a single real item in an aesthetic construction. There are obvious historical connections with the Cubist collages again, with the ready-mades of Duchamp and the Dadaists, and with the Surrealist cult of the found object and the shocking or amusing metaphor. Without the irony there would also be connections with shopwindow displays, theatrical *mise en scène,* the realistic tableaux of folk carvers, and even the waxworks of Madame Tussaud. If the typical "construction" risks an empty sort of classicism, the typical "assemblage" risks an over-ripe sort of romanticism. The one tends to move beyond sculptural appreciation at the cool end of the spectrum, and the other at the warm.

V

Here my warning about the perils in the method of this book should be sounded again. In an effort to concentrate on what may raise issues, now or in the near future, I have said nothing about one of the most remarkable achievements of 20th-century sculptors: their revival of the power of tribal and archaic idols, fetishes, totems, icons, steles, and menhirs. In the best pieces of artists like Moore, Giacometti, Brancusi, Jacques Lipchitz, Calder (particularly his massive stabiles), Max Ernst, Joan Miró, Picasso, and their successors there is a peculiar hypnotic intensity which had been largely missing, with the exception of the Romanesque period, from Western art since the triumph of Greek classicism. It is as if Occidental man, having fallen out of love with his own im-

age, were about to be rewarded for his new humility, were about to re-establish his lost contact with the metaphysical universe and begin again—this time with more science and self-knowledge—the evolution from magic to religion.

In all probability he is not about to do anything of the sort, for the secular current which has been flowing since the 16th century appears to be irreversible. Also, one must grant that some of the savage religiosity in 20th-century sculpture is just Surrealist joking or at best a variant on the purely aesthetic primitivism in many contemporary paintings. Even so, the residual achievement is worth pointing to. Modern sculptors, perhaps because of the advantages inherent in their three-dimensional art, have been better than other artists at finding objective correlatives for the invisible and subjective gods and imps discovered by psychoanalysis. Given a little more practice, they may develop a neoprimitive iconology to go with Freud's and Jung's psychological substitutes for the terrors and consolations of primitive religion.

The trend toward depth-psychology has been accompanied, however, by two trends, often among the same artists, toward an emptying of sculpture of its psychological content. This has been alluded to in our discussion of constructions and assemblages, but it is time to be a little more specific.

VI

The first of these "emptying" trends is toward the conversion of sculpture into fun and games, and it is naturally most evident in the kinetic branch of the art. Although thousands of pages of serious analysis have been devoted to Calder's delightful mobiles, the plain fact is that his primary appeal is to our play-impulse: one has only to watch a spectator yielding to the temptation to blow or flick the apparatus into unpredictable motion. A good deal has been said, with considerable accuracy, about the profound implications for our technological era in Tinguely's insane machines, but again the spectator-test is apt to be conclusive: the profound implications are lost in the feeling that the machines are innocently crazy—that they are mostly just boisterous, if sometimes sly, toys. Similar remarks can be made about almost any of the Op and kinetic sculptors who have been getting renewed critical attention recently (the genres are not as new as the attention) and who of course cannot easily be separated from the Op and kinetic painters mentioned in the previous chapter. Their presumably serious scientific and technological messages, and often their real aesthetic achievements, are likely to be forgotten in the midst of the pleasure they provide as creators of novel games. To attend a large show of their works is to enter the equivalent of an amusement fair, full of people playing the ball machines, laughing at themselves in the distortion mirrors, getting lost in the mazes of light.

Now perhaps there is not much cause here for alarm. The idea of an analogy

between the art-impulse and the play-impulse, first elaborated by Friedrich Schiller at the end of the 18th century, has much to recommend it. Sculpture, after a hundred years of being usually humourless and often pompous, was in need of some comic relief, and the modern world can do with some fresh play-fulness. There are signs, however, that the trend is getting beyond the stage of easy dismissal or justification; something deliberate and philosophical enough to be called a ludification of sculpture (although not in the sense of deriding the discipline) is apparently being attempted. It is worth attention because it happens to be an unusually clear example of something in the air of the late 20th century, something I have touched in previous chapters without giving it a common name. John Cage and his followers appear to be working toward the ultimate ludification of music. The producers, or provokers, of "happenings" seem to be intent on the ludification of drama, which is not quite the same thing as being intent on preludes and interludes. We shall presently have occasion to notice parallel developments in the cinema and the novel. Here and there the ludification of business and even science is being hinted. The theory of games fascinates modern mathematicians and modern philosophers. It would obvi-ously be too much to say that we seem to be moving toward the ludification of human life, but perhaps not very much too much—at least not for anyone who is tired of the number of games on radio and television programs. The whole many-pronged tendency can be linked, at the risk of being too solemn, to that loss of certitude which has been mentioned so often in this book. Deprived of authenticity, Vladimir and Estragon play games while waiting for Godot. Con-fronting absence, painters and poets do tricks with pigments and words. Me-dia which cannot refer to familiar realities tend to become self-referring; and from self-reference to mere play the psychological distance is not great.

This is not the place for an analysis of Schiller's notion. But it may be worth-while to point out that he was talking about an analogy, not an identity. After experiencing a piece of art-sculpture the sensitive viewer is, if only very slight-ly, a different person—a bit wiser and riper. After experiencing a piece of play-sculpture he is an unchanged person who has made the time pass agreeably.

VII

The second "emptying" trend I have in mind is toward the reduction of pieces of sculpture to the status of mere objects. This is to some extent just part of a general modern tendency: the language of poetry has become more dense, music often seems to be just sound or noise, many modern pictures seem to be just paint and canvas. But even the extremists in these other arts have found it hard to avoid a metaphorical effect; there is nearly always a hint of something behind the form which the imagination can detect and amplify. The modern sculptor finds it easier to get rid of such content, for a piece of sculpture, unlike

a poem or a sonata and much more than a painting, exists as a physical thing. It actually is an object. In the past, to be sure, it was not merely an object; it was, like paint on canvas, a transparent medium through which the imagination looked at a strong referent, usually heroic man. But all this has changed since 1900. Our fresh awareness of bronze and stone and our surprise at the new materials have brought the real object forward in our minds, have made it more opaque for the imagination. The abstract construction has contributed to the trend by severely weakening referents. The figurative assemblage has contributed by uniting ready-made or found elements. Art critics have contributed by being reluctant to talk about such old-fashioned "subjective" matters as proportion and composition. Since World War II "object" has become the avant-garde way of referring even to a traditional statue.

The results can be seen in any recent show. Today a sculptor may emerge from modern quidditism with what appears to be an ordinary rock, a plain box, or a shabby relic from a junk heap—with simply an addition to our environment of things as opaque things ("environmental" has become almost as fashionable as "object"). In other words, while some of his companions have been ludifying the art, he has been reifying it. Can his object be called—following the definition of art in my introduction to this essay—a terrain of fraternal encounter? A fresh vision of our humanity? An enclave of human order in the non-human chaos? Admirers of the object can argue that it is properly "useless" and is evidently something created, or at least selected, by neither God nor nature. Non-admirers can reply that an automobile out of gasoline fits those specifications exactly. Admirers can come back with the contention that right there is part of the point to the whole operation: the modern sculptor has opened the way to the enjoyment of almost any object as sculpture. Duchamp and the Dadaists, according to this argument, were mistaken in thinking that an exhibit of ready-mades can only be a debunking of art, for it can also be an extension of art's domain.

At this stage a third party, not necessarily reactionary, may wish to shift the inquiry from general theory to specific evaluation. Granted that the object under discussion may be regarded as a work of art, is it a very good, or even a very interesting, work?

I hope that putting such a question at the end of this chapter will not imply an adverse judgment on the scores of gifted modern sculptors who are certainly not makers of mere objects, nor of games, and who have contributed handsomely to the present revival of sculptural activity and appreciation. There is, as I began by suggesting, much evidence that this particular visual art is in a great period. But that the death of the Occidental statue has had some troubling consequences can scarcely be denied. And perhaps these consequences were not entirely unforeseen during the centuries of traditionalism. Looking

back from some of today's trends, one can believe that the preference for images of man was due to something besides human vanity; it may have been sculptural prudence, based on a fear of releasing tendencies inherent in the materials and methods of the art. After all, a painter can do a still life without worrying about a loss of spiritual connotations, whereas a sculptor cannot; his medium is too apt to represent the material motifs as such—to reify everything.

Architecture is the will of an epoch translated into space LUDWIG MIES VAN DER ROHE

Actual representation of history has in modern times been checked by a difficulty, mean indeed, but steadfast; that of unmanageable costume
JOHN RUSKIN

Chapter 12 Toward a Dialectical Architecture

UNLIKE THE 20TH-CENTURY DEVELOPMENTS discussed so far in this volume, modernism in architecture is practically unchallenged (which is not to say there has been no grumbling). Swept around the world by the post-World War II building boom, it has been defeating traditionalism everywhere except in the artistically regressive Marxist nations, and even there the old guard has been looking for a dignified way to surrender. With success have come stylistic variety, a questioning of formerly sacrosanct premises, some misgivings about the future, and consequently a formidable question for the contemporary cultural historian, or situator. Where are we now? As always, an honest answer must be indefinite, and so my chapter title includes the "toward" which has been appearing above architectural essays for the past fifty years. But the evidence does strongly suggest that we are moving toward an architecture which will not translate the will of our epoch into a single mode, as seemed possible a generation ago and as Gothic architecture, for example, did with the will of its particular epoch. The most striking tendency today is toward a dialogue, or rather a collection of dialogues, between "-isms" that were once in stiff opposition and struggling for exclusive control of building programs. I have chosen to call the whole pattern dialectical, on the assumption that it will prove to be a dynamic interaction of theses and antitheses—an alternating cultural current which will power us nicely into the future. I grant, however, that my adjective may turn out to have been merely a device for seeming to organize confusion, or worse still, just a hopeful euphemism for eclectic and reactionary trends. In the present situation there are reasons for being uneasy as well as for applauding.

172

I

Some of the reasons for uneasiness (they have brought applause from certain quarters) can be wrapped up under the label "historicism," an awkward but accepted term for the deliberate borrowing of elements, sometimes of entire forms, from the architectural styles of past eras. Historicism, although practised and admired in various degrees from Hellenistic times forward, and although basic in the Renaissance outlook, can be regarded today as an architectural sin. It failed disastrously during the 19th century in Europe, partly because it was amplified into full revivalism by Romantic lovers of the bygone, partly because there was no longer an upper class whose taste was sure enough to pull the borrowings together in a coherent, urbane, contemporary style (as had been done as recently as the 18th century), and above all because the Industrial Revolution was under way. Old forms which, when history was relatively slow, were suitable architectural clothes became inconvenient fancy costumes when history, especially technological and social history, suddenly accelerated.

Twentieth-century architecture arose out of the conviction that such costumes were absurd. There are, to be sure, traces of the past in the work of the great elders of the movement. There are hints of traditional Japanese posts, beams, panels, and spaces in some of Frank Lloyd Wright's houses. Le Corbusier's forms may recall those on Mykonos and other Mediterranean islands, and his buildings are often sited in ways that show an Attic feeling for contrasts between natural and man-made structures. Even the steel and glass slabs of Ludwig Mies van der Rohe may evoke the rhythms and proportions of earlier periods; there is a romantic insistence in his stark classicism. All this, however, is a question of anonymous spirit and general attitudes; it does not involve us in anything like a Victorian or Second-Empire attempt to provide the pleasure of specific historical associations—a literary as well as an architectural pleasure.

The same—as any alerted tourist or buyer of architectural albums knows— cannot quite be said of the reminiscences in many buildings designed or completed since 1950. Eero Saarinen's Stiles and Morse Colleges at Yale recall the 14th-century Tuscan hill city of San Gimignano; and so, although less deliberately, does Alvar Aalto's picturesque town hall at Säynätsalo, Finland. Edward Durell Stone's Gallery of Modern Art in New York incorporates hints of Islam and Asia which are much too specific to be a question of anonymous spirit. Minoru Yamasaki's design (not accepted) for the new American Embassy in London, following the U.S. State Department's diplomatic directive to emphasize "the historical meaning of the particular environment," intentionally mixed "the typical English character of the Palace of Westminster with the elegant lightness of the Doge's Palace."

The new American Embassy in Athens, by The Architects Collaborative with the veteran modernist Walter Gropius in charge, has part of a peristyle and a facing of the same Pentelic marble that was used in the Parthenon. Philip Johnson, at one time an ardent propagandist for the smooth, cubic, undecorated, and strongly structured kind of modernism that emerged in the 1920s (sometimes referred to as "the International Style"), alludes overtly in his more recent work to the Romantic Classical architects of around 1800—especially to Sir John Soane and Claude Nicolas Ledoux—and also to Hadrian's Villa, Gothic buttresses, Baroque domes, Norwegian stave churches, Buddhist stupas, and the work of Thomas Jefferson. Kenzo Tange and other Japanese disciples of Le Corbusier have been taking long, affectionate looks at their ancient national manner. Italian architects have been turning from their gay post-World War II rationalism toward evocations of the silhouette of the medieval fortress; and some have been giving their buildings an ironical look by alluding to the Art-Nouveau decorative trend of 1900 (*stile Liberty* in Italian): the first of the 20th century's antihistorical styles thus becomes a source for historicism. In England there has been some neo-Palladianism, in France a hint of neo-Gothic, in Mexico some allusions to Indian and Spanish colonial traditions. In all countries it has become current modern practice in domestic architecture to imply here and there the presence of a detail from a historical style—to suggest the shadow of a classical cornice, for instance, or the pattern of a roof truss.

So far, perhaps, there is not much in the trend to justify the disarray it has produced in the ranks of the more orthodox modern critics. Twentieth-century architecture is now successful and mature enough to dispense with the puritanism it needed during its pioneer phase. The historicism which has reappeared is of a very mild sort; none of the examples we have mentioned is on the level of a 19th-century revivalist work, and most of them can be defended as distinguished pieces of modern architecture. Moreover, orthodox modernism—a modified and refined International Style—is still thriving in the United States and in the world at large; its strength becomes obvious as soon as one thinks of Mies's and Philip Johnson's influential Seagram Building, of the glass towers, beginning with Lever House, produced by Skidmore, Owings and Merrill, of the engineer-architects in France and the new Germany, of rationalists like Franco Albini in Italy, of practical artists like Marcel Breuer. All that has happened is that a bit of a dialogue with the old alleged wickedness has been initiated, for the most part by men whose past allegiance to strict modernism ought to make a hostile critic cautious. One can disagree with them on the grounds of personal taste (the reader has probably guessed already that I do, more often than not). But at this stage anyone interested in architecture (everyone, that is, ideally) ought also to weigh as objectively as he can the disadvantages and advantages in the trend, assuming it continues.

II

We can get at some of the disadvantages by thinking about the types of shelter which did not exist, or did so in only a rudimentary way, when the traditional architectures of Europe and Asia were created. Factories, railway stations, office blocks, apartment houses, hotels, sanatoriums, shopping centres, welfare institutions, garages, bus terminals, airport facilities, community schools, and large universities come to mind. Here the strict modernist can say there is no argument. To dress up such buildings in costumes taken from temples and palaces, which are about the only ancient forms large enough to serve as style-lenders in this instance, would be absurd indeed. It would be absurd even if the efficiency of the contemporary structure were not affected. To allude to the Basilica of St. Mark's in a tractor factory would be to commit a breach of decorum and to risk looking unmanly. Of course the new historicism has not been guilty of anything as bad as that. But may it not be the first step toward such wickedness?

The voice of the strict modernist is apt to be less firm when the discussion turns toward museums, theatres, opera houses, churches, individual homes, and a few other non-machine-age types of shelter, including embassies perhaps. On the whole, the needs which such buildings fill are not radically new. There have been changes, but family living, religious worship, theatre-going, and art-exhibiting are close to what they were before the Industrial Revolution. We want them to have the benefits of up-to-date equipment and modern planning. But there would seem to be no strong reason, in the context of use, for carrying on such traditional activities in completely untraditional buildings. A few allusions to the architectural past will not be incongruous in the way they would be in a factory. Here we can say it is often the ultra-modern architect who perpetrates absurdity. By insisting on an all-out machine-age style in edifices intended for partly pre-machine-age experiences he commits the sin of historicism in reverse. And that this is more than a debating point can be felt by anyone who has watched the Baroque art of opera in a bleakly anti-Baroque auditorium, or who has participated in the ancient rituals of Christianity sheltered by the stylistic equivalent of a tractor factory.

In the commonsense context of use, then, a case can be made for at least some architectural reminiscing in at least some kinds of buildings—for an enrichment of historical associations. I repeat: in the context of use. For there are other, possibly more elevated and pure, contexts for appreciation, including some in which the foe of the new historicism may find himself refreshed for battle.

Architecture can be enjoyed as a kind of abstract painting (figurative perhaps in details), as a kind of habitable sculpture, and—which is the uniquely architectural way—as an order imposed by man on space. Most people would

add that it ought to be enjoyed as art, as an arbitrary, humanly expressive pattern; while it must be useful, it must not be merely so. A few people, including most architects, would insist that the art cannot be properly enjoyed in a vague or sentimental way: a fine building has to be understood, to a much greater degree than a fine painting or piece of sculpture. In all these approaches to appreciation, 20th-century building materials and techniques have brought significant, sometimes startling, changes. Steel, glass, and concrete reinforced at points of stress with steel bars or mesh have become common. So has the curtain wall: a sheath or skin which performs all the traditional separating and insulating functions of a wall, but which turns over to a steel or concrete skeleton the traditional wall function of bearing the weight of floors and roofs. So has the cantilever: a slab or beam supported at only one end and projected daringly into space. So have *pilotis:* free-standing piers, pioneered by Le Corbusier, upon which even great skyscrapers may be lifted free of the ground. So have many other transparent structures, continuous structures, suspension structures. The result is that the typical modern building differs profoundly from the typical traditional Western one (and also, although slightly less so, from the typical Oriental). It tends to emphasize volume instead of mass, openness instead of confinement, continuous instead of broken rhythms, the principle of tension instead of compression in structural members, weightlessness instead of weightiness, and dynamic space-time instead of static space. In this context it is hard to see how stylistic borrowing from the masterpieces of the European and Asian past can lead to anything but decoration—incongruous decoration—for eyes which have learned to appreciate, to understand, modern buildings. Historicism was possible for centuries not only because of the tempo of history, but also because the essential principles of architecture, and hence of its enjoyment, had not changed. Now they have, pretty drastically; and such things as the new space frames and new plastics prove that the change has just begun. We seem to be evolving, as Richard Buckminster Fuller has suggested, toward invisibility.

One of the answers of the new historicists to this argument is disarming: it is that we have had enough of structural and spatial excitement for the moment, and can do with a little more of the pleasures of decoration and "literary" association. After all, such pleasures were long considered legitimate. The great Gothic architects, who in their own way were as fascinated by structure and space as modernists are, did not rely exclusively on the appeal of their superbly engineered vaults; they added sculpture and converted their vast windows— their curtain walls—into pictures of sacred history. Moreover, it is possible to reminisce in a modern building in a manner which is just as modern as machine aesthetics and flowing space. Berg, in his Violin Concerto, achieves a thoroughly 20th-century effect by using a phrase from a Bach chorale in a seri-

al context. Dozens of modern painters, from Picasso to Rauschenberg, have alluded ironically to Renaissance masterpieces. Eliot is seldom more modern than when he quotes Spenser in *The Waste Land:*

Sweet Thames, run softly, till I end my song.[1]

In a similar, if more confident and less ironical, spirit a modern architect can "quote" a Tudor window, a Greek cornice, an Islamic screen, even, if he has a taste for dangerously large allusions, something like the sweep of the Royal Crescent at Bath. He can rely, that is, on our awareness of the essentially modern character of his buildings, and can use this awareness to produce historical perspective and contrast. The new American Embassy in Athens is made arguably more, not less, modern by its dialogue with the Parthenon.

However, it must be said that some of the new historicists are clearly not trying to be modern in a sophisticated way. Their allusions to the past weaken instead of heightening the contemporary feeling in their buildings. The plain intention is simply to provide clients and the general public with a dash of the good old-fashioned sort of architecture. And back of this intention lies resignation, sometimes weary and sometimes eager, to a manifest cultural lag: most people, in the late 20th century, still find an uncompromisingly modern building difficult to appreciate, to understand aesthetically. Their eyes still see traditionally. They still look unconsciously for stone instead of steel, glass, and reinforced concrete; for load-bearing instead of curtain walls; for enclosed static space instead of open space-time; for the old principle of compression instead of the new principle of tension. As in many other realms of thought and feeling, the old realities have been discarded and the new ones do not seem quite real. When the concrete had set in the great waterfall balcony of the Kaufmann house at Bear Run, Pennsylvania, Wright himself had to grab an axe and begin knocking away the supporting scaffold; his nervous workmen did not believe in cantilevers enough to stand under one. Today such "invisible" structures obviously inspire more pragmatic faith, but probably not much more aesthetic belief. Certainly they do not, except to a relatively small number of connoisseurs, provide the satisfaction derived from familiar arches, columns, and lintels in stone or wood.

Are the new historicists wrong in making concessions (admittedly slight in most instances so far) to this lag? Notice that the issue is not what it would be in music, painting, or poetry. Nobody is obliged to listen to Boulez, to look at a Vasarely, or to read René Char. People are more or less forced to look at and live in buildings. Should they be forced to experience buildings they do not appreciate, on the assumption that eventually—since the architecture is to a connoisseur both beautiful and logical—their eyes will cease to yearn for old-

1 T. S. Eliot, *Collected Poems 1909–1962*, Harcourt, Brace & World, Inc., New York; Faber & Faber, Ltd., London, 1963.

fashioned reassurance? Most of the pioneers of 20th-century design, who were prophets and authoritarians out to destroy sin, would have answered with a fervent Yes. The new historicists are of a milder breed, less addicted to social and political crankiness; and they can be pardoned for being weary of the old Wrightian and Corbusian self-assumed obligation to save an unwilling universe. They can be forgiven for offering the retarded customers some small traditional comforts. Let us simply be clear about the possible implications for the future. In nearly all the arts today, to produce new work in a traditional style is to stop being completely serious, to lose the stimulus and support of a demanding minority audience, and to begin willy-nilly a debasing process of appeasing a majority taste. Architecture may be to some extent an exception; it may have to be an exception, unless a devout Miesian happens to become world dictator. But the new historicism is going to take some alertness, if it is not to lead in architecture to something like the sharp division between elite and popular which exists in contemporary music, painting, and poetry.

III

By beginning this discussion under the heading of historicism I began with everything, for of course all the problems of modern architecture are historical. Today's dialectical tendency can be got at, however, under the headings of several other -isms, including "functionalism"—the catchword of the 1920s and 1930s and one of the most fertile sources of sense, hope, cant, and confusion in 20th-century building practices.

Much of the confusion has been due to not noticing that functionalism is actually several doctrines. One, which is as old as the first hut but which had to be forcefully reasserted when architecture became fancy costuming, is merely that a building ought to do its job efficiently; the kitchen ought not to be too far from the dining area, and the roof ought to let the rain run off properly. Another, which also had to be reasserted, is that a building ought to look as if it were doing its job; an office block ought not to look like a cathedral. Another, which began to be formulated when critics of historicism in the 19th century remarked on the clean lines of such non-art objects as tools, bridges, American silos, and clipper ships, is that if attention is paid to efficient function a beautiful form will follow automatically. Another, which has links with the Gothic revivalists' admiration of ribbed vaults and flying buttresses, is that each element in a construction ought to express its function separately and visibly; the frame, for example, ought to be undisguised enough to announce its support of the floors. Another, which was at one time strongly advocated by Le Corbusier and German architects, is that in a machine age a building ought to be and to look functional by analogy with a machine: the forms ought to be geometrical and the finish smooth.

One of these doctrines does not necessarily imply another. You can want a house to do its job efficiently and yet not want it to look like a machine. You can enjoy visible structures without taking "form follows function" to mean that a beautiful form will emerge if an architect thinks about nothing but function. There are, however, some attitudes which are recurrent enough to unite the various doctrines into a system which can be loosely referred to as functionalism. There is a hostility toward subjective artiness, a liking for a kind of matter-of-factness in buildings—for a quality which the German pioneers in the movement called *Sachlichkeit* (almost untranslatable, but roughly "essentiality", or "suchness"). There is a fondness for decorum and for economy of means which gives many functionalist buildings a definitely classical look. And of course there is a dislike of decoration; no functionalist could possibly accept John Ruskin's dictum that "ornamentation is the principal part of architecture." In a thoroughly functionalist building the "decoration" is in the natural qualities of the materials.

That functionalism in its several varieties is still going strong in the late 20th century scarcely needs saying. The reader can probably see an example by glancing across the street, if he does not happen to be sitting in one. In fact, the movement has won so many victories over architectural nonsense we are apt to be ungrateful and take its products for granted. We forget how revolutionary it was, as recently as 1930 even in the United States, to scrape gingerbread applied ornament from the walls of skyscrapers, to let enough light into school buildings, to take a housewife's instead of an archaeologist's view of the problems of kitchen design, and to use new materials frankly and efficiently. A good deal of foolishness has been written about "honesty" in architecture, but it should not cause us to overlook the genuine moral earnestness and social conscience which functionalism at its best achieves. Nor should we forget that the moral earnestness may have aesthetic consequences. Every large city today contains proof that the functionalists are correct in their assumption that a designer is likely to emerge with satisfying and properly architectural forms, as distinct from pictorial and sculptural ones, when he is wrestling seriously with the problem of an awkward site, or where to put the bathroom, or how to get thousands of commuters in and out of a station at train time. Although sound building is not necessarily great architecture, all great architecture is sound building.

However, a reaction—a dialectical swing—is clearly under way. There are many reasons for it. Functionalism, like certain fundamentalist religious movements, has proved corruptible in the hands of promoters: many stripped-down modern buildings are truly functional only in terms of an entrepreneur's pocketbook. Many functionalists seem not to have perceived that the Miesian formula "less is more" works only when accompanied by careful planning, exquisite

detailing, supervised execution, and fairly expensive materials. Moreover, notions which made excellent battle cries a generation ago, at least in the lower reaches of architectural appreciation, have not stood up in the light of worldwide practice and sophisticated—or simply commonsense—theoretical examination. A look at any home planned only for its owner's physical needs is enough to show that beautiful forms do not follow automatically from attention to functions; a creative artist must intervene at some point. The idea of letting the elements of a building express their functions separately and visibly is curiously limited to rather traditional elements. Only a few extremists feel that the functions of water pipes and electric wires ought to be expressed separately and visibly. What about the equipment for air conditioning? In many ways, combined with artificial light, central heating (increasingly from a centre outside the building), and the curtain wall, it converts the architect into a designer of a package for invisible functions; his windows, chimneys, and ventilating facilities tend to become either reminiscences or devices for obtaining rhythm, proportion, and scale. A similar difficulty may appear if he chooses to emphasize the nature of his materials and of the jobs they do. Traditional stones, bricks, posts, and beams may lead to forms which reflect a familiar necessity, whereas reinforced concrete may not; it can be shaped into a cantilevered slab, an egg, or a wave, and its structurally important steel bars and mesh are inevitably hidden. In general, the modern principle of tension cannot be expressed as obviously as the old principle of compression can. I do not wish to overwork the argument, for something that can be called the Functional Style does exist. It is, however, in part an arbitrary artistic style, whose affinities with Cubism, Mondrian's geometrical abstractionism, sculptural constructivism, rationalistic music, and antipoetical poetry are evident. As such it can be opposed on artistic grounds by architects who are just as concerned about "truth" and "honesty" in buildings as functionalists are.

Moreover, many of the functionalist theses have a cunning way of transforming themselves into their antitheses without any action from the outside—they are, so to speak, innately dialectical. Given the peculiar invisibility of certain forces in modern architecture, and the nature of modern materials, a determined functionalist is apt to become a historicist expressing the visible structures of the past. While he is talking about matter-of-factness and *Sachlichkeit,* the idea that a factory ought not to look like a church becomes insensibly an argument for symbolism. The idea that a structural skeleton ought to announce its weight-bearing function becomes, pushed beyond a point hard to define, a justification for nonfunctional expressionism. The idea that a machine-age building ought to conform to a severely machine-age aesthetic becomes, since buildings are not really machines, an excuse for creating nonfunctional but sculpturally interesting cubes, cones, and cylinders. The idea that a house

ought to reflect its user's needs becomes untidy as soon as a designer remembers that the user may have emotional needs which will not be reflected in a strictly rational plan.

IV

One of the strands in the dialectical swing is "Brutalism." The term was invented in England in 1954, in the climate of the revolt of the angry literary young men against the Establishment, and was originally applied to unusually "honest" tendencies within the Functional Style. An excellent example is the Hunstanton School, Norfolk, designed by Alison and Peter Smithson; it is roughly Miesian, but exposes pipes, electrical conduits, and other services as well as the structure and materials. But "Brutalism" was too good a catchword to remain tied to anything so relatively moderate and specific, and has since that time come to refer to a wide variety of post-World War II expressionistic trends in architecture. A frequent feature in so-called Brutalist work is the use of raw, shutter-patterned concrete (*béton brut* in French), which was given currency by the erstwhile functionalist Le Corbusier's Unité d'Habitation at Marseilles.

Another feature is sculptural rather than conventionally architectural form; here one can cite (with the understanding that "Brutalist" is a wild adjective) Le Corbusier's pilgrimage church of Notre Dame du Haut at Ronchamp, France; Wright's snail-like Guggenheim Museum in New York; Bertrand Goldberg's cantilevered plant-like shapes for his Marina City apartment towers in Chicago. Some of the trend is a resumption of the expressionism of the early 1900s and the fantasy of Antonio Gaudí; and some of it parallels phenomena in other arts in the 1950s: the Abstract Expressionism of Pollock, the *art brut* of Jean Dubuffet, the aformal jazz of John Coltrane, the Whitmanesque flux of the Beat poets, random serialism, and *musique concrète*. Everybody seems to have begun to look for a reality without rational subterfuges at about the same time.

In a different category, functional but not "functionalist," is the recent work of Louis I. Kahn, in particular his Richards Medical Research Building at the University of Pennsylvania. Kahn makes no pretense of liking water pipes and electrical conduits, and covers even his steel when he can. His massive, picturesque towers, with their abrupt contrasts of forms, reflect a romantic vision of mankind which is as remote from Miesian rationalism as it is from early-Corbusian worship of machinery. Also romantic, in its own way, is the work of Paul Rudolph, notably the School of Art and Architecture at Yale and the Milam house in Florida. Rudolph dismisses functionalism as completely inadequate for the needs of 20th-century people, and insists on the importance of such factors as the environment created by other buildings, the influence of re-

gion and climate, the spirit of the times, and the "psychology"—the movement and mystery—of an edifice.

Some of the new Brutalism, the new expressionism, the new romanticism, and the new humanism amounts to a restatement of the "organic" theory of architecture. Organicism, which was the favourite doctrine of Wright and Louis H. Sullivan in the United States, and which has been strongly advocated by Bruno Zevi in Italy since World War II, has inspired its own share of the confusion in thinking about modern buildings—especially modern houses. But in practice it usually comes down to a relatively weighty, baroque sort of functionalism, in opposition to the relatively weightless, classical rationalism of Mies. In principle it rests on analogies with plant and animal life instead of with machines; its connections with 19th-century vitalism and even with Rousseau's nature worship are evident.

There has also been a revival of interest in symbolism, or at least in something too close to symbolism for the taste of a strict functionalist. This is of course most apparent in religious architecture, which was given a sadly large opportunity to renew itself in post-World War II Europe. Today France has dozens of agreeably modern but "nonfunctionalist" village churches, a sculptural masterpiece in Le Corbusier's Ronchamp chapel, and Guillaume Gillet's symbolically soaring Notre Dame of Royan. Germany has a series of profoundly moving churches designed by Dieter Oesterlen, Rudolf Schwarz, Paul Schneider-Esleben, and Dominikus Böhm. Finland has, among others, Aalto's almost aleatory Vuoksenniska Church at Imatra. What can be called a yearning for symbolism can be seen also in many secular buildings. Gio Ponti's Pirelli tower in Milan has a boat shape (I am not sure why). Eero Saarinen's TWA Terminal for New York has a shape suggesting flight, and so, seen from certain angles inside, has the St. Louis airport reception building, designed by Minoru Yamasaki, George Francis Hellmuth, and Joseph William Leinweber. The Congress Hall in West Berlin, by Hugh Stubbins, Jr., is meant to represent freedom of speech. Oscar Niemeyer's poetic public buildings at Brasilia are not so much functionalist as symbolic of their purposes. Where one of today's architects shrinks from symbolism in his own work, he is likely to show a quite unfunctionalist willingness to provide space for symbolic sculpture, or to adapt his design to the desire for decoration which clients have been manifesting. And here the new symbolism merges with the new historicism.

Is there anything for the citizen and architectural tourist to worry about in this multidirectional movement away from the doctrines of simon-pure functionalism? Several aesthetic gains can be listed. Modern architecture has more richness, freshness, and individuality than it had a generation ago. The rational, linear, Apollonian, diagrammatic aspect of the art is now balanced by an intuitive, picturesque, Dionysian, detailed aspect; and both aspects are needed if

20th-century man is to make a properly human response to the splendid and dangerous environment his technology has created. But it should be observed that a large number of the new antifunctionalist buildings have the aesthetic defect, from the point of view of cityscape fanciers, of being unique solutions. One cannot imagine even two Guggenheim Museums in downtown Manhattan, whereas the Miesian facade is demonstrably repeatable—it has, so to speak, better manners for living in town. Also, many of the picturesque new buildings are being designed and built as solutions for problems which lie somewhat outside the category of general social advance. Meanwhile, all over the world, millions of families are hoping for decent housing, millions of children are without adequate schools and playgrounds, and thousands of factories are waiting to be built. The moral earnestness of the functionalist elders is going to be needed, however much we may enjoy seeing it balanced by concessions to variety and sophistication.

V

To talk of functionalism is to be reminded that not long ago many informed people were predicting the total replacement of architects by engineers and industrial designers. It was felt that the individual creator, who is arbitrary by definition and may be secretly absorbed in erecting a monument to himself instead of a shelter for his client, must soon become a rare luxury, and finally a casualty, in our accelerating—and necessarily collective—technological-economic progress. In sum, the "useless" art of architecture was expected to succumb to the anonymous business of putting up mere buildings.

How is this prediction—this group of interlocking predictions—working out in the late 20th century? So far at least, it is scarcely working out at all. The engineers, the industrialists, and their accountants have simply been added to the dialectical pattern. The modern managerial class all over the world is becoming as appreciative of the art in architecture, and of its institutional prestige value, as church and state used to be (and today often are not). It is true that 90 percent of the new construction consists of mere buildings, which at best are aesthetically neutral and at worst appear to have been randomly excreted by the zeitgeist. But that was often the situation even during the glorious architectural periods of the past; ancient Athens below the Acropolis seems to have been largely devoted to unimaginative functionalism (here let me repeat that a period, like a single artist, ought to be judged by its best work). It is also true that important post-World War II commissions have been going to big, efficient, impersonal firms like Skidmore, Owings and Merrill instead of to individual architects. However, the reader has only to glance back over the names mentioned in this chapter to be convinced that the individual creator, complete with all his arbitrary fantasy and costly eccentricity, is not about to become ex-

tinct. Also, it is only the size of firms like SOM that is novel; Mansart, whose Versailles classicism proliferated exactly as SOM classicism has since 1950, was so much the head of a firm that historians are still arguing about who actually designed some of the buildings for which he got the credit. And finally we should remember that today's big architectural firms, for all their far-flung branch offices and squads of specialists, are seldom as anonymous as they may seem; the style-setting Lever House, for example, can be attributed to the personal artistry of the chief SOM designer, Gordon Bunshaft.

I hope I am not being overly optimistic, for it is part of even a cultural historian's duty to keep the critical pressure high. Granted again, a lot of post-World War II buildings are characterless sheds. But anyone who notices the many exceptions is bound to find pessimism hard to justify. As we move toward the world of the 21st century it is becoming more and more clear that the whole idea of a grim struggle between art and technology for the soul of architecture is an anachronism—a hangover from the European Romantic period, when architects were assumed to be scholarly experts in applied ornament and engineers were supposed to be merely practical fellows who built bridges or dark Satanic mills. In the modern period, especially since about 1950, this snobbish separation of the professions can no longer be defended (although it has survived in the building codes of many states and municipalities). Today the most artistic architects are apt to be those with the imaginations of engineers, and the best engineers are also creative artists.

The newest shapes and structures combine the beauty of exotic organisms with the fascination of advancing science and technology. A good example is the suspended roof, which attracted attention in 1952 on the arena at Raleigh, North Carolina, designed by Matthew Nowicki, William H. Deitrick, and Fred Severud. Here the principle of tension is utilized in a way as ancient as tents and rope footbridges, but with modern materials which change nearly everything. The roof of the arena is carried by steel ropes which are suspended from two sloping parabolic arcs; the resulting uninterrupted spatial flow, the apparent weightlessness, the continuous rising and falling rhythm of the smaller elements, and the external look of a giant saddle or an alighting butterfly add up to a surprising contrast with conventional rectangularity. For an open eye and mind, however, they are just as aesthetic as a sequence of groined vaults.

Equally remote from the usual conceptions of architecture are the concrete shell structures designed by, among others, Eduardo Torroja, Felix Candela, Bernard Zehrfuss, Minoru Yamasaki, Eero Saarinen, and, much earlier, the German engineers Walter Bauersfeld and Franz Dischinger. In this type of construction the amount of technology and mathematics required may at first be distracting for an ordinary appreciator of buildings; everything seems to be a matter of economizing with materials and calculating precisely the stresses in

hyperbolic paraboloids. But the visual art which emerges from these calculations is in a language of vast spans, egg shapes, wave shapes, and ribbed patterns—a marvelous mixture of strength and refinement. This is as much an architecture of sheer taste as the Baroque was. And the artistic results are not accidental; Torroja, for instance, once remarked that he used mathematics only to see if the forms he had imagined were strong enough, and Candela has insisted on the importance of intuition in his own remarkably thin shells.

The space frames developed by "nonarchitects" like Robert Le Ricolais, Konrad Wachsmann, and Richard Buckminster Fuller are less deliberately poetic. Le Ricolais' achievement has been that of the laboratory researcher content to let other people construct the minimal surfaces—the bubbles and fine-spun webs—made possible by his experiments. Wachsmann's most significant role has perhaps been as a planner and propagandist for mass production of cellular structures. Fuller is famous as an inventor, principally of the light, stress-dissolving grid known as the geodesic dome. In short, all three would have been dismissed by academic 19th-century critics as mere engineers, and they would not have minded. Yet all three have contributed in a spectacular fashion to the current discovery of a new emotional content for architecture—a new sense of spiritual space and human aspiration derived from, instead of being in conflict with, modern technology. At their level of making, arguments about our alleged cultural dichotomies become tiresome.

I suppose I am overestimating the need for examples. However, one more mere engineer, Pier Luigi Nervi, must be mentioned, both for his quality and as a clincher for the case. Nervi began as exactly the type of builder the late-Romantic connoisseurs feared: a practical and inventive man of affairs interested in stimulating the market for his manufactured elements. To make things worse from the late-Romantic point of view, his business and aesthetic commitment was to reinforced concrete, usually considered the least attractive—the most rawly reifying—of modern materials. But anyone who has considered, even in photographs, the great, flowering, honeycomb roof for the open space in the Turin Exhibition Building, or the strange, undulating conference hall for UNESCO in Paris, must agree that Nervi is one of the finest artists, and certainly the most prodigious, Italy has produced since the death of Verdi. Notice also that, along with the designers of suspended roofs, shell vaults, and space frames, he takes prefabrication of parts as the normal modern condition for creative building. Industrial processes, since they call for a degree of standardization, have long been thought a menace to the art in architecture. Today they are opening up possibilities which compensate brilliantly for the potential danger. The most recent cellular structures often recall those found in nature, and their use can be just as imaginative as the use of bricks, man's oldest prefabricated building elements.

VI

In the above dialectical context the question of the rate of stylistic innovation needs a second look. Previous chapters in this book have stressed the fact that all the fine arts went through a spell of explosively rapid change during the first decades of this century, for several interdependent reasons: Occidental man's sense of progressive history had to be appeased, the arts had got out of phase with science and technology, the old value systems had decayed, the traditional modes had run low on expressive power and specificity, there were new patterns of daily living, and so on. However, we have also observed that since World War II there have been fewer and fewer genuine innovations in aesthetic activity; although modernism has been spreading, it has not been evolving very much. Is this slackening of tempo altogether a good thing?

So far in this volume I have been accepting it without alarm and even with some satisfaction. After all, phases of relative stability are normal in art history, and frequently splendid; there were long ones in Europe after the Gothic style shift and after the Renaissance shift. Although it is true that everything moves faster today, it is also true that modernism is a cultural phenomenon on the same grand scale as Gothicism and the Renaissance (liking or disliking it does not change the scale). What happened in the early decades of this century was not in the realm of mere fashion. It was the establishment of a recognizable *period* style, a *period* sensibility system; and new historical periods in art do not begin every other year. Webern is still modern. So is Eliot. So is Kandinsky. The reader, if he is not a professional avant-gardist, can easily continue the argument and wind up reassured about the present state of most of the arts.

But what about architecture? Can this art—the great unavoidable—really afford to slow its rate of change in the late 20th century? We may argue that it can, if we choose to regard it as a pure art—as simply a compound of sculpture, painting, and organized space. Wrightian, Corbusian, and Miesian forms are still modern in the way Webern's music is; they resonate with the rest of our period sensibility system, and in particular with the other visual arts, whose rate of stylistic change has slowed very perceptibly. Moreover, still from the pure-art angle, there is something to be said for a pause just now in the evolution of architectural shapes and structures; it can give people time to learn to appreciate the modernness we already have. And there is nothing to be ashamed of in the pure-art angle; we nearly always adopt it when enjoying the fine buildings of other eras.

The fact remains, however, that architecture is not a pure art. There are even people who maintain that it is not an art at all—at least not a fine art. Although they are mistaken, in my view, they have a point we cannot neglect without falling into a repetition of the errors of the 19th century. An architect is not a free artist in the way painters and sculptors are. He is an artist plus a

practical builder who has a social obligation. Even though he may be creating purely aesthetic forms which are adequate for the modern period sensibility, he must continue to experiment with new forms, techniques, and materials, for he has a duty to build as well as he can. Even if his impulses as an artist are relatively conservative, he is constantly being pushed—or ought to be—by modern technology into an avant-garde position. Hence, far from deploring what artist-engineers have been doing recently, a late-Romantic critic might be better occupied in inquiring if they are doing enough. In spite of the new shapes and structures I have cited, there are signs of a dangerous academic tendency in the modern architectural profession as a whole. Most of the ideas and materials now current are more than half a century old, and in the meantime technology has been advancing in its usual seven-league boots. Art critics have a right to be happy with our Miesians, Corbusians, organicists, functionalists, mild historicists, and mild romantics. But we could do with a few more Nervis and Buckminster Fullers, to keep the dialectical pattern moving into a future which is already the present for many scientists and technologists.

This future is bound to be upsetting. It will raise in an acute form the problem of preserving, especially in Europe, the atmospheric continuity and local character of cities and towns. It will also raise, at least for adults, a problem with which modern housing experts are already familiar: that of learning to live better in a better building when you have long been living badly but somehow happily in a bad building. A surprising number of people do not at first enjoy having more light, cleaner air, more greenery, more efficiency, and less clutter. But such problems can be hopefully classed as problems of transition, which may call for some concessions during only a brief phase. In any event, they are not very sound reasons for delaying the beginning of the transition.

VII

I have just mentioned cities. Does the rather zigzagging discussion of building design in this chapter have any relevance for questions of city design? First let us glance at some facts, most of which are dismal.

City planning, in spite of the efforts of a few men like Georges Eugène Haussmann in Paris, city-park creators in the United States, and Sir Ebenezer Howard in England (all of whom had very debatable notions), can scarcely be said to have existed during the 19th century; municipal areas were in general allowed to evolve toward chaos after the Industrial Revolution shattered their ancient shapes and functions. In the 20th century a large professional corps of urbanists has arisen: traffic controllers, slum-clearance experts, garden-city advocates, Corbusian rationalists, and down-to-earth pragmatists. But their successes, however admirable, have been isolated, and their failures have been deeply discouraging. Although just about every old urban pleasure has been

more or less sacrificed to the automobile, traffic continues to get worse and even the more ruthless controllers have begun to have doubts about their solutions; freeways, for instance, are now accused of wasting land and generating new congestion. Far too often, slum clearance leaves the poorer families, who may be members of a racial minority, without housing they can afford, or in worse housing than what they had before; the disappointments have led many experts to hope merely for "planned slums"—shabby buildings with halfway decent facilities. Garden cities and suburbs, although agreeable at first sight, tend to become dormitories on the greensward, deplorably lacking in municipal vitality and diversity; increasingly they are suspected of being bourgeois-romantic evasions of the tough problems of a metropolis. The Corbusian rationalists, with their cheerful blueprints for radiant cities, high-rise and widely spaced housing blocks, green belts, distinct zones for working and living, and the separation of pedestrian and automobile traffic, have been widely and sometimes beneficially influential; but their plans imply a type of land control which is economically difficult in built-up areas and politically unacceptable in most democracies. And they too have begun to have dry doubts; they now talk of the need for density, variety, and community life, and of the possibility of re-inventing the traditional attractiveness of a busy street.

Meanwhile, the problems are growing in size and complexity. The populations of entire regions, even nations, are being urbanized. The metropolis is cursed for its savagery and at the same time regarded as the chief source of our civilization and the place where modern man's hypothetical freedom tends to become actual, where choices are multiplied. Cities used to die naturally here and there, or be killed by armies, but not any longer; all of those that were bombed into apparent extinction in World War II have been rebuilt larger than ever. Brand-new cities—usually with gleaming modern cores and shanty-town fringes—have been set down in what was recently wilderness. Large towns are becoming mere elements in urban galaxies, and in many places—the northeastern United States, the Tokyo area, the French Riviera, southeastern Great Britain—you can now see a galaxy clearly turning into a megalopolis. In many other places what used to be out in the country is now part of what critic Ian Nairn has named Subtopia: "the world of universal low density mess."

In these circumstances, to talk of purely aesthetic matters is to risk looking ridiculous and almost criminal. Obviously, the bulk of the problem lies far beyond the scope of the present essay. Jane Jacobs, one of the most penetrating critics of recent city planning, has this to say (the italics are hers):

> When we deal with cities we are dealing with life at its most complex and intense. Because this is so, there is a basic esthetic limitation on what can be done with cities. *A city cannot be a work of art* To approach a city, or even a city neighborhood, as if it were a larger architectural problem, capable of being given order by converting it into a dis-

ciplined work of art, is to make the mistake of attempting to substitute art for life. The results are taxidermy.[2]

Common sense must force any veteran city dweller to agree with her. But the trouble—which is by no means merely theoretical—with her position is that as soon as we have decided to banish art from our municipal thoughts it seems to return in fairly transparent disguises. After all, we do not want the modern city to be merely efficiently ugly, and the line between the pattern of a metropolis as a whole and the patterns of its individual architectural components is hard to draw. The researches of Kevin Lynch[3] in Boston, Jersey City, and Los Angeles have demonstrated beyond any reasonable question that people do experience a city as an image, as a pattern of paths, edges, districts, nodes, panoramas, and landmarks. Mrs. Jacobs herself has a lot to say about the need for visual order; she simply insists that the order should arise from and make legible the actual life of the city.

My conclusion is that city design cannot be a *fine* art; it cannot, that is, involve the sacrifices needed for the creation of a pure order of unity, coherence, and emphasis. It can, however, be a useful art to which much of this chapter is indeed relevant. Historicism, for instance, is today almost as much of a problem for city-street designers as it is for architects.

[2] *The Death and Life of Great American Cities,* Vintage Books, Random House, Inc., New York, 1963, pp. 372–373.

[3] *The Image of the City,* Harvard University Press, Cambridge, Mass., 1960.

Never leave well enough alone.
RAYMOND LOEWY

*... do not let the effeminate doctrine of the modern
beautymonger make you too tender* GOETHE

Chapter 13　The Free and the Unfree

THE DISCIPLINES VARIOUSLY CATEGORIZED as decoration, applied art, and de-
sign (interior and industrial) lie almost as far beyond the scope of this book as
town planning does. These are the unfree visual arts—painting and sculpture
tied to domestic, commercial, technological, and other nonaesthetic considera-
tions. They have, however, enough of a connection with the fine, or free, arts to
call here for a few general observations and questions.

I

Some history can help to locate the issues. For hundreds of years Orientals
have been happy to find pictorial masterpieces on fans and screens, and have
not worried about theoretical distinctions between makers of tea bowls and
makers of statues. Apparently the ancient Greeks behaved similarly. In *The
Republic* Plato remarks that "there is grace or the absence of grace" in "every
constructive and creative art—painting, weaving, embroidery, the art of build-
ing, the manufacture of utensils." Medieval Europeans agreed. In that marvel-
ous book *The Waning of the Middle Ages* Johan Huizinga even ventures "the
paradox that the Middle Ages knew only applied art." He points out that the
great painters of the 14th and 15th centuries were willing to undertake almost
any kind of decorating or designing task:

Thus Melchior Broederlam ... puts the finishing touches to five sculptured chairs for
the palace of the counts. He repairs and paints some mechanical apparatus at the castle
of Hesdin, used for wetting the guests with water by way of a surprise. He does work on a
carriage for the duchess. He directs the sumptuous decoration of the fleet which the duke

190

had assembled at Sluys Statues were painted in Jan van Eyck's workshop. He himself made a sort of map of the world for Duke Philip. . . .Hugo van der Goes designed posters advertising a papal indulgence at Ghent. When the Archduke Maximilian was a prisoner at Bruges in 1488, the painter Gerard David was sent for, to decorate with pictures the wickets and shutters of his prison.[1]

Remnants of the attitude implied by such work persisted into and after the Renaissance. Leonardo da Vinci did the decors for court festivals at Milan and designed a mechanical lion to throw lilies at the feet of the French king. One of the most magical of Antoine Watteau's paintings was a shop sign for the picture dealer Gersaint. Throughout the European 18th century the best cabinet-makers and goldsmiths were honoured almost as highly, and in much the same terms, as the best painters and sculptors. Jacques Louis David was not above designing clothes.

In sum, although we probably should assume that some sort of felt distinction between fine art and decoration or design, between the free and the unfree, has always existed, our present separation of the categories is mostly Occidental and dates largely from the 19th century. It is evidently not a consequence of some universally recognized law of artistic creation and appreciation. Hence we are permitted to wonder if it is actually as sound as we habitually suppose it is.

The wondering ceases to be idle when we recall that the 19th century, in spite of its upholstered comfort and seductive bric-a-brac (I write as an admirer), was on the whole one of the least distinguished periods in the history of the unfree arts. Of course the separation of the categories was not the only cause, and it was also in part a result, of the drop in quality. Nevertheless, the coincidence is worth remarking. The word "decorative" came into use in 1791. The era of the great English and French furniture designers came to an end around 1825, and from then on the decline was rapid. As the gap between the categories widened there were fewer and fewer people with the talent and authority needed to control and resist mass production, middle-class taste, and stylistic revivals. Decoration and design came to be regarded as something added to a useful object instead of being created with it. The arts and crafts movement which began in the 1860s in England brought an improvement in patterns and forms, but failed ultimately because of its anachronistic, essentially medieval methods of production. By the close of the century the very idea of decoration was in ill repute among advanced spirits. In Chicago Louis Sullivan announced that "ornament is mentally a luxury." In Vienna the functionalist Adolf Loos proclaimed a "law" of history: "As culture develops, ornament disappears from everyday objects." He felt that a patterned cigarette box was only a little less savage than a tattooed face.

1 Edward Arnold Ltd., London, 1924, pp. 224, 226.

It would be unfair, and inaccurate, not to say that the situation has changed for the better during the 20th century, especially since World War II. Industrial designers are turning out handsome automobiles, refrigerators, high-fidelity components, jet liners, electronic computers, kitchen utensils, ski poles, dial telephones; and in many instances they have successfully reversed the form-follows-function slogan—the better-looking gadgets seem to work better. Packaging designers provide shapely boxes, cans, and bottles; and some advertisements and product displays can be enjoyed as minor art. Interior designers (nobody seems to want to be called a decorator) provide furniture, fabrics, and room arrangements which work well, wear well, look good, and are often consonant with the visions of contemporary sculptors, painters, and architects. Even a severe critic can find things to praise.

Such things are not, however, anywhere near numerous enough. Nor are they, one hopes, as handsome and functional as they might be. In general, the modern unfree arts (I am ignoring the millions of products which cannot even be discussed in terms of decoration and design) have been much less satisfactory than the modern free, or fine, arts; and the whole situation is a great deal less satisfactory than what prevailed before 1791—to take that as the date when the separation of the free and unfree categories became definite.

II

In theory and to a considerable degree in practice the separation is obviously defensible. A rug, a chair, a typewriter case, or an automobile body does not achieve its aesthetic effect—if it has one—through uniqueness, whereas a painting or a piece of sculpture usually does. A work of interior or industrial design puts to practical use the sort of visual order which is "useless" in the strictly fine arts. It may be an object without a referent, or a form whose content is little more than the everyday job the form performs. In any event, it cannot be as intensely expressive as a work of free art; a rug with the intensity of an El Greco would be intolerable, and nobody would want to sit on the expressive equivalent of a Rodin.

But cannot much of all this be said about architecture? A possible answer is that it certainly can and that therefore no building should be experienced and judged as a work of free, fine art. However, people do not generally give that answer, for they have learned that the visual order of a great building can be appreciated, in part at least, in the same way we appreciate the "useless" order of a musical composition, a painting, or a piece of sculpture (with the important difference that the architectural order is spatial). They have learned too that, while the emotional content of a building may be less strong and concentrated than that of a sonata or a painting, it may indeed exist, and may be enriched by awareness and study.

But cannot much of all *this,* properly scaled down by common sense, be applied to works of interior or industrial design, which are simply smaller than buildings and a bit further along on the spectrum toward the indefinable point where function is all and art ceases? Chairs have sculptural and architectural qualities; a wallpaper or a rug may have some pictorial qualities. The intensity of a single Louis XV chair may be very low compared with that of a piece of sculpture, but a number of Louis XV chairs taken together in an alert imagination can accumulate a good deal of expressive content; they can say something about human life, society, and conversation—something that springs from shape and pattern, not just from historical associations with French salons and boudoirs. Similarly, the design of a mass-produced typewriter case can say something more than "typewriter," even if the functionalists are correct in insisting that it should begin by saying "typewriter" in a forthright manner.

The best way out of this speculation, it seems to me, is to admit that there is indeed a difference between the free category and the unfree, and then to admit that the difference has been harmfully exaggerated during the last hundred and fifty years. A chair is not a work of fine art. One might even argue, thinking of its practical aspects, that it is not a work of art at all. But there is an analogy between it and a work of fine art, a common denominator in creation and appreciation, which was properly recognized before 1791 and which we tend to neglect. We could do with less of the Romantic reverence for "inspired" painting and sculpture, and with less of the habit of using "decorative" with a disparaging intention.

Perhaps modern painters and sculptors cannot perform today's equivalent of repairing the duchess' carriage and embellishing the archduke's prison. However, if they were to become seriously, relevantly active in decoration and design, they might bring about some needed improvement (some are intermittently active, but not enough, I think, to make these remarks unnecessary). They might also find their "free" creation benefiting from a more definite relationship with the public and from specific assignments. Too much of today's painting and sculpture is conceived with no destination in mind except a commercial gallery and eventually a museum.

III

That modern artists are in a good position to re-establish at least some of the old, fruitful confusion between free and unfree art becomes evident when one reflects on what caused the 19th-century separation of the categories.

The separation did not, of course, occur all at once one morning in 1791. The emphasis on easel pictures and free-standing statues, which began to be strong with the Renaissance, was probably a contributing factor, for when painting and sculpture had been integrated with Gothic architecture they had

been decorative and fine simultaneously. The academies, royal and otherwise, which were formed all over Europe in the 16th, 17th, and 18th centuries can be thought of as both effects and causes; they reflected and at the same time helped to create a new, thoroughly unmedieval distinction between the creative artist and the mere craftsman. More subtly and slowly, the illusionism which became dominant in painting and sculpture widened the gap between the fine category and the decorative, for in the latter a large amount of fantasy and pure abstractionism continued to be accepted as traditional, desirable, and, in fact, unavoidable. And finally there was the Industrial Revolution, the great, complex cause of a bit of everything. So long as the decorator or designer of useful objects had worked with his own hands he had done fairly well in the prestige competition with the makers of "useless" painting and sculpture. He too was a maker, whatever the academies might think. But when machines began to turn out his patterns his separate category became clear. It is significant that the word "industrial" came into general use shortly before the word "decorative."

Of these four separators of the free and unfree categories, machinery alone is still important in the late 20th century. The academies of fine art have lost influence everywhere. The easel picture and free-standing sculpture are still with us, but in forms easy to convert into the "applied" sort. The illusionism ushered in by the Renaissance has given way to various degrees of an abstractionism which is so suitable for decoration it is regularly denounced for precisely that reason. This is not to say that all a modern painter or sculptor has to do when he enters the unfree category is to continue to create in his usual way. On the contrary, he must re-create his visual orders in functional terms and without the expressive power and content of unique works of fine art. He must learn to get along with technology the way modern architects do (Mies, Le Corbusier, Breuer, Wright, and Aalto have all designed furniture). Unless he is willing to agitate for profound changes in the capitalist system, he must adjust himself to fashion changes in interior design and to manufacturers' demands for rapid obsolescence in industrial design. But the whole aesthetic effort is bound to be less difficult than it would have been in the 19th century. Something like a return to the decoration-and-design creativeness of the Orient and pre-1791 Europe has become possible in a new context.

Mass production? There is no need to dwell on its familiar ability to multiply vulgarity, destroy the special pleasure, and dull the edge of quality. But surely there is no need either, at this late date and with the evidence everywhere, to point out that the machine is not always nor inevitably the enemy of good design. It merely asks to be treated as a machine and not as an ersatz artisan; it has to be provided with designs which do not look as if they were meant to be turned out by hand. The machine is in decoration what the new building

materials and techniques are in architecture: a strong reason for being wary of historicism. And finally, to get back to the main point and halt what is becoming a sermon, we should remember that the machine has done harm rather less as a machine than as a contributor to our exaggerated, and now reparable, separation of the free and unfree categories of art.

Yes—oh dear yes—the novel tells a story.
E. M. FORSTER

I am not an entertainer. WILLIAM S. BURROUGHS

Chapter 14 Since "Finnegans Wake"

TO JUMP FROM DECORATION and design to the novel is perhaps surprising enough to call for assurance that nothing is meant by it. I am not about to find, for instance, a stylistic parallel between Art-Nouveau historicism and Vladimir Nabokov's prose. The present chapter is where it rather illogically is simply because it would not seem to go well anywhere else; its subject matter asked for isolation and at the same time needed the perspective provided by our inquiries into other arts.

This little awkwardness about procedure is worth mentioning because it is a sign of a larger difficulty about substance. The fact is that since 1939, when the publication of James Joyce's *Finnegans Wake* apparently marked the limit for one line of development, nobody has been very sure of where we are in the novel. Traditional and modern trends interpenetrate more than they do in contemporary music, poetry, drama, painting, sculpture, and architecture. The landmarks produced earlier in the century by men such as Joyce, Marcel Proust, Thomas Mann, and Franz Kafka do not give us our bearings as easily as do those produced in other arts. New landmarks have been slow to appear.

The following remarks, then, are tentative. And at least half of them are more theoretical than descriptive. My intention is not to survey post-1939 fiction; it is rather, with that fiction as illustration, to suggest ways of thinking about the novel in general in our era. My "since" means "in view of" *Finnegans Wake* as well as "after."

196

I

How can the traditional novel be identified?

Let us ignore ancient epics, silver-age pastorals, medieval romances, satirical anecdotes, Oriental tales, moral fables, travel yarns, allegories, and the like. Our identification ought to proceed from the inner quality of a reading experience, and we do not get the feel of a traditional novel from just any long story or collection of short ones.

The authentic feel becomes available almost for the first time in *Don Quixote*. But even there it is weak; much of that famous book has to be enjoyed less as a traditional novel than as a superb realization of the possibilities in the romances of chivalry Cervantes set out to parody. A somewhat similar observation can be made about all the long fictions turned out in the 16th and 17th centuries. The early picaresque narratives, with their episodic form and cynical attitude toward life, are apt to remind a reader that Charles Dickens is in the distant future and the medieval fabliau in the near past. John Bunyan's allegorical method takes the edge off his realism. The interminable chains of dialogue and abduction composed by Madeleine de Scudéry are best appreciated by someone who knows the flavour of the old code of courtly love. Even Madame de La Fayette's remarkable psychological analysis has a formal quality which is non-novelistic. In sum, what we feel in all these works is at most a potentiality. The traditional novel did not exist before the European 18th century. One can even argue that the authentic feel of it, the specific psychic and aesthetic substance, is seldom recognizable before the 19th century. Compared with *War and Peace, The Brothers Karamazov,* or *Middlemarch,* the work of Henry Fielding seems almost as non-novelistic as that of Madame de La Fayette, although of course in a different way.

The specific, recognizable psychic and aesthetic substance? It is *prose,* with all the connotations of that word. Much as a painting is made of paint, a building of space, a poem (according to Mallarmé at least) of words, and a sonata of sound, the traditional novel is made of ordinary discursive language. In it we are a long way from the abstractionism, quidditism, weakened referents, and unanchored metaphors discussed in previous chapters of this undertaking. We are where art and life can be experienced as coinciding, where the medium is supposed to be transparent instead of opaque, where the artist aims at verisimilitude as well as at truth, and where the critic assumes a right to complain if things do not happen as he feels they really would have, given the circumstances. For of course the prose substance in a traditional novel does not merely lie on the surface of the fiction. It is also in the setting, the plot, the characters, the motivation, the time sequences, and the implied moral outlook. It is carefully tamped into every cranny. There is a disposition to endow the entire fabric with the sort of probability, progression, and inner consistency we ex-

pect in the subject, predicate, clauses, and phrases of a responsible statement of fact. Usually there is a disposition to be what the Latin derivation suggests "prose" ought to be—straightforward. (I write "disposition" because of course there are no absolutely pure traditional novels, every kind of art being a matter of degree.)

The result is read as we read history or a newspaper: with our awareness focused on what is being said rather than on how it is said, and with an almost complete suspension of disbelief. The traditional novel is drenched and steeped in plausibility. It is art using art to deny it is art, make-believe claiming over our imagination the authority, not of an imposed aesthetic order, but of fact. It does not aspire toward the condition of music.

There we have the evident heart of the matter. There is something else, however, that ought to be mentioned—something which, while it cannot be called an exclusively identifying trait, is important and is frequently neglected by historians of literature. It is that the traditional novel is an entertainment, in a sense and to a degree in which the word cannot be applied to comparably serious music, poetry, drama, and visual art. It is an entertainment even when it happens to be the vehicle for earnest moralizing about appearance, reality, human life, and the aims of society. Some of the entertainment springs, of course, from the simple fact that a story is being told. All of the great 19th-century novelists were experts at contriving suspense and building up vivid incidents. But one has only to imagine their narratives recast in an artificial substance— that of the pastoral, for example—to feel how much of the entertainment is due to the use of a medium which can convey an illusion of the variety and reality of everyday existence.

II

The historical context in which this complex, monumental sort of anti-art (there is no reason why the avant-garde should have a monopoly on fashionable words) appeared has often been analyzed. The rising middle class had an appetite for facts and did its thinking in a language more prosaic than that of peasants and aristocrats. Science and secularization were weakening the taste for myth and allegory. People felt more responsible for their lives. Interest in actuality, present and past, was widespread; the 18th and 19th centuries saw the beginnings of journalism and of the writing of carefully researched history. Empiricism was a prevailing mode in philosophy. The masterpieces of the traditional novel came in the mid-1800s at the same time as the development of photography. Democracy was helping to spread the consequences of the invention of printing, consequences which were apparent in the way people apprehended reality as well as in the actual distribution of books: to print anything is to give it a touch of the anonymous authority of fact.

Yet, when all these explanations have been considered, the advent of the traditional novel remains astonishing. Serious prose fiction is exceptional in the history of world literature, and great prose fiction is exceedingly rare before the 16th century. We think of Sir Thomas Malory's *Morte d'Arthur,* Giovanni Boccaccio's *Decameron,* Lady Murasaki's *Tale of Genji,* perhaps Lucius Apuleius' *Golden Ass,* and then we are apt to be out of titles if we are not specialists. Moreover, during the Renaissance, vernacular prose itself, all over Europe, had to be disengaged from poetry and speech-plus-gesture and practically re-created as a precision instrument for literature; the advocates of poeticalness— the English euphuists, their foreign counterparts and Baroque successors— were not fully defeated until well into the 17th century. Then the novelistic genre had to be disengaged, and the operation becomes inherently improbable when we remember that this was the first important new kind of literary art in centuries, the first important kind to be addressed primarily to the bourgeoisie instead of to the folk or the aristocracy, the first to have the printing press as its initial disseminator, and the first to be silent at birth, to have no real equivalent for the voices behind poetry, the drama, and the old kinds of prose fiction. It is no wonder that even today many scholars, in particular those with classical backgrounds, refuse to believe that the whole thing ever happened; they insist that the typical 19th-century novel is just an ancient epic, tragedy, comedy, pastoral, or romance disguised for the taste of the European urban middle class. And of course there is no way to prove them wrong; one can only suggest that, in spite of certain similarities, *War and Peace* does not have the feel of the *Odyssey.*

These thoughts lead to others which are directly relevant to what has been happening since *Finnegans Wake.* Suppose we grant that the traditional novel is as different from earlier types of long fiction as, say, architecture is from sculpture. We are dealing, then, with a distinct kind of art. It is one which, in view of its large audience and numerous masterpieces, must be ranked alongside music as a major achievement of the European 19th century. But do not the very qualities and circumstances which led to its astonishing emergence and rapid public acceptance suggest that it was a special response to a special kind of sensibility? Do they not suggest some trouble for it in the 20th century? There is plenty of historical proof that success in one era may be accompanied by an inability to make it across the period frontier. Mosaics have never quite recovered from the loss of the peculiar Byzantine demand; stained glass has been a minor art since the end of the Gothic era. Nobody can write an epic today, or a romance of chivalry. Are we not now in an era which is as distinct from that of the 18th and 19th centuries as the Renaissance was from the Middle Ages?

Of course there is a danger, in talking about literature, of exaggerating the

importance of Henry Adams' feeling of a snapped cultural continuity. Language is doubly conservative; it tends to preserve and to stand pat. Still, in theory, the traditional novel does seem destined to lose at least some of the power it had during roughly the period from Jane Austen's irony to Émile Zola's naturalism. It does, in theory, look a bit out of phase with the general modern movement. Here I feel obliged to repeat for emphasis, with apologies. The modern movement has brought, not facts and verisimilitude, not the prose substance of everyday life, but the distortions and ambiguity of art freshly conscious of itself as art. The focus of awareness has shifted from what is said toward how it is said, so much so that many modern thinkers are willing to argue that the how is really all there is to the what. In all activities, the nonaesthetic included, there are experts who behave as if they accepted that argument, even though they might not accept it overtly. Among typically modern philosophers the whetting of the scalpels is often all there is to an operation on reality, and the same tendency exists among scientists. As for humble prose, who does not feel today that it is on the defensive against images, nonlinear notions, and fields of perception? I think Marshall McLuhan, in his influential and irritating *Understanding Media,* overstated his case, but the fact that his "the medium is the message" could become a catch phrase all over Europe and America in the 1960s is symptomatic of a sensibility radically different from that of the 1860s. And this new sensibility does not seem very compatible with a literary genre in which art is used to conceal art, in which the imaginative priority given to content is great enough to create an impression that there is no form at all, that the message is the medium.

There are, however, from the point of view of the cultural historian who is trying to be neat, some vexing difficulties which appear as soon as he stops theorizing and begins to actually read some recent long fiction. A large number of excellent people seem never to have heard of the imperatives of the new sensibility, at least so far as novelistic form is concerned. Asked to list some good novels published since 1939, today's equivalent of Dr. Johnson's "common reader" might think of items like Albert Camus' *The Stranger,* Boris Pasternak's *Doctor Zhivago,* Ralph Ellison's *Invisible Man,* Saul Bellow's *Herzog,* William Golding's *Lord of the Flies,* J. D. Salinger's *The Catcher in the Rye,* Alberto Moravia's *Conjugal Love,* perhaps Muriel Spark's *Memento Mori,* or Graham Greene's *The Power and the Glory,* or some Japanese works— Tanizaki Junichirō's *The Thin Snow,* Yukio Mishima's *After the Banquet* (let me stress here that the sampling in this chapter, even more than in previous ones, is done merely to bring out the issues and is of course without the time perspective needed for nominating classics). Although all of these books have some modern technical aspects, and can be termed up-to-date because of their content, none has a form which would have greatly startled Tolstoi, or even

Samuel Richardson. Certainly none can be called stylistically "modern" or "modernistic" in the sense in which those adjectives can be applied to the work of Picasso, Webern, Pound, Brecht, or Mies. How are we to account for this apparently successful survival—in this major art alone, unless the performing art of ballet is brought into the argument—of traditionalism? How can such novelists, the list of which could have been much longer, get away with their defiance of the 20th-century period style?

An answer one hears now and then is that, after all, they are not getting away with it as well as they suppose. The story of Meursault, for instance, the unmotivated murderer in *The Stranger,* might convey an even stronger sense of the absurd in life if told with techniques comparable to those used in aleatory music. The adventures of Holden Caulfield, the antiadult adolescent hero of *The Catcher in the Rye,* might lack their tinge of sentimentality if told in a less conventionally picaresque form. In general, the old methods do not seem to be producing the results they once did; among the novelists I have mentioned there are no Balzacs. But criticism in the might-have-been vein proves nothing, and talking about the history of forms in terms of individual talent can be dangerous: a new Balzac may be looking for a publisher right now.

A second answer might be that perhaps the novelists cannot get away with it in the long run. The day may come when they will have to face what many other conservative (in terms of form) artists now face: the inexorable evidence that, whatever one thinks of modern art, to persist in traditionalism in the late 20th century is to lose power and begin to subside into the role of a catering popular artist. But that day for the novelists cannot yet be said to be in sight, and so we can predict it only by means of analogies which may not be sound.

A third possible answer is that there is something in the other answers but that they are altogether too formalistic. The traditional novel is perhaps a special case in the general modern movement only apparently, only because it lacks the noticeable kinds of form possessed by music, poetry, and the visual arts. Perhaps it can meet the demands of the new sensibility of our era in its own way, precisely because of its prose substance, because of its focus on the what rather than the how. Being a type of fiction which claims the authority of facts, it can perhaps move from one period style into another in much the way that the art of writing history can: simply by updating its facts—its material, to use the word favoured by professional novelists. In that event, the cultural critic's job is to examine the material and think again about the old problem of form and content.

I shall get back to these "possibles" and "perhapses" after we have looked at some of the post-1939 novelistic material. Meanwhile, they call for remarks about the method of this chapter. Evidently the simple opposition between "traditional" and "modern" which can be used to describe the situation in other

arts should not be used for the novelistic situation. It does not correspond to the common reader's experience. Yet there is indeed a kind of polarity in that experience. There is another type of novel (again a distinction of degree, since of course the two types may exist in a single book), a type which critics often refer to as modern, forgetting that the traditional type can be thoroughly modern in its content. What should we call this other type? The untraditional novel? The meta-novel? Punningly, the X-novel? I propose to call it the art novel, with an allowance for subdivisions.

III

How, still thinking of the inner quality of reading experience, can we identify the art novel?

Evidently, we can do so by noting the presence of something other than the prose substance of the traditional novel. This other something will usually involve the reader in dozens of considerations, but can be presented as a matter of language. Ordinary prose focuses awareness on the *signified;* so does the traditional novel. Nonprose (it need not reach the level of poetry) focuses partly at least on the *signifying* and on itself as *signifier;* so does the art novel. The two kinds of "substance" can be conveniently sampled in the last paragraph of Joyce's story "The Dead," in the collection *Dubliners.* Gabriel, the principal character, is lying beside his sleeping wife, who has just told him of her love affair with the dead Michael Furey:

> A few light taps upon the pane made him turn to the window. It had begun to snow again. He watched sleepily the flakes, silver and dark, falling obliquely against the lamplight. The time had come for him to set out on his journey westward. Yes, the newspapers were right: snow was general all over Ireland.

So far we are in the ordinary prose that focuses awareness on the signified. But with the next sentence the substance begins to change:

> It was falling on every part of the dark central plain, on the treeless hills, falling softly upon the Bog of Allen and, farther westward, softly falling into the dark mutinous Shannon waves. It was falling, too, upon every part of the lonely churchyard on the hill where Michael Furey lay buried. It lay thickly drifted on the crooked crosses and headstones, on the spears of the little gate, on the barren thorns. His soul swooned slowly as he heard the snow falling faintly through the universe and faintly falling, like the descent of their last end, upon all the living and the dead.[1]

Here, with some evident help from late 19th-century English aesthetes and French *décadents,* Joyce has begun the shift toward an awareness of signifiers which was to lead him some 30 years later to the last lines of *Finnegans Wake:*

1 The Viking Press, Inc., New York; Jonathan Cape Ltd., London, 1925, pp. 287–288.

> End here. Us then. Finn, again! Take. Bussoftlhee, mememormee! Till thousendsthee. Lps. The keys to. Given! A way a lone a last a loved a long the[2]

Here we are in the substance of what is probably the closest thing to a pure art novel that will ever be written. And we are also right up against a question which every common reader of novels, in spite of college appreciation courses and the drumming of the avant-garde, is bound to have in the back of his mind: What in the world is the point to all this?

Let us stalk the answer through a little more theory and history. Clearly, *Finnegans Wake* is an isolated and extreme case, valuable in itself and useful as a point of reference, but not representative enough for our purposes. Often the common reader's big question is not mainly about language, unless the word is given the large sense it has in references to the "languages" of the visual arts and music. The type-defining shift in the focus of awareness may be toward any of the "signifiers" in a novel: characters, story, plot, dialogue, time sequences, points of view, various formal devices, and the shape or structure of the whole work. When these have the quality of ordinary prose, when they lend the fiction the authority of fact, the result is a traditional novel. When we become conscious of them as things in themselves even slightly, we are to that degree in an art novel. Thus the reader himself can convert any traditional novel into an art novel by deliberately shifting his attention, just as a viewer of paintings can concentrate on sheer paint and pattern sufficiently to convert a Rembrandt into a kind of Pollock. For criticism, however, such phenomena are scarcely more interesting than the ability of Polonius to see a cloud as a camel. The art novels being discussed here are those that cannot be easily read as anything else, those created and at least partly controlled by the intentions of their writers. And of course Joyce was by no means the first writer to have the decisive awareness-shifting intentions.

Any long fiction written before the European 18th century can be loosely designated as an art novel, but doing so is like calling pretonal music atonal, or designating Adam as a male before Eve was created. The art novels worth the label are those that exist in relation to, almost as a commentary on, the traditional prose type. An early example is Laurence Sterne's *Tristram Shandy,* in which a reader can have the feeling that the author, almost as much as the famous parentheses, asterisks, and blank pages, is soliciting attention for the aesthetic surface of the story. An example of a different sort is Emily Brontë's *Wuthering Heights,* which has a shape odd enough to attract attention as an imposed pattern. Minor examples can be found elsewhere in the 19th century. An author's aside or a rhetorical passage may of course make any traditional novel feel like an art novel temporarily. The type can be said to begin its true career, however, in Gustave Flaubert's *Madame Bovary,* and that it does so

2 Faber & Faber, Ltd., London, 1939.

gives me a chance to say that there is no inevitable incompatibility between realism and drawing attention to signifiers; poor Emma is depicted with hard-eyed cruelty by a creator who is simultaneously insisting that we be aware of her story as a carefully wrought aesthetic object. The succession continues with Henry James, whose best novels, for all their spidery fastidiousness, have structures nearly as evident as those of Mies, and whose criticism is the first important account we have of the art, as distinct from the craft, of fiction.

Then we are in our own era, where there is no need to hunt for examples of the art novel. In Proust's *Remembrance of Things Past* our awareness is focused on patterns of signifiers, particularly of sense associations, which are as prominent as—and quite similar to—the recurring leitmotifs in a Wagnerian music drama. In Joyce's *Ulysses* the art is so evident, in the applied *Odyssey* pattern and many other devices, that critics have had to struggle to keep from focusing on it alone. In Kafka's work the deliberate clichés and bureaucratic sentences become a kind of inverted, ironic poetry as the action becomes symbolic in our minds; we wind up experiencing *The Castle* as a complex unanchored metaphor, as a roving signifier for which the thing signified may be, according to our mood, philosophical, or political, or Jewish, or Freudian. In the psychological novel, as practised by Virginia Woolf, William Faulkner, and other writers of the 1920s and 1930s (including of course the old master, Joyce), the essential paradox of the art novel emerges in full bloom. Here the avowed intention is to go the traditional novelist one better by eliminating all traces of the presence of an author and by employing an absolutely transparent medium that will let us see, or feel, directly into a character's stream of consciousness. But while this intention is being carried out, the strikingly unusual techniques focus our awareness on signifiers as signifiers. Few devices in the history of literature, poetry included, are more obviously literary than the internal monologue; it is form waving for attention while it pretends to be mere content. And few pieces of music, the leading time art, have abstract time patterns more artful than those in Faulkner's *The Sound and the Fury*.

Without further sampling, the beginning of a reply to the common reader's question can be attempted. One of the aims of the art novelist is like one of the aims of the antiprose strategists in modern poetry; it is to catch the multiple import, the peculiar density, and the sharp immediacy of lived reality. The assumption is that the ordinary prose of the traditional novelist does not do the job. Another aim, however, is apparent in the work of Flaubert and James and becomes very evident in the 20th century; it is to give some form and artfulness to the ostensibly formless, ostensibly artless leviathan which the traditional novel became in the middle of the 19th century (James dismissed some famous examples of it as "fluid puddings"). It is to endow the leviathan with a language other than ordinary prose, with a language quite comparable to, al-

though of course less special than, the special nondiscursive languages of music and the visual arts. The basic assumption, like that of the modern painter who rejects optical naturalism, is that art is most satisfying when the tension between form and referent is most evident.

There is no need to repeat here what has been said in previous chapters about the arguments for and against such aims and assumptions. Peculiar problems, however, for which I do not pretend to offer solutions, arise when these aims and assumptions are looked at in a novelistic context. For instance, most people would agree that a novel ought to tell a story, and the common reader would add that the story ought to be entertaining—well supplied with suspense, climaxes, and exciting incidents. But the evidence in verse is that the antiprose strategy is pretty much anti-story; the long narrative poem has become relatively rare in the 20th century. Again, painters can increase the artistic tension in a work by calling attention to paint as paint, and composers can stress sound as sound. Can an art novelist do anything really comparable? Can he proceed by analogy with other arts and not end up violating the nature of his discipline?

IV

Such questions head up in an issue of aesthetic specificity. So far I have been talking about two kinds of novel and have not tried to define *the* novel—the essence from which the existences flow. Is there such a thing? Can we speak of the novel, without adjective, as we do of the drama, or architecture, or painting? Is there something which can be distilled as poetry can from poems? Novelry? Authorities suggest that doubts are permitted. Forty years ago E. M. Forster, in his lecture series *Aspects of the Novel,* felt obliged to describe the art as a "spongy tract" between the mountain ranges of poetry and history, with Miss Austen on a tump of grass near the middle; and he finally settled on a definition by the French critic Abel Chevalley that is merely a provocation: "a fiction in prose of a certain extent." More recently Jean Paul Sartre, in his preface for Nathalie Sarraute's *Portrait of a Man Unknown,* implies a positive notion by speaking of the "antinovel," but the anti-antinovel turns out to be nothing more specific than a book "which presents us with fictional personages and tells us their story." More recently still, in *The Modern Writer and His World,* G. S. Fraser declares that a novel is never an exposition of "a previously determined scheme of ideas," but is instead merely "an exploration of the variety of life, through realistic prose narrative, in the hope of finding a pattern."

It will be noticed that all these definitions, although resolutely vague, lean toward an assumption that what I have called the traditional novel is actually the novel. On that basis the art novel should indeed be referred to by some such label as meta-novel, or X-novel, or antinovel. And if the traditional novel

shows signs of historical fatigue, we may find ourselves arguing that the novel is dying. I prefer to think that *the* novel is still in a dialectical process of emerging, and that therefore the critics who in recent years have discovered a crisis in this historically young (in spite of its masterpieces) art may have discovered nothing more grave than a crisis in their definitions.

At the moment about all that can be said with assurance is that the issue is not as academic as it may look. However, while the outcome is being awaited, and debated, the Fraser definition can serve as a wholesome reminder. We may wish to argue that the art novelist ought to be considered a novelist, even though he is willing to go beyond the mere "hope of finding a pattern" and is doubtful about the realism a narrative in ordinary prose can achieve. But at the same time we stand warned that if an avant-garde experiment winds up as something other than "an exploration of the variety of life," as something actually the equivalent of a musical composition or an abstract painting, we should in the interest of clarity not call it, whatever its merits, a novel.

Equipped with this warning, and with an awareness of the polarity created by the traditional novel and the art novel, we can now glance at a few acres of the "spongy tract" that have been particularly cultivated since 1939.

V

Bellow's Moses Herzog is a Jewish college professor who has been emotionally routed in his career and his two marriages, has felt himself going half insane, and has taken to writing letters "endlessly, fanatically, to the newspapers, to people in public life . . . to the dead, his own obscure dead, and finally the famous dead." Salinger's young Holden Caulfield, who finds nearly everyone and everything phony, is a school truant and finally a case for psychoanalytical treatment. Humbert Humbert, the middle-aged narrator in Vladimir Nabokov's *Lolita,* is a lover of "nymphets"—girls between the ages of nine and fourteen—and finally an unrepentant murderer; he begins writing his story in a psychopathic ward and finishes it in prison. In the same author's *Pale Fire* the main character is Charles Kinbote, alias King Charles Xavier II of Zembla, an exiled and obviously potty scholar and homosexual. In Jean Genêt's *Our Lady of the Flowers* the characters are thieves, murderers, pimps, stool pigeons, and male prostitutes; and the narrator, Genêt himself, is a convict indulging in masturbation fantasies. Oskar Matzerath, the lecherous dwarf in Günter Grass's *The Tin Drum,* writes, or drums out, his picaresque tale of death, bawdiness, and Hitlerism from the barred bed of a lunatic. The characters in William S. Burroughs' *Naked Lunch* are drug addicts and victims or practitioners of sexual perversion.

Camus' Meursault finds no meaning, in fact no reality, in such middle-class

emotions as filial piety, romantic love, and contrition after murder, and goes to his death as if he were someone else. Roquentin, the narrator in Sartre's *Nausea,* has bouts of violent sickness and giddy solitude after discovering what seems to him a meaningless factuality in the objects around him—a rock, a bench, a beer glass, a blue shirt against a brown wall. The title personage in Samuel Beckett's *Watt* has a parallel difficulty with a simple object like a pot: "It resembled a pot, it was almost a pot, but it was not a pot of which one could say, Pot, pot, and be comforted."

The hero of Ralph Ellison's *Invisible Man* is a Negro in search of his identity who lives symbolically in a deserted basement lit by "exactly 1,369 lights," for which he steals the electricity. In Norman Mailer's *An American Dream* the hero is a half-Jewish war veteran, professor, television performer, drunkard, and occasional sodomite who has a recurring impulse to kill himself but strangles his wife instead. Old Gulley Jimson, in Joyce Cary's *The Horse's Mouth,* is a hilariously unsuccessful painter and saboteur of the right-thinking world. Jim Dixon, the hero of Kingsley Amis' *Lucky Jim,* is a square peg who finds that all the holes British society offers him are round. Geoffrey Firmin, in Malcolm Lowry's *Under the Volcano,* is an admirable person destroyed by alcohol. The priest in Greene's *The Power and the Glory* is a drinking man and literally a father. Athos Fadigati, in Giorgio Bassani's *The Gold-Rimmed Spectacles,* is a homosexual doctor driven from his practice and finally to suicide; his story is told by a young Jew who comes to realize that he too is being rejected by society. Alex, the narrator in Anthony Burgess' *A Clockwork Orange,* is a 15-year-old hoodlum in a superstate of the future; after a career of rape and murder he is temporarily reformed by a conditioning of his reflexes that has the defect, from a Christian point of view, of destroying moral choice. In Golding's *Lord of the Flies* children revert to savagery. Frank Alpine, in Bernard Malamud's *The Assistant,* is a reformed holdup man who has himself circumcised and becomes a Jew. George Caldwell, the dying highschool teacher in John Updike's *The Centaur,* is a clumsy failure in all of life's tests except that of sympathy. Half the personages in Joseph Heller's *Catch-22* are insanely engaged in making nonsense of the American effort in World War II, and the other half are lucidly engaged in the same operation.

This listing of persons, situations, and stories—of "material," since in a novel people are of the same stuff as predicaments and action—had better be halted before it gets out of control. It had also better be qualified right away; many of the novels mentioned are bound to fade in coming years, and there are trends which are not sampled, or at any rate not adequately. These shortcomings need not, however, rule out some general remarks. All of the books have been praised by competent judges. On the record one can guess that those which fade rapidly will be rapidly replaced by something similar in content.

Allowing for substitutions to suit a reader's personal taste, one can say that the listing is representative of the sort of material favoured by two-thirds of the better novelists writing since 1939 in the technologically advanced nations. Novelists in Marxist countries are omitted out of a desire to be fair; their art is just getting under way after the disaster of Stalinism and Zhdanovism and cannot yet stand comparison with the best work in the non-Communist Occident (Pasternak was more a survivor than a contemporary).

A comparison of this material with a sampling from 22 typical novels of the 18th and 19th centuries would bring out something everybody knows, although the evidence is sometimes forgotten. One of the most common stories of a hundred years or more ago is that of the fundamentally sound young man or woman who makes a few mistakes about appearance and reality, who may even rebel against the code of the majority, but who is at last gathered into the fold of community values and familiar certitudes—a satisfactory marriage being the usual sign of the completion of the process. It is a story of education leading to initiation and integration. Along the way there may be some criticism of society and conventional reality, but this usually boils down to nothing stronger than charges of hypocrisy or myopia; the system is merely being told to be more faithful to its own nature. Even when the hero or heroine fails to learn fast enough and winds up as an outsider, the author comments from a point of view within the community. In short—and to be rather abstract about an art that is never abstract—a dominant theme in these old novels is acculturation (there are other themes, naturally, and "acculturation" must be allowed a broad meaning). The theme is developed by writers belonging to very different categories, by James and Flaubert as well as by Tolstoi, George Eliot, Jane Austen, Fielding, and Richardson. These great novelists are too much artists to be preachers; they see to it that the moral to a tale is more enacted than pointed. But over and over it is the same moral: grow up, face reality, adapt yourself, and be integrated.

Something close to an exact reversal of this moral can be found in post-1939 fiction. In a sense, I suppose, the grand theme of acculturation is still being orchestrated; it can scarcely be avoided, since all novels are about people learning to live in society and adjust to reality. But it is orchestrated in such an atonal fashion, with so much dissonance and such a violent displacement of author sympathy, that we are likely to feel it as antiacculturation. And so, since there are more than enough anti-terms around, we may as well retreat into commonplaces and say, as every critic does sooner or later, that the dominant (again, not the only) theme in the contemporary novel is alienation.

To be sure, this theme did not make its first appearance in 1939. Any scolding of contemporary novelists for using it ought to begin with an admission that they are in good historical company. Alienation is of course evident in the

work of such diverse between-the-wars writers as Ernest Hemingway, F. Scott Fitzgerald, André Gide, Evelyn Waugh, and Louis Ferdinand Céline (my sampling is still aleatory). It is also evident in the work of such standard Americans as Nathaniel Hawthorne, Herman Melville, and Mark Twain: Huck Finn does not think at all highly of either adulthood or community values. It appears, with variations, in the novels of Fëdor Dostoevski, Stendhal, and Cervantes; the operas of Wagner; the poetry of Rimbaud and Baudelaire; the thinking of Hegel, Marx, Freud, and Jung. Hamlet is alienated, as are all of the mad or apparently mad revengers in Elizabethan and Jacobean plays. Faust is alienated, and so are many of the personages in Greek myths. A full history would have to begin with the story of the Fall in *Genesis,* or perhaps with the first indications that Satan was not going to face reality and settle down in heavenly society.

Nevertheless, it is hard to think of any past period in which the theme was as dominant as it has been during roughly the last thirty years, particularly in the novel. Admittedly, it has many kinds and degrees. One can even detect national styles: the French tend to be desperate in terms of psychologized philosophy, the English suffer sociologically, the Germans have angst over history, the Italians cannot communicate, the Japanese feel trapped between cultures, and the Americans, perhaps because they began as Europe's outsiders, often experience an estrangement that seems to be exuded by their cities and the land itself. But the word "alienation" spans the differences; evidently the novelists are all talking about the same sentiment. Why are they doing so?

We have already touched on this question in the chapters on poetry, the theatre, and the general feel of the modern era. The obvious answer a novelist can give is that he is committed, more than other artists, to "an exploration of the variety of life" and is simply reporting facts. A lot of 20th-century people are indeed apt to feel like exiles, to lose their sense of identity, and to have trouble with the nature of reality. Many feel cut off from the humanistic past and yet incapable of integration with the present as represented by modern art, science, and technology; they worry about becoming cultural zombies. Democracy and industrialization have weakened the social classes and professional groups which enable a man to know who he is without asking himself. It has become difficult to belong to God and difficult, even for professed atheists, not to want to. You can start a day feeling poorly adapted to the new materialism and go to bed feeling that mind has inundated matter and you are at sea in selfhood. Marxists are not alone in feeling that under capitalism whatever a person produces with his hands or brain is immediately made alien, somehow hostile, to him. Existentialists are not alone in their anguished conviction that every individual has got to create Man, without a blueprint. And nearly everyone is nagged by a hunch that he is forbidden to become, in a phrase of Ortega's, his "program-

matic personage," his own vital design, his authentic "I"; nearly everyone is a sort of sane schizophrenic.

All this is true. But that it is the whole truth about modern life can be violently contested by any non-novelist. Moreover, it does not explain the enthusiasm contemporary novelists have for writing about alienation. They like the theme; they are not just dutiful reporters carrying out an assignment. They are nearly always impatient with ideas of assimilation and acculturation; their sympathies and talents are reserved for racial or religious minorities and madmen, fools, homosexuals, alcoholics, adolescents, criminals, failures, addicts, and clowns. The recurring moral, taken literally, is that maybe the world would be better off if we all refused to grow up and join up. Of course it is not to be taken literally, and often there is no moral, in the sense of a guide for conduct; there is only an assertion that this is how things are. Most of these writers would probably argue that literature is a wisdom, not an ethic. That argument, however, merely brings up the question again: Why are they so devoted to this particular sort of wisdom?

VI

The answer to that question, I am afraid, is another commonplace—and a Romantic one. Alienation is notoriously congenial to artists. It helps them to create worlds within the world. It does part of their work for them.

To say this is not to underestimate talent and seriousness. No reader of *Herzog,* for example, can doubt the complete sincerity, and the erudition, with which Bellow explores the problems of the modern sensibility. Nobody can doubt either that Jewishness and a touch of lunacy make Moses Herzog a more intense representative of the modern world's outsiders than a perfectly sane Gentile might have been. Consider, however, the opening sentence of the book: "If I am out of my mind, it's all right with me. . . ." The reader soon comes to realize that it's all right too with Bellow the artist, as is the fact that the hero is a "big-city Jew." Herzog's unhinged mind, supplied as it is with memories partly in Yiddish, could be appreciated in real life as a work of art; it has ready-made arbitrary structures and aesthetic distance. In the novel it serves as a theater-in-the-round, brilliantly lit and carefully sealed off from linear time (the story, like *Finnegans Wake,* ends where it begins), within which all the characters—Herzog included—exist and the action occurs.

The fiercely alienated convict's mind of Genêt, narrating *Our Lady of the Flowers,* produces a similar—one might almost say automatic—aesthetic effect, heightened by the choice of material: the unholy integrity, futility, and absolute apartness of the Montmartre milieu of pimps and perverts add up to a real-life parody of a work of art, a world within the world. I do not wish to discount the artistry of Genêt, nor the large symbolical significance of his work.

But it is plain that he begins the process of artistic creation with an advantage over the novelists who do not write about outsiders.

The same advantage comes into play for Salinger when he gives his young hero the apartness of a teen-age subculture, for Nabokov when he makes Humbert and Kinbote perverse and potty, for Grass when he makes Oskar Matzerath a self-created dwarf, for Sartre when he has Roquentin develop that strange allergy to physical reality, for Bassani when he chooses a homosexual protagonist and a Jewish narrator, for Ellison when he makes his Negro narrator go through an initiation in reverse, an initiation into ostracism. The reader can continue the examples. Once again, my point is not meant as a slight on the sincerity of these novelists. In creating their worlds within the world they do not have the crude intentions of the potboiler author who throws his characters into an Atlantic luxury liner, or a grand hotel isolated by a blizzard. But is it not clear that the alienation theme may be dangerously attractive?

All artists, of course, impose apartness and set up arbitrary little worlds. There are, however, distinctions worth noting. Take one of the fine acculturation novels of the past, say James's *The Portrait of a Lady* (even the title is acculturative). James does make us aware of a work of art. But the arbitrary "little" world he creates is nothing less than a complex working model of Atlantic-basin civilization above a certain income level, within which the independent—not alienated—young Isabel Archer is forced to learn to find her way. The material, in other words, is structured and given a quality of apartness, is aestheticized, only at a relatively late stage in the creative process, a stage late enough to let the novelistic facts ripen into a broadly varied simulacrum of social reality. On the other hand, in a typical post-1939 alienation novel, even such a mild one as *The Catcher in the Rye,* the little world apart can be said to exist at the very beginning of the creative process—in fact, before the beginning. James selects a broad slice of life and works it up into a form. Salinger selects a narrow slice which has a form already. His novel, like many of those under consideration, is made of pre-aestheticized material.

Here, as in the similar problems posed by modern meta-theatre and absurd drama, critical temperament is apt to govern judgment, and so I must offer some of my promised tentativeness. Alienation seems to provide the novelist with an alarmingly Romantic facility for confusing reality with art. Used as a dominant theme, it even seems to weaken the very essence of the genre, of novelry, for it discourages "an exploration of the variety of life" and fosters a premature kind of apartness in material. It is ultimately amoral, as all opting out is. At its worst it becomes intolerably snug and smug, an excuse for a literature of opposition to something which cannot actually be opposed, about which nothing can be done. All too frequently it turns the protagonist into a portrait of the artist. And yet the day is past when a novelist, with a straight face, could

simply tell people to join up. Join up with what? The acculturation theme supposes a confidence in community values which a contemporary writer cannot assume exists (except possibly in Communist countries). Alienation is an important fact in modern society, and it will probably become more important everywhere in the near future—its prevalence in an advanced country like the United States is prophetic. It cannot be avoided by serious novelists. They must learn to live with this rather antinovelistic theme, must get out their long spoons and sup with their devil. My tentative conclusion is that great novels are likely to get even harder to write than they evidently are already.

Of course we should remember that alienation, although of top importance, is not the only theme in post-1939 fiction. There is a chilling indictment of racial prejudice in *Invisible Man;* there are pleas for tolerance and fraternity in *The Gold-Rimmed Spectacles* and other books; *The Tin Drum* is about war, politics, and, ultimately, good and evil; *The Power and the Glory* is about faith and charity; *A Clockwork Orange* is about tyranny and the human dignity that goes with free will; *Lolita* is about old-fashioned romantic love of the Poe sort, and not entirely a spoof of the subject, whatever Nabokov intended. There is no room for an adequate account of the variety of these themes, and they do not lend themselves to generalization. The fact, however, that the books I have just mentioned are among the best of the lot might be read as a warning to novelists against overindulgence in straight alienation.

VII

With the intention of making a point, I have not attempted to divide my sampling (which will be extended in a moment) into art novels and traditional ones; and by now the point has probably made itself. It is what was proposed some pages back: the traditional novel, being a type of prose fiction claiming the authority of facts, can move into a new period simply by changing its facts—its material, plus the themes that emerge from the material. Only eight of our listed books gravitate definitely toward the art-novel pole: *Pale Fire, Our Lady of the Flowers, The Tin Drum, Naked Lunch, Watt, A Clockwork Orange, The Centaur,* and *Catch-22.* The others show some of the disposition, but not enough to warrant the label. Yet all seem modern.

Would the mostly traditional ones seem modern if they were about acculturation? Perhaps not; in any event the alienation theme has the advantage of being doubly modern. It stems from the facts of modern life and at the same time implies, in terms of content, what the general modern movement frequently implies in terms of form: a defensive reflex of withdrawal which can be interpreted as an insistence on humanity in the face of much that is no longer very human. The analogies are of course emotional and unprovable. But for me at least the alienation of Herzog belongs in the same sensibility system as the al-

leged craziness in Abstract Expressionism, modern music, and Surrealism. I suspect that Tinguely's machines and many of the characters in contemporary novels are insane for the same basic reason, if we think about the matter long enough. It seems probable that the antibourgeois obscurity in modern poetry is not unrelated to the contemporary novelist's impulse to opt out of majority society and identify himself with a racial or religious minority. Behind the new forms in many modern disciplines one can often detect an inclination to prefer appearance to reality, somewhat in the manner of Don Quixote. Is this not at bottom the same inclination we find in a lot of the new novelistic content?

My plan was to add something here about how artificial, particularly in the traditional novel, the critics' separation of form and content is; but that point too has probably made itself by now. In any event, not much can be done about it. Criticism cannot mimic its object very exactly.

VIII

An insistence on humanity in the face of much that is no longer very human may require, as the creators of Oedipus and King Lear realized before 1939, drastic means. This requirement is the best explanation—the one, that is, which is most to their credit—for the marked tendency among contemporary novelists to rely, in their writing as well as their choice of material, on raw power, on the haymaker instead of the jab. The tendency existed, of course, before World War II: in the torrential obscenity of Céline, for example, in the grotesque material and unrestrained rhetoric of Faulkner, in the immoral morality of Gide, in the tough manner of Hemingway, who liked to think of novelry as pugilism. But since the war it has become more general.

Occasionally, as in Golding's *Pincher Martin,* the modern little man is pushed into a Promethean stance. Martin is an intelligent, selfish ex-actor whose ship has been torpedoed and who is now presumably struggling for survival on a rock in the Atlantic. In fact his body is already dead; it is only his vain, sinful ego, his "centre," which is still resisting as a storm lashes the rock:

> The mouth quacked on for a while then dribbled into silence.
> There was no mouth.
> Still the centre resisted. It made the lightning do its work according to the laws of this heaven. It perceived in some mode of sight without eyes that pieces of the sky between the branches of black lightning were replaced by pits of nothing. This made the fear of the centre, the rage of the centre vomit in a mode that required no mouth. It screamed into the pit of nothing voicelessly, wordlessly.
> "I shit on your heaven!"
> The lines and tendrils fell forward through the sea. A segment of storm dropped out[3]

3 Faber & Faber, Ltd. London; published in the United States under title of *The Two Deaths of Christopher Martin* by Harcourt, Brace & World, Inc., New York, 1960.

It is difficult to think of a well-known 19th-century novelist who might have written such a passage. A hundred years ago, even for a French satanist or a Russian nihilist, man was less fallen and the pit of nothing was less empty.

However, the cosmic shock is essayed today less often than the repellent subject, the demented glint, the sadomasochistic shudder, the gratuitous crime, the obscene reverie, and the four-letter word. Beckett's *Comment c'est* ("How It Is," with a pun on "begin") is entirely about a naked man crawling in mud: "push pull the leg slackens the arm folds . . . the other side left leg left arm push pull." One can guess that a third of the current novelistic population would be put away by psychiatrists in the real world. When Alex and his teenage gang, in *A Clockwork Orange,* are not engaged in planned crimes they amuse themselves by driving over unknown creatures on a dark highway, preferring "something big with a snarling toothy rot in the headlamps." In Mailer's *An American Dream* what might be called our entire physical imagination, the sense of smell included, is assaulted in descriptions of murder, bowel movements, vomiting, and assorted sexual activity. In James Baldwin's *Another Country* nearly every imaginable barrier to sexual union comes down, including those created by race and abnormality. Add the aberration of Humbert Humbert, the hand of Genêt under the prison blanket, the fantastic dirty stories in John Barth's *The Sot-Weed Factor,* the vivid incest scene in Iris Murdoch's *A Severed Head,* the naked dance of desire on the threshing floor in Moravia's *Conjugal Love,* the extravagant grossness in *The Tin Drum,* and dozens of examples of the influence of Rabelais and the Marquis de Sade. Some of these books are too outspoken to be called typical. Some, I am pleased to grant, show no signs of immortality. But there seems little doubt about the trend; a growing number of serious novelists assume that part of their job is to commit an act of violence on the reader's nervous system—an assumption which would have knocked Miss Austen off her tump of grass and driven Mr. Forster out of the spongy tract forever. To account for it as an insistence on humanity seems a little high-flown in many instances. Are there supplementary explanations?

Opportunity is one such. Since World War II the courts in Western nations, with the occasional exception of Gaullist France, have been more and more tolerant of utter frankness. The case of D. H. Lawrence's *Lady Chatterley's Lover* in England and that of Henry Miller's *Tropic of Cancer* in the United States have resulted in rulings from which it now appears impossible to retreat; in fact, the arguments in these cases have begun to look quaint in the light of what is being printed today. Legal authorities show a disposition to surrender at the first flourish of the standard notions that art can justify the apparently undesirable and that there is an analogy between free thought and an obscene vocabulary. And back of this disposition there lies, as always in matters of law, a disposition in society at large. Total candour is increasingly regarded as a

good in itself; the proprieties, including those that used to cover, and protect, our most private acts are increasingly regarded with suspicion. Repression, in the Freudian sense, is considered more sinful than open sinning. Studies like the Kinsey Report have assured everybody that everybody does the same things. There is a new public for the novelists who want to tell all at the lowest level of linguistic usage.

The opportunity, however, does not explain the way it has been seized. One must allow for commercial exploitation of pornography, and also for an inevitable tendency to write about abnormality, since the modes of ordinary heterosexuality are tiresomely finite. But the extremism in today's novels, the evident wish to hit the reader with raw power, is apparent in too much besides the erotic material to be accounted for by a simple theory of willed vulgarity. Perhaps it is best understood in the full context of political and social history, where it can be linked to incessant war, racial hatred, and the rising crime rate. Or it can be interpreted once again as a consequence of alienation, which would eventually bring us back to the notion of a strenuous insistence on humanity. The outsider resorts to extreme measures because he is without the power inherent in community values and the certitudes of the past. The lone wolf has to howl more intensely than a member of the pack.

At this point the art historian, slightly embarrassed by the narrowness of his approach, can add a word. Today's novelistic extremism is reasonably analogous to expressionism in other arts. It can be compared with the violence in the music and librettos of Richard Strauss, Schoenberg, and Berg, or with the rough textures and emotional subject matter of Van Gogh, Ensor, and Munch. The analogy is interesting, for these names are reminders that expressionism often flares up at the end of one period and the beginning of another, when an old stylistic system has been partly disrupted and a new system is not yet firmly in place. In recent music and painting expressionism is of course a personal operation, an attempt to convert sound and paint into a private cry of anguish, or a defiant shout. But it was also part of the historical transition between late Wagner and serialism, and between 19th-century optical naturalism and Cubism, much as it was one of the dislocating agents in Gothic painting, sculpture, and architecture just before the Renaissance. Will it turn out to have been something comparable in the history of the novel?

We had better not prophesy, since this is the first time the novel has had to move from one period to another. However, a disruptive action and a pull in the general direction of the art novel can be discovered. The brutality in material and language tends paradoxically toward an aesthetic effect, toward a focusing of the reader's awareness on signifiers and artfulness. When Golding turns on the power, *Pincher Martin* ceases to be fiction claiming the authority of fact, rises free of its story, and becomes an allegory about ourselves on our

planet. Although *An American Dream, Another Country, Conjugal Love,* and possibly *A Severed Head* would be called traditional in form by most critics, the big scenes are perversely artistic. And of course the Beckett, Burgess, Barth, Nabokov, Genêt, and Grass books are clearly art novels.

IX

But one should not talk about the new novelistic brutalism and the four-letter words without mentioning the peculiar comic (that may be the wrong term) impulse which often informs the violence and is sometimes present without the violence. Post-1939 fiction must have one of the highest gags-per-novel averages in the history of the genre.

There is a lot of sport with words, names, and poetic or prose styles. In *Pale Fire* Nabokov parodies the manners of, among others, Pope, Wordsworth, Poe, Eliot, Frost, Romantic novelists, and American professors, and gives his personages such names as Oswin Affenpin, Baron Harfar Shalksbore (known as Curdy Buff), and Thurgus the Third, surnamed The Turgid. Carlo Emilio Gadda, in *That Awful Mess on Via Merulana,* writes in several Italian dialects, at several levels of usage, and with a Rabelaisian torrent of coinages, puns, and extravagant metaphors at his command. Most of Raymond Queneau's *Zazie in the Metro* is done in a carefully murdered French, like this: *"Es-tu un hormo-sessuel ou pas?"* Some of the characters in Heller's *Catch-22* are Milo Minder-binder, Hungry Joe, and Major Major Major Major; some of those in *A Clockwise Orange* are Dim, Wall, The Doctor, and Sojohn.

There is also a certain amount of the older sort of novelistic comedy based primarily on character. Holden, in *The Catcher in the Rye,* is funny as well as touching in his alienation. So is Herzog, sitting in the bathtub with his Japanese mistress, talking Yiddish French to her, and worrying all the while about the state of Occidental civilization. So are the English nonconformists: Gulley Jimson in *The Horse's Mouth,* Jim Dixon in *Lucky Jim,* Jake Donaghue in Iris Murdoch's *Under the Net.*

These kinds of humour, however, which have long been common in the novel, are less striking than a third kind, which appears to be gaining in popularity. It is best described as alienated farce, although it is apparent in both language and characterization as well as in plot, the normal element of farce. It has connections, according to nation and the temperaments of authors, with the American tall tale, the traveling salesman's smutty story, Jewish ghetto jokes, the broad peasant jest of the Till Eulenspiegel sort, the "black" humour given currency in the 1920s by the Surrealists, the television and radio gag, the Marx brothers, the ferocious practical joke, the picaresque yarn of low life, and—as this list reveals—the expressionistic extremism we have just been discussing. There are also some links with Beckett's and Ionesco's theatre of the absurd,

Brecht's bleak vulgarity, Cage's clownish music, farcical painting and sculpture, and the omnipresent spirit of Dada.

All that makes quite a bouquet of tendencies; but half a dozen examples may show that there is some unity in the variety. In James Purdy's *Cabot Wright Begins* the alienated hero, a clean-cut young Wall Streeter, turns against American society and begins a career of rape; as his total of more or less willing victims rises he becomes the equivalent of a national sports figure: "Cries go up as hallelujahs tell everybody it's happening again." In the nightmare events of *A Clockwork Orange* only the language, a partly Russian teenage argot, can be called funny, but it is uniquely so:

> Pete and Georgie had good sharp nozhes, but I for my own part had a fine starry horrorshow cutthroat britva which, at that time, I could flash and shine artistic. So there we were dratsing away in the dark[4]

Humbert kills his rival for Lolita in a scene hard to beat for grotesquerie:

> My next bullet caught him somewhere in the side, and he rose from his chair higher and higher, like old, gray, mad Nijinski, like Old Faithful[5]

The crazy airmen in *Catch-22* have to keep flying suicidal missions because of a catch in regulations: although certified craziness can get them grounded, to ask to be grounded is proof of sanity. In Thomas Pynchon's *V.* a character describes the consequences of selling baby alligators as pets in New York:

> Macy's was selling them for fifty cents, every child, it seemed, had to have one. But soon the children grew bored with them. Some set them loose in the streets, but most flushed them down the toilets. And these had grown and reproduced, had fed off rats and sewage, so that now they moved big, blind, albino, all over the sewer system. Down there, God knew how many there were.[6]

Oskar, in *The Tin Drum,* has the ability to "scream silently" at a pitch that breaks glass, and has trained himself in long-distance marksmanship. When he has enough of physical destruction he turns to sabotage of morality, lurking across the street from a jewelry store and cutting hand-sized holes in the window which tempt honest burghers to steal. "Oskar," he says to himself in his lunatic's bed, "you helped them to know themselves."

Alienated farce can easily become just a series of gags, or a single gag being worked to death. It tends to flatten characters into caricatures and to reduce every novelistic subject to a negation. But it has the not inconsiderable merit of leading to art novels (for of course there can be no question of the authority of fact in these works) which are without preciosity and obscurity and which offer a promise of something genuinely positive. Mixed with the frequently tiring

4 Anthony Burgess, *A Clockwork Orange,* W. W. Norton & Co., Inc., New York, 1963.
5 Vladimir Nabokov, *Lolita,* Olympia Press, Paris, 1955, p. 213.
6 Thomas Pynchon, *V.,* J. B. Lippincott Co., New York, 1962.

grossness, improbability, and mind-nudging jocularity of recent farceurs is some of the most zestful satire modern art has yet produced.

X

Beyond the zone of alienation, expressionism, and humour, but linked to and overlapping it, lies the zone of more deliberate focus on signifiers, of the more advertent art novels. Oskar meditates on the possibilities in this zone:

> You can begin a story in the middle and create confusion by striking out boldly, backward and forward. You can be modern, put aside all mention of time and distance and, when the whole thing is done, proclaim, or let someone else proclaim, that you have finally, at the last moment, solved the space-time problem. Or you can declare at the very start that it's impossible to write a novel nowadays, but then, behind your own back so to speak, give birth to a whopper[7]

His fun is to some extent justified. Since 1939 the more advertent art novels have been rather long on theory and short on persuasive accomplishment; many of them, like some of the recent music, painting, and sculpture, seem intended to be enjoyed less as art objects than as art-criticism objects. No vanguard writers of Joyce's skill and stamina have appeared. But the theories and experiments reveal a serious preoccupation with problems of novelistic form, and this preoccupation, examined closely, often turns out to be an earnest concern with the problems and the quality of daily modern life.

Nathalie Sarraute, in such books as *Portrait of a Man Unknown, The Planetarium,* and *The Golden Fruits,* narrows the field and refines the technique of the psychological novel. She concentrates on minute, half-submerged particles of consciousness, on the small fears, appetites, doubts, and wishes we often deny in conversation, on psychic pulses—in a word, on what she calls "tropisms," by analogy with the scientific term for an organism's involuntary response to a source of stimulation. Her novelistic world is at times little more than a brilliant mist of tropisms, in which a slight drift or a sudden swirl constitutes action and recognizable thickenings constitute characters, who may not even have names. At other times there may be an approach to the conventional novel of manners, but this is largely mere appearance; the underlying reality is made of human organisms' secret little responses. The reader may be reminded of Mallarmé's fear of destroying things by crude naming, and often there are effects like those of Webern's micro-structures and silences. Each consciousness is coloured by another, and so the contours of personalities are apt to be as dissolved as those of objects in Impressionist paintings. But the flickering technique calls attention to the aesthetic surface even more than Impressionist brushwork does, and so there is no prosaic naturalism. There is instead a strong

[7] Günter Grass, *The Tin Drum*, Crest Books, Fawcett World Library, New York; Luchterhand Verlag, Neuwied, 1964.

tendency to be self-referring: *The Golden Fruits* is a novel about a novel enti-
tled *The Golden Fruits*.

Alain Robbe-Grillet, if one reads only his early critical essays, can be called
as objective as Nathalie Sarraute is subjective. In *For a New Novel* he protests
against the tendency in the traditional novel to dissolve objects in significance:
". . . the empty chair was only an absence or an expectation, the hand on the
shoulder was only a mark of sympathy, the bars on the window were only the
impossibility of getting out." His opinion is like that of Sartre's Roquentin, but
without the nausea; the world is neither significant nor absurd, "it simply *is*."
The novel, he thinks, must emphasize the mere "thereness" of things:

Let it be first of all by their *presence* that objects and gestures establish themselves, and let
this presence continue to prevail over whatever explanatory theory that may try to enclose
them in a system of references, whether emotional, sociological, Freudian or meta-
physical.[8]

In other words, one might conclude, let us root out of our minds the last trace
of the Romantic pathetic fallacy, and then let us let the "things" in a novel
come forward in the imagination as do the opaque "objects" of certain avant-
garde sculptors: let us focus our awareness on so-called signifiers exclusively
enough to cause them to cease to signify. In fact Robbe-Grillet has rejected
such a drastic interpretation of his theory and practice; he points out that he,
too, is a "subjective" writer, since there is always a man in his novels who "sees,
feels, imagines." Critics have found plenty of significance behind the allegedly
neutral objects in his best-known works: *The Erasers, Jealousy,* and *In the
Labyrinth.* And yet, when all the qualifications have been admitted, there re-
mains in his whole enterprise something profoundly new and strange for read-
ers brought up on the traditional novel. There is a sense of a world in the process
of reification and of a familiar human comfort gone cold.

To these two leaders of the novelistic avant-garde we can add, to extend our
sampling, Michel Butor and William Burroughs. Butor, in such books as *Pass-
ing Time, A Change of Heart* (entitled *Second Thought* in England), and *De-
grees,* shows some of Robbe-Grillet's interest in objects and the sense of sight,
but he is best described (with a wince at the unfairness of these thumbnail
sketches) as a "musical"—sometimes aleatory—novelist in the line of Joyce.
He is an inventive technician; in *A Change of Heart* he solves the problem of
point of view and reader involvement by referring to the hero as "you."

> The train has stopped; you are at Rome in the modern Stazione
> Termini. It is still black night.
> You are alone in the compartment with the young married couple who
> are not getting off[9]

8 Translated by Richard Howard, Grove Press, Inc., New York, 1965

9 Union Générale d'Éditions, Paris, 1962, p. 282.

Burroughs is also inventive, but in a much more radical way. In his *Nova Express, The Soft Machine,* and the already mentioned *Naked Lunch* he puts to novelistic use the antiprose strategy of modern poets, the collage technique of modern painters, the randomness of modern music, and the familiar space-time devices of the cinema:

> Again at the window that never was mine—Reflected word scrawled by some boy—Greatest of all waiting lapses—Five years—The ticket exploded in the air—For I don't know—*I do not know* human dreams—Never was mine—Waiting lapse—[10]

There is a temptation to comment on this passage with the Burroughs line which just precedes it: "Clearly the whole defense must be experiments with two tape recorder mutations." But the answer could be that that line fits a lot of other things in the modern world.

On the basis of the work of these four writers we can try a generalization. Contemporary art novelists tend to proceed by elimination. They are in this respect like the painters who have abandoned perspective and figuration, the composers who have discarded tonality and recurring themes, the architects who have stripped buildings of ornament—like nearly all modern artists. Plot is often sacrificed for the sake of story structures that do not provide the traditional opportunities for narrative order, suspense, and sudden illumination. Normal time sequences, as Oskar points out, may be sacrificed for the sake of "striking out boldly, backward and forward." The vividly drawn and carefully placed characters of 19th-century fiction may be sacrificed for states of mind that have no very precise boundaries and tend to flood the action. The upshot, very often, is that the entertainment of the reader is sacrificed; many avant-garde novels, once started, are noticeably easy to put down. Their readers are apt to belong to the minority that is willing to work at understanding art as people work at understanding science.

Sometimes, however, the art novelist proceeds also by a kind of addition; he doubles his fable with a symbolic structure, with another story, or with devices borrowed from another art. Symbolic and even allegorical interpretations may of course be imposed on more or less traditional works; here what I have in mind is a structure as obvious as the story of humanity on earth with which Golding doubles his story of Pincher Martin on the rock, or the allegory of man's fate which doubles Beckett's stories, or—less precisely—the disaster of the Nazi occupation (plus other modern perils) which parallels the epidemic in Camus' *The Plague.* Doubling with an already existing story may involve, following Joyce's example in *Ulysses,* the use of Greek material; two post-1939 instances are Robbe-Grillet's half-hidden parallel with the Oedipus story in *The Erasers,* and Updike's explicit use, in *The Centaur,* of the myth of Chiron

[10] *Nova Express,* Grove Press, Inc., New York, 1965, p. 75.

and Prometheus to double the tale of the dying schoolteacher and his artistic son. Novelists who double their stories with devices borrowed from another art commonly turn to music and the cinema, as Butor and Burroughs have.

Do mystery and detective stories constitute a genre distinct from that of the novel? One can argue that they do, and even that they should not be considered fine art at all, in spite of the writing skill involved and the existence of many borderline cases. Perhaps they are best thought of as novelistic games or puzzles; they are to serious prose fiction what chess is to war and what—at a much lower and less complex level—jigsaw and other pictorial puzzles are to painting. At least such a classification corresponds to the usual intentions of their professional authors and habitual readers. And on this basis we can speak of another sort of doubling, for several post-1939 art novels have been written as mystery or detective stories without being intended to be read purely as such. Witold Gombrowicz's *Cosmos,* for instance, is a philosophical novel about the role played by the organizing human mind in the creation of "reality," but it is told as the attempt of two young men to get to the bottom of the mystery of a hanged sparrow. Nathalie Sarraute presents her *Portrait of a Man Unknown* as the narrator's attempt to penetrate the mystery of the characters—the patterns of tropisms—of an elderly man and his daughter. In Pynchon's *V.* the wildly alienated farce is accompanied by an improbable thriller about the mysterious woman "V.". Nabokov's *Pale Fire,* besides being a satire on pedantic obtuseness and much else, is an elaborate puzzle, the keys to which, if they really are the keys, are in the notes to a long poem. Robbe-Grillet's *The Erasers* can be cited again, for in addition to being Oedipal it is the story of a police agent looking into a presumed assassination.

These remarks bring us back to what I called ludification in talking about sculpture. Is the art novel in danger of getting caught in the sequence that leads from self-referring to mere play? Possibly the danger is not great, and maybe it is not of awesome importance anyway. But it is certainly easy to detect. Ludification is apparent not only in the doubling of presumably serious material with detective-story forms but also, in different guises, in many other aspects of post-1939 novelry: in the frequently irrelevant gags of farceurs like Heller, Grass, and Pynchon, in the word play and pastiches of Nabokov, in at least some of the randomness of Burroughs, in the Baroque eccentricities and double structures of a book like Barth's *Giles Goat-boy.* There is more than a little of it even in the use of those Greek parallels which are meant to add profundity and poetic resonance; let the reader ask himself honestly if his experience is moral, or aesthetic, or mostly sportive when, having been alerted to the possibility of an Oedipal structure, he catches the detective in *The Erasers* looking at a picture of the ruins of Thebes, or when, in *The Centaur,* he notices that the automobile mechanic Hummel has the lameness of Hephaestus. Joycean schol-

ars can ask themselves the same question as they work out the allusions in *Ulysses* and *Finnegans Wake*. There is much in the current literary scene to suggest that Hermann Hesse was a sound prophet when he imagined, for his *Magister Ludi,* a monkish hierarchy of intellectuals adoring knowledge in the form of a game.

This appeal to the play impulse is not, of course, a bad thing in itself. It can be regarded as the art novel's compensation for the sacrifice of the entertainment offered by the traditional novel. Fun with Oskar's pranks, and self-satisfaction over noticing Hummel's mythological limp are as legitimate as enjoying the suspense and illusionism in Dickens. There is a tension-and-release pleasure in all literature, plus a delight in recognition, which can be related ultimately to our pleasure in gags and in the challenge of games and puzzles. As we move into the realm of the less representational arts, toward the condition of music, this kind of pleasure increases inevitably. But since every pleasure is a potential vice, and since a novel is supposed to be an exploration of the variety of life, I think avant-garde writers ought to worry a bit about ludification, just as traditional writers ought to worry about an excess of their sort of entertainment. The best—the great—justification for the art novel's focus on signifiers, for detaching them in the reader's awareness from the signified novelistic "facts," is not to create novelistic sport, nor even art for art's sake; it is to free the signifiers—Hummel's limp, Oskar's scream, Humbert Humbert's words, the hanged sparrow, the picture of Thebes, the rock of Pincher Martin, the tropisms, the opaque objects and fragmented cinematic images—from the business of prosaic verisimilitude and transform them into patterns which, like the patterns of music, poetry, and the visual arts, will be available for multiple meaning. If the results are primarily jokes and puzzles the case for the avant-garde novel becomes hard to maintain.

XI

The case for the novel in general may eventually become hard to maintain. Some pages back I remarked that the critics who in recent years have discovered a crisis in this relatively young art may have discovered nothing more grave than a crisis in their definitions. Was I being unfair and hastily optimistic? Let me expand and qualify that remark a little as a way of concluding, or at least halting, the present discussion (I do so with renewed regret at not having mentioned dozens of interesting novelists).

The notion of a crisis is not entirely new. More than a century and a half ago, in *Northanger Abbey,* Jane Austen complained that "there seems almost a general wish of decrying the capacity and undervaluing the labour of the novelist"; and shortly before the publication of *Ulysses* T. S. Eliot went on record, with his customary assurance about cultural catastrophes, to the effect that se-

rious prose fiction had become impossible. But the older voices of pessimism are isolated, mild, and merely personal in comparison with those that have been heard since World War II, particularly in the United States and England. A large number of authoritative American and British critics have been speculating about the present situation of the novel, and to read their views is to realize how widespread has become the conviction that trouble is upon us and that its causes lie deep.

Harry Levin suggests that the "crisis" has been provoked by the defection of the bourgeois audience to the cinema, the radio, and television.[11] Many commentators fear that the novel is tied to the fate of the middle classes and that the latter are now in the process of losing their 19th-century vitality and fading out of history. Gilbert Phelps, examining the situation in Great Britain, says flatly:

The trend of the English novel since the war has been . . . a turning aside from the mainstream of European literature, a complacent rejection of the culture of the past, and a retreat into parochialism.[12]

Clifton Fadiman, observing that "the novel's history is imperialistic, a record of the taking in of more and more territory," goes on to speculate:

Are there any areas still untouched, or taboo? Is it this sense of exhaustion that has produced the novel of fantasy, joke, *chosisme,* the heroless novel? With character absent from the "modern" novel, or obsolescent, what new specific sensitivities must I cultivate in order to enjoy fiction? Or—need I continue to read it at all?[13]

William Peden believes that it is now the short story which is "the most challenging and vital of contemporary literary genres as well as the type most suited to the spirit and temper of our times."[14] Alfred Kazin suggests that "the increasing identification of truth with science alone has made for the restrictions which writers so warily take upon themselves now." He adds:

I would insist that the present already marks the culmination of a long process of separating art from formal knowledge, truth and ideas. And I am convinced that this is a worldwide process, and that the more science becomes the exigent and universal instrument everywhere of knowledge, progress, health and happiness, art—even literature, once the queen of the arts—will become more self-consciously limited and perhaps—the fundamental issue before all of us—trivial.[15]

Paul Goodman, cited by Kazin, thinks that during the present century literature has in many ways become "a minor art, more important than pottery or weaving, perhaps less important than block-printing or other graphics."[16]

11 *The Gates of Horn,* Oxford University Press, London, 1963.
12 "The Novel Today," in *The Modern Age,* ed., Boris Ford, Penguin Books Ltd., Harmondsworth, 1961, p. 475.
13 Notes prepared for the Center for the Study of Democratic Institutions, Santa Barbara, Calif., 1963.
14 *The American Short Story,* Houghton Mifflin Co., Boston, 1964, p. 189.
15 Notes for the Center at Santa Barbara, 1963.
16 *Dissent,* Summer, 1958.

George Shuster agrees with some of the Kazin thesis, but strongly doubts that the growing importance of science is the whole explanation:

The reasons were implicit in the structure of Romanticism, and this in turn was derivative from the dichotomy between collective man and the individual. Of course at this juncture the individual had lost his confidence in older forms of orientation. But perhaps the trouble basically was that the individual who wanted to have a fling at being himself had to shirk responsibility for the masses—the others.

McLuhan suggests that a good way to understand what has happened is to take any phrase in *Finnegans Wake* and "mime it until it yields the intelligible."[17]

Since my agreement with much in these opinions has been made clear in the course of this chapter and of this entire volume, my comments will be mostly about areas of disagreement—or possibly about my misunderstandings and misinterpretations of what was meant. I do not doubt, for instance, that some of the audience for films, the radio, and television consists of defectors from the novel. But since the great majority of these would certainly be readers of quite ordinary popular novels, a reason for a crisis is hard to see. An art which is still economically possible, as the novel obviously is, can get along very well with a reduced audience; poetry and classical music are proof. A crisis develops only when the good audience defects. That the novel still has a good audience is proved by the crisis talk itself.

The cinema has of course had an influence on the novel—a triple influence. As a source of sudden wealth for authors it has encouraged the writing of slick movie-like replicas of the traditional novel, well supplied with stock characters, sexual excitement, sentimental morality, and the apparent authority of fact. As a source for technique it has been studied by many novelists besides Burroughs. As a competitor with a corner on many standard story formulas it has stimulated the search for new novelistic materials and methods. But not much of this influence can be called a reason for a crisis.

The traditional novel could conceivably die out with the transformation of the bourgeoisie into a leisure class lacking the old interest in facts, prose, and money; but this death, as I have already remarked, need not be the death of *the* novel. In any event, the bourgeoisie is beginning another historical career in the emergent nations of Asia and Africa. The possibility that these new societies will repeat the evolution of traditional Western art has been discounted elsewhere in this book; they appear inclined to move from their own poetry, music, painting, sculpture, and architecture straight into international modernism. But the old-fashioned realistic novel may be an exception to the rule; since World War II it has been thriving in Japan, a nation which can be taken to represent the cultural future of much of the rest of Asia.

The English "retreat into parochialism" is admittedly a trifle depressing, but

17 *Understanding Media: the Extensions of Man*, McGraw-Hill, New York, 1964, p. 263.

one should not forget the exceptions, several of whom have been mentioned in this chapter. One should not forget either that, as Phelps points out, a lot of the parochialism is put on; Kingsley Amis once pretended in a book review that he "had never heard of" Kierkegaard, Nietzsche, Dostoevski, and Blake. Such behaviour, which fits in with the attitude back of a good deal of post-1939 English fiction, might be described as just a local variety of alienated farce and hence as a quite cosmopolitan sort of parochialism after all. In any event, the main explanation for the English novelistic decline since the glorious days of Forster, Lawrence, and Virginia Woolf appears to lie outside the problems of the novel and its public—perhaps in the whole configuration of England's difficult transition from a capitalist world power into a welfare state occupied with local issues.

The "sense of exhaustion" in recent novels, insofar as it exists, is more alarming than the alleged death of bourgeois man and any loss of readers to the cinema, for finally we can make the best guess about the life of an art form from internal symptoms, however difficult they may be to detect and interpret. Naturally, we cannot theorize about the symptoms very objectively, since if anything is "exhausted" it is actually our sensitivity, not the novelistic material. But I think the symptoms do exist, particularly in the category of the social epic. Today there are still many novelists who are haunted by the old "imperialistic" ambition to get on paper the sweep of history and even the realistic details of an entire society. However, with a few exceptions, they are not among the better writers, and most of the exceptions evidently feel obliged to add to the familiar dish the hot sauces of farce and expressionism. A curious flatness has crept into things that were done vividly before World War II by people like Malraux, Ignazio Silone, John Dos Passos, James T. Farrell, and John Steinbeck. Of course one must reckon with the change in intellectual climate since the "proletarian" 1930s, and not forget that *Invisible Man,* for example, weaves into its alienation and identity themes a stirring account of social and racial unrest. Nevertheless, an impression remains that a lot of formerly usable novelistic material has been worn thin by literary realism, by high-pressure promotion and distribution, by films and television, and above all perhaps by journalism, history, biography, and other kinds of documentation which not only claim, but actually have, the authority of fact. The impression can be widened to include other kinds of material besides the social—especially all kinds of normal love-and-marriage material. It may help to explain the tendency to dispense with the protagonist or to convert him from the admirable hero into the antihero: little Oskar may be nasty, but at least he is not shopworn. But are we talking here about a possible crisis in *the* novel, or merely in the traditional type? Every aesthetic theorist is always in some corner of his mind an agitator, or a mourner, for the kind of art he likes.

The notion of "exhaustion" strengthens the case for calling the short story the literary genre most suited to the spirit and temper of our times. Even without such help, the case looks good in theory. Twentieth-century man is in a hurry and supposedly likes having his cultural fare predigested and encapsulated. Also, once again, the modern movement favours sacrificing whatever in an art can be sacrificed: modern painting and music tend to be synecdochic, putting the part for the whole, which is what many short stories do. There is a warning for novelists in the way brief and highly compressed poems have triumphed over long narratives in verse. Peden, in the critical study already cited, quotes V. S. Pritchett:

In a nervous and reckless age which is overwhelmed by enormous experience, we have inevitably formed the habit of seeing . . . in fragments rather than as a solid mass . . . and, because of this, the brief, quickly moving, epigrammatic, allusive habit of the short story usually seems to me a more natural form for our story-telling than the novel.[18]

Moreover, the technical skill of recent short-story writers is remarkable. Most of the novelists I have mentioned have demonstrated their ability to handle the smaller form effectively, and it has been kept at a high average of laconic excellence by many other practitioners: Jorge Luis Borges in Argentina; Jacques Perret, Marguerite Duras, Félicien Marceau, and Pierre Gascar in France; Heinrich Böll in West Germany; Italo Calvino in Italy; Pritchett, H. E. Bates, William Sansom, and Angus Wilson in Great Britain; John Cheever, Flannery O'Connor, John O'Hara, Irwin Shaw, Isaac Bashevis Singer, Eudora Welty, and Jean Stafford in the U.S. (I apologize for this uneven representation).

There are, however, some very strong reasons for doubting that the novel is about to be vanquished by its little rival. In spite of some recent improvement, the short story is in extremely poor economic health; the wealthier magazines, with the notable exception of *The New Yorker,* are not seriously interested in it, and book publishers regard it as a bad investment. Obviously it cannot, even in the hands of a master, provide a reader with the peculiar delectation of long fiction—with the narcosis, the slow revelation, the sense of actually inhabiting the world of a work of art. And finally, with only a few changes, what has been said in this chapter about the novel can be said about the short story. There is a traditional type of short story which strives for the plausibility of a prosaic statement of fact, and there is an art type which shifts the focus of awareness toward signifiers and may create a metaphorical effect analogous to that of poetry. Alienation, expressionism, and farce are to be found in the post-1939 short story. So are avant-garde aestheticism, double structures, and ludification. So are fragmentation and a tendency to sacrifice readability and narration (today hardly any well-known writer tells a straight, stark story in the fashion of Hemingway). In sum, if the novel is in a plight so is the short story.

[18] Preface, *The Sailor, Sense of Humour, and Other Stories,* Alfred A. Knopf, Inc., New York, 1956.

The important and thoughtful thesis advanced by Kazin puts all the arts in a plight, and clearly has too many implications to be discussed in detail here. I shall merely state my understanding of the gist and then embroider some personal thoughts on that understanding—with a suggestion that the reader carry on the meditation. The thesis appears to consist of three quite distinct statements: first, "the present . . . marks the culmination of a long process of separating art from formal knowledge, truth and ideas"; second, the separation has been provoked by "the increasing identification of truth with science alone"; third, the "process of separating" must lead to art, including literature, which is "more self-consciously limited and perhaps . . . trivial." I agree with the first statement on the whole, but would underline the qualifying word "formal" and point out that the "long process of separating" suddenly accelerated at the beginning of the 20th century for all the arts—enough to justify our speaking of a new period and perhaps even of a new series of periods. The second statement seems to me a very incomplete account of what has happened; it reminds me of the idea that painting went abstract merely because photography monopolized the rendering of reality. As for the third statement, I recognize the danger of triviality referred to (after talking of ludification I cannot do otherwise), but I think Kazin overestimates it.

Picasso's Cubism, Brancusi's egg-heads, Eliot's smashed syntax, Brecht's playhouse irony, Joyce's double structures, and similar separations of art from "formal knowledge, truth and ideas" cannot be adequately explained as the results of an "identification of truth with science alone." Such an identification was certainly in the cultural atmosphere which was influencing sensitive artists, but so were many other things. So—very much so—was Shuster's Romantic personage, "the individual who wanted to have a fling at being himself" and who therefore "had to shirk responsibility for . . . the others." Secularization was an already ancient part of the pattern. In *The Disinherited Mind,* Erich Heller describes a dispute at Marburg between Martin Luther and Ulrich Zwingli:

> The dispute is about the nature of the eucharist, the sacrament of the Lord's Supper. The bread and the wine—are they the body and blood of Christ, or are they "mere symbols"? Luther is . . . the man of the Middle Ages. The word and the sign are for him . . . the thing itself. Yet for Zwingli, steeped in the enlightened thought of the Italian Renaissance, this is a barbarous absurdity. The sacrament is "merely" a symbol; that is, it symbolically represents what in itself it is not.[19]

Shall we say that the "process of separating," and hence our modern literature of mere signifiers, really dates from that day at Marburg? Heller is of course just dramatizing the faint beginnings of the change which suddenly gathered speed around 1900. But the fact that his illustration is theological is a reminder

19 Bowes & Bowes Ltd., London, 1961, p. 229.

of how many different strands there are in what he goes on to call our "complex fabric of unconsciously held convictions about what is real and what is not." In my view that fabric cannot be understood, except in details, as a causal sequence. It must be felt as a network of reciprocating analogies and resonances. To imply that the progress of scientific truth in our minds is somehow the cause of modern art—or of the art novel in particular—is rather like saying that south is the cause of north, east, and west. It is also to forget that scientists as well as novelists and theologians have been detaching signifiers from the signified. In this instance we can indeed take McLuhan's advice, and repeat "H. C. Earwicker," the name of the hero of *Finnegans Wake,* until it becomes Here Comes Everybody and Haveth Childers Everywhere.

It can be objected that to be aware of a signifier as such and to fail to relate it to "formal knowledge, truth and ideas" are two quite different things. Here there is a real risk of producing the worst kind of triviality—insignificance. The objection can be raised legitimately against some of the art novels cited in this chapter. But to press it very far may provoke several answers from the avant-garde. One, which has been mentioned perhaps too often in these pages, is that much of today's "formal" truth is too relative and emotionally meagre to be used with confidence by an artist (he may, of course, transform it into science fiction, but the result is apt to smell of ludification). Another is that art has its own truth insofar as it is man's vision of his own humanity, and that this truth is often well served when an artist concentrates on being "self-consciously limited." (A disturbing, although certainly not intended, implication in the Kazin thesis is that such more or less abstract arts as music and architecture are trivial in comparison with a 19th-century realistic novel.) A third answer is that the great literature of the past does not, after all, tell us very much in a positive sense about the meaning of the world. It makes us wiser and riper by posing instead of solving problems. Cannot some truly serious problems about the meaning of life and the meaning of meaning itself be posed in terms of ambiguous novelistic signifiers? "Life," Virginia Woolf thought, "is not a series of gig lamps symmetrically arranged; but a luminous halo" May it not also be thought of as a brilliant mist of tropisms? Or, perhaps, as a tape-recorder mutation?

Such questions make one wonder how far novelists can proceed in this direction without getting into territory which is properly that of verse. But then how far can they proceed in the traditional direction without leaving the territory of fiction altogether? Apparently they must resign themselves, at least for the foreseeable future, to finding their way through Forster's spongy tract, perhaps skirting the mountain range of poetry more often than that of history. And while I think we have had too much talk of a crisis, I grant that, all things considered, the going promises to be rough.

The apparatus is the muse. BÉLA BALÁZS

A film is like a boat: it's just asking to be sunk.
FRANÇOIS TRUFFAUT

Chapter 15 The Movies' Second Chance

IN THE 1920s the silent film seemed about to become for the international 20th century what the novel had been for the European 19th—a combined majority and minority art, entertainment that did not exclude serious statements. Creators like Charlie Chaplin and Sergei Eisenstein were active, and there was a good supply of audiences, money, know-how, and theoretical understanding. Then, although interesting pictures continued to be produced, the opportunity for greatness seemed to fade.

Technology suddenly rendered much of the technique and theory of the cinema obsolete. Between 1927 and 1935 the advent of synchronized sound pushed the world's directors and actors from the primarily mechanical into the beginning electronic phase of the industrial revolution. Economic depression, the rise of dictatorships, and World War II compounded the difficulties, but at the same time they delayed further developments which were to push the film medium into new territory after the advent of television. In the postwar years the number of small screens in American and European homes grew inexorably, and cultural critics began to predict the final defeat of the movies.

The predictions proved wrong. Hollywood, and the equivalent production centres elsewhere, have certainly suffered economically, and they no longer dominate the mass audience. But the cinema as an aesthetic activity has shown no signs of collapsing or even retreating under the onslaught of television. On the contrary, the theatre film has maneuvered itself, or has been maneuvered by circumstances, into what looks like a second chance to become a genuinely major and representative modern art.

229

I

The relationship between television and cinema has no close parallel among other arts. The phonograph record is both a friend and a rival of live music, and the colour print is in a somewhat similar relationship with painting. But television is obviously not much of a friend of the cinema, although it may be a source of revenue; neither is it a serious rival on artistic grounds, as the disk is for the concert. Much of TV fiction (factual reporting is another matter) is radio drama with pictures added; some is reproduced theatre, from Shakespeare to vaudeville turns, with a certain intimacy added: and the best is apt to consist of old films—whose constriction may remind the viewer of the superiority of the movie house's big screen, privatizing darkness, and freedom from the interruption of commercials. In other words, television is significant in this situation almost entirely because it is very accessible and very compulsive. It is a substitute, not for the *art* of the movies, but for the pre-World War II movie-going *habits* of a large part of the population—the custom that took the whole family to the neighbourhood theatre once or twice a week regardless of what might be on the bill.

Hollywood, of course, has adapted to the new electronic dispensation, and now devotes much of its facilities and talent to producing film or video tape for television. In 1935 the studios turned out 525 feature films; the average has dropped to less than 200 a year since 1960, when TV had become universally available in the United States, Great Britain, and much of Western Europe, and had gained footholds in most of the world's urban places. And today many of Hollywood's feature films are produced with the television audience strongly, if not predominantly, in mind; these hybrid products may first see the light in the greatly reduced network of motion-picture theatres, but they are likely to return real profits only when they are released for recurrent showing on the home screens.

The conventional film-maker's first reaction to the electronic invasion was to fight back with whatever put the TV set at a disadvantage: wide screens, stereophonic sound, handsome colours, sweeping landscapes, strong sex appeal, and controversial themes considered too gamy for home-style family viewing, big-name stars (when they could be had), and hours-long blockbusters derived from ancient Rome, the Bible, or such contemporary epics as the Normandy Invasion. The novelty and magnitude of these developments also tended to divert attention from the sharp increase in admission prices—in both Europe and America—which helped maintain gross income in the face of the declining audience total.

These efforts to hang onto a significant share of the mass audience in the face of mounting TV competition can be rated as only partially successful. They have, however, had considerable impact on the style and the techniques

employed in the industry as a whole. Italy has shown a marked interest in the flamboyant, outsize Cecil B. deMille approach, and so has the Soviet Union in its more earnest fashion, notably with director Sergei Bondarchuk's eight-hour, giant-screen version of *War and Peace*. Major film industries in Japan and India have continued to thrive, largely by holding down costs and keeping a knowing eye out for special local appeal.

The most significant by-product of the new TV age, however, has been the discovery that the shrunken conventional movie audience could be bolstered by a substantial group of new recruits—the sophisticated minority formerly dismissed by the industry as merely an arty, essentially noncommercial fringe of the total movie-going public. It required about a decade for TV to expand from a curiosity in a few major cities to a nationwide visual communications system in many of the countries that had long provided primary markets for the Hollywood-style product; everywhere evidence piled up at the box offices that the new medium was capable of providing, handily and usually without direct cost, entertainment of a quality that satisfied the demands of many of those who had previously filled the movie houses. The cash register pointed the moral that the theatres required something different not only in technique but in content. If the middlebrows were staying home, unless jarred loose by highly expensive blockbusters, why not try for the highbrows? When a producer started calculating in these terms he was well on his way to the conclusion that television, while difficult to counter with the once habit-forming family film, was highly vulnerable as art. In any event, the result has been the discovery that the prewar arty fringe has grown into a sizable international audience which can justify an occasional bet on quality.

This new audience is certainly not large by the old standards even in places like Paris, Rome, London, New York, and Los Angeles, where it is highly articulate and not without influence on prevailing standards of popular taste. It is, however, large enough to render commercially viable at least a limited number of serious films which a generation ago would never have obtained an adequate production budget, and if completed on a cut-rate basis would have been consigned to a sort of closed-circuit distribution on campuses and in little experimental art theatres. Moreover, the new audience is steadily being augmented by the addition of young people who have come of theatrical age in the post-1945 world of TV images, audiovisual education, cinema (not fan) clubs, film museums, international film festivals, and intellectual film criticism—all those new developments which seem to have produced what amounts to a youth cult that exalts visual and sensual perceptions. These new movie-goers are as familiar with the language of shots, sequences, cuts, dissolves, tracking, panning, and the like as their grandfathers were with the conventions of the 19th-century novel. In the wake of the general relaxation of censorship they de-

mand, and get, much on film that only a few years ago would have been thought too daring or too obscure—Ingmar Bergman's depiction of lust in *The Silence,* for example, and Alain Resnais' study of memory and identity in *L'Année dernière à Marienbad.*

The new generation of Hollywood professionals, although basically they may be no less commercially oriented than their predecessors, recognize the new trend and attempt to act upon it. Larry Turman, the 40-year-old producer of *The Best Man,* a political satire by yesterday's *enfant terrible,* Gore Vidal, concluded that the work was "talky, and at that it was an older generation talking about itself." He would not again do a film, he said, without a strong, direct appeal to the younger generation and to foreign audiences, which means a major visual emphasis to provide a minimal reliance on subtitles.[1]

The principal victim of this shift in style seems likely to be the good, solid entertainment film that Hollywood once turned out in journeyman fashion at a level between the super-epics and the B-grade potboilers that filled out the double bills. The old American and British features were in fact a kind of film repertory that provided a training ground for writers, actors, directors, and technicians that has not been duplicated in the slapdash film productions made directly for broadcast. Moreover, they provided a primary source of adult entertainment—most notably of good-humoured comedy, which was not intended as satire but nevertheless was not without significance as social comment—for the generation now grown to middle age and beyond. It is doubtless true that these past achievements have been overrated by nostalgic critics; certainly those who turned out for a recent revival of Greta Garbo's most famous films witnessed some harrowing damage to the old mythology. Nevertheless, anyone with memories of durable big stars and well-made hokum is likely to be sorry if one evening there is nothing available in or out of the house except TV soap opera, *Ben Hur,* and Marienbadism. And champions of the new wave might ponder whether an art form that provides nothing between lavish spectacle and subtle drama may not lose too much quality in one direction and too much vitality in the other.

However, the dangers do not alter the fact that the more discriminating part of the world's film audience, partly because of its growth and partly as a result of the loss to TV of most of those who once established the common denominator of taste, is now having a significant effect on cinema history.

II

Economics and aesthetics have always been at odds in movie-making. Today, of course, all kinds of artistic production are apt to be hampered by financial considerations. Even writing, which has the lowest overhead of any art except

1 Quoted in the *Los Angeles Times.*

whistling, may become dependent upon the industrial and merchandising operation which delivers the product to the consumer. But the maker of a feature film has long been nearly unique (architects should not be forgotten, although their situation is usually easier) in his need for a large amount of money for the very act of creation—an amount which director John Grierson once put at "between the price of a hospital and the estimated cost of clearing the slums of Southwark." This need has not only discouraged experimentation and encouraged a low aim at the mass market, it has also undoubtedly kept some gifted people out of the producing and directing field. Presumably no poet or novelist ever turned off his muse because he could not find half a million dollars, but the record of motion pictures is replete with financially frustrated geniuses.

The problem still exists, and has been compounded by the still-rising cost of labour, which largely accounts for the postwar rush of American producers to foreign locations where the overhead costs could be held down. However, there has been a slight improvement from the point of view of the more modest filmmaker, and getting started in the art does not look quite as impossible as it once did. Cameras, lights, and other equipment have become smaller, less expensive, and more manageable, and the trend toward working on location (more sensitive film has helped to solve the problem of dimly lit interiors) has reduced the cost of studio sets. The demand of the new audience for different faces has reduced the emphasis on high-salaried stars. The rapid-fire direction now in vogue can reduce everything in a budget; it is not at all unusual to complete the shooting of a film in less than a month and then spend only another week or so on the editing, an unheard-of schedule in the golden days of Hollywood's loose-leaf budgets.

Many governments have adopted more generous and enlightened policies in their financial aid to, or control over, the industry. The motion-picture renaissance in Eastern Europe, particularly in Poland, has shown what such policies can achieve in Marxist nations, where, except for obviously political matters, there is now not much more censorship than the cinema suffers everywhere. Since 1950 literally hundreds of young directors have found state money in France for their first films, and the patronage system turns up in less likely places, often with remarkable results, as witness Satyajit Ray's *Pather Panchali,* which after many financial vicissitudes was finished with the help of the West Bengal government.

International financing has become common in Europe and even between European and Oriental nations, and offers the advantages of sharing risk among several producers, guaranteeing wide distribution, getting around national import quotas, and obtaining state aid from more than one country for a single film. It appears to encourage, or at least it cannot be said to discourage,

artistic freedom. Michelangelo Antonioni's difficult and unsentimental *L'eclisse* (*The Eclipse*), for example, had as co-producers Paris-Film, Interopa, and Cineriz (Rome). The co-producers of Resnais' *Hiroshima mon amour,* which has become one of the best-known of the controversial vanguard films, were Argos Film, Como Film, Pathé Overseas, and Daiei Motion Picture (Japan). Such a work would probably never have been made under the usual American and British system which assigns full financial responsibility to a single producer dependent upon the private money market and a quick return on investment.

III

These basic economic factors have always pushed the movies toward the merely popular category of art, in which there is little place for the unifying vision of the individual artist. To the men who provide the means of production and distribution, without which the movie artist must remain mute, "creation" involves a calculation of what the customers will buy, and they are not likely to permit a moody creative genius to undertake this vital function unattended. Until quite recently the average film, which as a matter of mathematics was a Hollywood product, was almost as anonymous as a medieval church—or a circus. It was conceived by a committee of idea men and business executives, and brought to completion by a team of specialists. For the public it was primarily a vehicle for the star, whose presence could alter the details and often the whole nature of the story. The man in charge of the script and its interpretation before the cameras was not a creator in the way a novelist or a dramatist is; he was a craftsman overseeing the efforts of other craftsmen. Only an occasional gifted and strong-willed director—an Eisenstein, a John Ford, a René Clair, a Carl Dreyer—mustered enough personal authority and audience recognition to turn out the cinema equivalent of a signed work of art. Moreover, technological progress was a constant threat to originality, for each change—the addition of sound in 1927, successful colour in 1935, wide screens in the early 1950s—suggested to film executives the possibility of redoing the tried and true successes of the past (just as stereophonic recording provided one more gallop for the war-horses of 19th-century music).

This condition has been modified by the new cinema, although it can hardly be said to have been eliminated. The atelier system is to some extent inherent in film-making; nobody can be the sole author of even a Keystone Cops sequence. Also, the star system has lost only a part of the oneiric and religious force it had during Hollywood's years of world power; a contract with one of a few dozen high-voltage names still guarantees instant financing for a hard-pressed independent producer, and so these dominating personalities still constitute a major aesthetic nuisance, capable at any moment of spoiling the seriousness and unity of an author's vision. Declining though it may be, the star system has deep

roots in show business; people went to see Sarah Bernhardt rather than Racine, David Garrick rather than Shakespeare—and Shakespeare, by the way, suffered greater mutilation in those days of flourishing repertory than he ever did in the movies.

Even so, we seem to be entering upon a new age of directors, and a growing number of these have obtained enough personal control over their productions to be called at least the chief authors, and to be publicly recognized as such. Although Marcello Mastroianni was an international star by the mid-1960s, *8½* is not "a Mastroianni film" in the sense that there were "Garbo films." It is a thoroughly personal work by director Federico Fellini, recognizable in terms of both content and visual style, and it was so promoted in the commercial theatres where it enjoyed box-office success. Similarly, *Ikiru* (*Living*) bears the signature of director Akira Kurosawa, *Dr. Ştrangelove* is by Stanley Kubrick, *Jules et Jim* by François Truffaut, *The Exterminating Angel* by Luis Buñuel, *Knife in the Water* by Roman Polanski, *Electra* by Michael Cacoyannis (this list indicates that this tendency is not, as some critics have implied, merely Italian and French). The idea of the director as author (or at least chief creator) becomes rather confusing in films derived from literary classics or from scripts by well-known writers, but there is less of Fielding than of Tony Richardson in the latter's *Tom Jones,* and Resnais easily overshadows scenarist Marguerite Duras in *Hiroshima mon amour.* Occasionally more than a hint of directorial authorship may creep into even the expensive spectaculars, in which stars and producers are normally dominant and directors tend to be technicians carrying out orders. *Lawrence of Arabia,* for example, has been recognized as not only a Sam Spiegel production but also a work by David Lean.

The director's new freedom carries a risk; some of the recent "author films" are technically awkward in ways which are unlikely under the committee system—in a sense, there can be no mistakes in even a poor Hollywood production. But the risk will seem worthwhile to anyone who believes that the movies, like other arts, must make personal statements in order to make masterpieces.

IV

In the practical terms, then, of customers, costs, and creative liberty the movies' second chance looks reasonably good, if not exactly wide open. Possibly it means that the new cinema will be, for a long while anyway, to some extent a minority art. In this the movies would join the new novel, the new poetry, and the new music, for the same thing is true of all the arts today in their more alive sectors. One may find this a source of particular regret in the case of the movies, because they have had both the external equipment for a broad appeal and the internal potential, being mostly a representational and narrative art.

But the regret has its limits. If television does not destroy the movies utterly, one can feel that it has done them a good turn by forcing them into a more difficult market.

How well is the second chance being exploited? One way to reply is simply to name some of the directors who have been active since 1945 (a few on my list started their careers earlier, of course). I have already mentioned Bondarchuk, Ray, Antonioni, Fellini, Bergman, Resnais, Truffaut, Kurosawa, Kubrick, Buñuel, Cacoyannis, Polanski, Richardson, and Lean, who are representative of the state of the art in Russia, India, Italy, Sweden, France, Japan, the United States, Spain, Mexico, Greece, Poland, and Great Britain. One can add the Italians Roberto Rossellini, Luchino Visconti, and Vittorio de Sica; the Frenchmen Robert Bresson, Roger Vadim, Jean Luc Godard, and Jean Renoir; the Englishmen Carol Reed, Karel Reisz, Peter Brook, and Richard Lester; the Americans Orson Welles, William Wyler, Joseph Losey, and John Huston; the Russians Grigori Chukhrai, Mikhail Kalatozov, and Grigori Kozintsev; the Poles Andrzej Wajda, Andrzej Munk, and Jerzy Kawalerowicz; the Czech Milos Forman; the Japanese Kenji Mizoguchi and Yasujirō Ozu; the Spaniards Luis Berlanga and Juan Antonio Bardem. The list is very incomplete and reflects my subjective taste, but it should serve to refute the critics who still proclaim that the movies are dying. It would be difficult to name forty pre-1945 directors of the same quality, and with the same claim to being called the authors of films.

Another way to appraise the viability of the new cinema is to attempt to describe it in general terms—to define the cinema that appeals to the recently enlarged minority audience. Let me grant right away that this new cinema is not entirely new and does not exist as an international movement supported by a consistent body of theory. It is fragmented into national and personal styles. But some tendencies are widespread enough, or strong enough in one or two countries, to be called characteristic.

V

The movies, to the dismay of theorists, have always been at once a distinct art form and a reproducer or transposer of other arts—in particular of painting, the theatre, and the novel, but also of music and poetry. On the whole, they show few signs of giving up their mixed way of life. The animated cartoon, although pushed by Walt Disney's methods toward excessive naturalism and a kind of sterile gigantism, has managed to retain its fantasy and liberty in the work of many East European artists and of Americans like John Hubley.

Animated non-narrative painting, often abstract or Surrealist and sometimes done directly on the film in the manner of Norman McLaren, has its avant-garde audience. In commercial features many directors have been experiment-

ing with symbolic or mood-setting colour and composition; one of the finest examples of this painterly approach is Antonioni's *Il deserto rosso* (*The Red Desert*). The standard types of adaptation have not been neglected; nearly all of the recent British film output, for instance, has been based on successful plays and novels (critics who disapprove of this practice can be reminded that it was Shakespeare's). That the movie-and-music combination still works is proved by such hits as the film versions of *West Side Story* and *My Fair Lady,* and also by the relative success of Jacques Demy's *Les Parapluies de Cherbourg* (*The Umbrellas of Cherbourg*), in which all the lines are sung. Poetry on the sound track has been provided by the Shakespeare productions of Welles, Kozintsev, and Laurence Olivier. Visual "poetry" can also be cited, a good example being the dog frisking madly on a wintry Deauville beach in Claude Lelouch's *Un Homme et une femme* (*A Man and a Woman*). The image does nothing to advance the story; it has to be "read" as a metaphor—perhaps for the persistence of memory and life in a bleak period.

None of these hybrids and analogies, however, is as important in the new cinema as a tendency to create, or to try to create, a type of visual narrative which in its exploration of the variety of life resembles the novel but is entirely free of those overtones of a derivative, second-degree art which are common in filmed novels. There is a strong impulse—I am speaking of a vanguard group, of course—to get away once for all from the notion that a movie is a kind of illustrated literature. The ideal is a purely filmic work, a work written in a cinematic language composed of what the Italian poet, philologist, and filmmaker Pier Paolo Pasolini has referred to as *im-segni,* image-signs. In theory this ideal does not exclude adaptations of prose fiction, provided they are done with a proper attention to what is specifically filmic. In practice, however, an original script, often prepared by the director himself, or simply a vague but suitably cinematic idea is favoured as the point of departure.

There are many nuances in the tendency. Antonioni has referred to his recent films as "novels in images." Alfred Hitchcock (who has been a surprisingly avant-garde director in the midst of commercial success) has said that "the screen ought to speak its own language freshly coined." Fellini has spoken of "just parking yourself in front of reality" as the right way to create. Bergman has insisted that the movies are like music and have "nothing to do with literature" and that therefore book adaptations must be avoided:

The irrational dimension of a literary work, the germ of its existence, is often untranslatable into visual terms—and it, in turn, destroys the special, irrational dimension of the film.[2]

He regards even a script as just a necessary evil, and longs for "a kind of notation

2 *Four Screenplays of Ingmar Bergman,* Simon and Schuster, Inc., New York, 1960, pp. xvii–xviii.

which would enable me to put on paper all the shades and tones of my vision." Godard evidently feels the same way, for he has said that he often waits until shooting time to write out the dialogue, the most literary part of the operation.

Central, however, in the whole movement is the idea of a new specificity in the art of the movies, and at the centre of this idea there is an apparent paradox. Shortly after World War II the French critic Alexandre Astruc (like many of the movie critics of those years, he became a director) boldly proclaimed this apparent paradox in an essay—now regarded as a key document—on what he called *La Caméra Stylo,* "The Camera-Pen":

I call this new age of the cinema that of *La Caméra Stylo.* This metaphor has a very precise sense. It means that the cinema will free itself little by little from the tyranny of the visual, from the image for the sake of the image, from the immediate anecdote, from the concrete, in order to become a method of writing as supple and subtle as our ordinary written language. No field must be closed to it. The most abstract sort of meditation, economics, psychology, metaphysics, ideas, passions are all within its capacity. In fact, we can say that these ideas and these visions of the world are such today that only the movies can express them. . . . If Descartes were alive today, he . . . would lock himself in his room with a 16-mm. camera and write his *Discours de la méthode* on film. . . .[3]

In other words, the movies must free themselves, if the theory is correct, from literature and develop their own visual language in order to cease to be *merely* visual. They must learn to "say" something and thus become, in the deepest sense, a transparent medium. This theory has been the program of a large number of directors in recent years.

Astruc was writing, of course, in an intellectual tradition almost as old as the cinema itself. Before World War I a Parisian-Italian critic, Ricciotto Canudo, was already arguing that the movies had to free themselves from literary and theatrical modes (he pinned his hope to American film-makers, whom he found less bookish than those in Europe). In 1916 Marinetti and the Futurists published a manifesto demanding the liberation of the cinematic art; throughout the 1920s this was the theme of recurring avant-garde movements, often led by Expressionist or Surrealist poets and painters. All of this coincided with the trends toward specificity in other arts, and with the general modern movement away from discursive language—for example, in the emphasis on the performed rather than the written play. Meanwhile, Vsevolod Pudovkin, Eisenstein, and other practitioners who stressed montage were elaborating the idea of a distinct filmic language, in which the shot would be analogous to the word, the sequence to the phrase, the cut to the comma, the juxtaposition of images to the simile, and so on. Critics like Gilbert Seldes helped to destroy the notion that the movies, being a popular medium, were not to be taken seriously, and they were supported by theorists like Béla Balázs and Rudolf Arnheim. In 1935 Raymond Spottiswoode pulled together much of the existing theory in his

3 *L'écran français,* March 30, 1948.

A Grammar of the Film. By 1947 Bresson could remark, and know he was being understood, that "the cinema is not a spectacle, it is a writing."

This summary may make these developments appear smooth and inevitable. However, the intellectuals, in this instance as in most, were not all on one side. In the *Boston Transcript* of March 31, 1915, in an article on D. W. Griffith's *The Birth of a Nation,* Walter Prichard Eaton observed: "The assumption . . . that we can go back to what amounts to sign language at this stage of civilization is one of the most touchingly naïve examples of motion-picture makers' credulity." He also had some unkind things to say about what he called "amateur kodakery" in the movies. The other side had an inning in a vigorous reply from Henry MacMahon, in the *New York Times* of June 6, 1915:

How about the "sign language" of pure music? The "sign language" of sculpture? The "sign language" of painting? Mr. Eaton's choice of a sneer at the motion-picture art seems singularly unfortunate. For the function of all art is to touch the emotions ideally, and it matters not whether the "signs" or media be words or tones or carvings or pigments or mere facial and bodily attitudes and expressions.[4]

But in the 1930s many critics denied the meaningfulness of montage, questioned the creative role of the director, and proclaimed the movies "mechanically superb and intellectually contemptible."[5] In fact, the argument has not yet ended. Quite recently, Lawrence Durrell was still willing to declare in print that the sound track had killed the cinema's chance to become "a form of art like the ballet" and had left nothing but "a drug for the masses."[6]

VI

Critical essays, however, do not make films. The test is how the post-World War II vanguard directors actually have been using Pasolini's *im-segni,* Hitchcock's "language freshly coined," Bergman's "irrational dimension," Spottiswoode's "grammar," Astruc's *caméra stylo,* and their increased independence as creative authors. They have done so in various ways, of course, but a number of these reveal very clearly the perhaps surprising fact (for those who habitually think of the movies as a dream machine) that realism in one form or another has been the principal source of—or catalyst for—the new cinema.

Some of the realism has come from the stage and prose fiction. The brutal naturalism of August Strindberg reappears in many of Bergman's films. Kurosawa has brought to the screen Japanese versions of Dostoevski's *The Idiot* and Gorki's *The Lower Depths.* Vadim has done Zola's *La Curée.* Wyler's remake of Lillian Hellman's *The Children's Hour* is an example of several postwar

4 Reprinted in *Introduction to the Art of the Movies,* ed., Lewis Jacobs, Noonday Press, New York, 1960, pp. 47–48.

5 Raymond Spottiswoode, *A Grammar of the Film,* University of California Press, Berkeley, 1950, p. 311.

6 *Cahiers du Cinéma,* no. 185, 1966.

American movies based on plain-speaking plays and novels about realities formerly shunned in Hollywood. Reisz's *Saturday Night and Sunday Morning,* based on a proletarian novel by Alan Sillitoe, helped to start a trend in Great Britain in the early 1960s. Robert Musil's "scientific" style has apparently had some influence on young West German film-makers. Italian directors have obviously read the hard-boiled American novels of the 1930s and those of Cesare Pavese, Ignazio Silone, and Giovanni Verga. Visconti's *Ossessione (Obsession)* in 1942, which for most critics marked the beginning of the new cinema, was derived—in fact, pirated—from James Cain's story *The Postman Always Rings Twice.*

Wartime experiences were reflected in the early Italian "neorealist" films—Rossellini's *Roma, citta aperta (Rome, Open City)* being the most celebrated example—and have continued to be a kind of antifantasy factor in Eastern Europe. In Kalatozov's *The Cranes Are Flying,* which in 1958 revealed the Soviet Union's conservative equivalent of the West's new cinema, the note of authenticity is due not only to the post-Stalin thaw and the accent on personal problems but also to the picture's realistic background of ruins, refugees, demoralization, and senseless killing. The young Polish directors have been particularly fascinated by the war, and have often treated it in an unromantic, even antiheroic, fashion.

A leftist political outlook has also been important, and not only in Eastern Europe. A considerable number of the new Italian directors are Marxists or have been profoundly influenced by the large and well-led Italian Communist Party. Their attitude at the crest of the neorealist wave in the early 1950s was forcefully stated by Cesare Zavattini, the scriptwriter for De Sica's *Sciuscia (Shoeshine)* and *Ladri di biciclette (Bicycle Thieves)*:

I believe that the world goes on getting worse because we are not truly aware of reality A starving man, a humiliated man, must be shown by name and surname; no fable for a starving man, because that is something else, less effective and less moral. The true function of the cinema is not to tell fables, and to a true function we must recall it The cinema . . . should accept, unconditionally, what is contemporary. *Today, today, today.*[7]

It should be noted that his ideas, which have been subscribed to by film-makers elsewhere—notably in socialist England and in some of the New York avant-garde groups—and which can be applied to many problems besides poverty, go much further than the official Communist doctrine. In the Soviet Union "realism" does not exclude the telling of cinematic "fables."

The contribution of the documentary-film movement is evident. Here a fair commentary must go back to 1920–22, when Robert Flaherty demonstrated with *Nanook of the North* how stories could come out of shooting on location. In Russia a few years later Dziga Vertov pushed the idea as far as it would go (a

7 "Some Ideas on the Cinema," in *Sight and Sound,* October, 1953, pp. 65–69.

little further, actually) with his Kino-Eye program, which called for films made by just letting a supposedly objective camera catch life on the fly. In the 1930s the movement became more and more serious in the work of directors like Pare Lorentz in the United States, Grierson in Great Britain, Walter Ruttmann in Germany, Jean Vigo in France, and Joris Ivens in Holland. The *March of Time* films, among others, developed the old newsreel into something halfway between reporting and art. During World War II the documentary approach was used for propaganda; the American *Why We Fight* series, supervised and in part directed by Frank Capra, was one of the impressive results. Since 1945 the television networks and the rapid success of educational films have greatly increased the demand for the imaginative treatment of information on the screen. All of this past and present documentary climate is worth bearing in mind, for it helps to explain the evolution in public taste which has made the new cinema possible. It is also relevant to the outlook of today's directors, many of whom learned their craft as documentarists. They have an interest in facts which is not apt to be acquired in the usual studio or theatrical career.

Now I must hedge again, and remind the reader that I have referred to realism as merely a source or a catalyst. There are several reasons for this cautious phrasing. Experience has shown that the filmic realism derived from literature can easily turn back into Romanticism, its predecessor in 19th-century fiction and painting, or move up into Symbolism, or down into melodrama; it can often be found going in all of these directions in the work of Bergman, Kurosawa, and especially Visconti. The realism fostered by the experience of World War II is bound to lose some of its force with the passage of time and the maturing of a generation of film-makers who know little of the way the conflict intensified (and simplified, too) moral problems and emotional relationships; soon even the Nazi camps will be as aesthetically distant as Brecht's Thirty Years' War. Leftist, liberal, and humanitarian social realism ought in theory never to lose its force, but in fact, as the decline of the Italian neorealists in the 1950s and of their British counterparts in the 1960s shows, its limited subject matter and the perils of sentimentality make it cyclical; after a few movies the best of hearts ceases to be moved by Roman poverty and the drabness of a working-class Sunday in the Midlands. The documentary approach, which is almost inseparable from social realism, can take a director only so far; a genuinely objective camera is an absurdity in a fictional film, and it usually takes a good deal of art to seem artless.

To these reasons for caution can be added the subjectivity implied by what has been said about the *caméra stylo* and personal statements by director-authors. There is also a trend toward the "cinematic" film, which I shall get to in a moment. In sum, one cannot say that the new cinema—in particular that part of it which has appeared since the late 1950s—is "realistic" as a whole, or

in an obvious sense, or in a doctrinaire fashion that promises to govern the future. And yet the importance of realism as a source or catalyst can be felt by an attentive movie-goer. There is a hard-to-define but quite perceptible sort of verism in the best of the recent films which makes the best films of the 1930s seem, if not exactly false, at least very stagy (one must allow, of course, for the peculiar artificiality of all old photographs and for the long-term trend in acting styles toward naturalism). This verism has been the most evident element in the new cinema's break with the old entertainment-film tradition, much as an intention to confront reality has been evident in modern poetry's break with the poetical tradition. Antonioni is to Rouben Mamoulian what Robert Lowell is to Alfred Noyes.

Part of the verism can be attributed to a documentary feeling for actual rather than studio places. Even a hostile critic, ready to find the movie hopelessly pretentious, is not likely to forget melancholy Nevers in *Hiroshima mon amour*—nor gray Nottingham in *Saturday Night and Sunday Morning,* the vivid slums of Mexico City in Buñuel's *Los Olvidados* (*The Young and the Damned*), the industrial landscape around Ravenna in *The Red Desert,* ancient and modern Rome in Fellini's *La dolce vita* (*The Sweet Life*), the bright island of Hydra in Cacoyannis' *A Girl in Black,* the forest of Dalarna in Bergman's *The Virgin Spring,* the naked islet in Kaneto Shindo's *Hadaka No Shima* (*The Island*). In each of these and other examples which could be cited the place is more than a pretext for travelogue photography; it is an integral part of the film. Almost in the style of Flaherty, minus his Rousseauism, the story seems to emerge from the decision to shoot on location.

A more exact tone in the interpretation should also be mentioned. This is largely the achievement of the post-World War II generation of screen actors—people like Jean Paul Belmondo and Jeanne Moreau in France, Marcello Mastroianni and Monica Vitti in Italy, Marlon Brando in the United States, Zbigniew Cybulski in Poland, Albert Finney in England, Harriet Andersson in Sweden, Toshiro Mifune in Japan. These stars have been self-effacing in ways which probably never occurred to Clark Gable and Jean Harlow. In fact, the careers of such recent myth-makers as Marilyn Monroe and Brigitte Bardot already seem like echoes of another era, for the trend in the new cinema has been definitely away from the Hollywood concept of the actor as an archetypal figure and toward the theatrical concept of the repertory professional (Bergman and Kurosawa have come close to actually having their own repertory companies). Hence the new director-authors have been able to control their human image-signs more strictly than their predecessors did; Jeanne Moreau in *Jules et Jim* is a Truffaut personage, in *La notte* (*The Night*) an Antonioni personage, and in *The Chimes at Midnight* a Welles personage.

The idea of using nonprofessional actors, advocated by Flaherty, Pudovkin,

and Eisenstein, was successfully revived by De Sica in *Bicycle Thieves* and by Ray in *Pather Panchali*. It has not become a very prominent part of the new cinematic philosophy, since it calls for a special kind of directorial patience, a certain amount of luck, and a great deal of editing. Also, it of course deprives a film of the publicity a star gets. But it crops up here and there in many recent European and New York films, and is central in the method by which Bresson achieves his austere, personal sort of verism.

I have already mentioned the relaxation of censorship, which has encouraged what might be called a documentary attitude toward sexual intercourse in the new movies, especially those made in Sweden, France, and Italy. Here it is often difficult to distinguish between a wish to present the truth and a yearning to sell tickets, between verism and voyeurism. Are all those French close-ups of ecstatic hands on bare backs really needed in order to make the cinema at last fit for adult minds? Must there be an orgy sequence in every Italian film? Cannot Bergman continue his search for God's presence in the modern world without realistic depictions of rape? These are not easy questions, although I may have revealed some impatience in the way I have put them. And the mere fact that they can be asked today shows how far we are from the time when a French director could handle the most significant event in his story simply by putting in a dissolve for the passage of time and then letting the lovers address each other as *tu* instead of *vous*.

Realism can be of the eye, of the mind, and of the heart—naturalism, verism, and ordinary honesty—and it is hard to know in a given movie which kind we are reacting to. So let me take advantage of this vagueness by suggesting that there is something else in the break with the entertainment-film tradition, something besides a preference for working on location, a more exact tone in acting, and a more explicit treatment of sex. We can get at it through an old fact and a chance remark. The fact, reported by critic Dwight Macdonald, is this: when King Vidor directed his ambitious and generally praiseworthy film *The Crowd* in 1928 he felt obliged to make three endings—happy, ambiguous, unhappy—which could be used according to the type of audience. The chance remark, in Lillian Ross's book *Picture,* is that of a Hollywood executive:

I don't care too much what kind of pictures we make. . . . All of us here like the kind of pictures that do well at the box office.[8]

These confessions of aesthetical and ethical confusion can be compared with Bergman's frequently quoted commandment to himself to "make each film as if it were thy last," with Losey's remark that he made *King and Country* "as unendurable as I could," and with the following declaration by Fellini:

[8] Cited by Penelope Houston, *The Contemporary Cinema*, Penguin Books Ltd., Harmondsworth, 1963, p. 47.

By giving happy endings to films, you goad your audience into going on living in a trite, bland manner, because they are now sure that sometime, somewhere, something happy is going to happen to them, too, and without their having to do anything about it. Conversely, by not serving them the happy ending on a platter, you can make them think; you can remove some of that smug security. Then they'll *have* to find their own answers.[9]

I am not suggesting that all of the older movie-makers were cynical entertainers, nor that the new ones are opposed to making money. But there does seem to be more intellectual honesty in the industry than there used to be or at least more opportunity to display it and survive. What Truffaut once described as "a revolution of intentions" could turn out to be the most important aspect of the movies' second chance.

VII

The more obvious kinds of documentary realism can recall the traditional novel; they are fiction claiming the authority of fact. But there is another trend in the new cinema, one which shifts the spectator's focus of awareness toward filmic signifiers as such, and may therefore recall the art novel. This trend can be labeled filmism, if one wants to be neutral. It is often credited to, or blamed on, the French New Wave directors who appeared in 1959, although it existed earlier in the form of inside jokes in Hollywood movies and has since been almost as prevalent in England, Italy, and New York as in France.

Filmism includes a lot of playhouse irony, cinematic allusions, attention-getting technique, and other things calculated to remind the spectator that a movie is after all a movie. In Richardson's *Tom Jones* there are tricky wipes of the image and other old-fashioned transitions, and at one point an actress addresses the audience—the camera. In Godard's *A Bout de souffle* (*Breathless*) there are blurred and overexposed patches, jump cuts which shatter the time continuity, and silent-film iris fades; and the whole picture is an allusion to Humphrey Bogart and American gangster movies. In Demy's *Lola* there are allusions to Gary Cooper, *A Bout de souffle,* Max Ophuls' *Lola Montès,* Vigo's famous slow-motion sequence in *Zéro de conduite* (*Naught for Behaviour*), and Bresson's *Les Dames du Bois de Boulogne;* and the characters re-enact each other's stories—they "rhyme," one French critic said. In Demy's *Les Parapluies de Cherbourg* there are half a dozen allusions to Demy's *Lola.* The old trick of projecting the negative of the image has been revived by Godard for sequences in his *Alphaville.* Truffaut uses double exposures, speeded-up motion, frozen shots, and World War I newsreels (distorted on the wide screen) in his *Jules et Jim.* Lester uses reverse motion in *The Knack;* Losey uses still photographs in *King and Country,* and slow motion in *The Servant.* A remarkable tracking shot

9 Gideon Bachmann, "Federico Fellini: an Interview," *Film: Book I,* ed., Robert Hughes, Grove Press, Inc., New York, 1959, pp. 97–105. Reprinted in *Film: a Montage of Theories,* ed., Richard Dyer MacCann, E. P. Dutton & Co., Inc., New York, 1966, p. 381.

through the corridors of the hotel in *L'Année dernière à Marienbad* is bleached by the overexposed negative. In *The Red Desert* Antonioni did many sequences with a telephoto lens in order to avoid depth of focus. The film *8½* is loaded with allusions to Fellini's career as a director, beginning with the title, which refers to the number of films he had made up to then.

Commenting on the trend, the English critic Francis Wyndham has written:

> The cinema, that precocious art, has entered a phase of self-consciousness which is threatening to stunt its growth. . . . Serious films today tend to concentrate, with an incestuous cannibalism, on purely cinematic material—endlessly celebrating, in self-consciously affectionate satire, a medium which has produced too few masterpieces to justify this narcissistic obsession.[10]

Although the judgment seems much too severe for the crime (which is often not noticed by the public anyway), one can understand the irritation. There is a difference between a "quotation" of a Godard film in a Demy film and a line of Dante in a modern poem, or a Bach phrase in a serial work, or a dash of historicism in a contemporary building. In the first instance there is a coterie effect; in the others there is a dramatic contrast—at least there is a possibility of such—between the present and the past. Also, there is a great difference between the whimsy in using silent-film techniques and the power that may be derived from primitivism in modern painting and sculpture. In short, filmism is hard to defend with any easy analogy drawn from the allusiveness of modern art in general—precisely because the movies are not modern by comparison with a tradition. Mack Sennett is almost as new as Godard.

But there is more to the trend than "incestuous cannibalism," spot-that-quotation pedantry, and ludification for insiders. These directors have won the right to be considered serious artists. In their allusiveness there is often a witty, magical awareness of how photography and the movies' unique sort of space-time have created and peopled a complex double for the allegedly real world, a double very unlike those created by the novel and the theatre. In the new emphasis on cinematic signifiers as such there is often an almost Elizabethan delight in conceits and the resources of a "language freshly coined"; for instance, people commonly find that part of the pleasure in seeing a Truffaut film comes from sharing the evident pleasure he took in making it (critic Penelope Houston of the British Film Institute has likened him to "a man running down a long, sunlit road with a camera in his hand"). In all of this there is of course the same—and certainly legitimate—concern for tension between form and referent which we have found in modern painting and other modern arts. And finally it should be said that the majority of the cinematic signifiers are indeed signifiers; they are intended to mean something even when attention is being solicited for them for their own sake. Filmism is sometimes the opposite of

10 *Encounter*, October, 1965, pp. 38–39.

everyday photographic naturalism, but on the whole it is not the opposite of verism, any more than the antiprose strategy in modern poetry is the opposite of an attempt to confront reality.

In fact, filmism is sometimes indistinguishable from verism. It becomes so, for instance, when we consider improvisation, which may be a characteristic procedure in the new cinema. I write "may be" because it is hard to say exactly what constitutes improvisation in film-making and even harder to say how much of it is going on; Hitchcock has said that for him a picture is finished in his mind as soon as he has completed the shooting script, and one can certainly not imagine Resnais starting out in the morning without a clear plan for the day's work. But that a number of prominent post-World War II directors have tended to make things up as they go along is clear from their own testimony. Fellini, in the interview from which I have already quoted, says his method is "very open":

First, I have to be moved by a feeling. . . . I don't really need a very well-written story or a very detailed script. I need to begin without knowing that everything is in perfect order. . . . Because for me, to make a picture is like leaving for a trip. And the most interesting part of a trip is what you discover on the way.[11]

Truffaut has said the same thing in almost the same words. Bresson and Antonioni have admitted that while they usually know in advance what they want to do they do not always know how they are going to do it. After he had finished his *Pierrot le fou,* Godard confessed:

Most of it came out of my head just before it was shot. I worked without notes, like a painter. Anything I saw might end up in the picture.[12]

In such procedures there is an implication, as there is in Action painting and aleatory music, that the spontaneous is more apt to be "true" than is the calculated; and the result may be (particularly in the work of Truffaut and Godard) a roughness in the technique which calls attention to itself—just as Action painting which begins in sincerity may end up as an emphasis on paint as paint.

The situation has been exaggerated—most helpfully for the theorist in search of evidence—in New York, where a large number of amateur, "underground," and avant-garde movies, notably John Cassavetes' *Shadows,* have been more or less completely improvised. Many of the young American innovators (their tendency has appeared in London also) take the position that shaky and out-of-focus shots are evidence of honesty and inner creative freedom.

The argument may not satisfy the spectator who is inclined to share Eaton's 1915 scorn for "amateur kodakery," but it makes my point.

11 Bachmann, op.cit.
12 *The Observer,* London, Sept. 5, 1965, p. 21.

VIII

Let me grant again that the new cinema is not a consistent international movement. It does have, however, quite a web of interconnections for its national and personal stylistic fragments. For instance, one of the familiar arguments for the documentary film, and hence for realism of the kind advocated by Zavattini, is that the photographic medium has, in the words of theorist Siegfried Kracauer, "an outspoken affinity for unstaged reality" (we tacitly admit this by preferring candid snapshots to posed ones). Cannot the argument be made to work for the jumping and ludified fantasy of Godard's improvised *Pierrot le fou* as well as for De Sica's neorealist *Bicycle Thieves?* Again, one reason for giving directors the power of authors is that, other things being equal, a personal artistic statement is likely to be stronger, more integrated and true, than one by a committee. But how can a director make a personal statement in cinematic terms without calling attention to his own way of handling filmic signifiers? Without, that is, indulging in what I have called filmism? Add a rejection of Hollywood's smooth, professional illusionism, and we are back with the verism which connects such fragments as New York avant-gardism, the French New Wave, the Italian Marxist group, the British kitchen-sink school, Swedish psychological realism, and East European antiheroic impulses.

Several of the issues raised by this web have been glanced at. There is one, however, which calls for more than a glance, if we want to form a defensible notion of how well the movies are using their second opportunity for greatness. It has been stated with angry vigour by the American critic Pauline Kael:

> Movies are going to pieces; they are disintegrating, and the something called cinema is not movies raised to an art but rather movies diminished, movies that look "artistic." Movies are being stripped of all the "nonessentials"—that is to say, faces, actions, details, stories, places, everything that makes them entertaining and joyful. . . . Cinema, I suspect, is going to become so rarified, so private in meaning, and so lacking in audience appeal that in a few years the Foundations will be desperately and hopelessly trying to bring it back to life. . . .

The indictment is sweeping, but two paragraphs further on it appears that Miss Kael's main target is the French and Italian new cinema:

> There is more energy, more originality, more excitement, more art in American kitsch like *Gunga Din, Easy Living* . . . than in the presumed High Culture of *Hiroshima, Mon Amour, Marienbad, La Notte, The Eclipse*[13]

Such opinions are fairly common, in spite of the enlarged minority audience I have been talking about. How—after due discount for patriotism and anti-intellectualism—should they be answered by one who greatly admires the four European films Miss Kael mentions? For myself, I can say that my experience

13 *The Atlantic Monthly*, Little, Brown and Co., December, 1964, pp. 61–66.

is evidently limited, for I have not been aware of any pronounced tendency to strip any but the most experimental of avant-garde movies of faces, actions, details, and so forth. However, I must concede that the films of Resnais, Antonioni, and several other post-World War II directors are relatively hard to understand, often in single sequences and once in a while as wholes. This cannot be denied, any more than one can deny the difficulty in Schoenberg's music, Eliot's poetry, Joyce's novels, Beckett's plays, Mies's architecture, Kandinsky's painting, and Brancusi's sculpture.

Some of the reasons for the obscurity have to do with recent developments in cinematic "language"; some are linked to the dramatic or novelistic structures which most movie-goers take for granted; many are related to the attitude of the new film-makers toward their material—toward, that is, the problems of modern living. The three categories of reasons are seldom distinct while we are watching the screen, but it may be helpful to discuss them separately.

IX

In each of the major hybrid arts one discipline tends to carry the most important part of the meaning: an opera makes sense primarily in its music, a play in its dialogue. In the movies the visual element has continued to be dominant to a degree which few critics would have predicted back in 1927, when the era of audibility began. The word "talkie" has dropped out of use. We seldom recall a line from a film as we do lines from plays. Music may contribute much to the effect of a film, but it is usually so deliberately subordinate to the visuals we are scarcely aware of it.

Hence the majority of film theorists have continued, with apparent justification, to think in approximately pre-1927 fashion; they talk about the camera-pen, not about the microphone-pen. Yet, while still predominantly visual, cinematic language is today very different from what it was a generation ago. Moreover, it has been used by some of the post-World War II director-authors in ways which can only be described as expressly inexplicit—and which therefore raise some hard questions about exactly what we mean by the "language" metaphor in this context.

Part of the inexplicitness is in the acting; and here I must qualify slightly my remarks a few paragraphs ago about the new stars and their repertory-house naturalism. Certainly no one wants to return to the eye-rolling, the grimaces, and the pantomime of the bad old days. But if the cinematic language is indeed a visual one, then there must be a limit to thespian naturalism; acting is not simply behaving. After a visit to the average film festival one may wish for a limit to the use of the international new-cinema mumble and the new-cinema deadpan stare (my impression is that both originated, along with several other new-cinema mannerisms, in the American gangster movie).

Another and quite different kind of inexplicitness may be the result of editing or montage (in the sense of the cutting and assembling of the component shots of a film), and of the type of camera work that goes with a particular type of editing. In this realm there has always been a lot of variety among individual directors and among the national industries. However, the type of editing most characteristic of the late 1920s and early 1930s was that which was favoured in an extreme form by the Russians (and is still favoured by many writers of textbooks). It stressed the articulation and often the association of images; for example, Pudovkin's *Deserter* is broken up into some 3,000 separate shots, and in Eisenstein's *October* there is a famous cut from the allegedly vain Kerenski to a shot of a peacock. Although the method could produce its own kind of obscurity when the cutting was too rapid and the associations too arbitrary, the intention was to "write" an absolutely explicit story in ideograms, with the director in precise control of the viewer's eyes and mind throughout each sequence of expository long or medium shots and underlining close-ups. Such an intention would strike a new-cinema author as being both naïve and crude, and more suitable for a propagandist, schoolteacher, or adman than an artist. Since World War II the trend has been definitely away from associative montage and in general away from extremely articulated images; when possible, camera movement (facilitated by lighter equipment) is preferred to chopping a sequence into shots. In 1948 Hitchcock issued a sort of manifesto on the subject with *Rope,* in which there are no apparent cuts at all. It has become common for a film to consist of less than five hundred shots, which would have constituted a very slow rhythm around 1930. In sum, while there is usually no serious obscurity in a sequence, the spectator is no longer being told every other second exactly where to look and exactly what to think. And the director who wants ambiguity has a technique for it.

Wide screens have contributed to the trend. Much depends, of course, on how they are used; and some of the early predictions about their aesthetic effects have been ruined by ingenious directors. But obviously they do not encourage a retention of the old articulated and associative montage techniques, which depended in part on the narrowness of the image. Also, the mere fact that they get more things into the picture tends to reduce explicitness of meaning; the spectator has to look for the important signifiers.

Setting in depth, however, has been more important than the crowded tapestry effects and the settings in width fostered by the new screens. It is not exactly new; before World War I cameramen generally used narrow lens apertures which kept everything from the foreground to the distant background in sharp focus. During the 1920s wide apertures and hence short depth of field became the rule, for several interrelated reasons: adaptability of the technique to the lenses and film stock in use; a general tendency toward soft-focus roman-

ticism; the desire to work in dim light; and the already mentioned style of editing, which favoured separate shots of foregrounds and backgrounds. Even when more sensitive film and stronger lighting became available in the 1930s, directors were slow to see the possibilities in a return to the narrow aperture and the deep field. Jean Renoir was one of the first to do so, in 1935 with *Le Crime de Monsieur Lange* and especially with *La Regle du jeu* (*The Rules of the Game*) in 1939. Then Welles went over to the new style in 1940 with *Citizen Kane,* Wyler followed in 1946 with *The Best Years of Our Lives,* and during the next decade use of the technique developed into a small aesthetic revolution. For of course setting in depth involves more than an extension of sharp focus. It is central in the rejection of the old montage techniques. It means that several aspects of an event—persons, objects, and decors—which in the past might have been articulated into successive shots, may now be deployed, with the help of a mobile camera, along an axis from the spectator deep into the screen, and thus viewed simultaneously.

As always, there are exceptions to my generalizations, partly because any dominant style provides opportunities for effects by contrast. I have mentioned Antonioni's use of a telephoto lens to flatten some of the sequences in *The Red Desert.* Occasionally a new-cinema director may return to rapid cutting, along with other pre-World War II techniques, as a part of his self-conscious filmism. One can find examples of associative editing in the manner of Eisenstein in many recent films, particularly avant-garde ones. Articulation of images has certainly not been abandoned; it could not be without a sacrifice of much that makes the movies an intelligible medium. Cuts and dissolves have to be used for transitions in time and space, since within a single shot dramatic time is identical with real or clock time and since there are after all some limits to camera movement: one cannot swoop from London to Tokyo.

Nonetheless, the change is unmistakable. The older shooting and editing techniques tended to produce a kind of linear code, designed to be "read" in a way analogous to the way we read a line of print, although of course the image-signs and their combinations never even approached the richness of words and sentences (the Kerenski-peacock sort of juxtaposition pays dearly for its explicitness by being too simple). Today the frequently long-held shot, the moving camera (which often practically destroys the distinction between sequence and shot), the wide screen, setting in depth, and the frequently understated acting tend to produce the opposite of a linear code. The spectator is immersed in a field of vision and a constantly evolving space-time continuum. The gain in verism is evident; persons, objects, and their often real locations are connected by visible vectors of dramatic force instead of being fragmented into montage signs. There is a spaciousness in recent films apt to be found a generation ago only in Westerns, in which the narrow aperture continued to be used.

Hostile critics, however, do have a point; story lines are on the average less clear than they used to be, and some of them are not clear at all. The new-cinema director, although he may be eager to make a personal statement, does not always tell the viewer to notice this and then notice that and then put this and that together.

Even so, it seems to me that a fair appraisal of the facts indicates that the movies are doing the opposite of going to pieces, that kitsch is not better than non-kitsch, and that there is no sin, although there may be economic danger, in rarefied meaning. Having said this, one must also note that since World War II the movies have hatched for themselves an up-to-date version of their ancient problem: namely, how to convey in a language of percepts an approximation of concepts, which of course cannot be photographed.

An obvious solution to the problem is to render the visuals more explicit by means of dialogue, music, significant noise, and the expressive silences that paradoxically became possible when sound was added to the silent film. This solution has not been neglected; there are some thoroughly literary patches in the work of directors like Welles, Bergman, Resnais, and Antonioni. And one can argue that an increased reliance on dialogue is logically implicit in the shift away from the old montage techniques—logically and also ironically, since one of the strong arguments for setting in depth is that it makes the movies less theatrical. But the objections to any extensive explanation of images with words are serious: film dialogue has to be relatively casual to go with photographic naturalism, redundancy on either the verbal or the visual side is hard to avoid, camera movement and editing possibilities become restricted as the continuity becomes attached to the dialogue, and the result may be another example of the filmed play—a mixed genre which is by no means invariably bad, but which is open to the charge of failing to use the full resources of the movies while giving up such theatrical advantages as live actors, intensified speech, and accepted stage conventions.

X

The problems posed by recent changes in shooting and editing practices may be complicated by a kind of false artistic analogizing—a mistaken assimilation of different disciplines. The same thing happens, of course, outside the movies; it is at the root of much that is troubling in all of the modern arts. We unconsciously assimilate atonal music to tonal, and then strain to hear structures that are not there instead of paying attention to those that are. We assume an analogy between modern and traditional architecture, and wind up with worried eyes. Although we know better, we cannot refrain from seeking representation in nonrepresentational painting and prose meanings in poetry expressly intended not to have them.

Possibly the issue is not very grave in the movies, since there is general agreement that a film ought to tell a story—that the primary analogy is with the novel and the drama. But for that very reason it is important to remind ourselves that every once in a while the analogy is false, in a detail and even in an entire work. By being alert for something in addition to narrative structures we can get more out of any film, and in some cases avoid that murky exasperation which the new cinema may provoke in minds nourished on explicit literature. I have already cited several films which illustrate the point; a few expanded examples may help to make it clear.

Bergman's *Wild Strawberries* cannot be called obscure. The story is about an old and rather self-satisfied professor, Isak Borg, who drives from Stockholm to the university at Lund to receive an honorary degree and who, during the trip, recalls his past life. Yet the structure of the film is only incidentally narrational. There are dream sequences which must be read as Symbolist poems or Surrealist paintings, and purely cinematic flashbacks in which setting in depth conveys spatial, temporal, and psychological perspective simultaneously: for instance, Borg (admirably played by Victor Sjöström) may be seen in close-up on one side of the axis of a scene from his past. A flashback may begin simply with a movement of the camera instead of a cut or a dissolve, since the old man is driving through the countryside of his youth. The people he meets throw light on his character, not so much by what they do as by what they are. Item by item the evidence is brought in, one by one the witnesses testify, until the film's structure becomes that of a legal trial. Borg finds peace of mind not only in his memories but also by accepting the verdict that he has lived selfishly.

The plot of Resnais' *Last Year at Marienbad* scarcely exists: a man and a woman, whose relationship is not clear, are staying at a baroque hotel-chateau, and another man seems to be convincing the woman that somewhere the year before she promised him her love, all of which may or may not be true. Times, places, and points of view shift as they do in dreams. The film has been praised as the finest in history, denounced as simply a misty, mawkish romance, dismissed as a maze with an empty centre, and variously interpreted as a study of insanity, a satire of the idle rich, an exercise in cinematic style, a criticism of sculpture, a revival of the myth of Orpheus, Eurydice, and Death. One thing is certain: to try to appreciate it in terms of ordinary narrative is to end up baffled and bored. Resnais has said that for him it is "an attempt, still crude and primitive, to approach the complexity of thought and its mechanisms." Hence an analogy with ambiguous modern poetry, or with the complex memory structures of music, is bound to be more useful to a spectator than one with the novel. And perhaps the right course is to avoid any analogy whatever with another art and simply remember that the movies are the most suitable visual equivalent yet invented for the space-time structures of the dreaming human mind.

Antonioni is not interested in dream structures. Also, as we have noted, he has himself referred to his pictures as "novels in images:" However, he has added that part of his artistic aim has been to "undramatize" reality (a reminder of his early career as a documentarist) and "to analyze sentiments as they are to-day"; and the fact is that in his best films he does not so much tell stories as describe modern emotional situations. Moreover, although he can handle dialogue effectively, he plainly prefers to describe a situation with the camera—often so exclusively that the spectator feels forced to forget any analogy with prose fiction. One of the longest sequences in *La notte* is nearly as undramatic and unsymbolic as reality itself; it merely shows the unhappy wife (who at the end of "the night" tells her husband she no longer loves him) taking an apparently aimless stroll from the centre of Milan out into the suburbs, stopping occasionally to look at a stopped clock, a decaying wall, railway lines, a fight, a launching of homemade rockets. In *The Eclipse* the last words of the lovers are promises to see each other every day "and the day after that" and especially "tonight, at eight, at the same place." Then, in a dusk sequence lasting several minutes, the camera stares at a pile of bricks outside the woman's apartment, a piece of wood she had thrown into a barrel of water, a nurse wheeling a pram, an empty street, a newspaper (with a headline suggesting war), buildings, trees, and a street lamp. Neither of the lovers appears at the spot agreed on for their date, and the spectator is left to draw his own conclusions about the meaningless solidity of reality and the growing fragility of "sentiments as they are today."

XI

Such films, although they do not represent the whole of the new cinema, have irritated many people (not always without reason) and have led to the charge that today's directors are in favour of form without content. This is easily answered. Fellini, in his own words, is concerned with "the terrible difficulty people have in talking to each other . . . the desperate anguish to be *with*." Resnais has shown that one of his major concerns is memory, and this is not recent: he once made a documentary on the French National Library entitled *All the Memory of the World*. Bergman's many films are so much a record of his personal search for salvation that he objects strongly to their being shown out of the order in which they were made. A serious concern with the problem of violence is discernible in the melodramatic improvisations of Godard. Antonioni is a humanist who worries not only about the death of love but also about the rate of technological change in comparison with the rate of change in our nervous systems. Kurosawa is, among other things, a grim satirist of Japanese bureaucracy. Buñuel has been a foe of bigotry, injustice, and hypocrisy throughout his long career. Many of the New York avant-garde films are about

racism, civil rights, war, and poverty. I have mentioned the English type of social realism, the Polish hard look at heroism, the Hollywood attempt to handle formerly shunned topics. One can find serious content in comedies; Jacques Tati's *Les Vacances de M. Hulot* (*Monsieur Hulot's Holiday*) is about banality and regimentation (besides being very funny).

I think that what people really mean by the charge of form-without-content is that many—certainly not all—post World War II directors tend to ask questions without answering them. The inexplicitness in the new cinematic language and in the narrative structures carries over into subject matter. In *Hiroshima mon amour* the problem of forgetting, which is related to the problem of living fully in the present, is presented on the small scale of personal disaster and on the almost unthinkable scale of atomic war; but Resnais does not offer a solution. In none of his films does Antonioni suggest what we can do about the death of love and the rate of technological change, except possibly to increase our pity for each other. Toward the end of *The Virgin Spring* Bergman allows the father, who has killed his daughter's murderers, an enigmatic prayer: "I don't understand you, God . . . yet I ask forgiveness for I know of no other way to live." In Buñuel's *The Exterminating Angel* everybody is kept from walking through an open door by a mysterious, contagious paralysis of the will. What does this apparent parable really mean? "After all," one of the characters remarks, "nothing explains anything."

Often the lack of commitment to a single interpretation is reflected in an ambiguity in the personages and the action. We are not told with whom we should sympathize, nor why certain characters have behaved in a certain way. Occasionally, as in *Last Year at Marienbad,* we cannot even be sure that they *have* behaved in a certain way. Recently the French critic Gilles Jacob summed up the trend:

Not so very long ago, the public was merely asked to be present. Then, since the show was no longer masticated and digested in advance, an intense participation was required of the public. Today, to all appearances, the spectator is expected to create the film himself.[14]

There are several possible explanations for this aversion to full explicitness. Some undoubtedly are related to a wish to stick to the specific nature of the medium; one can assume, that is, that photography's proper function is to show things as objectively as possible, and that since cinema is "naturally" in the present tense a film ought to offer no more clues to its meaning than an actual event would if it were unrolling before our eyes. Also, in all of the arts today the tendency is to stress the experiencing rather than the understanding of a work. And finally we must allow for some honest diffidence; many of today's directors find the problems of the modern world hard to solve, and feel that to

14 *Le cinéma moderne*, Serdoc, Lyons, 1964, p. 191.

pretend otherwise would be wrong. We are back with the impulse toward verism.

XII

Thus the movies' second chance and the way it is being used are full of bristling contradictions, and I hope I have not smoothed them over in the course of this discussion. Television is for film-makers a threat and a spur, a limitation, and a release. The larger minority audience provides an opportunity, but if it is cultivated too exclusively the result may be preciosity and finally economic disaster. A director-author may become the prisoner of his personal style, or, if he succeeds too well, the prisoner of the industry. The cinematic language has become more and more cinematic and much more faithful to reality, and at the same time somehow less and less explicit and perhaps less suitable for straight narrative. The best directors rightly reject the old entertainment outlook, rightly insist on truthfulness, and then somehow find themselves avoiding commitment and moral instruction. Since the whole business has only recently grown out of the fairground sideshow, and since it is in large part still a popular and even a mass medium, some of its professional critics make the appearance of every serious film an occasion for derision and demagoguery, whereas others are defensively and sometimes rather absurdly aesthetic in their approach.

So I suppose the proper—at least the prudent—conclusion is simply that the cinema will bear watching. But I cannot resist adding, not as a historian but as a movie-goer, that something very hopeful and exciting seems to be under way.

Alas, I do not even know what I do not know.
SAINT AUGUSTINE

To think is to forget a difference, to generalize
JORGE LUIS BORGES

Chapter 16 The Open Future

SINCE THERE IS no proper way to end a discussion of contemporary art, the usual methods are those of amateur weathermen—a hazardous projection of current trends, a consideration of prophetic personal aches, a damp finger in the local breeze, and a guess that the morrow will be unsettled, stormy, or fair. However, I have already applied such methods to the separate arts, and the reader has my guesses about the next decade or two: slightly unsettled for jazz, drama, and design; rather stormy for painting and the novel; mostly fair for poetry, ballet, sculpture, architecture, the movies, and art music. This final chapter will therefore be devoted to a few brief and very general remarks about what could happen to the modern movement as a whole in a future more open and much more distant—say sometime in the 21st century.

Let me insist on that "could," for these speculations should not be read as forecasts. My intention is merely to invoke an uncertain, even an improbable, future as an aid to understanding the present. Wondering about possible changes in the assumptions which underlie modern art seems a good way to review those assumptions, note their importance, and perhaps uncover contradictions in them.

I

Modern artists and their loyal public, myself included, are convinced that to create in the style of a past era is to risk producing minor art almost automatically. During the course of this book I have noted degrees in the conviction. It is stronger among architects, composers, painters, and sculptors than among

256

novelists, poets, and dancers. It is a caricature of itself among some avant-gardists, who apparently regard anything that is more than a couple of years old as belonging to a past era. It may be scarcely perceptible among some conservative modernists, who are willing to work in any manner that is even faintly characteristic of the 20th century. But it is clearly basic in the whole modern movement.

Is there much prospect of a change in this conviction during the next century? Offhand, one would say there is none at all. As was emphasized in Chapter 5 of this volume, the assumption that history is a forward-moving, man-made process of innovation has been fundamental in Occidental thought and feeling since at least the 11th century, when Western European civilization broke definitely with Byzantium and the Orient and began to develop its own patterns and drives. The assumption has been apparent in small matters as well as great; styles in dress, for instance, were largely tribal, racial, national, and social everywhere in the world (as they still are in much of the East) until the European Middle Ages developed fashion, a temporal distinction in clothes. Since the 18th century the fundamental assumption has been greatly reinforced by theories of progress and evolution. And since 1900 it has been inescapable. We are haunted by the rate of technological innovation. What millenarianism was for an imaginative person in the early Christian era, historical accelerationism is for us. The hope and dread once inspired by Biblical prophecies now come from our awareness that six thousand years elapsed between the invention of the wheel and the building of the first steam railway, one century between the railway and the first airplane, and half a century between the airplane and the passenger rocket.

There are, however, other aspects of our general cultural situation which ought to be kept in mind. The belief that today's artists must innovate constantly—that change itself is our period style—has already, in my opinion, pushed painting to the end of its revolutionary history and made it a matter of private visions and individual talents expressing themselves in ways familiar for a generation or more. The same thing appears to be happening in other arts. Most of today's aesthetic "movements" are neo-this or neo-that. Increasingly, the whole modern stylistic system has come to resemble a closed reservoir formed by the convergence of several kinds of water. Currents far below the surface unite and separate in manifold ways, and sometimes roar up into spectacular waves which look new, are given new labels by journalists, and seem to be rushing somewhere. But it is always the same water. The American critic Harold Rosenberg, at the height of the Abstract-Expressionist vogue in New York, could write:

The "latest" styles in art have been with us from birth; for many, their manifestations have become part of Nature. There are people who are made nostalgic, if at all, by the

sight of the Modern. . . . The famous "modern break with tradition" has lasted long enough to have produced its own tradition.[1]

Another informed and sensitive, and much less cheerful, observer, Stephen Spender, has said:

Carried out programmatically in a few works of heroic dimensions (*Sacre du Printemps, Ulysses, The Waste Land, Guernica,* etc.), the great modern achievements were wagers which made gestures, invented methods, but laid no foundations for a future literature. They led in the direction of an immensity from which there was bound to be a turning back, because to go further would lead to a new and completer fragmentation, utter obscurity, form (or, rather formlessness) without end.[2]

From such observations one can proceed, as indeed Spender does in regard to literature, to the conclusion that today we are already in the post-modern period.

As my earlier chapters have indicated, I would at the moment disagree sharply with any such conclusion. The history of Western culture seems to me full of proof that a multi-art period style like our own, which has recovered from its birth trauma and has reached a confident maturity, can continue to be vital for a long while without any radical changes in its makeup. But how long is "a long while" in the present and rapidly coming phases of our continuing technological, scientific, economic, and social revolution? There does seem to be something *ultimately* contradictory in a description of a stylistic movement springing from our dynamic conception of history and then ceasing to move— stabilizing itself as a closed energy system.

In other eras this sort of contradiction has been resolved by going ahead into unexplored aesthetic territory, by borrowing from outside cultures, and by reviving styles of the past (these too were often unexplored territory). Soon, however, there may not be any very interesting areas still unexplored; already many artists are tacitly agreeing with Spender that "to go further would lead to a new and completer fragmentation, utter obscurity, form (or, rather formlessness) without end." And modern art is already international enough for us to suppose that by the middle of the 21st century there may not be any outside cultures, unless one is discovered on another planet.

So we are left with revivalism as a strong possibility for sometime around the year 2050. Also, if it is true that to create in a style of a past era is to produce minor work, we are left with a probability that the art of that not-so-distant year will not be highly regarded by serious people. It can be envisaged as an eclectic entertainment, or game, or sentimental appeasement, designed for tired technocrats—in short, as the triumph of certain unfortunate trends which have become noticeable since World War II.

1 *The Tradition of the New,* Grove Press, Inc., New York, 1961, p. 9.

2 *The Struggle of the Modern,* University of California Press, Berkeley, 1963, pp. 258–259.

II

This discouraging probability can be dismissed, however, by arguing that, at least in the realm of art, nothing is but thinking makes it so and by assuming that in 2050 stylistic revivalism will somehow have ceased to produce the "minor" psychological effect it does now. An optimist can suppose that, again at least in the realm of art, our Occidental feeling for linear evolution, for the need to realize all potentialities, and for an accelerating rate of change will be replaced by something like the ancient and Eastern notions of cyclical history or an eternal present.

Such a drastic shift in our intellectual and emotional stance could well make possible the use of traditional styles without any loss of expressive power. Several centuries of Oriental art are proof. Are there signs such a shift could occur?

There are, and some are oddly located in the middle of the modern movement (I realize that here I am being inconsistent with my previous generalizations, but there are contradictions within our cultural pattern itself which need some attention). Artists who have behaved in terms of form and style as if they were committed to the Western belief in forward-marching history have sometimes conveyed a contrary opinion implicitly or explicitly. In *Finnegans Wake* Joyce adopts the cyclical theory of history formulated by the Italian cultural theorist Giambattista Vico in the 18th century. The poetry of Yeats is informed by an esoteric doctrine of cycles, or spirals, symbolized by whirling cones he called "gyres." Mondrian thought that art "should not follow the intuitions relating to our life in time." In Pound's *Cantos* fragments of Eastern, Western, present, and past civilizations are mixed in a chaos of simultaneity. Eliot, in his now classic essay on "Tradition and the Individual Talent," displays a spatial and mildly Oriental, rather than a temporal and Occidental, conception of "tradition":

> It involves, in the first place, the historical sense . . . and the historical sense involves a perception, not only of the pastness of the past, but of its presence; the historical sense compels a man to write not merely with his own generation in his bones, but with a feeling that the whole of the literature of Europe from Homer and within it the whole of the literature of his own country has a simultaneous existence and composes a simultaneous order. This historical sense . . . is a sense of the timeless as well as of the temporal and of the timeless and of the temporal together[3]

Since World War II such religious, psychological, and philosophical doctrines as Zen Buddhism, Taoism, Hasidism, Existentialism, and Structuralism, each of which to some extent conflicts with the Western idea of history forever on the march, have found favour with avant-gardists. Even the Marxists, although they are apt to be shy about saying so, have their mystical belief that the histor-

[3] *Selected Essays,* Harcourt, Brace & World, Inc., New York; Faber & Faber, Ltd., London, 1934, p. 14.

ical process will end some year—which just might be 2050. And if we are to believe Beckett the whole sorry business has already ended.

In thinking about what this semi-Oriental, antihistorical climate of opinion could become in the 21st century, we should not forget the pressure of past styles generated by museums, tourism, reproductions, and critical studies. It is true that today this pressure is scarcely felt by modern artists (although the recent resurgence of historicism in architecture could be cited as evidence to the contrary). It is kept dammed up, so to speak, by our belief in the historical relativity of artistic values; Bach's style, we say, was great for the early 18th century, Mozart's was great for the late 18th, Webern's is great for the 20th. But one can imagine the dam bursting when our knowledge and appreciation of the past are what they may be in 2050 and when our belief in the relativity of values is sufficiently eroded by a "sense of the timeless as well as of the temporal and of the timeless and of the temporal together." And if the dam were to burst, an infinite number of styles—of Latin odes, Peruvian feather cloaks, Italian madrigals, Baroque churches, Romantic painting, Japanese dances, and whatever you wish—would become as available for contemporary creative activity as they are now for appreciation.

In sum, it is not impossible, although I confess to finding it difficult and fanciful, to envisage a 21st-century sensibility which would call into existence an art both eclectic and major. Such an art might have the disadvantages we associate with the more extreme kinds of classicism and romanticism, since it would be outside of, and irrelevant to, the history made by technological change. But for that very reason it would have the advantage of never being out of date.

III

So far we have been supposing that our modern period style must run out of power eventually, as period styles have always done, and that when the sad day arrives the artists involved will find that their extremism has left them with no place to go except back into the pre-modern past. If they go back under present conditions, the result will be felt as minor art. If they have the help of an essentially non-Occidental attitude toward history—of a new type of audience expectation—the result could be felt as something detached, noble, and universal. Now let us suppose that they refuse to turn back into the styles of past eras. What might be the situation in 2050 if they continue in what Spender calls "the direction of an immensity"? Does it not seem likely, in view of the extremism of today's avant-garde, that the "immensity" will lie beyond the end of the history of what most of us think of as "art"?

Throughout this book I have been making conventional assumptions about my subject. Artists, I have assumed, are as-if thinkers. They create arbitrarily

limited orders—small worlds within the real world—in subjective, strictly human terms. They make enclaves in an apparently hostile universe. These enclaves reassure us about our common humanity. The reassurance works because we know the enclaves are made by man and not by God or nature. Art is man making a spectacle of himself, and in its pure, or "fine," form it is nothing but that—in ordinary language, it is useless. On the basis of these and some corollary assumptions, I have gone on to maintain that modern art is art freshly conscious of itself as *art,* as something arbitrarily, even extravagantly, different from non-art. It is make-believe proclaiming itself as make-believe (it is other things, too, of course) in order to reassert our common humanity. Hence it has a strong tendency toward anti-illusionism, ambiguity, formalism, and self-reference.

Since the beginning of the century, however, the insistence on art as art (often accompanied by an insistence on the specificity of each kind of art) has been countered by a tendency to blur the frontiers between art and science, between art and technology, between art and facts or objects, between art and life. This tendency has arisen partly from the inner, dynamic "logic" of the modern movement itself, partly from developments in science and technology, and possibly from a new feeling about the nature of reality and about the alleged difference between subjective and objective data.

The blurring, it seems to me, has become more noticeable in recent years. My remarks in Chapter 1 about how scientists, unlike artists, are constantly aiming at objectivity can of course still stand as theory; we have no Action astronomers and no aleatory economists with high reputations. Also, the direct influence of science on modern artists has been exaggerated by both optimists and pessimists. Nevertheless, it is often hard to say exactly what *emotional* difference there is between our thinking about a physicist's space-time continuum and our experience of certain aspects of modern music, cinema, and literature, between seeing a model of an atom, or a photograph of microscopic life, or a visual presentation of a mathematical formula, and seeing certain kinds of modern painting and sculpture. Moreover, there is an imaginative element in some of today's advanced scientific thinking which resembles the so-called intuition or inspiration of artists. And while this weakening of frontiers has been going on there has been a growing inclination among artists to regard "aesthetic" as an insult. John Cage's half-humorous, half-serious stunts, the number of elaborate, often expensive Happenings which have been staged in streets and on beaches, and the extreme ambiguity of some recent novels, plays, and movies are only part of the trend. To these avant-garde manifestations we must add some very sober-minded refusals to make a clean distinction between technology and such arts as architecture, sculpture, painting, and music.

All of this at the moment constitutes a very small part of our total cultural

situation. It can scarcely be taken to mean that by 2050 a sophisticated connoisseur will be able to enjoy the real world as a kind of vast combined Happening and collage, or that by then science and technology will have swallowed the last artist of the old-fashioned, arbitrary, dreaming breed. But it does strongly suggest that in thinking about the distant future we must be ready to modify our premises about the nature of the complex phenomenon we call "art." One of the effects of this phenomenon, according to Coleridge, is "to make the external internal, the internal external, and make nature thought, and thought nature." This effect is beginning to be apparent in many disciplines which we do not normally think of as being aesthetic.

Index